THE
ARTS

DENNIS J. SPORRE
University of North Carolina at Wilmington

PRENTICE-HALL, INC., Englewood Cliffs, N.J. 07632

Library of Congress Cataloging in Publication Data

Sporre, Dennis J.
 The Arts.

 Bibliography.
 Includes index.
 1. Arts—History. I. Title.
NX440.S66 1984 700'.9 83-3389
ISBN 0-13-046938-6

Editorial/production supervision
 and interior design: F. Hubert
Manufacturing buyer: Harry P. Baisley
Page layout: Meryl Poweski
Cover design: Christine Gehring-Wolf
Cover art: Detail of Bridge at Argenteuil
 on a Gray Day; *Claude Monet; National*
 Gallery of Art, Washington; Ailsa
 Mellon Bruce Collection

© 1984 by Prentice-Hall, Inc., Englewood Cliffs, New Jersey 07632

Printed in the United States of America
10 9 8 7 6 5 4 3 2 1

ISBN 0-13-046938-6

PRENTICE-HALL INTERNATIONAL, INC., *London*
PRENTICE-HALL OF AUSTRALIA PTY. LIMITED, *Sydney*
EDITORA PRENTICE-HALL DO BRASIL, LTDA., *Rio de Janeiro*
PRENTICE-HALL CANADA INC., *Toronto*
PRENTICE-HALL OF INDIA PRIVATE LIMITED, *New Delhi*
PRENTICE-HALL OF JAPAN, INC., *Tokyo*
PRENTICE-HALL OF SOUTHEAST ASIA PTE. LTD., *Singapore*
WHITEHALL BOOKS LIMITED, *Wellington, New Zealand*

CONTENTS

PREFACE

The purpose of this book is to present a skeletalized overview of the visual arts, music, theatre, dance, film, and architecture in Western civilization by focusing on selected developments and some of the historical circumstances which surrounded them. The reader of this text should gain a basic familiarity with major styles in Western arts history, some understanding of the idealogical, chronological, and technical implications of those styles, and also a feeling for the historical development of individual arts disciplines. In addition, this work attempts to provide the humanities instructor with a helpful textbook for courses which touch upon the arts in an inter- or multidisciplinary manner. To achieve these ends I necessarily have been selective and unabashedly practi-

cal. This text should not be considered an attempt to develop a profound or detailed history. It is comprehensive only in the sense that it spans the eras from ancient Greece to the present day and does so by *treating all the arts as uniformly as possible.*

Use of this brief text encourages utilization of other source materials. The instructor should develop emphases or foci of his or her own choosing by adding, in lecture or other form, detailed development of particular areas to the very general overview provided here. What, hopefully, I have done is provide a convenient, one-volume outline with enough flexibility to allow adaptation to a variety of purposes. Because of requirements for brevity, in many cases I have provided suggestions for, rather than details of, exam-

ination. Material is organized vertically and horizontally. One may isolate any subdivision, such as the general history or sculpture sections, and study the overview of that one area from ancient to modern times. Or one may read entire chapters or portions of chapters so as to gain a basic understanding and comparison of events and elements within a particular era. On the multisided debate concerning how a teacher should approach the arts, of course, this text takes a definite point of view. My focus, format, and choice of materials are based on the belief that one must be able to *describe* before he or she attempts to *theorize*. The issue is not a matter of right or wrong. Nearly all approaches have some merit. The issue, which is up to the individual instructor, is how and when a particular approach is applicable. This is one approach.

A significant problem in developing any inter- or multidisciplinary arts text is balancing thematic, chronological, and practical considerations. A strictly chronological approach works fairly well for histories of single or closely related disciplines because major movements tend to be compressed. When all the arts are included, however, we find a progression of shifting, sliding, overlapping, and recurring fits and starts which have not conformed to convenient chronological patterns. A strictly thematic approach, on the other hand, tends to leave the reader in limbo. Chronological guideposts simply cannot be ignored. So I have tried to maintain a broad and traditional chronological framework within which certain liberties can be taken to benefit thematic considerations.

The proper length for a book attempting to accomplish these ends is difficult to determine. How many pages can a student read in a semester, and how much detail can he or she be expected to learn? How much detail obscures the overview or curtails the flexi-

bility of the individual instructor? How little detail makes the book detrimentally superficial? How many pages make the book impractical to print or impossible to buy? The answers to these questions are debatable and unquestionably demand certain compromises. No longer does a textbook writer have the luxury of including more information than is necessary for a given course. Nevertheless, a study of arts history must treat all the arts uniformly; doing so within parameters satisfactory to classroom needs and publisher's requirements dictates the brevity occurring here. I have severely curtailed two components normally included in arts histories. One is biographical material. That choice is arbitrary and practical and not an implication that biography is irrelevant. Biography can be very important in understanding meaning in works of art. However, my task, as I see it, is to suggest an outline with a few principles and illustrations on which the reader or the instructor is free to build in whatever direction or manner suits his or her fashion. The second area of abridgement lies in analysis of specific musical and theatrical works. Analyzing a specific musical work or a play, as opposed to a painting, has limited value in a text such as this, because the student does not have the artwork immediately at hand and thus cannot link analysis to object. In addition, either classroom or outside study can always be linked to a picture in a text; availability of a given symphony or playscript for classroom use or outside study may be problematic. So I hope those who use this text will view it as a skeleton from which the student can gain a basic conception of the entire form. Adding flesh to the form for clarification or substantiation becomes, again, a matter of individual choice.

Basic to this discussion is a belief that teachers of arts survey courses should assist students to view the arts as reflections of the

human condition. A work of art is a view of the universe, a search for reality if you wish, revealed in a particular medium and shared with others. Men and women similar to ourselves have struggled to understand the universe, as we do; and often, though separated by centuries, their concerns and questions, as reflected in their artworks, were alike. In the same vein, artworks from separate eras may appear similar even though the historical context was different. Sometimes the medium of expression required technological advancement which delayed the revelation of a viewpoint more readily expressed in another medium. Sometimes disparate styles sprang from apparently the same historical context. We need to be aware of similarities and differences in artworks and to try to understand why they occurred. We may even need to learn that we did not "invent" a certain style or form. Through such efforts we gain a more enriched relationship with our own existence.

However, I am uncomfortable with detailed cause and effect relationships between the arts and history, especially in a broad treatment such as this. Significant uncertainty exists in many quarters regarding whether art is a reflection of the society in which it is produced or derives entirely from internal necessity, without recourse to any circumstances but artistic ones. I believe both cases have occurred throughout history and do not believe it within my purpose here to try to argue which or where. I also find continual linkages of general events to six (or seven) arts disciplines problematically repetitious. Therefore, I begin each chapter and some sections of chapters with a brief historical summary to provide a cultural context for the arts of that period. Some relationships of style to political, philosophical, and/or religious happenings are obvious; others are not entirely clear or may be questionable. In all cases the reader or instructor

is free to draw whatever connections or conclusions he or she deems appropriate. My purpose merely is to provide a relatively neutral overview.

One further problem is implicit. Artworks affect us in the present tense. Picasso did not do to Raphael what Darwin did to William Paley. Hard edged abstraction cannot antiquate our personal response to realism. Whatever the current vogue, the art of the past can stimulate meaningful contemporary responses to life and to the ideas of other humans who tried or try to deal with life and death and the cosmos, even as we do. Nonetheless, discussing dance, music, painting, sculpture, drama, film, and architecture falls far short of the marvelous satisfaction of experiencing them. Black and white and even color reproductions cannot stimulate the range of responses possible from the artwork itself. No picture can approximate the scale and mystery of a Gothic cathedral or capture the glittering transluscence of a mosaic or a stained glass window. No text can transmit the power of the live drama or the strains of a symphony. One can only hope that the pages which follow will open a door or two and perhaps stimulate someone to experience the intensely satisfying relationship that comes from actual works of art, of whatever era.

I have tried to keep descriptions and analyses of individual artworks as nontechnical as possible, but technical vocabulary cannot be avoided entirely. For that reason a Glossary is included. Although not all technical terms are accompanied by a recommendation to confer the Glossary, I have endeavored to define them either in the text or in the Glossary. (Instructors using this book might wish to consider *Perceiving the Arts* [Prentice-Hall] as a collateral text.) In addition, my approach sometimes varies from discipline to discipline and era to era. Although that variation creates some inconsis-

tency, I have tried to let the nature of artistic activity dictate the treatment given. Sometimes a broad summary of a wide-ranging style suffices; at other times a nationalistic separation is necessary; at still other times a more individualized or subdisciplinary approach is required. Regardless of what the circumstances appear to dictate, I have tried to keep my focus, ultimately, on style, or at least I have tried to develop the examination in such a way that the reader can infer stylistic characteristics.

I have separated the visual arts into architecture, sculpture, and two-dimensional art. The first two are fairly obvious, but the third is less so. At all stages in the history of art, pictorial art has encompassed more than easel painting. Drawing, printmaking, manuscript illumination, vase and mural painting, photography, and mixed media also have played a role, and we will note those roles where appropriate. Traditional painting, however, has formed the backbone of the discipline and will be our primary focus.

Theatre as an art form or discipline must be seen as a live performance, which actuates a script with live actors in some kind of physical environment. So our description of theatre will try to illuminate production, with a ready acknowledgement that the script is the basis, the style of which often determines the production style. As we examine theatre, we will focus on the production of plays written in the same period in which they were produced; but occasionally revivals of earlier plays give strong indications of the idea or style of production in that period.

Dance presents a problem because although dance is an intimate part of creative expression, and has been since the dawn of history, it also is an ephemeral art and a social activity. Even though I, personally, have a fundamentally relativistic approach to the question "What is art?", for the purposes of this text I have tried to limit "dance" to what for want of a better term we may call "theatre dance," that is, dance which involves a performer, a performance, and an audience. Such a limitation, still, is not entirely satisfactory since certain dances may in some cases, be "theatre" dance, in other cases, "social dancing," and in still other cases, both or neither. However, I hope the reader will understand that my choices are more or less practical, and that my purpose is to provide a general overview and not to argue for or against any particular theory.

Architecture and sculpture provide us with only a few minor problems either in definition or description. Both disciplines have the properties of immortality and, in general, give us a few excellent examples to draw upon, even from humankind's earliest days. Music, though also ephemeral, poses few problems, at least from the Middle Ages on. Finally, Chapter Six presents a new subject—film. A twentieth-century discipline, film has developed its own aesthetics and form, and is fully a part, if only a recent one, of Western arts history. So I include it as such.

I am guilty, as are most textbook writers, of robbing the arts of much of their excitement and rich interrelationships by utilizing neat, taxonomical divisions in each chapter so that one can see at a glance or focus conveniently on one art form or another. A history of the arts should read like a complex novel, because the history of the arts is a lively story—a story of humankind—full of life, breath, and passion. The ebb and flow of artistic history has created intricate crosscurrents of influence from society to individual to art; from other arts, to individuals, to society or societies, and so on in infinite variety.

It should be clear that a work such as this does not spring fully from the general

knowledge or primary source research of its author. Some of it does, because of my long-term and close affiliation with the various arts disciplines. Much is the result of notes accumulated here and there as well as re-search specifically directed at this project. However, in the interest of readability and in recognition of the generalized purpose of this text, copious footnoting has been avoid-ed. The bibliography at the end of this work is inclusive. I am indebted to many of my colleagues around the country and to John Myers, Sherrill Martin, and David Kechley, specifically. I also am indebted to Donna Cheatham, whose uncanny ability to read my handwriting made a final manuscript possible.

D.J.S.

INTRODUCTION

WHAT IS STYLE?

Our discussion of arts history will focus to a large degree on style. So before we begin we need to understand some of the things the term *style* implies. A standard dictionary definition would indicate that style comprises those characteristics of an artwork that identify it with a period of history, a nation, a school of artists, and/or a particular artist. We might say that style is the individual personality of the artwork. That definition is fairly concise, even clever, but how does it affect us? How do we use it? When we look at a painting, for example, or listen to a piece of music, we respond to a complex combination of all the elements that comprise the work—elements of form and of content. In the painting we see, among other things, colors, lines, and even perhaps the marks made by the brush as the paint was applied. In the musical piece we hear melodies, rhythms, harmonies, and so on. No two artists use these elements of his or her medium identically. Each artist has individual preferences and techniques. So when an expert compares several paintings by more than one artist, the expert can tell which paintings were painted by which artists. The expert extracts clues from the artwork itself: Are the colors bright, dull, or some combination? Are the lines hard or fuzzy, the contrasts soft or hard? Are the rhythms simple or complex? Those individual clues, those applications of elements,

help to indicate the artist's style, a style which may or may not be a reflection of society or philosophy, of biography or artistic considerations.

Many times groups of artists work in close contact with each other. They may study with the same master teacher, or they may share ideas of how their medium of expression can overcome technical limitations or more adequately convey the messages or concerns they all share. As a result, artworks of these artists may show characteristics of such similarity that the trained individual can isolate the works of these artists. The similarities which would allow for such identification would comprise the style of the group. Further expert examination could also isolate the works of individuals within the group as was mentioned earlier. This same process of isolation and identification can be applied to artworks coming from certain nations, and even to rather large slices of history, as we shall see.

Finally, how does a style get its name? Why is some art called "classic," some "pop," some "baroque," and some "impressionist"? The answer to that question is, "It depends." Some styles were named hundreds of years after they occurred, with the definition accruing from extended, common usage or an historical viewpoint. The Athenian Greeks, whose works we know as "classic," were centuries removed from the naming of the style they shared. Some labels were coined by artists themselves. Many stylistic labels are attributed to individual critics who, having experienced the emerging works several artists and noting a common or different approach, invented a term (sometimes a derogatory one) to describe that approach. Because of the influence of the critic or the "catchiness" of the term, the name was adopted by others, and used commonly. Thus, a "style" was born.

We must be careful, however, when we utilize the labels by which we commonly refer to artworks. Occasionally such labels imply stylistic characteristics; occasionally labels identify broad attitudes or tendencies which really are not stylistic. Often debate exists as to which is which. For example, romanticism has stylistic characteristics in some art disciplines, but the term also connotes a broad philosophy toward life in general. Often a style label is really a composite of several styles whose characteristics may be dissimilar, but whose objectives are the same. Terminology is a convenience, impossible to do without, but not always agreed upon in fine detail. Occasionally "experts" disagree as to whether certain artworks fall within the descriptive parameters of one style or another, even while agreeing on the definition of the style itself.

In addition, we can ask how the same label might identify stylistic characteristics of two or more unrelated art disciplines, such as painting and music. Is there an aural equivalent to visual characteristics, or *vice versa*? These are difficult questions, and potential answers can be troublesome as well as debatable. More often than not, similar objectives and chronological proximity, as opposed to directly transferable technical characteristics, cause usage of the same stylistic label in differing art disciplines. Nevertheless, some transferrence is possible, especially in a perceptual sense. For example, undulating line in painting is similar in its sense-stimuli to undulating melodic contours in music. However, the implications of such similarities have many hidden difficulties, and we must be careful in our usage, regardless of how attractive similarities in vocabulary may seem.

Styles do not start and stop on specific dates, nor do they recognize national boundaries. Some styles reflect deeply held convictions and/or creative insights; some styles are strictly mundane imitations of previous styles. Some styles are profound; others are

superficial. Some styles are intensely individual. However, merely dissecting artistic or stylistic characteristics can be a pretty dull experience for most of us. What makes the experience come alive is the actual experiencing of artworks themselves, describing to ourselves and to others such things about our reactions that can be described (and some cannot), and attempting to find the deepest level of meaning possible. Those experiences may help us to discern why individuals, groups, nations, and whole centuries of artists combined the elements of their art media to produce artworks that reflect a world so like or different from others'. Within every artwork exists a reflection of another human being attempting to express some view of the human condition. We can try to place that viewpoint (artwork) in the context of the time or the specific biography that produced it and speculate upon why its style is as it is. We can attempt to compare those contexts with our own. We may never know for sure the precise stimuli that caused a particular artistic reflection, but our attempts at understanding make our responses more informed and exciting, and our understanding of our own existence more profound.

Chapter 1

THE BEGINNINGS OF WESTERN CULTURE

- Hellenes, Mathematics, and Humanism
- The Arts of the Periclean and Hellenistic Periods
- Romans, Amalgamation, and Pragmatism
- The Arts of the Roman Eras

HELLENES, MATHEMATICS, AND HUMANISM

Why does man create works of art? Is there a special and insatiable need to convert perceptions of the world into something more "real" than outward appearances? Probably these questions are unanswerable—at least the answers will differ greatly from individual to individual. However, questions like these have been asked, and the answers debated, for centuries. We can trace the arts far into prehistoric eras. Sophisticated painting and sculpture existed in Paleolithic cultures 20,000 years before the Christian era. The cave paintings of Lascaux and Altamira probably are familiar to most of us, even if we have never formally studied art history. The history of the arts in Paleolithic, Neolithic, Assyrian, Mesopotamian, Egyptian, Mycenaean, and other pre-Hellenistic eras is important and fascinating, but our Western traditions are more recent and date essentially to the small city-state of Athens, Greece, in the fifth century B.C.

Athenian culture developed from complex interrelationships of politics, philosophy, religion, geography, and economics, and from previous civilizations and influences in the Mediterranean world, including Egypt. The ancient Greeks pointed with pride to some of the external roots of their culture. Athens shared a common heritage and religion with many independent city-states in the region. The people of these city-states called themselves Hellenes, and their civilization developed partially from two geographic factors. One was the mountainous terrain of the Peloponnesian penninsula and surrounding areas, which kept the city-states isolated from each other and which kept their confederations rather loosely organized. The other factor was the Aegean Sea, which provided an open highway for trade and commerce with the entire Mediterranean world. The seaport of Athens was particularly well served by both of these factors.

Greek religion consisted of a large collection of Olympian gods of suprahuman qualities. Their mythical history had been traced by the poet Homer in the *Iliad*. Greek religion had no scriptures or holy books, even though the Greeks were highly literate; but the stories of the gods were well known through oral tradition and through books such as Hesiod's *Theogony*. The Olympian gods dwelt on the mythical (and also real) Mt. Olympus and comprised a family descending from Uranus, representing the heavens, and Gaea, representing the earth. The struggles and genealogies of these deities formed numerous and varied myths which, although central to Greek religion, were nevertheless confusing and to some degree confused. In addition to the central family of gods, the Greeks worshipped numerous local deities who were thought to preside over certain human activities and to protect various geographic features such as streams and forests. Gods were just slightly more than human, had individual human form, and sometimes, very human characters and actions. The Greek mind was an earthy one, and Greek thought and religion centered on and loved this life. An ancient Greek often directed his view toward the constellations, but his universe counted "Man as the measure of all things."

Philosophy was central to the Greeks. A keen mind and a desire to attempt to answer life's critical questions were vital. In the years prior to the apex of Athenian civilization under Pericles, philosophers such as Thales, Anaximander, and Heracleitus had great in-

fluence. They wrestled with questions such as, "What is the basic element of which the universe is composed?" (water); "How do specific things emerge from the basic elements?" (Things are formed by "separating out."); "What guides the process of change?" (The universe is in a process of flow. Nothing *is;* everything is *becoming.*) However, the philosopher most important to Periclean Athens was Pythagoras. In his search for reality Pythagoras concluded that mathematical relationships were universal. His deduction and postulation of what we call the *Pythagorean theorem* illustrates his viewpoint: "The square of the hypotenuse of a right triangle equals the sum of the squares of the opposite two sides." Pythagoras saw this as a universal constant, a concept applicable to *all* circumstances. He, therefore, differed from other philosophers in that his universe was constant, with a single reality existing apart from substance, whereas others imagined a universe based on a single physical element and constantly in change. He also saw mathematics as central to all life, including the arts.

War and victory hurled Athens into its Golden Age and spawned a revitalized culture. Early in the fifth century B.C. the Persians under Xerxes I threatened conquest of the Greek peninsula. Responding to that threat, several city-states, Athens among them, allied to form the Delian League. In 480 B.C. the Persians occupied Athens, whose citizens had evacuated, and destroyed it. Within a year the Greeks had retaliated, defeated the Persian fleet at Salamis, and driven out the Persian armies. The Delian League, the destruction of Athens, and the victory over the Persians were three important catalysts for transforming the young democracy of Athens with her thriving commerce, unique religion, and inquisitive philosophies, into a cradle of immense artistic achievement. The ruined city had to be rebuilt; a spirit of victory and heroics prevailed; the Delian treasury,

moved to Athens by Pericles (ruled 461–429 B.C.), was available to help finance the immense costs of artistic and rebuilding enterprises.

Athens had witnessed a succession of rulers and had slowly developed a fascinating form of democracy. Historians estimate that when Pericles came to power in 461 B.C. the population of Athens was approximately 230,000 people. Approximately 40,000 were free male citizens; 40,000 were women; 50,000 were foreign born; and 100,000 were slaves. However, in Athenian "democracy" only "free male citizens" were allowed to vote, and the "Tyrant," or ruler, wielded tremendous power.

Conditions were right for a Golden Age of culture. By historical standards Athens' Golden Age was very brief, indeed, less than three-fourths of a century. However, that fifth century B.C. (other than the third of a century in Israel, 4 B.C.–30 A.D.) was probably the most significant period in Western civilization.

If war and victory ushered in the Golden Age of Athens, war and defeat brought that age to a close: Athen's Golden Age began to crumble with the onset of the Peloponnesian Wars between Athens and her rival city-state, Sparta, in the middle of the century. Although the Athenians showed military skill in the defeat of the Persians early in the fifth century B.C., Athens was not a militaristic society. What she accomplished in the arts she lacked in judgement in pursuing military strategy. Through what appears from our vantage point to be a series of blunders, Pericles led Athens toward defeat in a war of attrition with her Spartan adversaries. As Athenian glory waned, an increasing attitude of realism or naturalism grew. The heroics of victory and idealism turned into the reality of defeat. This change in outlook or attitude marked a change in style in the arts as well.

However, although Sparta commanded

political dominance, it did not assume a cultural leadership. Spartan society was a rigorous, militaristic, and uncultured one. In fact, the term *spartan* denotes conditions of austerity, self-discipline, political rigidity, and general fortitude—conditions basic to Sparta and its values. Therefore, Athenian impetus and influence in things aesthetic were not superseded by Sparta and continued despite Athens' diminished role as a political power.

As the calendar moved from the late fifth into the fourth century, a new and more powerful Athenian middle class arose. The stinging wounds of defeat, the rational Sophistic philosophy of the middle class, the supplanting of Plato's absolute ideas with Aristotle's search for the essence of things in the nature of things themselves, dominated Athenian thought. Idealism and intellectualism gradually changed to emotionalism.

In the fourth century a new star was rising to the north, and by the middle of the century King Philip of Macedon had united Greece in an empire, to the throne of which came Alexander the Great in 336 B.C. Under the influence of the Alexandrian or Hellenistic Empire, which stretched from Egypt in the West to the Indus River in the East, civilization and the arts flourished. The influence of Hellenistic art extended beyond the fall of the Empire to the Romans and carried well into the Christian era.

The conquests of Alexander were Alexander's, and as might be expected, the unifying, ruling force of so dominant an individual crumbled with his death in 323 B.C. Regional fragmentation and struggles for power marked the post-Alexandrian, Mediterranean world. Nevertheless, the imposition of so vast an empire created an internationalism in culture that persisted and strengthened under the Roman Empire. Commerce flourished and international communication continued to carry Greek thought and artistic influence to all parts of the known world. Intercultural relationships blossomed, for example, Buddhist sculpture in India showed Greek influence, and the European pantheon of gods reflected a more emotional, Eastern approach. Throughout this new internationalism Athens remained an important nucleus for ideas and cultural accomplishments, however weak her commercial and military acuity may have become.

THE ARTS
OF THE PERICLEAN
AND HELLENISTIC PERIODS

Two-Dimensional Art

Humankind is complex, often seeking order from chaos, rational explanations, and intellectual challenge, while at the same time recognizing that emotions and intuitive feelings cannot be denied. The struggle between intellect and emotion may be the most significant undercurrent in human existence. Certainly the two forces are not mutually exclusive; one need not be denied to satisfy the other. Nevertheless, the history of Western arts often reflects the conflict between the two. The fifth-century Athenians recognized that struggle; indeed, so did Greek mythology, and the difference between intellectual appeals and emotional appeals was illustrated in a story, which demonstrates Periclean belief in the superiority of one over the other. Marsyus, a mortal, discovered an aulos discarded by the goddess Athena. (An aulos is a musical instrument associated with the wild revelries of the cult of Dionysius. See Fig. 1.1.) With Athena's aulos in hand Marsyus challenged the god Apollo to a musical contest. Apollo, patron of the rational arts of reflection, chose the lyre (a stringed instrument). According to mythology Apollo won the contest and thereby proved the dominance of intellect over emotion.

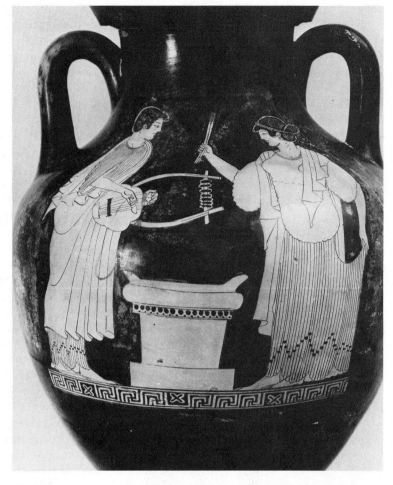

Fig. 1.1. Vase painting of Apollo playing a lyre and Artemis holding an aulos before an altar. The Metropolitan Museum of Art, Rogers Fund, 1907. All rights reserved. The Metropolitan Museum of Art.

Appeal to the intellect was the cornerstone of classic style in all the arts. In painting, as well as other disciplines, four characteristics reflected that appeal. First and foremost was an emphasis on form, that is, an emphasis on formal organization of the whole into logical and structured parts. A second characteristic was idealization, that is, an underlying purpose to portray things as better than they are (see Aristotle, *Poetics,* 1448), or to raise them above the level of the mundanely human. For example, the human figure is treated as a *type* rather than as an *individual*. A third characteristic is concession to convention, that is, to established customs, accepted principles, or rules. A fourth characteristic is simplicity. Simplicity does not mean lack of sophistication. Rather, it means freedom from unnecessary ornamentation and complexity.

These emphases were basic to Greek classicism, the predominant style of the era and the cornerstone of Western artistic tradition. The antitheses also existed, and as time progressed from the Age of Pericles to the Hellenistic period, dominant characteristics modified gradually to a less formal, more naturalistic, and more emotional style.

Such few examples of Greek classic paint-

ing as have survived can best be understood if we compare them with an example of an earlier style. Figure 1.2 shows a painted vase of the *archaic* style, just prior to the classic age. Compositional format, degree of realism, and use of convention help to illustrate for us. Even though the figures are recognizably human, they are handled in a geometric manner and appear primitive. Less obvious, but critical, is the convention of portraying the torso in full front while the head and legs are in profile. By convention, turning the head alone to the rear would have denoted a figure in motion.

Fifth-century Athenian painting of the classic style reflected some of these characteristics, including the principally geometric nature of the design. Such a compositional

Fig. 1.2. Vase painting. Dipylon Vase. 8th Century B.C. Height 42½″. The Metropolitan Museum of Art, Rogers Fund, 1914.

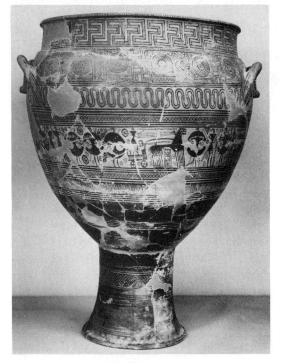

format indicated a concern for form and order in the organization of space and time. What separated the classic style in vase painting (our only extant evidence of Greek two-dimensional art) from its predecessors was a new sense of *idealized reality* in figure depiction.

In addition to a change in attitude, such realism also reflected a technical advancement. Many of the problems of foreshortening, the perceivable diminution of size as the object recedes in space, had been solved, and, as a result, figures had a new sense of depth. Depth and reality also were heightened in some instances by attention to light and shadow. Some records imply that mural painters of this period were highly skillful in representation, but we have no surviving examples to study. Also and unfortunately, the restrictions inherent in painting on a vase limit what an artist can or cannot do, and so we shall never know for sure the true level of skill and development of the two-dimensional art of this period. However, in vase painting of this style concern for formal design, that is, logical, evident, and perfectly balanced organization of space, is fundamental.

We generally relate style to treatment of form, as contrasted to content or subject matter; but often form and content cannot be separated. When classicism modified to a more individualized and naturalistic treatment of form, its subject matter broadened to include the mundane, as opposed, for example, to the heroic. In some vase painting we find an early transition. Figure 1.3 depicts "Women Putting Away Their Clothes." The graceful curves and idealized form of the classic style are present, but the subject matter clearly is mundane. The implications of this apparent departure are not entirely clear. Perhaps the utilitarian, as opposed to ceremonial, purpose of vases of this variety accounts for the early change.

Later, in the Hellenistic era, mundane

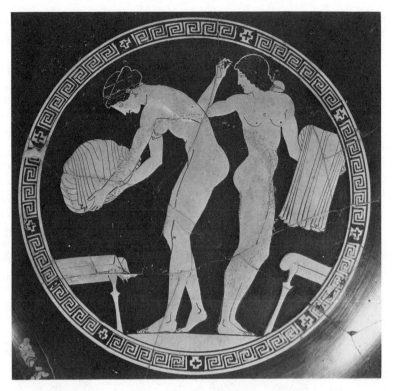

Fig. 1.3. Vase painting. "Women Putting Away Their Clothes." From a Kylix attributed to Douris. The Metropolitan Museum of Art, Rogers Fund, 1923. The Metropolitan Museum of Art.

scenes, sometimes comic and vulgar, were common in wall painting. Remarkable in these scenes is the use of aerial and linear perspective to indicate deep, receding, three-dimensional space.

Unfortunately for us, the few extant examples of classic and Hellenistic two-dimensional art furnish us with only a glimpse of these two important styles, so closely linked, but reflective of such different attitudes.

Sculpture

We are a bit more fortunate when our examination turns to sculpture. Stone and metal have the potential for immortality, and sculpture often exceeds all the arts in its ability to survive the centuries. However, great quantities of Greek sculpture do not exist, and more than likely some of the greatest examples have been lost forever. Much of what we

surmise of Greek classic sculpture actually comes from copies made at a later time. Existing sculpture basically is of two categories: independent, that is sculpture created for its own sake, and architectural, that which is executed to serve as part of the decoration of a building.

Styles do not start on a given date and end on another, even when they are as local and compressed as those of the small city-state of Athens during the rule of Pericles. The Greek classic style, especially in sculpture, was a style continually in a state of change, and one artist's works will be different from others' even though, in general, they reflect the basic characteristics described earlier.

Again, a contrast with the archaic style is in order. In Figure 1.4, the "Kouros," or heroized youthful athlete (c. 600 B.C.), we find two significant characteristics. First, is a clear

attempt to depict the human figure in fairly realistic form. However, the figure is not a human. It is a stereotype, a symbol, and, in a sense, an *idealization* of heroism. Nevertheless the sculpture lacks refinement. It may be idealized, but it does not depict ideal or perfect human form, and this difference helps separate the archaic from the classic style. The second characteristic is an attempt to indicate movement or dynamics. Even though the

sculpture is severely frontalized and static, notice that the left foot is extended forward in an attempt to create a greater sense of motion than if both feet were in the same plane. However, the weight of the body remains equally divided between the two feet.

The age of Greek classic style probably began with the sculptors Myron and Polyclitus in the middle of the fifth century B.C. Myron's best-known work "Discus Thrower" (Fig. 1.5), illustrates concern for restraint, subdued vitality, subtle control of movement coupled with balance, and a concern for flesh and idealized human form. Although our example of the "Discus Thrower" is a marble copy, Myron worked in bronzes and, because of the characteristics of that medium, was

Fig. 1.4. "Kouros" figure. The Metropolitan Museum of Art, Fletcher Fund, 1932. The Metropolitan Museum of Art.

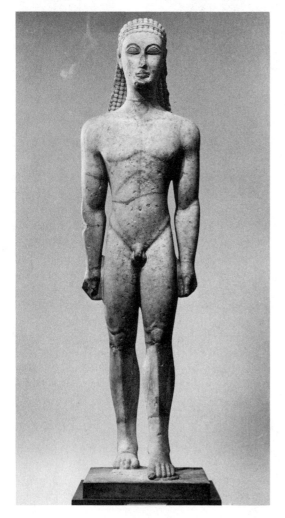

Fig. 1.5. Myron. "Discus Thrower." Roman copy after Myron. Photo courtesy of Heaton-Sessions Studio, New York.

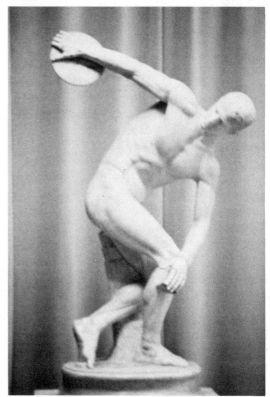

able to free his sculpture from many of the constraints of marble. A work of statuary, as opposed to relief sculpture, must stand on its own, and supporting the weight of a marble statue on the small area of one ankle poses significant structural problems. Metal, having greater tensile strength, provides a solution to many of these problems.

A second sculptor, Polyclitus, also contributed to the development of cast sculpture (see Glossary), and he is reported to have achieved in his "Lance Bearer" (Fig. 1.6) the ideal proportions of the male athlete. It is important to note, again, in our pursuit of the elements of Greek classic style, that the "Lance Bearer" represents *the* male athlete, and not *a* male athlete. In this work the body's weight is thrown onto one leg in the *contrapposto* stance. The resultant sense of relaxation

Fig. 1.6. Polyclitus. "Lance Bearer." Scala New York/Florence.

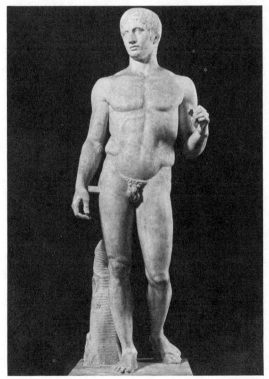

and controlled dynamics in the realistically treated human body and the subtle play of curves made possible by this simple but important change in posture are also characteristic of Greek classic style. The same reflection can be seen in Figure 1.7, the "Kritios Boy."

Fig. 1.7. Standing Youth (Kritios). Acropolis Museum, Athens. Alison Frantz.

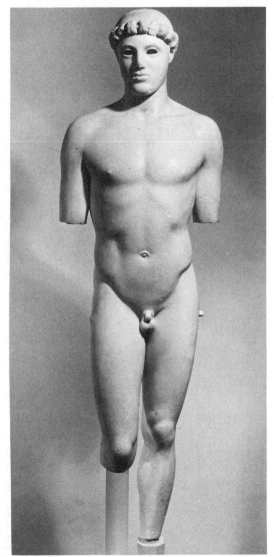

The east pediment of the Parthenon contains marvelous sculptural examples (Figs. 1.8 and 1.9). What strikes us first is the compositional accommodation to the confines of the pediment (see Glossary). This group of "Three Goddesses" or "The Fates" is now a breathtaking separate display in the British Museum in London. Originally, however, it formed part of the architectural decoration high on the Parthenon. It depicts the mythological story of the birth of Athena from her father's head. Also from the east pediment is the figure of Theseus. Together they illustrate Greek idealization in their suprahuman deities. We can learn much about Greek style and technique from these marvelous but battered figures. To begin, treatment of cloth is highly sophisticated. The drape and flow of fabric carefully reinforce the overall but reasonably simple line of the work; the technical

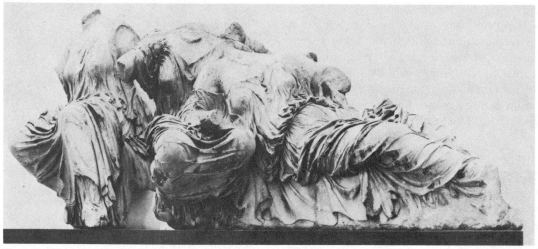

Fig. 1.8. "Three Goddesses." East Pediment, The Parthenon. British Museum, London.

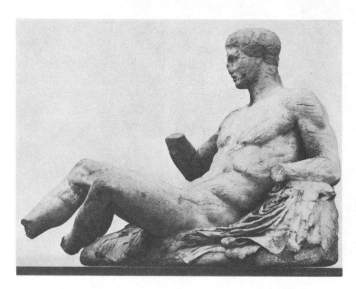

Fig. 1.9. "Theseus." East Pediment, The Parthenon. British Museum, London.

achievement this represents should not be minimized. However, this depiction is far from mere decoration. It is cloth in texture and form, but it is more than mere cloth. The manner in which this cloth reveals the perfected human female form beneath it forms a sophisticated aesthetic experience which once again reveals the classic purpose—not naturalism but the ideal. The purpose here is to raise these forms above the human or the specific to a symbolic level. Even in repose these figures show subtle and controlled grace and movement. The dynamic counterthrust of tensions and releases is obvious, but it always is restrained, never explosive or emotional.

The overall form and design of these figures, although constrained by the geometric parameters of the space of the pediment, show comfortable harmony in rhythmic flow of line as our eyes move from one part to the next. Control, again, is evident, with formal restraint the object. Compare these figures with those of a later style in Figure 1.10. The composition is more open, its movement violent and emotional, and subtle curvatures are replaced with a nearly geometric triangularity in a line that leads the eye in jerks and spurts from one form to the next.

Sculpture of the fourth century B.C. illustrates clearly the change in attitudes reflected in postclassic styles. Praxiteles is famous for individualism and delicacy of themes such as the "Cnidian Aphrodite" (Fig. 1.11). There is

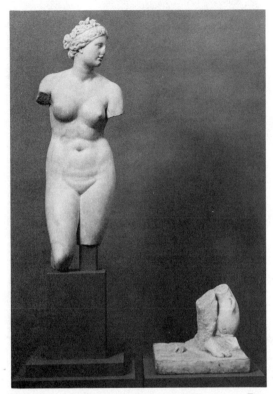

Fig. 1.11. "Cnidian Aphrodite." Undraped cast. The Metropolitan Museum of Art, Fletcher Fund, 1952. All rights reserved. The Metropolitan Museum of Art.

a "looking inward" in this work, which is different from the formal detachment of earlier sculpture such as "Theseus" (Fig. 1.9). Also, for the first time nudity appears in feminine form. Aphrodite rests her weight on one foot; her body sways to the left in the famous Praxitelean S-curve. Strain on the ankle of the sculpture is minimized by the arm's attachment to the drapery and vase.

The late fourth century found in the sculpture of Lysippos (a favorite of Alexander the Great), a dignified naturalness and a new concept of space. His "Apoxyomenos," or "Scraper" (Fig. 1.12), illustrates an attempt actually to put the figure into motion, in contrast to the posed figures at rest we have seen previously. The theme of the Scraper is mun-

Fig. 1.10. East Frieze, Halicarnassus. British Museum, London.

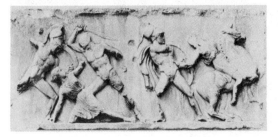

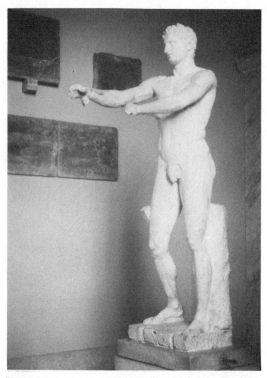

Fig. 1.12. Lysippos. "The Scraper" (Apoxyomenos). Photo courtesy of Heaton-Sessions Studio, New York.

dane: an athlete scraping dirt and oil from his body. The proportions of the figure are even more naturalistic than Polyclitus'; but the naturalism is still not photographic. Style had moved dramatically from earliest classic reflections, but classic influence remained.

Hellenistic style in sculpture continued dominant in the Mediterranean world until the first century B.C.; and as time progressed, style changed to reflect an increasing interest in *individual human differences,* in the variety of humankind's nature. Rather than idealization, the Hellenistic sculptor often turned to pathos, to banality, trivia, and flights of individual virtuosity in technical exploration. These characteristics appear in Figures 1.13, 1.14, and 1.15. "The Dying Gaul" is a powerful expression of emotion and of pathos as it depicts a noble warrior on the verge of death. "Winged Victory of Samothrace" displays a dramatic and dynamic technical

Fig. 1.13. "The Dying Gaul." Roman copy in marble and bronze executed in Pergamum. c. 240–200 B.C. Photo courtesy of Heaton-Sessions Studio, New York.

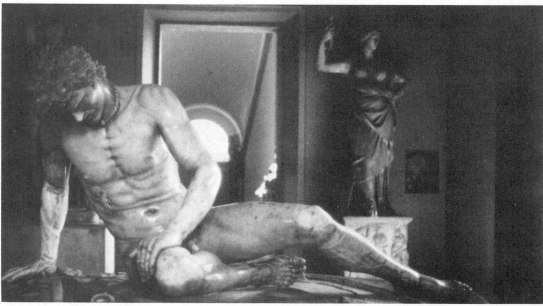

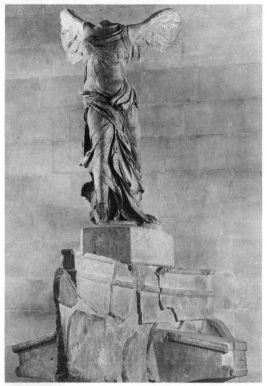

Fig. 1.14. "Winged Victory of Samothrace." c. 200 B.C. The Louvre, Paris.

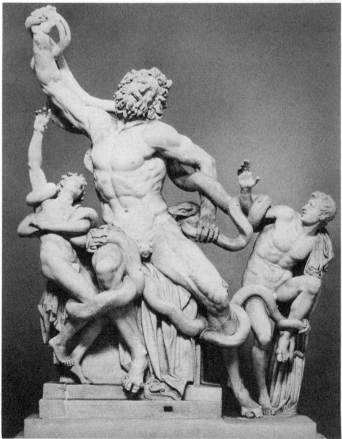

Fig. 1.15. "The Laocoön Group." c. 160–130 B.C. Photo courtesy of Heaton-Sessions Studio, New York.

virtuosity that has made it one of the most popular sculptures ever created. Finally, "The Laocoön Group" removes nearly all restraint from movement and emotion in an explosive moment, which might find a comfortable home in the baroque style.

Music

Very few examples exist of Greek music of any era, a handful of fragments and no clue as to how they were supposed to sound. However, thanks to surviving vase paintings and literature we at least can speculate on Greek classical philosophy or theory of music and about tone quality or *timbre*. The lyre and the aulos were the basic instruments of Greek music, and each played a significant role in preclassic ritual. In the era of classicism both the lyre and the aulos were used as solo instruments and as accompaniment. The contests which were so popular with the Greeks, apparently extended to instrumental and vocal music. As with all the arts, music was regarded as an essential to life, and participation was widespread among the Athenian population. Perhaps the word "dilettante," "a lover of the arts," would describe the average citizen of Athens. Professionalism and professional artists were held in low esteem, and Aristotle urged that skill in music stop short of the professional. Practice should develop talent only to the point that one could "delight in noble melodies and rhythms" (*Poetics*, Book VI, 6, 1341A). He also called for restraint from excessive complexity.

So during the Classic Age complexity apparently existed in some Greek music. We should not infer too much from such an observation. Complexity for the Greeks would no doubt still be simplicity by our musical standards. For instance, it appears reasonably clear that all Greek music of this era was monophonic. So "complexity" might imply technical difficulty within the scope of the

instruments used and perhaps melodic ornamentation, but not textural complication. Whether that is contrary to the classic spirit we do not know. A specific reaction against complexity occurred sometime after 325 B.C., and it is from the Hellenistic era that our only remnants of Greek music come. Scholars can only guess how the fragments must have sounded and only extrapolate from them concerning the music of the Periclean era and the Greek classic style. A few characteristics are apparent for some music. As stated in Aristotle, the idealizing characteristic was implicit. Music should lead to noble thought. There is no question that some music in the Greek repertoire led to the opposite. Dionysic rituals were emotional and frenetic, and music played an important role in these. Assumably calls for restraint and pursuit of the ideal imply some presence of music of an intellectual spirit.

If Plato can be taken as an accurate guide (see the *Republic*), Greek music relied on convention. Most of the performances in Periclean Athens appear to have been improvised (which may seem a bit at odds with order and formality). However, improvisation should not be interpreted here as excessively spontaneous or unrehearsed. The Greeks had specified formulas or "rules" concerning acceptable musical forms or modes for nearly every occasion. So the musician, though free to seek the momentary inspiration of the Muses, the mythological sisters who presided over the arts, was constrained by the conventions or "rules" applicable to the occasion.

A reliance on form, characterizing classic style, was reflected in music through relationships to mathematics in philosophy and religion. Greek classicism exemplified an orderly, formal, and *mathematical* approach to life, that is, reality. Pythagoras taught that an understanding of numbers was the key to understanding the entire spiritual and physical

universe. Those views, expressed in music, as well as the other arts, led to a system of sounds and rhythms ordered by numbers. Perhaps we are fortunate in this viewpoint, for without it Greek music would be even further beyond our reach. The intervals of the musical scale were determined by measuring vibrating strings. The results yielded relationships which even today are basic to musical practice: 2:1 = an octave; 3:2 = a fifth; 4:3 = a fourth. Since the characteristics of vibrating strings are the same today as they were then, this aspect of Greek music, at least, is comprehensible.

The Greek musical system was technical and highly organized, and those familiar with music history and theory will recognize the terms *enharmonic, chromatic,* and *diatonic,* as well as *tetrachord* and *Mixolydian* and *Dorian modes.* However, since we cannot reproduce the actual music of Periclean Greece and since discussion of the technicalities of the Greek musical system is outside the general scope of this book, we can move forward without further considerations.

Some musical fragments from the Hellenistic period give us a view of life and love among mortals—subject matter different from classic idealization but consistent with Hellenistic naturalism. For example, "Skolian," a drinking song composed as an epitaph in the second century B.C., commented on the ephemeral nature of earthly pleasures.

Finally, the Hellenistic period (about 265 B.C.) gave us a musical invention of great consequence, the organ. It was called *hydraulos,* water organ, and sound was produced by using water to force air upward through the pipes.

Theatre

The theatre of Periclean Athens was a "theatre of convention," and "convention," as it applies here, adds another dimension to this important term. Every era and every style have their conventions, those underlying, accepted expectancies and/or "rules" which influence the artist subtly or otherwise. In some styles conventions are fundamental; in others the conventions are the unconventional. Theatre of convention implies a style of production lacking in illusion, that is, stage realism. So, a bit in contrast to sculpture and painting which pursued the noble and the ideal with fair dependence upon a verisimilar but idealized treatment of subject matter, the Greek classic theatre pursued the same ends through a slightly different means.

Theatre of convention is to a large extent freer to explore the ideal than "theatre of illusion," in which scenic details are realistically portrayed, because dependence upon stage mechanics does not hamper the playwright. An audience will accept a description in poetic dialogue, but by convention does not demand to see it. Imagination is the key to theatre of convention. The Greek dramatist found that with freedom from the restraints imposed by dependence on illusion or depiction he was much better able to pursue the lofty moral themes fundamental to his perception of the universe. Although we have some extant plays from the era indicating what and how the playwright wrote, we are, however, at a loss to know specifically how that word became theatre, that is, a production. A playwright is always a man of his theatre, and so by not knowing for sure how a play was produced on the stage, we really do not know the style of the theatre either. Nevertheless, we can try to build a picture of production from descriptions in the plays themselves, other literary evidence, and from a few extant archeological examples.

Theatre productions in ancient Greece were part of three yearly religious festivals, the City Dionysia, Rustic Dionysia, and

Lenaea. The first of these was a festival of tragic plays and the last, of comic. The City Dionysia was held in the Theatre of Dionysius in Athens. The contests were begun in 534 B.C., before the classic era. Our knowledge of Greek theatre is enhanced somewhat by the fact that although we do not have the plays, we do know the titles and the authors who won these contests from the earliest to the last. From the records (inscriptions in stone) we know that three playwrights figured prominently and repeatedly as winners in the contests of the era.[1] They were Aeschylus, Sophocles, and Euripides. Our entire collection of complete tragedies is from them—seven from Aeschylus, seven from Sophocles, and eighteen from Euripides.

A playwright entering the contests for tragedy or comedy was required to submit his plays to a panel of presiding officers who selected three playwrights for actual production. The early plays of the classic style had only one actor[2] plus a chorus, and at the time of play selection the playwright was assigned the chief actor plus a *choregus,* a patron who paid all the expenses for the production. The playwright was the author, director, choreographer, and musical composer. Often he played the primary role as well.

At the same time as a sculptor created the "Kritios Boy" (Fig. 1.7) Aeschylus, the most famous poet of ancient Greece, began to write for the theatre. Clearly fitting the classic mold, he wrote magnificent tragedies of high poetic nature and lofty moral themes. In *The Agamemnon* Aeschylus' chorus warns us that success and wealth are insufficient without goodness:

Justice shines in sooty dwellings
Loving the righteous way of life,
But passes by with averted eyes
The house whose lord has hands unclean,
Be it built throughout of gold.
Caring naught for the weight of praise
Heaped upon wealth by the vain, but turning
All alike to its proper end.[3]

Aeschylus probed questions we still ask: How responsible are we for our own actions? How much are we controlled by the will of heaven? His characters were larger than life; they were types rather than individuals, in the idealistic vein noted previously. Yet his characters also were human, as evidenced by his portrayal of Clytemnestra in *Agamemnon.* Aeschylus' early plays consisted of one actor and a chorus of fifty, conforming to the convention of the time. He is credited with the addition of a second actor, and by the end of his long career a third actor had been added and the chorus reduced to twelve.

In Aeschylus's plays we find a strong appeal to the intellect. Aristophanes, the master of Greek comedy has "Aeschylus," a character in *The Frogs,* defend his writing as an inspiration to patriotism; to make men proud of their achievements. This is inspiration in an intellectual, not a rabble-rousing, sense. Aeschylus lived through the Persian invasion, witnessed the great Athenian victories, and fought at the battle of Marathon. His plays reflect this experience and spirit.

Overlapping Aeschylus was Sophocles, and he produced at his peak during the zenith of the Greek classic style. Sophocles' plots and characterizations illustrate a trend toward increasing realism similar to classic sculpture's. The movement toward realism was

[1]In each Greek tragic contest a playwright was required to present four plays in succession—three tragedies and a satyr play.

[2]Thespis is said to have initiated the single actor's role, breaking away from the choric composition of early Greek drama around 534 B.C.

[3]Peter D. Arnott, trans., in *An Introduction to the Greek Theatre* (Bloomington, Ind.: Indiana University Press, 1963), pp. 76–77.

not a movement into theatre of illusion, and even Euripides plays, the most "realistic" of the Greek tragedies, are not realistic in our sense of the word. However, Sophocles is a less high and formal poet than Aeschylus. His themes are more humane, his characters, more subtle, although his personages are not quite individuals. His plots show increasing complexity. Nevertheless, the formal restraint of the classic spirit remains. Sophocles lived and wrote beyond the death of Pericles in 429 B.C., and so he experienced the shame of Athenian defeat. Even so, his later plays maintain control, as opposed to the "action" noted in sculpture. Classic Greek theatre was mostly discussion and narration. Themes often dealt with bloodshed, but, though the play led up to violence, blood was never shed onstage.

Euripides was younger than Sophocles, although both men died in 406 B.C. They did, however, compete with each other. They do not share the same style. Euripides' plays carry realism to the furthest extent we see in Greek tragedy. His plays deal with individual emotions rather than great events, and his language, though still basically poetic, is higher in verisimilitude and much less formal than his predecessors'. Euripides also experimented with and ignored many of the conventions of his theatre. He experimented with the mechanics of scenography and questioned in his plays the religion of his day. His tragedies are more tragicomedies than pure tragedies: Some critics have described many of his plays as melodramas. He also was less dependent on the chorus.[4]

Plays such as *The Bacchae* reflect the changing Athenian spirit and dissatisfaction with contemporary events and show the same modification toward the mundane noted in sculpture and vase painting. Euripides was not particularly popular in his time, perhaps because of his less idealistic, less formal, and less conventional treatment of dramatic themes and characters. We might speculate whether his lack of popularity illustrated a question we can ask of any artwork that we find objectionable. Do our objections stem from the fact that the artwork tells us something about our world that we do not wish to hear or to acknowledge? Was Euripides too reflective of the reality of his age? Euripides' plays elicited much greater enthusiasm in later years and are unquestionably the most popular of the Greek tragedies today.

Tragedies and satyr plays (Euripides' *Cyclops* is the only example we have of that genre) were not the only works produced in the theatre of the classic era in Athens. The Athenians were extremely fond of comedy, but we do not have any examples from the Periclean period. Aristophanes (c. 450–c. 380 B.C.), of whose plays we have eleven, was the most gifted of the comic poets, and his comedies of the postclassic period are highly satirical, topical, sophisticated, and obscene. Translated productions of his comedies are still produced, but the personal and political objects of his invective are unknown to us, and so these modern productions are mere shadows of what took the stage at the turn of the fourth century B.C.

In the period from the middle of the fourth to the middle of the third century comedy was the staple of the Hellenistic theatre. Only five incomplete plays by Menander survive, but the characteristics of his style are fairly clear. In this New Comedy as contrasted with the Old Comedy of Aristophanes, the action was still bawdy, but the biting political invective was gone. The situations were pleasant and domestic, as opposed to the heroic nature of classic tragedy, and for the most part, superficial and without satire. Religion no long-

[4]The chorus was a distinctive feature of Greek drama, portraying the dual function (in the same play) of narrator and collective character—responding to the actors.

er played a central role in the theatre, and the chorus had disappeared.

If the plays of the Greek classic style treated lofty themes with language high in theatricality or poetic value, production style showed no less formality, idealism, and convention. Larger than life characters were portrayed by larger than life actors; that is, actors made larger than life by their conventionalized costumes. Actors and chorus wore brightly colored robes whose colors denoted specific information for the audience. The robes were padded to increase the actor's size; his height was increased by thick-soled boots called *Kothurnoi* and large masks whose fixed, conventionalized expressions carried specific information for the sophisticated and knowledgeable audience of the Greek citizenry. His height was further increased by an *onkos,* a wiglike protrusion on top of the mask.

Scholars are divided concerning the exact nature of the classic Greek theatre building and the nature of its acting area and scenery. Since our purpose is an overview, we can summarize some of the architectural and ar-

cheological speculation. Nevertheless, we must be well aware that these descriptions are speculation. Nothing of substance remains of the classic Greek theatre building except its auditorium, that is, seating area, and parts of the "orchestra," the original, circular acting and dancing area. The presence or absence of a stage and scenic background and at what date these were introduced are subjects of great debate.

It appears that in its earliest forms, and prior to the Periclean period, the theatre was nothing more than a completely circular orchestra in which ritualistic dances were performed. The seating area, originally just a hillside, nearly encircled the orchestra. Later, a scene building of some variety was added, and still later the scene building had moved forward to encroach upon the orchestra itself. Figure 1.16 shows the theatre at Epidaurus. In it we can see the foundation for the scene building, or *skene,* and the *paradoi,* between the auditorium and the *skene,* through which the chorus entered. The large, circular orchestra is obvious, and at its center is the ves-

Fig. 1.16. Theatre at Epidauros. Courtesy Mast Keystone Company, Davenport, Iowa.

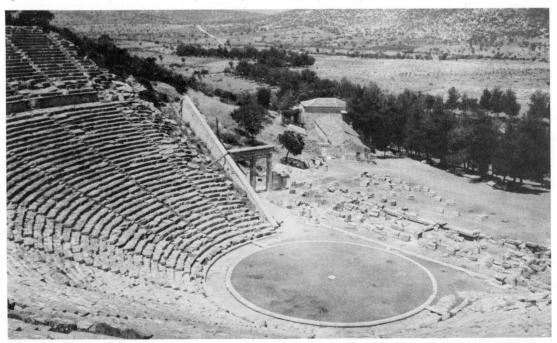

tige of the altar, which remained throughout the Greek era even though its ritualistic necessity had vanished.

In the Hellenistic period the stage area had developed into an elaborate, two-storied scene building with projecting wings at each end and a raised stage. Undoubtedly great variation existed among theatres in various locations, but, again, time has removed most examples from our grasp. The many theories of how Greek theatre productions worked, how scenery was or was not used, and whether or not and when a raised stage was present make fascinating reading, and the reader is encouraged to explore this area in detail elsewhere.

Dance

The religious rituals of ancient Greece centered on the dance. In fact these great festivals brought choruses of "dancers" from each tribe together on special occasions for competition. Most scholars agree that the Greek Theatre developed directly from these dances with their chorus of fifty. Dance, music, and drama were inseparably entwined, and each was a fundamental part of early and classic Greek philosophy, religion, and life. However, "dance" had a broader definition for the Greeks than it does for us and denoted almost any kind of rhythmic movement. As just noted, dance and music were inseparable; dance and poetry were likewise closely associated. A Greek could "dance" a poem, "interpreting with rhythmic movements of his hands, arms, body, face, and head the verses recited or sung by himself or another person."[5] Convention, apparently, was fundamental.

Dance in the Age of Pericles illustrates both classic and anticlassic styles. Certainly

[5]Lillian Lawler, *The Dance in Ancient Greece* (Middletown, Conn.: Wesleyan University Press, 1964), p. 12.

the dance of the Dionysic cult revels, which may have diminished but certainly continued under Periclean rule, must have disregarded form, order, restraint, and idealization. Their appeal was to emotional frenzy, not the intellect. However, the philosophies of the era, the relationship of dance to music and drama, and the treatment of dance by Plato and Aristotle indicate that those aspects of dance which were associated with the theatre, at least, must have reflected classic characteristics.

Dance, though, is an evanescent art form. Today, even with *labanotation* (see Glossary), we cannot know what a dance work looks like if we are not in attendance at the live, or at least filmed, event. So the treatises in literature, the musical fragments, and the archeological evidence on which so many have tried so hard to reconstruct the dances of the Greeks, give us no picture whatsoever. In fact, the very conventional nature of Greek art is our most formidable obstacle. It is clear that some vase paintings and sculpture depict dancers (Fig. 1.17), but we do not know to

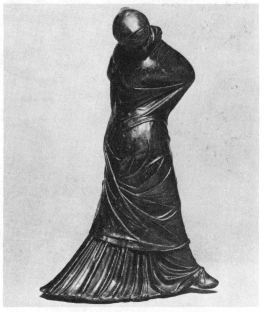

Fig. 1.17. Cloaked dancer. The Metropolitan Museum of Art, Bequest of Walter C. Baker, 1972. The Metropolitan Museum of Art.

what set of abstractions the conventions of these forms belong, and, therefore, we cannot reconstruct the acts in life that they symbolize. We simply do not know.

Architecture

Existing examples of Greek architecture, to which the arts of the Western world have returned for the past twenty-three hundred years, offer a clear and consistent picture of basic classic style. Nothing brings that picture so clearly to mind as the term "Greek temple." Even the most lightly educated among us have an amazingly accurate concept of the structure and proportions of a Greek temple. H. W. Janson makes an interesting point in his *History of Art* when he suggests that the crystallization of characteristics for the Greek temple is so complete that when we think of one Greek temple, we basically think of *all* Greek temples. Even so obvious a structure as a Gothic cathedral does not have this capacity, for we can only call to mind a specific Gothic church when we employ this recollection technique. Despite the explicit symbol of the Gothic arch, its employment is so diverse that no one work typifies the many.

The classic Greek temple as seen in Figures 1.18, 1.19, 1.20, and 1.21, has a structure of horizontal blocks of stone laid across vertical columns. This is called "post and lintel structure." It is not unique to Greece, but certainly the Greeks refined it to its highest aesthetic

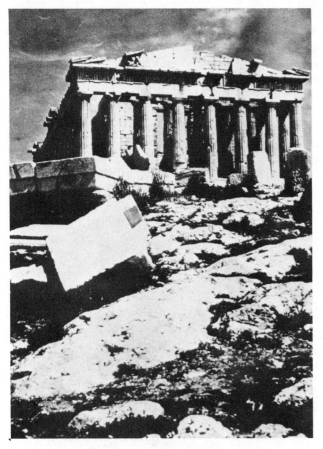

Fig. 1.18. The Parthenon. 448–432 B.C. Acropolis, Athens.

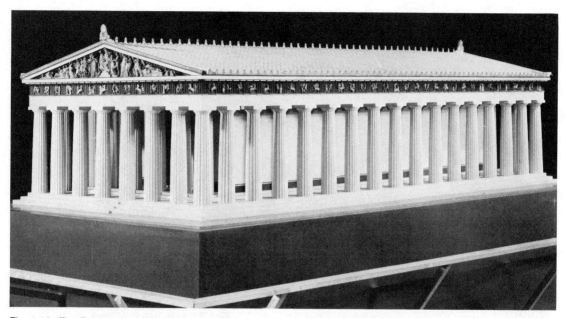

Fig. 1.19. The Parthenon. Model. The Metropolitan Museum of Art, Purchase, 1890, Levi Hale Willard Bequest. All rights reserved. The Metropolitan Museum of Art.

Fig. 1.20. Greek Temple. British Museum, London.

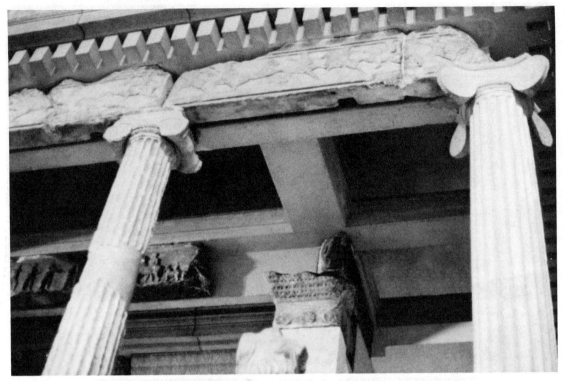

Fig. 1.21. Greek Temple. Detail. British Museum, London.

level. This type of structure creates some very basic problems. Stone is not high in tensile strength, that is, the ability to withstand bending and twisting, although it is high in compressive strength, the ability to withstand crushing. Downward thrust works against tensile qualities in horizontal slabs (lintels) and works for compressive qualities in vertical columns (posts). As a result, columns can be delicate, whereas lintels must be massive. However, only limited open space can be created using this structural system. Such a limitation was not of great concern to the Greeks because a Greek temple was to be seen and used from the outside. The Greek climate does not dictate that worshippers crowd inside a building. Exterior structure and aesthetics were of primary concern.

Greek temples were of three orders: Ionic,

Doric, and Corinthian. The first two of these are classic; the third, though of classic derivation, is of the later, Hellenistic period. The contrasts make an important, if subtle, stylistic point (Fig. 1.22, 1.23, and 1.24). We noted in the introduction to this chapter that simplicity was an important characteristic of the Greek classic style. Ionic and Doric orders maintain clean and simple lines in their capitals. The Corinthian order is more ornate and complex. When taken in the context of an entire building, this small detail appears not of great consequence; but it is significant in understanding the rudiments underlying this style and changes effected in it. Columns and capitals are a convenience in identifying the order of a Greek temple; but the orders denote more than just columns and capitals, even though our illustrations cannot ex-

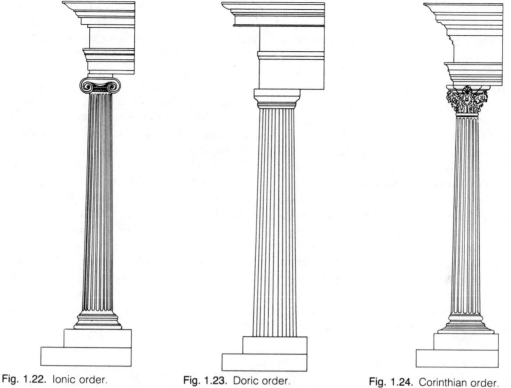

Fig. 1.22. Ionic order. Fig. 1.23. Doric order. Fig. 1.24. Corinthian order.

emplify differences existing in other parts of the temple in each order.

The Parthenon typifies every aspect of Greek classic style in architecture. It is Doric in character and geometric in configuration. Balance is achieved through symmetry, and the clean, simple line and plan represent a perfect balance of forces holding the composition together in perfect unity here on earth. We can compare the implications of this plan with those of a Gothic cathedral in which upward striving line, in leading the eye to the apex of a spire and then off into space, becomes a symbol for an unknowable God. But for the Greeks, deities were just slightly more than mortal men, and in the Greek temple, deity and humankind met in an earthly rendezvous reflected clearly in the compositional factors just noted. The human-centered phi-

losophy is also represented in the human scale of the temple.

The number of columns across the front and down the sides of the temple reflect specific conventions. The internal harmony of the design shows consonant harmony in the regular repetition of unvaried form. Each column is alike and spaced apparently equidistant from its neighbor, except at the corners where the spacing is clearly lessened to give a subtle, but important, aesthetic adjustment. Such sophisticated variations create a sense of regular repetition and balanced grace and perfection, but they save the building from the boredom of overregulated and unvaried repetition. The proportions of the parts are delicate and graceful but not weak or weedy. There is never a hint of feebleness in a classic Greek temple, nor is there ever a hint of pon-

derousness. The balance of forces is classic, that is, perfection. Perfection is achieved by sophisticated understanding of perception and not through slavery to mechanics or pure mathematics. Each element is carefully adjusted. A slight outward curvature of horizontal elements compensates for the tendency of the eye to perceive a downward sagging if all elements were actually parallel. Each column has about a seven-inch, gradual dilation to compensate for the tendency of vertical parallel lines to appear to curve inward. The columns also tilt inward at the top so as to appear perpendicular. The stylobate is raised toward the center so as not to appear to sag under the immense weight of the stone columns and roof. Even the white marble color, which in other circumstances might appear stark, was chosen to harmonize with and reflect the intense Athenian sunlight. There is some debate concerning the adjustments and refinements noted above. Vitruvius, the Roman architect, is our earliest known source to treat these adjustments as aesthetic. Some scholars now believe that practical concerns also played a role.

So here we have the perfect embodiment of classic characteristics: convention, order, balance, idealization, simplicity, grace, and restrained vitality; of this earth but mingled with the divine.

The temple of the Olympian Zeus (Fig. 1.25) illustrates Hellenistic modification of classic style, similar to painting, sculpture, and theatre. Scale and complexity are considerably different from the Parthenon, with an intent to produce an overwhelming emotional experience. Order, balance, moderation, and consonant harmony are still present, but even in these ruins we can see the change in proportions from the Parthenon in the slender and ornate Corinthian columns.

Fig. 1.25. Temple of the Olympian Zeus. c. 174 B.C. Athens.

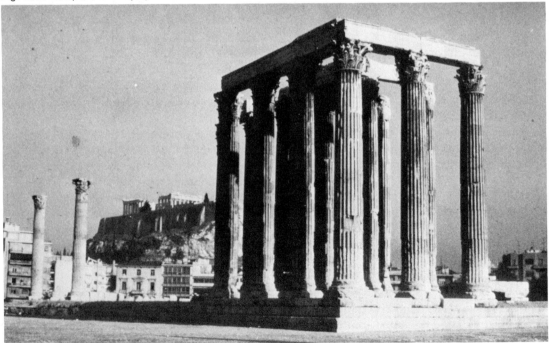

ROMANS, AMALGAMATION, AND PRAGMATISM

The rise of Roman civilization parallels, historically, that of ancient Greece. By the sixth century B.C. Asian–Greek invaders, the Etruscans, dominated the Italian peninsula, bringing to that area a militaristic and practical society, an anthropomorphic conception of the deities, and arts of Greek influence roughly equivalent to the archaic style. During the centuries of the Greek classic and Hellenistic periods, Rome existed under a Republic characterized by frequent class struggle and attempts to assimilate other Italian peoples.

Roman expansion came through military conquest. Very little commerce and industry existed in Rome itself, unlike Athens, and the quality of life in Rome came to depend directly upon the wealth of conquered regions brought to Rome as spoils of military victory. By the middle of the second century B.C. Rome had conquered Carthage in North Africa and Corinth in Asia Minor, and had thus assumed a place of political dominance in the Hellenistic world. The internationalization of culture, evident in Hellenic times, increased under the Romans. Later, of course, Rome would extend its control throughout Europe and eventually to the British Isles.

Control of such a vast empire for so long a time showed Roman genius at its best. The Romans were supreme managers and administrators; they brought to their world a significant code of law and innumerable engineering projects such as aquaducts and roads, some of which are still in use. Roman concern was for the utilitarian and the practical, as befitted Rome's Etruscan heritage, and such concern can be seen in the focus of her architecture. For example, Greek architecture focused on religion and nearly always reflected mythic or religious conventions. Roman architecture solved practical problems. The temple symbolized Greek architecture; the Triumphal Arch, the bath, and the amphitheatre symbolized Roman (Fig. 1.26). Rome assimilated much of her philosophy,

Fig. 1.26. Amphitheatre. 290 A.D. Verona. Photo courtesy of Heaton-Sessions Studio, New York.

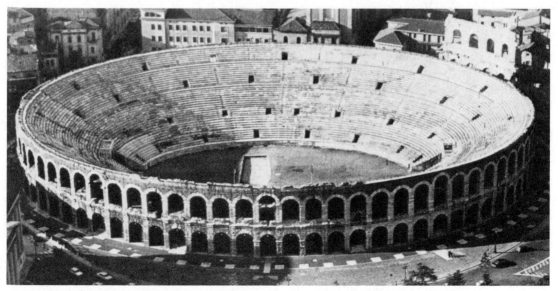

science, and arts from the Greeks and the Hellenistic world. An example would be Stoicism. Reason or *logos* governed the Stoic's world, and the Great Intelligence was God. Specific guidelines for goodness and nobility gave order to life. Stoicism centered upon acceptance of fate, duty, and the brotherhood of all men. The last belief had significant effect on the Western world because it gave Roman law, one of Rome's great contributions to Western culture, the ideal of bringing justice to all men. Essentially, however, Stoicism was pessimistic: All things were believed to be controlled by the Great Logos, and man could do nothing but submit to this greater Will.

By the turn of the Christian age the Emperor Augustus (27 B.C.–14 A.D.) had launched Rome into a significant rebuilding period which emphasized arts and literature. This was the age of the poets Virgil and Horace, and Virgil's *Aeneid* is said by some critics to have brought "instant mythology" to the Romans. Virgil recognized the greatness of the Golden Age of Athens and the influence that Homer's earlier *Iliad* and *Odyssey* had had upon that era. The *Aeneid* created a mythic history of Rome complete with a founding hero, Aeneas. The Flavian–Antonine period of the late first and second centuries A.D. produced the influence and style we identify today as typically Roman, with its vaults and arches. In this era Roman expansion moved eastward, culminating in the siege and destruction of the Temple of Jerusalem in 70 A.D.

In 180 A.D. the army took command, and for all intents and purposes central authority in Rome collapsed. For the succeeding century and a half emperors came and went, largely at the whim of the army, until early in the fourth century when Constantine I assumed the throne. During his reign two vitally important events occurred. First, Christianity was recognized as the state religion in 337 A.D.; second, the capital of the Empire was split between Rome and Byzantium. By the fifth century A.D. Rome had fallen to the Goths, and a new era in the history of Western art and civilization was beginning.

THE ARTS OF THE ROMAN ERAS

Two-Dimensional Art

Very little Roman painting has survived, most of it from Pompeii and preserved by the cataclysmic eruption of Mt. Vesuvius. However, frescoed wall paintings, paintings on wet plaster, which become a permanent part of the wall surface, appear to have comprised the bulk of two-dimensional art, much of which was an outright copy of classic and Hellenistic works. Greek artists and craftsmen were imported to Rome and produced most Roman artworks. So we should not find it unusual that Roman painting reflected classic and Hellenistic characteristics, although certain uniquely Roman qualities were added. It is difficult to state with any certainty that the illustrations which follow are typical; certainly they are typical of what exists for us to examine.

The work "Hercules and Telephos" (Fig. 1.27) clearly reflects the naturalism of figure depiction characteristic to the Hellenistic style, and we note with interest the mythic and heroic subject matter portrayed. In contrast, the painting "Lady Playing the Cithara" (Fig. 1.28) combines naturalistic detail with everyday (or genre) subject matter. Each of these is a formally composed picture, with a self-imposed boundary. However, some Roman painting moves in a different direction.

Some Roman painting combines landscape representation with painted architectural detail on a flat wall surface to create a panoramic vista seen through an imaginary window. The detailed complexity of orna-

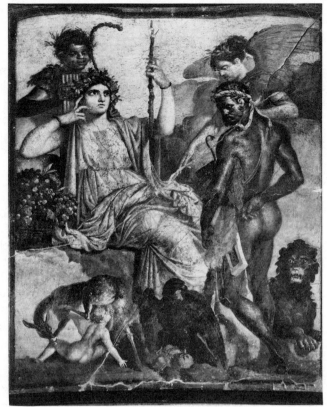

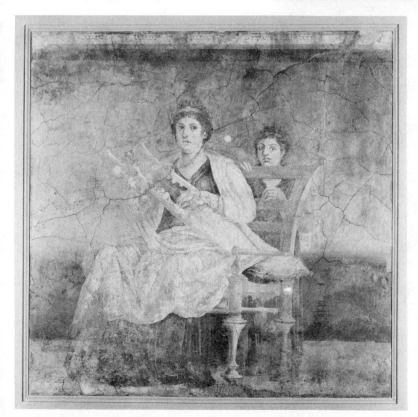

31

mentation of such landscapes, framed by fake architectural detail, has been suggested by some scholars to be remarkably similar to the rococo style of the eighteenth century.

Sculpture

Times and viewpoints change; the revelation of humankind in artworks changes as well, and this is clear in Roman sculpture. We should not be tempted to classify all Roman art as an imitative and sterile reconstruction of Greek prototypes. Certainly some Roman statues fit that category, but some show a vigorous creative life that is uniquely Roman and uniquely expressive of Roman circumstances. All the same, scholars are divided not only on what various works of Roman sculpture reveal, but also on what motivated them.

The "Portrait of an Unknown Roman" (Fig. 1.29) dates from a time in which

Hellenistic influence was becoming well established in Rome as the fresco painting of the previous section illustrates. So attributing the highly naturalistic representation of this work to the same tendency or viewpoint governing Hellenistic style, thereby making it a natural continuance or copy of Hellenistic work, is tempting. Such a conclusion, however, neglects an important Etruscan–Roman religious practice, undoubtedly of stronger influence. Portraits were an integral part of household and ancestor worship, and the image of a departed ancestor was maintained in a wax death mask. Wax is not a substance ideally suited for immortality, and so the naturalism of portraiture of this style may stem from the possibility that the bust was made from a death mask. However, there may be more than mere portrait accuracy in such a work, and some scholars point to an apparent selectivity of features and a reinforcement of an idea or ideal of ruggedness and character, for example.

The straightforward naturalism of the Republican era changed during the Augustan period. Hellenistic influence had grown by the late first century B.C. In certain quarters Greek classic influence dominated, but always with a Roman, that is, a more practical and individual, character. By the time of the empire, classic influence had returned sculpture to the idealized characteristics of Periclean Athens. Emperors were raised to the status of gods, perhaps, as some have speculated, because a far-flung empire required assurances of stability and suprahuman characteristics in its leaders.

The reality that men are men and not gods was not long in returning to Roman consciousness, however, and third-century sculpture exhibited a stark and expressive reality. In the fourth century A.D. a new and powerful emperor had taken the throne, and his likeness (Fig. 1.30), part of a gigantic sculpture (the head is over eight feet tall),

Fig. 1.30. Head of Constantine. 4th Century A.D. Photo courtesy of Heaton-Sessions Studio, New York.

shows an exaggerated, ill-proportioned intensity that we can compare with expressionist works of the early twentieth century. This work is not a reflection of Constantine's actual likeness. Instead, it is the artist's view of Constantine's perception of himself as emperor and of the office of emperor itself.

Music

We know that music was very popular among the Romans. Extant reports describe festivals, competitions, and virtuoso performances. Large choruses and orchestras performed regularly, and the *hydraulus,* the water organ, was a popular attraction at the Colosseum. The hydraulus, apparently, was so loud that it could be heard a mile away, and

the fact that it provided "background music" for the infamous feedings of the Christians to the lions banned it from Christian churches for centuries. Many Roman emperors were music patrons, and Greek music teachers were popular and very well paid.

Aristotle deplored overprofessionalism in the pursuit of music. Music for him was an art for its own aesthetic qualities and as a moral factor in character development; it was a measure of intelligence. Clearly the pragmatic Romans did not regard music in those terms. Professional dexterity and virtuosity were used as social tools, and such inane accomplishments as who could blow the loudest tone or hold a note the longest were heralded with great acclaim. Musical entertainment, though far from the Greek concept of art and inspiration, did fulfill an important social and political function for the Romans. As more and more people flocked to Rome from conquered territories, and the number of the idle unemployed grew, the state provided entertainments to keep the rabble occupied and under control. "Bread and Circuses" were problematic parts of Rome's approach to conquest and governance, and music played an important role in keeping the lid on some of the trouble. Music became less and less an individual activity and more and more an exclusively professional enterprise.

It appears doubtful that the Romans contributed much to musical practice or theory. They took their art music from the Greeks after Greece became a Roman Province in 146 B.C., incorporating both Greek instruments and theory. They did invent some new instruments, principally brass, such as trumpets and horns for practical, military usage. However, as with Greek music, we may know of the presence of music in this society and a bit about its theory, practice, and instrumentation, but we have no real conception of how Roman music may have sounded, melodically or rhythmically.

By the end of the fifth century A.D. secular music had virtually disappeared. Certainly secular music must have existed, but we have no record of it.

Theatre

The Romans loved entertainment, and the drama provided an exciting satisfaction for that love. In style, Roman drama, for the most part, occupied the opposite end of the intellect/emotion continuum from Greek classicism. Roman theatre was wild, unrestrained, lewd, and highly realistic. Accounts of stage events suggest that very little was left to the audience's imagination. We might find the Roman theatre buildings somewhat strange in their conventions, and we would need to learn the conventions of various masks, but for the most part we would have little difficulty identifying with and understanding the events portrayed. Undoubtedly we would find the grotesquely padded costumes and farcical actions of the actors as hilarious as the Romans did.

Three important dramatic forms occurred at various times in Roman history: phlyakes farces, Roman comedy, and the mime. The earliest of these was the phlyakes farce, which some authorities trace to a Grecian origin as early as the fifth century B.C. in Sicily. Whatever its sources the *phlyakes* (from the word for *gossips*) had an earthy style. Its themes first parodied mythology and later, burlesqued tragedy. Very little literary evidence exists about the phlyakes, but a considerable number of vase paintings testify to its existence and character. If such evidence can be taken at face value, the phlyakes were bawdy and lewd with actors grotesquely padded and masked. Apparently these farces used a raised stage consisting of a rough wooden platform containing a simple background and doors for entrances and exits by the actors. Curtains masked the area below the stage.

Roman comedy developed from third and second century B.C. influences of Hellenistic comedy with its large theatres, high stages, and elaborate scene buildings. The New Comedy of Menander was easily understood by the Romans and was assimilated quickly. From the importation to Rome of Greek New Comedy came the rise of two of Rome's most important playwrights, Plautus (c. 254–184 B.C.) and Terence (c. 185–159 B.C.). Twenty of Plautus's plays survive, and they provide a picture of a playwright who, principally, was a translator and adaptor. He copied Greek originals, changing the locations to Rome and inserting details of Roman domestic life. His characters were *types,* not individuals: the braggart soldier (*miles gloriosus*), the miser, the parasite, and the wily, but mistreated slave. These stock characters were extremely important in later developments, influencing both Shakespeare and Molière. Plautus's plays are full of and depend upon slapstick humor and "sight gags" for their effect. They are full of farcical energy and appeal directly to the emotions, not the intellect. They are not particularly well-written, and as is the case with much theatre, these works play better than they read.

Terence was a better writer and was better educated than Plautus, and he enjoyed the support of a wealthy patron. From his six extant plays we deduce a dramatist capable of drawing universal situations and characters. Like Plautus, he had a tremendous influence on the theatre of later ages. However, Terence, perhaps because he did not utilize banality and buffoonery, was not particularly popular with Roman audiences.

The third form of Roman theatre, the *mime,* probably was as old or older than the previous forms, but it did not achieve prominence in Rome until the time of the Empire. Mimes dealt with low life, and appealed to all classes of Romans. Some mimes were adventures similar to some drama in Elizabethan England. Some mimes ridiculed Chris-

tianity, particularly the rite of baptism, and consequently were not well favored by the Christian community. Early Christian writers condemned the obscenities of the mimes, noting that adulteries actually took place on stage. That may be an exaggeration, however. Nevertheless, the style of Roman theatre in general clearly was anticlassic. Idealization, formality, simplicity, and appeal to the intellect were *not* the characteristics one finds.

Like music, the theatre fulfilled an important social function. It kept the idle masses occupied. It also served as a forum in which the general public could address grievances with the bureaucracy. When an official of the state had betrayed his trust, when a wrong had been suffered, and/or when an impropriety of state had become flagrant, the satirical bite of the Roman theatre was felt in full measure, with grotesque masks, bright costumes, and penetrating directness.

The physical theatre of Rome, like all theatre "buildings" provided an important environment. For years the rough, raised stage of the phlyakes sufficed; and for centuries no need was seen to construct theatres from anything but wood. However, a time for permanence occurred. With the attempt to build a permanent stone theatre came an occurrence which illustrates some of the conflicts within Roman philosophy, morality, and government. In 154 B.C., one year after construction of the first stone theatre had begun, the Roman Senate, on the grounds that theatre was injurious to public morals (remember that theatre was used by the state to pacify the rabble) decreed that no seats should be provided in any theatre, that no one should sit down at any theatre production in the city or within a mile of its gates. Three years later the emperor Pompey, nevertheless, built a permanent stone theatre (seating 40,000), copied, according to Plutarch, from the Hellenistic theatre at Mytilene. To circumvent the Senate, he placed a shrine to Venus at the

highest point in the rear of the auditorium so that all the "seats" served as "steps" to the shrine. By the turn of the Christian era the orchestra of the early Greek theatre had been infringed upon by the scene building and the theatre had become a single architectural unit. The Romans also added two new features to their theatres. One was a curtain, which could be raised and lowered from a slot across the front of the stage. The second was a roof over the stage to protect the *scenae frons* and also to improve acoustics.

Dance

One of Rome's significant contributions to the Middle Ages and the Renaissance was the unique dance form called pantomine. Although the words are similar and sometimes used interchangeably in our vocabularies, *mime* (just discussed under theatre) and *pantomine* are two completely different art forms. Around 22 B.C. Pylades of Cilicia and Buthyllus of Alexandria are said to have "invented" pantomine by combining dance elements, some of which dated to prehistoric Greece.

The intent of the pantomime was serious and interpretative. Some pictorial evidence suggests that a single dancer portrayed many roles through costume change and the use of masks. He was accompanied by wind, brass, and string instruments as he leaped, twisted, and performed acrobatic feats or delicate interpretations. Themes occurring in pantomimes often were tragic, apparently taken from Greek and Roman tragedies and mythology. Many pantomimes were sexual in orientation, and some sources call them pornographic. It is clear that the pantomime fell into disfavor as its lewdness increased. It may be that lewdness, comically treated as in the mimes, has a tolerable and endearing quality, whereas the same subject treated seriously, as in the pantomime, became tedious, even to the pragmatic (and decadent?) Romans. The

more notorious emperors, such as Nero and Caligula, apparently loved pantomine, as did certain segments of the populace. Eventually, however, pantomimists were forced to leave the major cities, wandering throughout the countryside as itinerant entertainers. Some opinion suggests that these itinerants helped to keep the Hellenistic and Roman spirit alive, and with it the concept of theatrical dance, through the Middle Ages into the Renaissance.

Architecture

Given the practicality of the Roman viewpoint, we should not be surprised to find that the only easily identifiable Roman style in the arts occurred in architecture. The clear crystallization of form we found in the post and lintel structure of the classic Greek temple we find somewhat in the Roman arch. However, here the whole is suggested, and to a certain degree summarized, by the part, whereas the Greek composition finds the part subordinate to the whole.

Very little remains of the architecture of the Republican period, but those evidences suggest a strong Hellenistic influence with Corinthian orders and fairly graceful lines. There were notable differences however. Hellenistic temples had an impressive scale. Roman temples were even smaller than the classic Greek, principally because Roman worship was mostly a private rather than public matter. Roman temples also utilized engaged columns, that is, columns partly embedded in the wall. As a result, on three sides Roman temples lacked the open colonnade of the Greek.

In the Augustan age at the turn of the Christian Era a refashioning of Roman into the Greek style, as we mentioned regarding sculpture, took place. This accounts to a large extent for the dearth of surviving buildings from previous eras. Temples were built on Greek plans, but proportions were significantly different from the classic Greek.

The first through fourth centuries A.D. brought us what we typically identify as the Roman style, the most significant characteristic of which, is the use of the arch as a structural system in arcades and tunnel and groin vaults. The Colosseum (Figs. 1.31 and 1.32), best known of Roman buildings and stylistically typical, could seat 50,000

Fig. 1.31. The Colosseum. 70–80 A.D. Rome. Scala/Editorial Photocolor Archives.

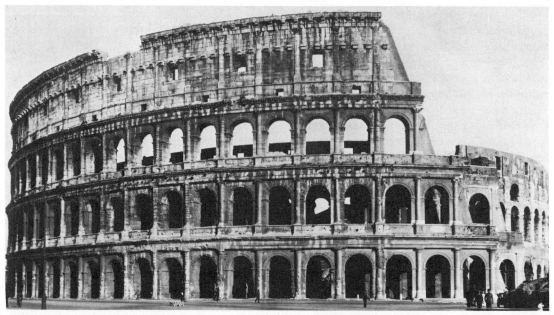

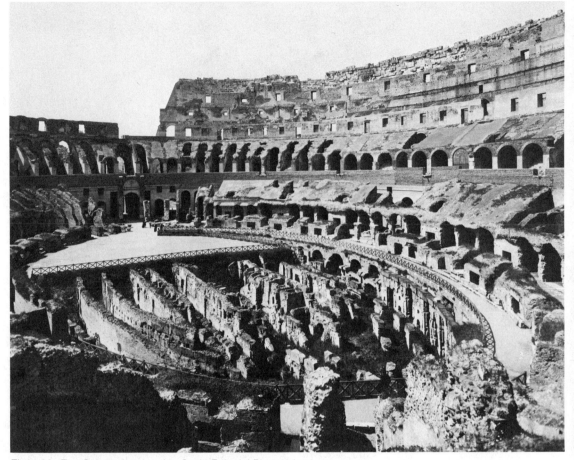

Fig. 1.32. The Colosseum. Interior. Scala/Editorial Photocolor Archives.

spectators. Combining an arcaded exterior with vaulted corridors, it was a marvel of engineering. Its aesthetics are reminiscent of Greek classicism, but fully Roman in style. The circular sweep of each level is carefully countered by the vertical line of engaged columns flanking each arch. Doric, Ionic, and Corinthian columns mark each level and progress upward from heavy to lighter orders.

The Pantheon (Figs. 1.33 and 1.34 color) fuses all that is Roman in engineering, practicality, and style into a mammoth, domed temple dedicated, as the name suggests, to all the gods. Around the circular interior are niches carved in the massive walls and oc-

cupied by statues of the gods. Corinthian columns mark the lower level, adding grace and lightness. Heavy horizontal moldings accentuate the feeling of open space made possible by the expansive dome, which is 140 feet both in diameter and height (from the floor to the occulus, or "eye," the round opening at the top of the dome). The circular walls supporting the dome are twenty feet thick and seventy feet high. Recessed square coffers on the underside of the dome give an added sense of lightness and reflect the framework into which concrete was poured. Originally the dome was gilded to suggest "the golden dome of heaven."

Fig. 1.33. The Pantheon. 138–117 B.C. Rome.

Summary

Western traditions in the arts date essentially to the small city-state of Athens, Greece in the fifth century B.C. During this time, called the Age of Pericles, complex interrelationships of politics, philosophy, geography, and economics, as well as influences from throughout the Mediterranean world gave rise to significant efforts in the visual and performing arts and architecture. Artistic style was related to religion, which consisted of a large collection of gods who were suprahuman in quality. Religion and philosophy, and therefore, the arts, centered on and loved earthly life. Man was the measure of all things. The philosopher most important to Periclean Athens was Pythagoras, who concluded that mathematical relationships were universal and central to all life and art and that the universe was constant. After the formation of the Delian League and the defeat of the Persians in the early fifth century B.C. the young democracy of Athens, with her thriving commerce, unique religion, and inquisitive philosophy, became a center of immense artistic achievement. In a Golden Age lasting somewhat less than three-fourths of a century, the foundations of Western arts were laid.

Although much of Periclean Greek artistry has been lost, enough remains to form a picture of what has come to be known as Greek classicism, a style which emphasized appeal to the intellect. Basic to the appeal of the classic and neoclassic was an emphasis on form (formal organization into logical and structured parts), idealization, concession to convention, and simplicity. Vase painting exhibited a strong sense of geometric design, concerned itself with form and order, and portrayed a new sense of idealized reality in figure depiction. Sculpture, such as that of Myron and Polyclitus, illustrated concern for restraint, subdued vitality, subtle control of movement coupled with balance, and a concern for idealized human form. Significant to Greek classic sculpture was employment of the *contrapposto* stance and its resultant sense of relaxation and controlled dynamics. How

closely music reflected the qualities of the other arts can only be speculated upon, because very few, and only fragmented, examples have survived. The lyre and the aulos were the basic instruments, and each played important roles in ritual and as solo instruments and accompaniment. Music and the arts in general were important to the Periclean Greeks, and frequent contests occurred in music, and, especially, in theatre.

The theatre of Periclean Athens also reflected classic concerns, especially in tragedy. In the few surviving examples of Aeschylus and Sophocles poetic language and purposes probe universal questions. Appeal to the intellect remained foremost. Dance must have predated and formed an essential part of Greek tragedy and was also entwined inseparably with music. Dance had a broader definition for the Greeks than it does for us, and rested heavily on convention, as did theatre, which substituted convention (suggestion) for illusion (depiction) in its physical trappings.

As a summarizing example of the concerns of the classic, Periclean Greeks, nothing suffices better than the temple, outside of which the citizenry of Athens gathered for worship of their humanlike gods. Temples such as the Parthenon turned post and lintel structure into an intellectual expression of symmetrical balance, clean and simple line, religious convention and symbolism, and a human scale; all of which culminated in balanced grace and perfection.

War and victory ushered in Athens' Golden Age, and war and defeat brought that age to a close in the Peloponnesian Wars. Although defeated by Sparta and eclipsed as a political force, Athenian artistic influence remained strong. However, a new realism in a population which had had its dreams and ideals dampened by military defeat changed its artistic style to more naturalistic qualities. By the late fourth century B.C. a modified style

in Greek arts, the Hellenistic, had spread throughout the Western world on the heals of the mighty conqueror from Macedon, Alexander the Great.

In the years from the late fifth to late fourth centuries, increasing naturalism, unrestrained action, new concepts of space, as well as emotional appeals typified painting, sculpture, and the theatre. Humans as individuals rather than types became the focus; that focus was seen in the tragedies of Euripides, in the sophisticated Old Comedy of Aristophanes, and in the mundane New Comedy of Menander from the middle of the fourth to the middle of the third centuries B.C. Gradually the centrality of religion in the theatre had disappeared.

As in the Periclean years, music in the postclassic or Hellenistic era remains essentially hidden from our view. However, architecture showed the same changes from intellectual appeal and restraint to greater emotionalism as occurred in painting, sculpture, and theatre. Order, balance, moderation and consonant harmony were maintained, but intent, as seen in increased scale and complexity, turned increasingly to the creation of an overwhelming emotional experience. In these transitions lay the stylistic fluxes which have characterized the Western arts since Greek times: a thrust toward appeal to the intellect countered by a thrust toward appeal to the emotions, and *vice versa*.

The rise of Roman civilization paralleled that of ancient Greece, and spread through military conquest. By the middle of the second century B.C. Rome had assumed a place of political dominance in the Hellenistic world. Internationalization of culture increased. The Romans were supreme managers and administrators and were extremely pragmatic in their approach to life. Much of their philosophy, science, and arts was assimilated from the Greeks and the Hellenistic world, and, in recognition of the influence of

Greek mythology, a Roman mythology came from Virgil's *Aeneid*, much in the same sense that the Greek mythology had come from Homer. Progressing through a series of emperors and political periods, Roman civilization moved from the second century B.C. to the fourth century A.D., by which time the Empire had been split into East and West, and in the West, for all intents and purposes, the central authority in Rome had collapsed. Christianity was recognized as a state religion in 337 A.D., and by the fifth century the Goths had conquered Rome.

Perhaps because of Roman pragmatism and assimilation of other cultures, as well as some egotistically inspired Imperial rebuilding projects, "Roman" artworks tended to reflect the Greek in both classic and Hellenistic characteristics, to which some Roman qualities were added. Naturalism and complexity were basic to painting and sculpture, but after the late first century, idealism, in a classic sense, returned briefly to sculpture, especially. Emotion and earthiness underlay the visual arts and theatre, with theatre witnessing in all Roman periods an increasing realism and lewdness in phlyakes farces, mime, and the comedies of Plautus and Terence, as well as in dance pantomime, which was serious and interpretative. Both theatre and music played important social functions in entertaining the masses of unemployed Romans. Technical virtuosity in music was more important than any artistic considerations. Roman architecture tended to be practical, and in the Augustan Age, at the turn of the Christian era, it adopted basic Greek-oriented characteristics and the recognizable Roman arch, on which elaborate systems of arcades and vaults were built. New possibilities in space enclosure resulted from Roman engineering of the arch as a structural system and in the spansion architecture made possible by the dome.

Chapter 2

THE

MIDDLE

AGES

- Death, Devils, and Disillusionment
- The Arts of the Early Middle Ages
- Toward Space and Light
- The Arts of the Late Middle Ages

DEATH, DEVILS, AND DISILLUSIONMENT

If Periclean Athens was a culmination of forces, a focusing of diversity to create a single, blinding arc of light, then the early Middle Ages was dissolution fragmenting the Western world into a chaotic jumble of confusion and, to a large degree, darkness. The dissolution did not occur in a flash, nor does it date from a specific year. In a natural desire to create order historians place specific dates on nearly every phenomenon; so we have been taught that Rome "fell" in either 410 A.D. or 476 A.D. Had we been living at that time we probably would not have noticed anything particularly different about any of the 365 days in 410 A.D. as compared with any of the 365 days in 409 or 411. Nor would we have been aware of the "darkness" scholars attributed to this period. Only through the luxury of a viewpoint well removed are we able to draw conclusions about changes that, in this case, were slow in developing and that spanned several generations.

The terms "Dark Ages" and "Middle Ages" were given to parts of the thousand years between the fifth and the fifteenth centuries, principally because this period was viewed as an age of darkness between the classical perfection of Greece and Rome and its revival in the fifteenth century. We continue to use the terms as a convenience rather than as a statement of viewpoint. In an overview such as ours we must constantly remind ourselves that while certain aspects of an era may be summarized, specific exceptions did exist. This is especially true in a world as fragmented as that of the Middle Ages—as our own is fragmented.

Pessimism and disillusionment increased in Rome over the centuries and carried into the Middle Ages. A well-known epitaph is often cited as illustrative: "I was not; I was; I am not; I care not." Civic, secular government had all but ceased to exist. When Constantine I shifted the capital of the Roman Empire to Byzantium he began a significant separation that became formal and permanent in 395 A.D. In the West the cloak of internationalism, which had loosely united the Mediterranean world since Alexander, became threadbare and fell apart. It was every locality and every people for themselves.

And peoples there were. Since the turn of the Christian era the Roman Empire had been besieged from the outside while decaying from within. The Germanic Goths, the Asian Huns, the Visigoths, and the Vandals, and in the seventh century the armies of Islam pressured and pierced the perimeters of the empire. Literally, the Western world was in perpetual motion. As one people pressed against another, the one pressed against turned upon its opposite neighbor. Nations as we know them did not exist. Borders changed from day to day as one people wandered and warred into the nebulous territory of its neighbors.

Meanwhile an infant Christianity struggled to survive. As with any emerging entity it felt an intense need to institutionalize. Christianity was a loosely organized, theologically divergent body, drastically different from the religions around it. It needed a "united front" to grow and to make its way in a "pagan" and suspicious world. In the first centuries of its existence the Christian Church shed its own blood as its various sects battled to settle questions of dogma imperative to institutionalization. However, in the thrust and counter-thrust so common to our

existence, the emerging Church *was* a force in the process of coming together in a world in the process of coming apart.

Constantine's decision to move his capital to Byzantium, later named Constantinople, had the effect of dividing the Christian Church, as well as the Roman Empire. The Bishop of Rome, who was believed to have derived his power directly from St. Peter, had been the acknowledged head (the Pope) of the Christian Church. The Constantinian division laid the grounds for a profound schism resulting in Roman Catholicism on one hand and Eastern Orthodoxy on the other—a division which still exists. Our story stays in the West—in Rome. Byzantine (Eastern) culture and its arts affected the West and were significant during the Middle Ages. We will see some of its influences soon; however, its traditions are more a part of Eastern culture, and so the scope of our examination dictates that we turn our backs on Constantinople. In so doing, we turn our backs on perhaps the only significant stylistic development of the fifth to tenth centuries. This does not mean that the arts of the West lacked style, but rather that the nature of societies in the fifth to the tenth centuries prohibited the development of any viewpoint widely enough reflected in the arts to be characterized as a "style" in any sense beyond an individualized one.

Europe during the sixth to ninth centuries was a place of dismal illiteracy and primitive living conditions. Death was a constant companion, and death-related superstition and fear flourished amidst general ignorance. A slowly emerging system of government called feudalism did little to elevate the lot of the common man; nor for that matter did the church do much. Feudalism was a political division of territory into units small enough to be governed by one man. It tended to increase warfare and bloodshed since no ultimately powerful authority controlled the individual parts. Therefore, feudal lords continually raided each other in attempts to increase wealth and property. Feudalism was a system of governance, and in that system were kings and barons, the latter supposedly responsible to or a vassal of the former. However, very rarely did enough power exist at any level above the individual landholder to effect any control, and so despotic rulers flourished. Trapped at the bottom of this rigid social structure (and often in the middle of the bloodletting) were the common people, the serfs. Serfs were little more than slaves, "attached" to the land, working for the local lord, and subject to the lord's bidding. It was a life of ignorance and destitution, looked upon as a "vale of tears." As Christianity spread, the terrors of "today" were endured in anticipation of some more glorious life "beyond."

The "devil" as a symbol of the powers of darkness and of evil was a strong force in medieval thinking and superstition, and the Church manipulated those fears and images as it sought, often fanatically, to convert the pagan world of the early Middle Ages. The promise of Heaven and the prospect of the fires of Hell if a Chrisitan life, as determined by the clergy, were not followed, were constant themes of the times. So whether pagan or Christian, death and devils were the constant companions of Medieval men and women. Interestingly enough, ever-present devils and demons fostered a certain fascination as well as fear. As we shall see, in medieval theatre, for example, the devil often is the best part, and his role and popularity grew to staggering proportions. Stage portrayals of Hell often were fantastic technical achievements with flame, smoke, and gargantuan monsters—all of which enthralled the audience.

The Church, nevertheless, played an important stabilizing role in that desperate and frenzied world. It provided a source of continuity and, as its influence spread, medi-

eval attention and philosophy turned from Man as the measure of all things to God as the measure of all things. Death and demons were constant companions, but the Western world slowly came to a belief that the latter could be escaped and that the former promised an even greater life in the hereafter, at least for a selected few. Although providing an important stabilizing force, the Church was itself divided and did little to reduce the isolation and ignorance of its environment. Very early the clergy were divided into two parts. One was the regular clergy consisting of monks and others who preferred to withdraw into a cloistered life. Perhaps because of the general nature of life at the time such a lifestyle held strong appeal for many intellectuals as well. The second part of the Church was the "secular clergy," that is, the Pope, bishops, and parish priests who served in society at large. The overall effect of such a division was one of encapsulating learning and philosophy within the monastery, and thereby withholding intellectual activity from the broader world. In both cases inquiry was rigidly restricted. Specific and unquestioned dogma was deemed necessary for the Church's mission of conversion—and for its very survival. As a result, the medieval world was a world of barriers and barricades— physical, spiritual, and intellectual. Each man, woman, and institution retreated behind whatever barricade he, she, or it considered most protective for itself.

Education was a slave to the service of the Christian Church. But we should not minimize the influence and accomplishments of the theologians and scholars of the era, such as St. Augustine, Boëthius, The Venerable Bede (who began the practice of dating from the birth of Christ), Pope Sylvester II, and others.

As feudalism developed and life went on, the human spirit tried to free itself from these unbearable restraints and return to a broader sense of political order. Occasionally a ray of hope shown through. One such hope was Charlemagne. The expanding threat of Islam and the Moorish Conquest had been repelled by Charles Martel in 732 A.D. The succeeding period, the Carolingian period, under Charlemagne saw the first significant organized political centralization since the fall of Rome. Charlemagne united parts of Spain, France, western Germany, and northern Italy, and was crowned Holy Roman Emperor by the Pope in 800. He also revived an interest in art, antiquity, and learning. Charlemagne's "renaissance" had a slightly different viewpoint from the Renaissance we shall find six hundred or so years ahead; but it did rekindle some of the spirit of art and inquiry, if only in cloistered circles. The Carolingian Era lasted until late in the ninth century but failed to pull Europe and Western civilization out of its lightless and localized entombment.

The ninth and tenth centuries shifted the focus of Europe to Germany in the guise of a "universal empire" under the Ottonians. The German Emperors Otto I, II, and III successfully sought coronation by the Pope. Subsequently they attempted to control the still struggling Church. The resultant conflict between emperor and Pope, coupled with the strongly developing feudal and monastic system we discussed earlier, continued Europe's fragmentation and isolationism.

The Ottonian Emperors could not subjugate the growing Christian Church, and by the eleventh century the Church, especially its monastic orders, had come to great power and wealth. Christianity had triumphed throughout Europe, and the threat of invasion from the perimeters had ceased. A fervor of religious fanaticism resurfaced. More and more pilgrimages were being made to sacred sites, and the crusades to liberate the Holy Land had begun. Trade was beginning again

as the Italian port cities of Venice, Genoa, and Pisa began to reclaim the trade routes of the Mediterranean. Towns and cities were growing, and a new middle class was placing itself between the aristocracy and the peasants.

THE ARTS
OF THE EARLY MIDDLE AGES

Two-Dimensional Art

In the beginning of this era medieval painting and Christian painting were identical. Early Christian painting reflected the styles appropriate to the locations Christians inhabited. For example, in the catacombs of Rome, the only safe haven for Christians, painting showed a Roman style adapted to Christian symbolism. Roman Christians were converted Roman pagans, and it should not surprise us that the paintings done by these converted Romans had a Roman style and a frankly practical intent. In its earliest phases (before Constantine) Christian painting was a secret art in a secret place; its function was to affirm the faith of the follower on his tomb. Early Christian painting, essentially, was burial art.

One often finds in early Christian painting a primitive quality, and probably this quality is more a reflection of technical inability than anything else. The need to pictoralize the faith was implicit. The presence or absence of artistic skills or ability was not important.

Christian painting developed through several stages. From the beginning it reflected the absolute belief in another existence in which the individual believer did not lose his or her identity. Painting was a tangible expression of the Christian's faith. Later, painting was used to make the rites of the Church more vivid. Finally, it developed to a depiction and record of Christian history and tradition. Inherent in Christian painting from the beginning was a code of symbolism and communicable signs whose meanings could be grasped only by a fellow Christian.

As the Roman world divided and the West plunged into chaos, painting became once again a nonpublic art, more an instrument of intellectualism than of inspiration to the faithful. So we find, outside of Byzantium, a new and exquisite form of two-dimensional art emerging, not from canvases or public church walls, but from the beautifully illustrated pages of restricted, scholarly, Church manuscripts. Figure 2.1 is a manuscript illustration telling the story of the gospels. It was sent by Pope Gregory the Great to St. Augustine in England. Its detail and symbolism attest to the presence and vitality of artistry in the West kept alive, if hidden, in the Church. Such a miniature, which borrows freely from pagan tradition to serve a new belief, has color and intricacy to rival the tremendous wall mosiacs and decorations of Byzantium. However, it typifies certain stylistic qualities which became more markedly characteristic of medieval painting and sculpture. Compositions of this age are close and nervous. Figures bump against each other and a frenetic energy emerges. We feel a certain discomfort in these "walled-in" and crowded scenes, as the medieval illustrator must have felt in his own circumstances.

During the period from the fifth to the eleventh centuries, a tremendous wealth of artistic work emerged in nontraditional, two-dimensional areas of art. As we noted in the introduction to this chapter, a fluid pattern of life was prevalent in the early Middle Ages throughout Europe. It was, therefore, to very mundane and portable media that nonmonastic, nomadic men and women turned much of their artistic energies. Clothing, jewelry, and shipbuilding, for example, all exhibited artistry among the Germanic, Irish, and Scandanavian peoples (Fig. 2.2).

Emotionalism in art increased as the ap-

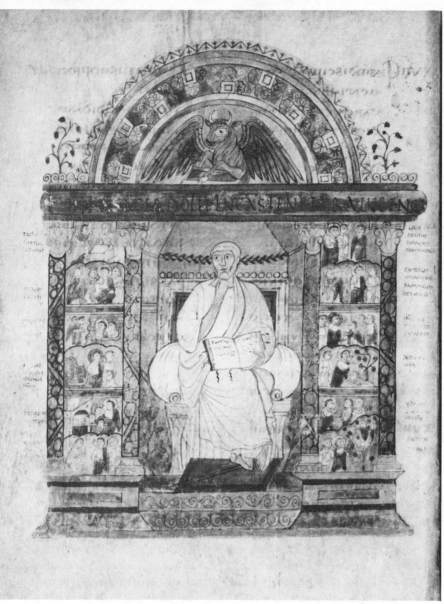

Fig. 2.1. St. Luke, from the presumed St. Augustine Bible. Roman 6th Century. Manuscript illumination, Ms. 286, fol. 129 v. The Master and Fellows of Corpus Christi College, Cambridge.

Fig. 2.2. Purse lid from Sutton Hoo Burial. 7th–8th Century A.D. British Museum, London.

proach of the millennium sounded its trumpet of imminent doom. The fact that the world did not end on January 1, 1000 reduced emotionalism only fractionally. Emotionalism strengthened with an influx of Eastern art into the Ottonian Empire when Otto II married a Byzantine princess. A combination of Roman, Carolingian, and Byzantine characteristics typified Ottonian manuscript illustration. Despite an inherent appeal to feeling and medieval crowding, such work shows evidence of the increasing "outward" direction of the early years of the second millenium after Christ.

Soon after the year 1000 a new style in painting began to emerge. It showed few characteristics to separate it immediately from its predecessors and was regionally fragmented. Because it was associated with a revolution in architecture, however, it took the name given to that style, *Romanesque,* and brought to a close the two-dimensional art of the early Middle Ages.

Sculpture

Sculpture played a very minor role in the centuries from the collapse of the Roman Empire until the rise of the Romanesque style in the eleventh century. Its minor role probably can be attributed to the fact that the era was one of Christian domination and the Old Testament prohibited "graven images." The association of statuary with pagan societies (notably Rome) was fresh in the memories of the Church, and so Christian sculpture began in less monumental directions. As did painting, sculpture focused on death, and the earliest examples are of sarcophagi that detail an expanding repertoire of subjects as time passed.

Some of the most beautiful sculptural work of the Christian era after Constantine mirrors manuscript illumination in its small-scale, miniature-like detail. It reflects a restless, linear style with great emotion and is very precise in its compositional details.

Equally poignant is the "Gero Crucifix" (Figure 2.3). The realism and emotion of a crucified Christ whose downward and forward thrusting body pulls against the nails is compelling indeed. Note the muscle striations on the right arm and chest, the bulging belly, and the rendering of cloth. There is a surface hardness in this work. The form is human, but the flesh, hair, and cloth do not have the soft texture we might expect. The face is a mask of agony and the total work full of pathos.

Like painting, sculpture of the eleventh and early twelfth century is called *Romanesque.* For all intents and purposes in sculpture such a title refers more to an era than to a

Fig. 2.3. "Gero Crucifix." c. 975–1000 A.D. Wood, 6′ 2″. Cologne Cathedral. Photo courtesy of Heaton-Sessions Studio, New York.

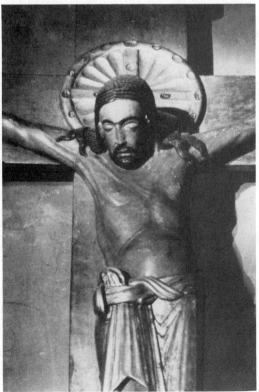

style. The era's architecture on the other hand has certain common stylistic qualities with which later scholars identified the term "Romanesque." Sculpture of the era saw some changes, mostly in monumentality and a vague similarity of form, but examples are so diverse that if most sculptural works were not attached decorations on Romanesque architecture, we probably could not group them under a stylistic label. Unlike painting, however, we can draw some general conclusions about Romanesque sculpture: 1) it is associated with Romanesque architecture; 2) it has a heaviness in feeling; 3) it is stone; and 4) it is monumental. The last two of these characteristics are revolutionary in comparison with previous sculpture. Monumental stone sculpture had all but disappeared in the fifth century. Its re-emergence across Europe in such a confined period of time was remarkable. As we shall see, Church architecture was prolific during the Christian era, but the emergence of sculptural decoration indicated at least a beginning of an outward dissemination of knowledge from the cloistered world of the monastery to the general populace. Romanesque sculpture was applied to the exterior of the building, a position in which it could appeal to the lay worshipper. The relationship of this artistic development to the increase in religious zeal among the laity is not without significance. In such works as the Last Judgment tympanum (Fig. 2.4) the illiterate masses now could "read" the message of the Church, a feat previously the sole property of the clergy. The message here is quite clear. In the center of the composition, framed by a Roman style arch, is a Christ figure of less than comforting qualities. Around him are a series of malproportioned figures in various degrees of torment. The inscription of the artist, Gislebertus, tells us that their purpose was "to let this horror appall those bound by earthly sin." Death is still central to the medieval mind, and devils share the stage, attempting to tip the scales in their favor and

Fig. 2.4. Last Judgment tympanum. c. 1130–35. Autun Cathedral.

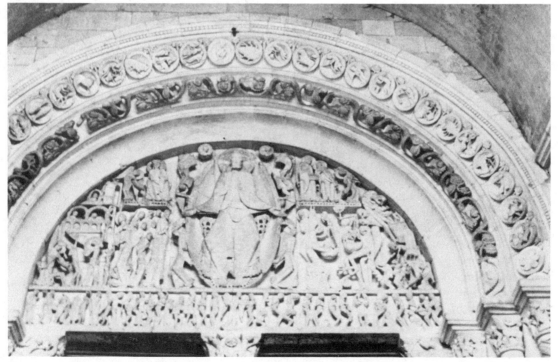

gleefully pushing the damned into the flaming pit. A pair of demonic hands reaches down (lower right) to grasp a poor soul by the throat. So, although revolutionary in its material, scale, and scope, Romanesque sculpture retains the emotional, crowded, and nervous qualities of previous medieval works. The Romanesque "style" was a close cousin of its predecessors—the end of an attitude or viewpoint about to be supplemented by another.

Music

Most of the music from the Greek, Hellenistic, and Roman traditions was rejected by the early Christian Church. Music cultivated for enjoyment as an art and any music or instrument associated with spectacles or activities objectionable to the Church was unsuitable, as was the hydraulos, which we noted earlier. Beyond these observations we know little of what music the Christian Church incorporated. Disapproval of Roman or Greek music apparently did not reflect negativism toward music itself, but, rather, reflected a need to break existing or potential ties to pagan traditions.

We know that music played a role in Christian worship from earliest times, and since Christian services were modelled on Jewish synagogue services, it is likely that musical practices in the church held closely to liturgical function. In the *responsorial psalmody* the leader sang a line of the psalm and the congregation sang a second in response. The melody for such responsive singing consisted of a single note for the first few words changing for the final words to a "half cadence." The congregation then sang the beginning of the response on the same note, concluding with a cadence. This is similar to some contemporary worship practices which utilize a responsive psalmody (Fig. 2.5). The early Church also used an *antiphonal psalmody* in which singing alternated between two choruses. Local churches in the West were relatively independent at first. So between the fifth and the eighth centuries A.D. several different liturgies and chants developed. Increasingly, after the eighth century, virtually all of these local variants were unified into a single practice under the central authority of Rome.

Early in the fourth century *hymns* were in-

Fig. 2.5. Responsive psalmody. Modern notation.

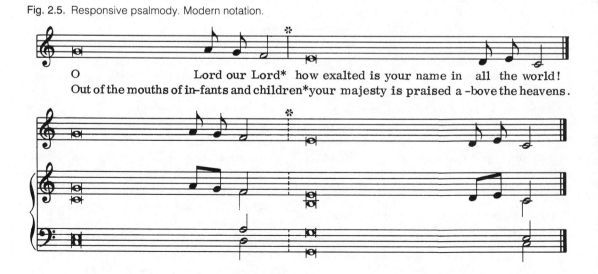

troduced into the Western Church. Some sources credit St. Ambrose for this innovation, and others, Hilary, Bishop of Poitiers. Early hymns had a poetic text consisting of several verses, all of which were sung to the same melody, sometimes taken from popular secular songs. Mostly the hymns were *syllabic,* that is, each syllable was sung on a single note, and they were intended to be sung by the congregations, as opposed to a choir or a soloist. In style and content early Church hymnody tended to express personal, individualized ideas; other portions of the liturgy were more formal, objective, and impersonal.

Another type of Church music at this time was the *alleluia,* which comprised an interesting contrast in style to the hymn. The alleluia was melismatic in style and was sung after the verse of a psalm. The last syllable of the word was drawn out "in ecstatic melody, soaring phrase 'in gladness of heart and flowing, joy too full to be expressed in words.'"[1] Eastern in influence and emotional in appeal, the alleluia came to the Christian service directly from Jewish liturgy.

Probably the most significant influence in medieval music was Pope Gregory I (c. 540–604). The tradition of the Gregorian chant is named for him, and he provided the driving force for codifying the diverse musical traditions of the early Church into one. Pope Gregory was not a composer, but, rather, an editor. He supervised the selection of melodies and texts he thought most appropriate for the musical setting of Church celebrations. Having organized Church music, he then became active in disseminating it throughout the West. In these efforts he not only created an additional unifying force in

and through the Church, but also began a basic universal musical language.

In this same era, or perhaps slightly before it, came a significant change in tradition and practice, which stemmed from very practical considerations. Christian zealousness for converting the pagan world created certain divisions in society and the Church that contributed to the unique character of the Middle Ages. Nevertheless, Christian missionary zeal was successful. As increasing numbers of converts strained the capacities of churches, monetary contributions created wealth which was, in turn, used to build larger sanctuaries. As larger sanctuaries filled, informal worship and antiphonal responses could not be conducted in an orderly fashion. So music became more the province of the choir and/or a chief solo singer, like the cantor in Jewish worship. Increased formality in the liturgy further divided cleric and layman. Formal solo and choir music led further to the development of a central training center, a *Schola Cantorum,* for Church musicians in Rome. Some sources date the Schola Cantorum before Pope Gregory, others, later. In addition to formalizing training of Church musicians, the Schola Cantorum also provided a channel by which Gregorian reform could be universally effected, in as much as Schola-trained musicians served congregations throughout Europe.

Chant melodies mostly were passed on by oral tradition from one generation of priests and monks to another. It seems likely that early chants had a simple, undulating, and haunting character. Their texture was monophonic, that is, a single melodic line. Chants were sung in a flexible tempo with unmeasured rhythms, which followed the natural accents of normal Latin speech. Melodic range probably did not exceed an octave, and chant melodies themselves consisted of groups of three or four notes related to one another. Medieval chants still exist in Christian worship, and they provided a unique and

[1]St. Augustine, "In Psalmum xcix enarratio, sermo ad plebem"; pr. Migne, *Patrologiae cursus completus, Series Latina,* XXXVII, 1272, in Donald Jay Grout, *A History of Western Music* (New York: W. W. Norton and Company; 1973), p. 19.

rich source of material for composers in periods to follow.

The Middle Ages also witnessed the growth of secular, that is, non-Church music. As might be expected, non-Church music utilized vernacular texts—the language of the common man as opposed to the Latin of Church music. Most secular music (like our own) concerned love, but other topics of varying nature also were popular. Probably secular music owed much of its origin to the dance pantomime of Roman times, whose performers, as we noted, were forced out of the cities to become wandering bands of entertainers. A strong link has been suggested between the traditions of the pantomime and the poet–musicians of later medieval Europe called *trouvères* in northern France, *troubadours* in southern France, and *minnesänger* in Germany. These wandering minstrels created, performed, and made significant contributions to early vocal music as they travelled throughout the countryside. Apparently most of their music was monophonic, like Church music, but they also sang with some form of musical accompaniment. Medieval secular song probably was *strophic,* that is, composed of several stanzas, all sung to the same melody.

Musical instruments of this era consisted of the lyre, the harp, and a bowed instrument called the *vielle* or *fiedel* (viol/fiddle). The *psaltery,* an instrument similar to a zither, the *lute,* the *flute,* the *shawm* (a reed instrument like an oboe), *trumpets, horns, drums,* and *bagpipes,* as well as the organ, were all popular. Small versions of the organ called *positives* and *portatives* were portable; the latter was played while held in the hands of the performer and the former while placed on a table and utilizing a second individual to work the bellows. Despite its Roman and unpleasant associations, the organ eventually found its way into the medieval Church.

While liturgical and secular traditions developed as we have just discussed, a different philosophy of music emerged from the monastic community in the work of a scholar named Boëthius. His theories had minimal effect in the world around him, but his work illustrates the fact that, in the arts, a seedling of a new or a past tradition may take root in the midst of other, more prominent ones. Boëthius emphasized, as did the Greeks, the relationship of music to character and morals. He utilized music as an educational device, and noted its mathematical properties as a springboard to higher philosophical inquiry. Boëthius conceived of music as an object of knowledge rather than an expression of feeling. The true musician for him was not the performer, but, rather, the composer/critic/philosopher who carefully examined "the diversity of high and low sounds by means of reason and the senses."

In the ninth or tenth century a new compositional and radically different texture appeared in music. *Polyphony* now brought more than one melodic line into musical composition. Earliest polyphony consisted of two parallel melodic lines at different pitch levels. When one line went up, so did the other, and so forth. Later, contrary motion separated the melodic lines so that, finally, the two lines became melodically independent. These early polyphonic compositions were called *organa* (*organum*). Polyphony is a textural component, and in earliest polyphonic forms the rhythmic component of music remained free and unstructured. However, as melodic lines gained freedom from each other, necessity dictated that some form of rhythmic structure be employed to coordinate them. So at the very end of this era a new rhythmic notation emerged called *mensural notation,* which made possible an indication of the precise duration of each tone.

The characteristics of Gregorian chant as we imagine it to have existed sound "medieval" to us when we listen to modern recordings. We may wonder why we do not hear in music the nervous, crowded qualities of style

we saw in painting and sculpture. The answer has many facets, not the least of which is our lack of musical evidence from the period; musical traditions were oral, not written. However, Church music was based on Jewish ritual, a fact we noted, and the strong presence of that formal tradition probably mitigated other factors while it reinforced appeals to the emotions.

Theatre

Some early scholars argued that theatre ceased to exist in the Western world for a period of several hundred years. That viewpoint is no longer widely held, and two basic evidences exist on which we may assume the existence of theatrical production. One is the presence of the wandering entertainers we already have noted. In this tribe of entertainers were mimists, jugglers, bear baiters, acrobats, wrestlers, and story-tellers. The mimetic propensity of human beings, which we can see even in children who "act out" whatever their fancies imagine, is too compelling to deny its existence amid the entertainments we know existed in this era. We do not know, however, the production characteristics. They may have consisted only of miming a story or "reading" a play script, rather than the more formal presentations we prefer to call "theatre."

However, our second evidence speaks more directly to theatre's existence (of whatever characteristics). Writings from the period in North Africa argue for the value of the mimic stage, and logic indicates that what still existed in North Africa probably persisted in Europe in general. Sisebert, King of Spain in the seventh century, refers to the popularity of *ludi theatrici* at marriages and feasts, adding that clergy should leave when these were performed. In the ninth century the Council of Tours and the Council at Aix-la-Chapelle indicated that clergy should not witness plays and the obscenities of actors.

We must assume the presence of theatre from the railings of the Church against it. Charlemagne ruled that no actor could wear a priest's robe under penalty of corporal punishment or banishment. Charlemagne's edict has been taken by some as evidence of theatrical presentation and also, perhaps inaccurately, as evidence for the beginnings of liturgical drama. If such were the case, the prohibition would imply the use of actors other than the clergy, in church drama. In the tenth century the German nun, Hrosvitha, is known to have written six plays based on the comedies of the Roman playwright Terence. We do not know if Hrosvitha's plays were performed, but if they were, the audience would have been restricted to the other nuns in the convent.

We are sure, however, that liturgical drama began as an elaboration of the Roman Catholic Mass, probably in France. These elaborations were called *tropes* and took place at special ceremonial occasions, usually Easter, which was the dramatic highlight of the Church year.[2] Records at Winchester in the late tenth century tell of a trope in which priests acted out the discovery of the tomb on Easter morning.

So, late in the medieval period theatre, which undoubtedly had been continuous in the secular world (even though we have no direct evidence of its nature), joined the other arts, excepting dance, in the arms of mother Church to become an instrument of God in an age of faith and demons.

Dance

An inclination as pervasive as dancing, one which predates the theatre, and one which

[2]An excellent depiction of the medieval *trope* has been recreated in the film *The Visit to the Sepulcher (Visitatio Sepulchri),* from the twelfth century "Fleury Playbook." This twenty-eight minute color film is available from Theatre Wagon, Inc., 437 East Beverly Street, Staunton, Va. 24401.

can be found at the religious and ritualistic center of nearly every culture in the world, surely did not surrender to the dictates of Christianity in the early Middle Ages. We know it did not because, as with theatre, Church writings continually condemn it from Constantine's time to the eleventh century—and beyond. St. Augustine complained that it was better to dig ditches on the Sabbath than to dance a "choric Reigen."

The age of expanding church influence in a previously pagan world must have seen bitter conflict as a religious philosophy in which all pleasures of the flesh were evil clashed with a pagan world in which the supernatural, superstition, and wild fertility dances were central. History records many examples of masked pagan dancers attempting to invade churches. Even when Christianity gained a firm hold it was impossible completely to eradicate deeply rooted ritualistic dancing. So, it appears, a certain unspoken compromise was reached. Dancing continued since people will continue to do what gives them great pleasure, Church or not, damnation and the devil notwithstanding. But, pagan contexts were put aside.

In actuality, the Christian Church made many compromises with life as it found it. Today we still celebrate ancient pagan festivals without a second thought of their affecting our spirituality. Which child who has danced around a Maypole or gone trick-or-treating has considered such an indulgence a fertility dance or a demonic mummery?

It is fairly clear, however, that most of the "dancing" to which various sources refer in the early Middle Ages, probably was not in any way significant as artistic expression or theatre dance (see the Preface). The frenzied outpouring of emotion which occurred in this period mostly was spontaneous and took no consideration of a performer/audience relationship. Such dancing was the primordial response to a frenetic and frightening world

in which man had been reduced, literally, to his basest self. Later, vestiges of demonic and death dances and animal mummeries would adopt a more formal, presentational character (death as a dancer was a frequent medieval image), but in these early years most "dance" probably is related to our survey in name only.

Nevertheless, the same logic we applied to the circumstances of theatre in the previous section can apply here. We are fairly certain that theatre dance remained alive through successors to the pantomime called *joculatores* (jugglers). They performed at fairs and festivals, nearly always for the peasants, rarely for the nobility. Some evidence suggests that a kind of undefined "hand dance" existed, as well as dances using the themes of Roman mythology.

Architecture

When Christianity became a state religion in Rome, an explosion of building took place to accommodate the needs of worship. Previously, small groups of the faithful had gathered as inconspicuously and as carefully as possible wherever it was practical and prudent for them to do so. Even had it been safe to worship publicly, no need existed to construct a building of any consequence to house so few people. Respectability changed all that.

As with painting, early Christian architecture was an adaptation of existing Roman style; for the most part churches took the form of the Roman *basilica*. We tend to think of that term as Christian in derivation, for example *St. Peter's Basilica* in Rome. However, the term refers to Roman law courts whose form the first large Christian churches took. A *basilica* has a specific architectural design, and to this design Christianity made some very simple alterations. Roman basilicas had numerous doors along the sides of the building to facilitate entrances and exits.

The needs of the Church called for a focus on the altar, where the ritual was enacted. Therefore, entrance to the Christian basilica was moved to the end of the building, usually facing west, so as to channel one's attention down the long, relatively narrow nave to the altar at the opposite end. Often the altar was set off by a large archway reminiscent of a Roman triumphal arch, and elevated to enhance sightlines from the congregation, which occupied a flat floorspace.

Another change brought to this architectural form was the treatment of interior space as different from the exterior shell. This is one of two contrasting viewpoints in architectural design. In one case the exterior structure is apparent and reveals the nature and quality of interior space—and *vice versa*. In the other case, as here, the exterior shell is merely an envelope, in many instances obscuring what lies inside. Whether intended or not, the basilica symbolizes the radical difference between the exterior world of the flesh and the interior world of the spirit.

Considering the nature of the medieval world, we might imagine that the fluid nature of the political situation would mitigate against anything so permanent as a significant work of architecture. To a certain extent that logic is correct. In a warring, destabilized world one does not give overmuch attention to great works of architecture. However, as we noted, this was an era of cloisters and barricades, and despite their lack of artistry (or permanence) monasteries were built and so were fortresses. As we might expect, the purpose of a fortress in a world of war places the odds decidedly against its survival.

Not until the rule of Charlemagne do we find any consequential attempt at architectural design. Charlemagne's "renaissance" included architecture, and Charlemagne returned to his capital from visits to Italy with visions of Roman monuments and a belief that majesty and permanence must be symbolized in architecture of impressive character. Realization of his dreams was tempered by some of the difficult facts of life that often stand between an artist and the completion of his work. In this case Charlemagne's model was the church of San Vitale in Ravenna (Figs. 2.6 and 2.7) built by Justinian in the Byzantine style. Charlemagne's materials, including columns and bronze gratings, all

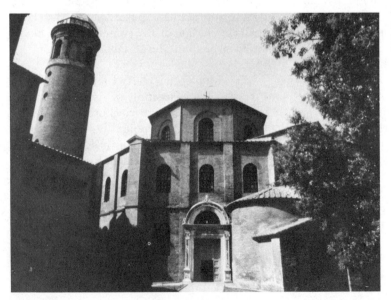

Fig. 2.6. San Vitale, Ravenna. 526–47 A.D. Photo courtesy of Heaton-Sessions Studio, New York.

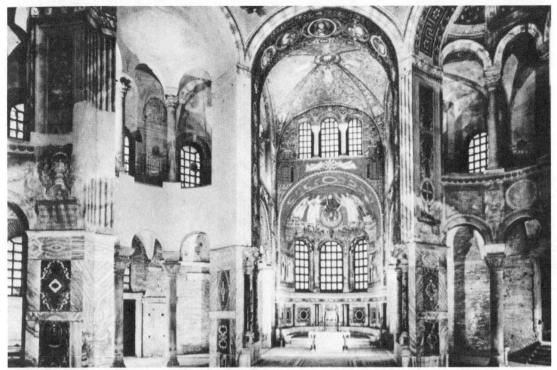

Fig. 2.7. San Vitale, Ravenna. Interior. Photo courtesy of Heaton-Sessions Studio, New York.

Fig. 2.8. Palace Chapel of Charlemagne, Aachen. 792–805 A.D. Interior. Photo courtesy of Heaton-Sessions Studio, New York.

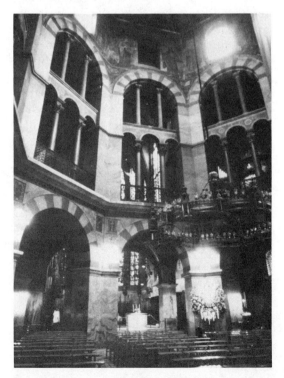

had to be transported over the Alps, from Italy, to Aachen, Germany. Likewise, skilled stonemasons were few and far between. The task, nevertheless, was accomplished, and Charlemagne's palace chapel stands today as a dominant design of compelling character (Fig. 2.8). Charlemagne also encouraged the building of monasteries and apparently developed a standard plan for monastery design that was used, with local modifications, throughout the Empire.

As Charlemagne's empire and the ninth and tenth centuries passed, a new and radical style in architecture emerged. Unlike its stylistic counter-parts in painting and sculpture, *Romanesque* architecture was a fairly definable style, despite its diversity. The Romanesque style arose throughout Europe in a relatively short period of time. It took its name from the Romanlike arches comprising its doorways and windows. To Renaissance men, who saw these examples throughout Europe, the characteristics clearly were pre-Gothic, post-Roman (but Romanlike) and, therefore, they

called them *Romanesque*. In addition to arched doorways and windows, this style expressed a massive, static, and lightless quality in which we perceive a further reflection of the barricaded mentality and life style generally associated with the Middle Ages.

Nonetheless, the Romanesque style exemplified the power and wealth of the Church Militant and Triumphant. If the style mirrored the social and intellectual system that spawned it, it also reflected a new religious fervor and relative to external, decorative sculpture a turning of the Church toward its enlarging flocks. Romanesque churches were larger than their predecessors, and we gain an appreciation for their scale from Figures 2.9 and 2.10. St. Sernin is an example of southern French Romanesque, and it reflects a heavy elegance and complexity we have not seen previously. The plan of the church de-

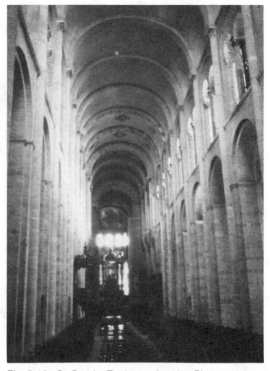

Fig. 2.10. St. Sernin, Toulouse. Interior. Photo courtesy of Heaton-Sessions Studio, New York.

Fig. 2.9. St. Sernin, Toulouse. c. 1080–1120. Photo courtesy of Heaton-Sessions Studio, New York.

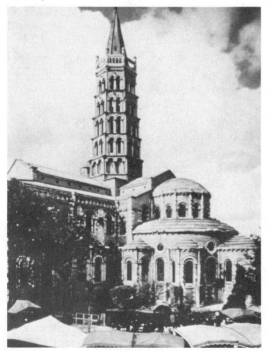

scribes a Roman cross, and the side aisles are extended beyond the transept (crossing) to create an *ambulatory* or "walking space" so that pilgrims (mostly on their way to Spain) could walk around the altar without disturbing the service.[3] One additional change is worth noting. The roof of this church is stone, as compared to earlier buildings which had wooden roofs. As we view the magnificent vaulted interior we wonder how or whether the architect reconciled the conflict-

[3]It is unfortunate that Spain usually is slighted in its contributions to the arts. These important pilgrimages were mostly to Spain, specifically, to Compostela, along the "Way of St. James." A significant amount of what Renaissance scholars knew about the Greeks came through the Moors by way of Spain and Spanish monks.

ing forces of engineering, material, and aesthetics. Given the properties of stone and the increased force of added height, did he try to push his skills to the edge of practicality in order to create a breathtaking scale? Were his efforts reflective of the glory of God or the abilities of Man?

Returning to the exterior view, we can see how some of the stress of the high tunnel vaulting was diffused. In a complex series of vaults, tranverse arches, and bays, the tremendous weight and outward thrust of the central vault was transferred to the ground, leaving a high and unencumbered central space. If we compare this structural system with that of post and lintel and consider the compressive and tensile properties of stone, we easily can see the superiority of the arch as a structural device for creating open space. Nevertheless, the stresses and weight in this style made possible only very small windows. So, although the fortresslike and lightless characteristics of Romanesque architecture reflect the historical context of the era, nevertheless, they had a practical explanation.

TOWARD SPACE AND LIGHT

The dramatic struggle of humankind's constant search for and defining of reality yielded some remarkable results in the twelfth to fifteenth centuries. When, why, or how these forces and ideas originated is uncertain. Nevertheless, they brought a new age to the Western world. Perhaps humankind possesses certain ideas of what *ought* to be, and no matter how oppressive the circumstances, these ideas struggle to be fulfilled. Perhaps life is, as some have called it, a search for personal freedom—*whose* freedom and under what conditions being subject to circumstances.

Circumstances certainly do play a role in humanity's image of reality, and the circumstances of the mid-Middle Ages, like those of all ages, were unique. The Christianizing of Europe and the approach of the millenium (1000 A.D.) cannot be underestimated in their interrelationships. The desperate conditions of feudal society and faith in a life beyond this "vale of tears" led to a widespread belief that the "second coming" of Christ and the end of the world would occur at the close of the millennium. One would imagine that the Second Coming and the end of the world would be a joyous fulfillment for a Christian. However, when Europe awoke to discover that the world had not ended at the turn of the millennium, rather than disappointment, there seems to have been a great sense of relief. Disappointment or relief, attitudes about things change drastically when they move from a short term to a long term condition.

Feudalism had reached its zenith, and the Carolingian and Ottonian Empires had suggested that a wider stability and order were possible. Life remained, however, in a polarized and rigid class system. The clergy and nobility were at one end and the serf was at the other. The situation was analogous to a vacuum, and into this vacuum came the missing ingredient out of which the new age formed, the town and the town guild.

At the same time, another Medieval phenomenon came to flower with a change in attitude that permeated society and the arts. Feudalism was a masculine, "men-at-arms" code of behavior. By the twelfth century a distinctly feminine point of view ruled ethics and personal conduct. This feminine orientation was *chilvalry* and the *courtly tradition*. Men were away from the home or the castle for long periods of time—whether trading, warring, or whatever. So it fell to women to control domestic matters and manners, and if Eleanor of Aquitaine (1122–1202) is any example, women controlled such enterprises

quite handily. Courts of love emerged with codes of conduct and etiquette that thoroughly changed society's viewpoint to a softer, gentler tone than the rough code of feudalism.

We may speculate that the Code of Chivalry was a practical and euphemistic way of glossing over illicit love affairs while the husband was away. However, we probably should not judge the morals of another age, one in which most aristocratic marriages were arranged for political convenience, by too rigid a standard. Chaucer gives us an excellent view of the enigma of the medieval love triangle in "The Franklin's Tale" from *The Canterbury Tales*. The Franklin's solution illustrates the "civilized" code and its peculiar influence on the era.

More important than its impact on morals is the impact of the courtly tradition on religious philosophy. We described the early Middle Ages as an age of death and devils—notwithstanding its faith. It was an age of fear whipped into frenzy as Christians suffered through life in anticipation of the harsh and inflexible judgement of God. Now, however, we find a warmer feeling, a quality of mercy. Christ the Savior and Mary the compassionate Mother are the focal points of faith. This change in viewpoint is reflected very clearly in the arts of the time.

Amid the changing points of view rose a new and important middle class, filling the vacuum between nobility and peasant and drawing thousands into emerging towns and cities, which offered a new hope for escape from slavery to the land. The crusades, at their height in this era, had opened new horizons for Europe's barricaded mentality. Returning soldiers brought with them tales of the East and marvelous fabrics and goods that immediately caught the fancy of nobleman and commoner alike. All of this caused a literal explosion of demand for trade goods and services, not only for the importation of de-

sired materials, but also for a transforming of the physical world. Response was nearly instantaneous, because Italian trading cities such as Genoa, Pisa, and Venice, had never fully declined as commerce-oriented centers.

Within the newly emerging towns and cities of the rest of Europe very powerful *guilds* of artisans and merchants rapidly developed. No order gives up power easily, and struggles, sometimes violent, pitted burghers against nobleman. The crusades had financially ruined many feudal landholders, and the taste of possible power and wealth strengthened the resolve of the new middle class. They needed a more stable society than feudalism could offer, and so they threw their newly emerging wealth and power behind strengthening monarchies. As a result, administration centralized, life stabilized, and a rudimentary democracy emerged. The thirteenth century witnessed the Magna Carta, which built upon twelfth century English common law, and the establishment of an English Parliament (1295). Democracy began in Switzerland, and in 1302 the *Estates General* were founded in France, bringing a spark of democracy to that country.

The final piece of this amazing medieval human and political jigsaw puzzle took the shape of the university and its consequent intellectual enlightenment. Many universities gained their charters in the twelfth and thirteenth centuries, for example, Oxford University in England, Salamanca in Spain, the University of Bologna in Italy, and the University of Paris in France. Many had existed previously in association with monasteries, but their formal chartering brought them out amid the public. Medieval universities were not as we know them today; they had no buildings or classrooms; rather they consisted of *guilds* of scholars and teachers who gathered their students together wherever space permitted. University life spawned a core of individuals who sought knowledge

for its own sake and who could not accept a condition of society or a state of mind that walled itself in and rigidly resisted any questioning of authority.

Within and from this context came new philosophy and thought. St. Thomas Aquinas built a philosophic structure which could accommodate divergent points of view. Dante suggested a new balance of viewpoints in *The Divine Comedy*. Aristotle was rediscovered and introduced throughout Europe, and Roger Bacon began a study of the physical world, on which he based all knowledge. Walls were collapsing, and light and fresh air flooded the Western world. A new freedom, comfort (both physical and spiritual), and potential affected every level of society. Thirteenth-century philosophy reconciled reason and revelation, the human and the divine, the kingdom of God and the kingdoms of man. Each were considered parts of a universal, harmonious order of thought.

By the fourteenth century some things had changed. Reason and revelation and God and the state, were considered separate spheres of authority, neither subject to the other. Individual nations (in contrast to feudal states *or* Holy Empires) had arisen throughout Europe. However, social and economic progress was disrupted by the plague (1348–50), which killed half the population of Europe, and by the Hundred Years' War (1338–1453). In the arts, secular forms emerged into prominence, respectability, and significance. These changes, of course, were gradual, and they reflected a shift of emphasis, not really a reversal of values.

Earlier in this book I used the terms "ebb and flow" and "shifting and sliding" to describe the manner in which the arts have crossed the centuries. So far in our examination, lack of record has muddied the impact of that concept. From the twelfth century onward our understanding and examples of most of the arts are fairly clear and broadly

based. We will be able to see that characteristics of style may or may not adhere to all forms in all places in the same time. A major stylistic label may refer to a rather broad chronological period even though that style may have come and gone in some places without reference to the parameters of the period—or may never have arrived at all in certain areas or art forms.

THE ARTS
OF THE LATE MIDDLE AGES

Two-Dimensional Art

In the twelfth to the fifteenth centuries traditional painting in the form of frescoes and altar panels returned to prominence. Two-dimensional art continued to illustrate the gradual flow of one style into another without the emergence of a clearly dominant identity. However, because the twelfth to the fifteenth centuries are so closely identified with Gothic architecture, and because painting found its primary outlet within the Gothic cathedral, we need to ask what qualities reflect a "Gothic" style in painting? The answer is not readily apparent as in architecture and sculpture, but several characteristics seem evident. One is an emergent three-dimensionality in figure representation; the second is a striving to give these figures mobility and life within three-dimensional space. Space is the essence of Gothic style. The Gothic painter had not mastered perspective, and so his compositions do not exhibit the spatial rationality of later works; but if we compare him with his predecessors of the earlier medieval eras, we discover that he has more or less broken free from the static, frozen, two-dimensionality of earlier styles. Gothic style also exhibits spirituality, lyricism, and a new humanism (mercy versus irrevocable judgement). Gothic painting is less crowded and frantic; figures are less entangled with each other.

It was a style in transition, with numerous variants; and were our examples to expand beyond the limits of these pages, discussions of any representative Gothic painter, whether Duccio, Simone Martini, Cimabue, Giotto, the Lorenzettis, the Limbourgs, or Broederlam, would be marked by influences of other styles on each painter's works. Nonetheless, despite those influences, of whatever nature, each still falls within the broader framework of characteristics appropriate to the Gothic.

Gothic style in painting could be found throughout continental Europe, but the center of activity and the area of greatest influence was Italy; Giotto, Duccio, Simone Martini, and the Lorenzetti brothers were the standard bearers. By the turn of the fifteenth century Italian and northern European Gothic had merged into an "international Gothic style" typified by the works of Melchior Broederlam and the Limbourg Brothers. Two examples serve to illustrate the several generalities we made earlier. Pietro Lorenzetti's Triptych "The Birth of the Virgin" (Fig. 2.11) shows a careful concern for three-dimensional space and figure depiction. The figures are lifelike and earthly; highlight and shadow give plasticity to faces and garments; the treatment of draping fabric in the gowns of the right panel shows precise attention to realistic detail. We have a sense of a scene in progress in which we are participants, as opposed to a rendering frozen on a two-dimensional surface. A relaxed atmosphere pervades the scene and the eye travels across the work in a lyrical sweep with a pause here and there to observe important focal areas. Figure groupings are spaced comfortably; the composition spreads through all

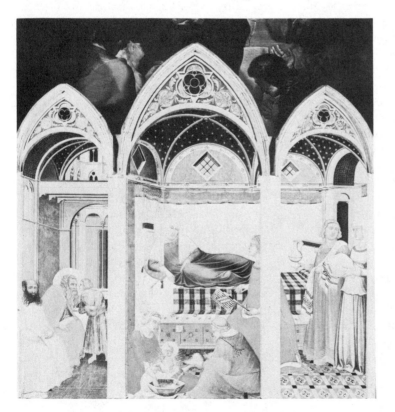

Fig. 2.11. Pietro Lorenzetti. "The Birth of the Virgin." 1342. Panel, 6′ 1½″ × 5′ 11½″. Cathedral Museum, Sienna. Scala/Editorial Photocolor Archives.

three panels, in a continuation behind the columns separating the panels. Giotto's "The Lamentation" (Fig. 2.12) illustrates the same concerns and many of the same solutions. Figures are plastic through highlight and shadow, although not as soft as Lorenzetti's; Giotto has hardened the edge of each form with an outline. His fabrics likewise do not drape freely. They retain an earlier decorative quality of lower verisimilitude. Figures are crowded, but still free to move. Emotion permeates the fresco, and although it is frenetic to some degree, it is human, individualized, and controlled. What makes Giotto's fresco so compelling is his unique conquest of three-dimensional space. His background utilizes atmospheric perspective, but unlike other painters who created deep space behind the primary focal plane, Giotto brings the horizon to *our* eye level. As a result, we participate in a three-dimensional scene that moves out to us. Space in the painting is contiguous with the space in front of it. Lorenzetti and Giotto are quite different, and a more detailed analysis would illuminate influences of other traditions in each work. Nevertheless, both examples contain clear general characteristics of the Gothic style.

Fig 2.12. Giotto. "The Lamentation." Fresco. c. 1305–6. Arena Chapel, Padua. Alinari/Editorial Photocolor Archives.

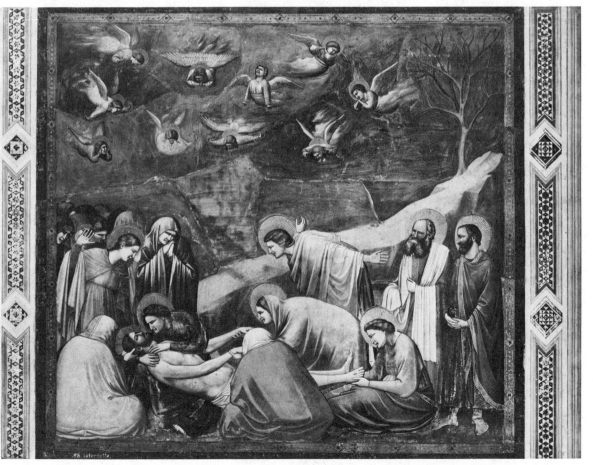

Sculpture

Gothic sculpture reveals the changes in attitude of the period. It portrays serenity, idealism, and simple naturalism. Gothic sculpture, like painting, has a human quality, and takes a kindlier view of life. The "vale of tears" and "death and damnation" are replaced with conceptions of Christ as a benevolent teacher and God as "beautiful." This style has a new sense of order, symmetry, and clarity. Its visual images carry with greater distinctness over a distance. The figures of Gothic sculpture are less entrapped in their material; that is, they stand away from their backgrounds, almost as if they could be released with only a small amount of chiselling (Fig. 2.13).

Schools of sculpture developed throughout France, and although individual stone

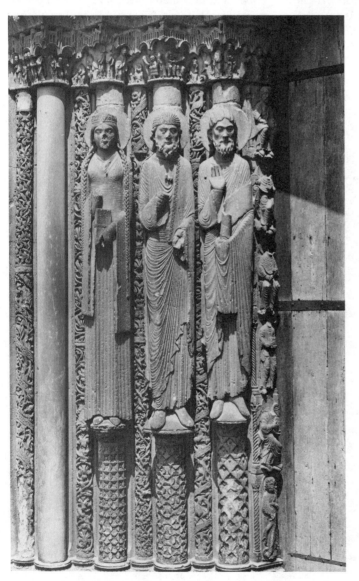

Fig. 2.13. Jamb statues. West portal. Chartres Cathedral. Begun 1145. Photographie Giraudon.

carvers worked alone, their common ties to a school gave their works a unified character. For example, Rheims had an almost classic quality; Paris was dogmatic and intellectual (perhaps a reflection of its role as a university city). As the period progressed, sculpture became more naturalistic. Spiritualism was sacrificed to everyday appeal, and sculpture took on a worldliness reflective of the increasing influence of secular interests, both middle class and aristocratic. Compositional unity also changed from early to late Gothic. Early architectural sculpture was subordinate to the overall design of the building; later architectural sculpture lost much of that integration as it also gained in emotionalism (Fig. 2.14). Restrained dignity and idealization gave way to individualized and emotionalized figure depiction.

Nothing illustrates the transition just noted more clearly than the sculptures of Chartres Cathedral, which bracket nearly a

century. The attenuated figures of Figure 2.13 reflect a relaxed serenity, idealism, and simple naturalism. They emerge from the portal columns of which they clearly are a part, in graceful and kindly spirit. Each is comfortable in its own space, and each presents a human dignity despite idealized depiction. Cloth drapes easily over the bodies; its detail is somewhat formalized and shallow, but we see a significant Gothic change in the fact that we now see the human figure revealed beneath the fabric—in contrast to the previous use of fabric as mere compositional decoration. Warm and human as these saints may be, the warrior saints of one hundred years later are even more so (Fig. 2.14). Proportion is more nearly lifelike, and the figures have only the most peripheral of connections to the building proper. Notice especially the subtle "S" curve of the figure on the extreme left. Fabric drapes much more naturalistically; its folds are deeper and softer. In

Fig. 2.14. Jamb Statues. South transcept portal. Chartres Cathedral. 1215–40. Photo courtesy of Heaton-Sessions Studio, New York.

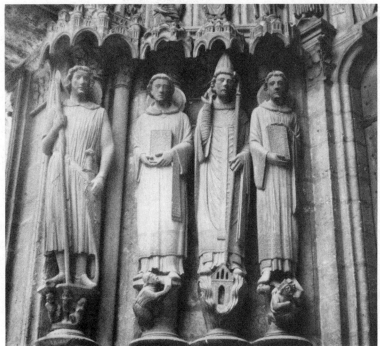

contrast to the idealized older saints, these young warriors have the features of specific individuals, youth whom the sculptors thought embodied qualities of spirituality and determination. Again we see in two diverse treatments, illustrations of the overriding concerns and characteristics of Gothic style.

The Gothic style was fairly consistent in France, Germany, and Spain. In Italy, it was quite different; Italian sculpture had a classical quality probably due to the influence of the German Emperor Frederick II who ruled southern Italy and Sicily (from which came one of the major Italian sculptors of the period, Nicolo Pisano). Pisano's works have both

Fig. 2.15. Nicola Pisano. Pulpit. c. 1259–60. Baptistry, Pisa. Photo courtesy of Heaton-Sessions Studio, New York.

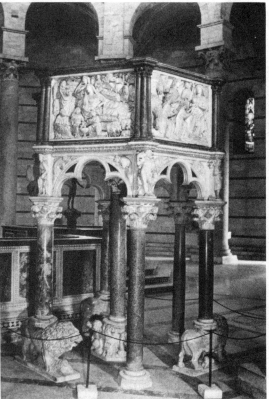

a Roman and a medieval quality in their crowded use of space (Fig. 2.15).

By the turn of the fifteenth century the *international style* noted in painting had virtually unified all of European Gothic, including Italian. This development in sculpture reinforced the deep space of Gothic painting and brought figures even further forward, not by detaching them from their background, but by making that background an empty space as opposed to a "wall."

One further aspect of Gothic sculpture is noteworthy, and that is its content. Gothic sculpture, like most church art, was didactic; it was designed to teach. Many of its lessons are fairly straightforward, understandable by anyone with a basic knowledge of the Bible. Christ appears as ruler and judge of the universe above the main doorway of Chartres Cathedral, with a host of symbols of apostles and others (Fig. 2.16). Also decorating the portals are the prophets and kings of the Old Testament, whose purpose is to proclaim the harmony of secular and spiritual rule by making the kings of France the spiritual descendants of Biblical rulers.

Other lessons of Gothic cathedral sculptures are more complex and hidden. According to some scholars specific conventions, codes, and sacred mathematics are involved. These factors relate to positions, groupings, numbers, symmetry, and recognition of subjects. For example, the numbers three, four, and seven (which we see often in compositions of all post-Gothic periods) symbolize the Trinity, the Gospels, the sacraments, and the deadly sins. Figures around Christ show their relative importance, with the position on the right being most important. Amplifications of these codes and symbols are carried to highly complex levels of communication. All of this is consistent with the mysticism of the period, which held to strong beliefs in allegorical and hidden meanings in Holy sources.

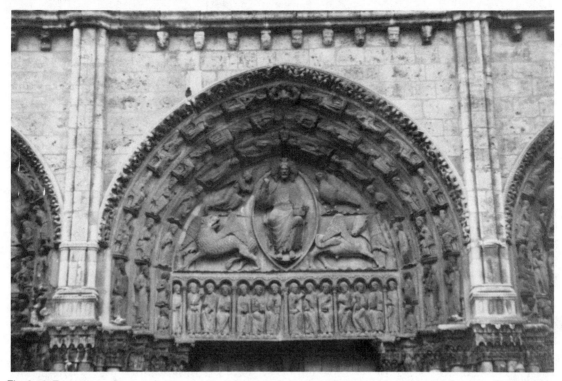

Fig. 2.16 Tympanum. Central portal, west front. Chartres Cathedral. Photo courtesy of Heaton-Sessions Studio, New York.

Music

Paris functioned as the center of activity in music in the twelfth and thirteenth centuries, and that century and one-half often is treated as a distinct period in musical style. Perhaps reflective of the relaxation, additional stability, and an increasing, designed complexity, as opposed to frenetic emotionalism we can see in the other arts of the period, music adopted formal composition, increased formalization of notation and structure, and an increased textural complexity. In earlier times improvisation formed the basis of musical composition. Gradually musicians felt the need to compose a piece of music so that it had a form of permanence—as opposed to improvising it anew on certain melodic patterns each time the piece was performed. As a result, in the late Middle Ages "musical composition" became a specific and distinct entity. Composers such as Leonine and Perotin would be noteworthy.

Even when specifically composed, music could be transmitted orally from performer to performer or from teacher to student. However, standardized musical notation made it possible for the composer directly to transmit his ideas to the specific performer. Such a device inserted the performer between the composer and the audience, making the performer a vehicle of transmission and interpretation in the musical communication process.

The structure of musical composition also increased in formality during this period. Conventions were established regarding rhythm, consonant harmony, and mode (similar to our concepts of *key*). As we saw earlier, polyphony began to replace monophony as the dominant musical texture. Monophony continued, with important examples of chant, hymns, and other forms emerging during this time.

Each of these developments contributed so

succinctly to music that modern scholars refer to the mid-twelfth and thirteenth centuries as *ars antiqua,* "old art," or the "old" method of composing. Very quickly, in the fourteenth century, music would undergo another change, characterized as *ars nova,* "new art."

Music of *ars antiqua* shared the change of viewpoint that characterized two-dimensional art and sculpture, that is, a more rational, as opposed to emotional, underlying approach and feeling. Increased formal structure and composer control, reflecting music's reaction to society's increasing stability, were illustrated by triple groupings of beats, composition based on conventions of the chant, deliberate limitation of melodic range, strongly linear texture, and *avoidance of characteristics of purely emotional appeal.*

A number of forms typify twelfth- and thirteenth-century music, among them various types of *organum* (simple early polyphonic works, kinds of "singing together" seen in early liturgy) and *cantilena* (monophonic and polyphonic secular songs). However, the most notable and typical forms were the motet (from the French *mot,* meaning "word") and the *madrigal.* Motets developed from *organa* and employed a second set of words in the upper melodic voice. Later, a third and then a fourth voice were added. Usually a motet is considered as a sacred polyphonic work compared with Italian madrigals whose texts were secular. However, in its early form motets had sacred and secular texts. In the fourteenth century motets were more lengthy and elaborate than in the twelfth and thirteenth centuries, but the motet almost always retained two aspects of its earliest history: The lowest voice in the composition was taken from the chant, and the melodic range remained restricted.

Not unlike movements in the theatre and visual arts, the fourteenth century witnessed a distinct change in musical emphasis and general style. Music of the *ars nova*[4] reflected greater diversity and freedom of rhythm. Harmonic organization changed to emphasize specific progressions focusing on tonal centers. Passages of parallel fifths, which we find characteristic of medieval music, were utilized less frequently than passages of parallel sixths and thirds. During this period the first complete Mass was composed by de Machaut. Other changes were prevalent, most of which are far beyond the scope of this work in their technical complexity. However, the mysterious and haunting "open" sound of medieval chant was definitely changing to a more "modern" sound. Music moved out of the church, as did theatre, reflecting the philosophical separation of church and state, of revelation and reason mentioned earlier. By the turn of the fifteenth century music witnessed a reunification of previously distinct French and Italian medieval styles into an "international style" such as occurred in the visual arts and architecture.

Secular music flourished in the twelfth to fourteenth centuries. The tradition of the troubadour and the wandering entertainer continued, and the courtly tradition found in music and poetry an exquisite forum for its love-centered philosophy. Ballads of love and honor (on, for example, Camelot and King Arthur) praising "m'lady's beauty" and the joys of loving her, even from afar, are typical. In Germany this tradition gave rise to *minnesänger* ("courtly love singer"), poet–musicians who mingled love and religion and sang songs of sadness and death.

We still have much to learn about instruments and their tonal quality (timbre) in this

[4]*Ars Nova* was the title of a treatise written by Philippe de Vitry in the early fourteenth century addressing technical points in compositional direction. Musicians of the period were very conscious of what they considered to be "modern" changes from the *ars antiqua.*

period. Timbres probably were clear and shrill, but about all we can add to what was indicated in the paragraph on early medieval instruments is the observation that performing ensembles, whether vocal or instrumental, were small in numbers. Although composition was formalized, composers seemed not to have had any inclination to indicate on a manuscript the instrument for a given part. Apparently custom was so entrenched that composers felt confident that adequate performances of their music did not require specific directions. Of quiet significance to the fourteenth century was the invention of the first keyboard instruments of the harpsichord variety. However, these did not come into common usage until a century later.

Dance

As mentioned earlier, *dance* was part of medieval religious and secular activity, but with the exceptions of *pantomime,* examples of which have perished with the ages, theatre dance was less important than forms of group dancing. Fascinating illustrations survive such as the *ring dance* on the "Hymn of Jesus" in which twelve dancers representing the apostles and the zodiac danced in a circle. Amid the ravages of the plague, the *danse macabre* (dance of death) appeared; in it people, whipped by frenzy and hysteria, danced until some dropped to die of exhaustion. *Choreomania,* an English version of the *danse macabre,* was characterized by group psychosis, dementia, and self-flagellation. Numerous folk and court dances also existed.

Within the courtly tradition theatre dance found its rebirth. Court dance was expressive and restrained with instrumental accompaniment. A certain degree of spontaneity marked court dances, but it increasingly conformed to specific rules. Court theatrical dance also utilized professional entertainers, and depended to a large degree upon the guid-

ing hand of the dancing master, perhaps more like a square dance caller at that time than the ballet master and choreographer for whom he was the professional prototype. However, it remains for a later age to give us adequate documentation of theatre dance upon which to develop any detailed discussion.

Theatre

Probably because of their relationship to the Church, major movements in the arts in the twelfth to fifteenth centuries were reasonably unified and widespread. Although local diversity was common, styles were generally alike. The theatre was no exception. As the Middle Ages progressed, drama associated with the Church followed the example of painting and included more and more Church-related material. Earliest church drama (the *trope*) was a simple elaboration and illustration of the Mass. Later, drama included Bible stories (*mystery plays*), lives of the saints (*miracle plays*), and didactic allegories (*morality plays*), with characters such as Lust, Pride, Sloth, Gluttony, and Hatred.

Theatrical development throughout Europe (including Germany, Italy, and Spain) appears to have been relatively similar, although the dates were different. Tropes were performed in the sanctuary, using niches around the church as specific scenic locations. On special occasions *cycles* of plays were performed, and the congregation moved from niche to niche to see each part of the cycle. It is difficult for us to pinpoint specific developments even in specific churches, but clearly these dramatizations quickly became very popular.

Over the years production standards for the same plays changed drastically. At first only priests performed the roles; later laymen were allowed to act in liturgical drama. Women's roles usually were played by boys, but evidence exists to suggest that women did participate occasionally. The popularity of

church drama soon made it impractical, if not impossible, to contain the audience within the church building. Evidence also suggests that as laymen assumed a greater role, certain vulgarities were introduced. Comedy and comic characters emerged, even from the Easter tropes. On their way to the tomb of Jesus the three Marys stop to buy ointments and cloths from a merchant. For some reason the merchant developed into one of the earliest medieval comic characters. Amateur actors seem never able to contain themselves when they discover something in their role that elicits laughter from the audience. The next performance inevitably sees the comic action expanded to prompt a bigger laugh. The most popular comic character of all was the Devil.

Whatever the reason or reasons, church drama eventually moved outside the sanctuary and, like church architecture and sculpture, opened itself more widely to the common man and woman. When medieval drama moved out of the church, various production practices developed in different locales. In France and Italy the stationary stage decoration of the church interior became a *mansion stage.* The specific configuration of the mansion stage differed from location to location; in Italy it was rectangular and linear, designed to be viewed from one or two sides. In some parts of France arena staging, in which the audience completely surrounded the stage area, was utilized. Whatever the specific application, the mansion stage had a particular set of aesthetic conventions that made its style unique. The individual mansions depicted their locations realistically. At the same time, areas between the mansions were treated conventionally. They could serve as any location.

The most interesting depiction on the medieval stage was Hell or Hellmouth. If we knew more about exact dates, the development of Hellmouth could provide interesting comparisons with sculpture, for example, in charting changing attitudes toward death, Hell, fear, and mercy. Audiences demanded more and more realism and complexity (compare with changes in Gothic sculpture) in Hellmouth, and descriptions are common of devils pulling sinners into the mouth of Hell (often depicted as the jaws of a dragonlike monster) amidst smoke and fire. One source describes a Hellmouth so complicated that it took seventeen people to operate it. Some plays, for example *Antecriste* and *Domes Daye,* clearly were intended to be frightening, but in the late Middle Ages even vividly depicted Hellmouths seem to have been comic in their intentions, rather than fearful. Plays such as *Abraham and Isaac* and *The Second Shepherd's Play* are humorous and compassionate, clearly reflecting the change in attitude of the age.

When the action of a play moved away from a specific mansion the aesthetic became conventional such as we saw in classic Greek theatre. The space between the mansions could be any location. The text of the play told the audience where the action was supposed to occur; the audience then imagined that locale.

In England and parts of France and the Netherlands another staging style occurred. Rather than move the audience or depict the entire set of locations on a multiscened mansion stage, theatre was brought to the audience on a succession of *pageant wagons,* like the floats of a modern parade. Each wagon depicted a specific part of the play cycle. Many wagons were very elaborate, two-stories tall, and curtained for entrances and exits like a modern theatre. In some cases a flat wagon combined with an elaborate background wagon to provide a playing area. This type of production mostly was used in cities; narrow wagons were needed to negotiate narrow streets. At intersections where more space existed, wagons were coupled and

crowds gathered to watch the play segment. When the segment finished, the wagon moved on, replaced shortly by another wagon that served as the setting for another short play in the cycle.

As time progressed theatrical production became more and more elaborate and realistic. Many productions were extremely complicated in detail and direction as well as in realistic depiction. Live birds, rabbits, and lambs gave life to the play, as did elaborate costumes that represented specific characters. Bloody executions, wounds, and severed heads and limbs were very common in later medieval drama.

When drama moved out of the church, local guilds began to assume responsibility for various plays. Usually the topic of the specific play dictated the guild responsible; for example, the watermen performed the *Noah* play and cooks presented *The Harrowing of Hell* because it dealt with baking, boiling, and putting things into and out of fires. Increasing secularization and fourteenth century philosophical division of Church and state gave rise to a separate secular tradition which led, in the fifteenth century, to French farce. Even religious drama came into professional secular control in France when King Charles VI granted a charter in 1402 to the *Confrèrie de la Passion.*

A typical mystery play was the *Adam* play of early twelfth century France. It was performed in the vernacular and began by reminding the actors to pick up their lines, to pay attention so as not to add or subtract any syllables in the verses, and to speak distinctly. (Whatever the time or the forum, the theatre is *theatre!*) The play told the Bible story of Adam and probably was played in the square outside the church, with the actors retiring into the church when not directly involved in the action.

Illustrative of the expanding subject matter of Christian drama was a play of the thirteenth century, John Bodel of Arras' *Le Jeu de Saint Nicholas.* The play is set in the Holy Land amid the battles between the Christian Crusaders and the Infidels. In the battle all the Christians are killed except a Monsieur Prudhomme who prays to St. Nicholas in the presence of the Saracen King. The king was told that St. Nicholas would safeguard his treasure, and when St. Nicholas actually intervenes to foil a robbery attempt, the king is converted. Similar plays of conversion of historical figures (usually amidst attempts to ridicule Christianity or vilify Christians) were very popular, as were plays about the intercessions of Mary (called Mary-plays).

Architecture

Gothic style in architecture took many forms, but it is best exemplified in the Gothic cathedral. The cathedral, in its synthesis of intellect, spirituality, and engineering, perfectly expresses the medieval mind. Gothic style was widespread in Europe; like the other arts it was not uniform in application, nor was it uniform in date. It began as a very local expression on the Île de France in the late twelfth century, spread outward to the rest of Europe, and had died as a style in certain locales before it was adopted in others. So, as is so often the case, we must view this style with a more flexible viewpoint than merely a chronological one. The "slipping, sliding, and overlapping" circumstances of artistic development adhered fully to Gothic architecture.

The cathedral was, of course, a church building whose purpose was the service of God. However, civic pride as well as spirituality inspired its proliferation. Various local guilds contributed their services in furtherance of financing or in actual building of the churches, and guilds often were memorialized in special chapels and stained glass windows. The Gothic church occupied the central, often elevated, area of the town or city. Its physical centrality and context symbolized

the dominance of the universal Church over all affairs of men—spiritual and secular. Probably no other style has seen such an influence across the centuries or played such a central role, even in twentieth-century Christian architecture. The Gothic church spins an intricate and fascinating story, only a few details of which we can highlight here.

Unlike any other architectural style, the beginnings of Gothic architecture can be pinpointed between 1137 and 1144 in the rebuilding of the royal Abbey Church of St. Denis near Paris. There appears ample evidence that, rather than merely an excellent advance of engineering in solving some inherent structural limitations of Romanesque building (as some have suggested), Gothic is, in fact, an outgrowth of philosophy. That is, its theory preceded its application. The philosophy of the Abbot Suger, who was advisor to Louis VI and a driving force in the construction of St. Denis, held that harmony, the perfect relationship of parts, is the source of beauty; that "Light Divine" is a mystic revelation of God, and that space is symbolic of God's mystery. The composition of St. Denis and subsequent Gothic churches perfectly expressed that philosophy. As a result, Gothic architecture is more unified than Romanesque. Gothic cathedrals express refined, upward-striving line symbolizing, both in exterior spires and the pointed arch, humanity's upward striving to escape (at the tip) from earth into the mystery of space (God).

Of course, the pointed arch is the most easily identifiable characteristic of this style, and it represents not only a symbolic expression of Gothic spirituality but also an engineering practicality. A pointed arch completely changes the thrust of downward force into more equal and controllable directions; the round arch places tremendous pressure on its keystone, which then transfers thrust outward to the sides. The pointed arch controls thrust into a downward path through its legs.

The pointed arch also adds design flexibility. Dimensions of space encompassed by a round arch are limited to the radii of specific semicircles. Since the proportions of a pointed arch are flexible, dimensions may be adjusted to whatever practical and aesthetic parameters are desired. The Gothic arch also increased the *sense* of height in its vaults. Some sources suggest that this structure actually made increased heights possible. That implication is not quite correct. Some Romanesque churches had vaults as high as any Gothic churches, but the possibility for change in proportion of height to width did increase the apparent height of the Gothic church.

Engineering qualities implicit in the new form made possible larger clerestory windows (hence more light) and more slender ribbing (hence a greater emphasis on space as opposed to mass). Outside, practical and aesthetic "flying butresses" carry the outward thrust of the vaults through a delicate balance of ribs, vaults, and buttresses gracefully and comfortably to the ground (Fig. 2.17). Every

Fig. 2.17. Flying buttresses.

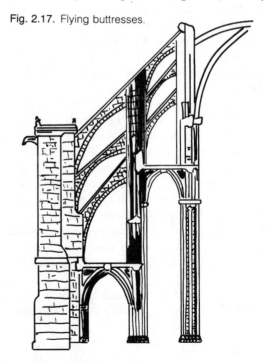

detail is carefully integrated into a unified whole. The severity of stone is transformed into a tracery of decoration emphasizing mysterious space. Three examples characterize Gothic style and illustrate the marvelous diversity that existed within it. The four-square power of Notre Dame de Paris (Fig. 2.18) reflects the strength and solidity of an urban cathedral in Europe's greatest city of the age. Its careful composition is highly mathematical, each level is equal to the one below it, and its tripartite division is clearly symbolic of the trinity. Arcs (whose radii are equal to the width of the building) drawn from the lower corners, meet at the top of the circular window at the second level. Careful design moves the eye inward and slowly upward. Outwardly expressed structure clearly reveals interior space, in contrast to the Romanesque.

Fig. 2.18. Notre Dame. 1163– c. 1250. Photo by Enell, Inc., courtesy of TWA—Trans World Airline.

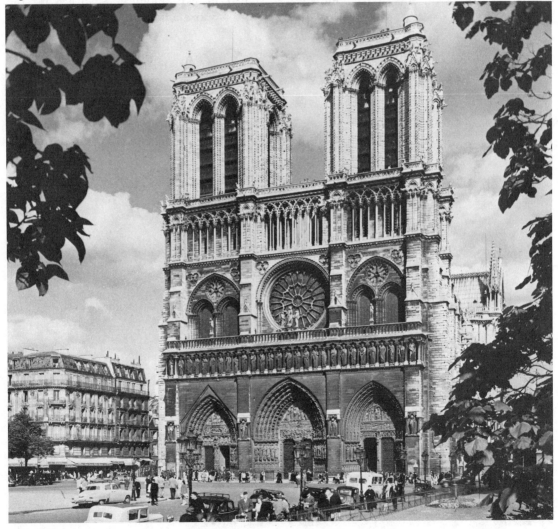

Chartres Cathedral (Figs. 2.19 and 2.20) stands in remarkable contrast. Chartres is a pleasant country cathedral raised above the center of a small city. As its sculptures illustrate a progression of style, so does its architectural design. Our first encounter leads us to wonder why its cramped entry portal is so small in comparison with the rest of the building. To understand the answer we must understand that Chartres represents a cumulative building effort over many years as fire destroyed one part of the church after another. So the main entry portal and the windows above it reflect Romanesque beginnings. The porch of the south transcept (the portal holding the statues of the warrior saints) is much larger and more appropriate in harmony with the rest of the building. Finally, as our eyes rise upward, we wonder at the incongruity of the two unmatched spires. Here, fire has added another layer to this marvelous revelation of Gothic development. The early spire on the right illustrates faith in a simple upward movement that rises, unencumbered, to disappear at the tip into the ultimate mystery—space. The later spire, designed in psychological balance with the other is more ornate and complex. The eye

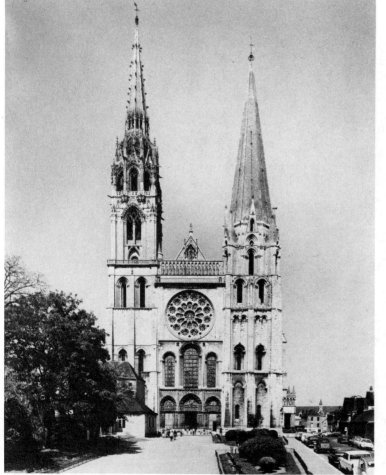

Fig. 2.19. Chartres Cathedral. 1145–1220. Photographie Giraudon.

Fig. 2.20. Chartres Cathedral. Porch, south transcept. c. 1205–50. Photo courtesy of Heaton-Sessons Studio, New York.

travels upward with increasing difficulty, its progress halted and held earthbound by decoration and detail.

The Cathedral at Amiens (Fig. 2.21) is similar in basic composition to Notre Dame, but rather than a sense of foursquare power, it gives us a feeling of delicacy. Amiens Cathedral illustrates a late development of Gothic style similar to the left spire of Chartres Cathedral. However, in scale and proportion Amiens is most like Notre Dame. The differences between Amiens and Notre Dame produce an important lesson in the relationship between design and its communication to elicit a response. Amiens is more delicate than Notre Dame, and the feeling comes from increased detail that focuses our attention on space as opposed to flat stone. Both churches are divided into three very obvious horizontal and vertical sections of roughly the same proportion. Notre Dame appears to rest heavily on its lowest section, whose proportions are diminished by the horizontal band of sculptures above the portals. Amiens, on the other hand, carries its portals upward to the full height of the lower section. In fact, the central portal, much larger in comparison, than the central portal of Notre Dame, reinforces the line of the side portals to form a

Fig. 2.21. Amiens Cathedral. c. 1220–59. Photo courtesy of Heaton-Sessions Studio, New York.

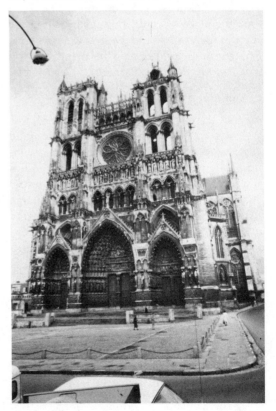

pyramid whose apex penetrates into the section above. The similar size of Notre Dame's portals reinforces its horizontal sense, thereby giving it stability, whereas Amiens has upward, dynamic movement. Similarly, each use of line, form, and proportion in Amiens reinforces lightness and action, as compared with stability and strength in Notre Dame. This discussion does not mean that one is a better design than the other. Each is different and reflects a different viewpoint. Perhaps the architects intended different messages. Nevertheless, both Cathedrals are unquestionably Gothic, and we easily can identify the qualities that make them illustrative of that style.

The importance of stained glass windows to the Gothic Cathedrals and viewpoint cannot be underemphasized. They carefully controlled light entering the sanctuary, reinforcing a marvelous sense of mystery. They also took the place of wall paintings in telling the story of the gospels and the saints, the walls of Romanesque style having been replaced by space and light in the Gothic.

Summary

The terms "Dark Ages" and "Middle Ages" were given to parts of the thousand years between the fifth and the fifteenth centuries. The early Middle Ages was a dissolution fragmenting the Western world into a chaotic jumble of confusion and, to a large degree, darkness. The dissolution occurred gradually, and changes were slow in developing and spanned several generations. Pessimism and disillusionment had increased in Rome over the centuries and carried into the Middle Ages. In the West the cloak of internationalism, which had loosely united the Mediterranean world since Alexander, fell apart. Nations, as we know them did not exist. Borders were in flux and warfare was constant. In this context an infant Christianity struggled to survive and began to institutionalize and develop its dogma. In Eu-

rope, as the Western Church sought to establish itself, illiteracy and dismal living conditions prevailed. A system of localized government called feudalism compounded fragmentation, and kept the masses, called serfs, in a state of near slavery. No broad, central authorities had enough power to stabilize the situation. The devil as a symbol of the powers of darkness and of evil was a strong force in medieval thinking and superstition, and the Church manipulated those fears and images as it sought, often fanatically, to convert the pagan world. Life was a "vale of tears" leading either to the glories of Heaven or the fires of Hell. Nonetheless, the Church played an important stabilizing role, providing continuity and turning philosophy and religion from Man as the measure of all things to God as the measure of all things.

After the threats of Islam's expansion and the Moorish Conquest had been repelled by Charles Martel in 732, a period of organized political centralization called the Carolingian Period occurred. Parts of Spain, France, western Germany, and northern Italy were united in a Holy Roman Empire under Charlemagne, who was crowned emperor by the Pope in 800. The late ninth and tenth centuries shifted the focus of Europe to Germany and a "universal empire" under the Ottonians, Ottos I, II, and III. By the year 1000 Christianity had triumphed throughout Europe, and commerce was beginning to flourish, especially in the Italian port cities. A new middle class was arising.

Painting in the early Middle Ages essentially comprised Christian painting, whose characteristics often were primitive and whose outlets primarily were nonpublic. The most significant visual, two-dimensional art of the era consisted of exquisite manuscript illustration, rich in detail and high in symbolism. Such work came from within the monastaries, in which erudition was kept alive but sheltered from the world at large. Compositions were close and nervous, with a "walled-

in" quality reflective of the barricaded mentality of the age. The transitory and unstable life style also turned artistic activity to portable outlets such as clothing and jewelry. Emotionalism increased as the millenium approached. Sculpture reflected many of the same emotional, miniaturized characteristics as did painting, although its importance remained minor, probably due in part to Christian prohibitions against "graven images" and sculpture's association with pagan activities and societies.

The eleventh and twelfth centuries saw the rise of an architecturally related style called Romanesque, which was characterized by Romanlike arches and heavy walls pierced by small windows. Romanesque sculpture became a part of the exterior surfaces of church buildings of the same style and shared architecture's heaviness and monumentality. Painting also followed its visual arts brethren, but stylistic characteristics changed only gradually, and painting did not reach a clearly definitive style of its own.

Sacred music was closely related to the Roman Catholic Mass. Responsorial and antiphonal psalmody, hymns, and alleluias formed important parts of the sacred liturgy. Codification of diverse Church chants occurred under Pope Gregory I, and large numbers of worshippers made changes in traditions and practices necessary. Sacred music became less of a congregational and more of a formal, choir activity. The *Schola Cantorum* formalized training of musicians and spread Gregorian reform throughout Europe. Sacred and secular music remained principally monophonic, although in secular music wandering troubadours often sang with instrumental accompaniment; love was a frequent topic. In the ninth or tenth century polyphonic texture appeared as did a new rhythmic notation called mensural notation, which made possible an indication of the precise duration of each tone.

Theatre's characteristics in the early Middle Ages remain hidden, although its continued existence is fairly certain. Liturgical drama began as elaborations of the Roman Catholic Mass called tropes. The presence of theatre dance is less certain, although continuation of the Roman pantomime is likely in the wandering entertainers so prevalent in the era. Numerous forms of group, nonartistic dance did exist, and death and the devil figured prominently in many of these.

Prior to the emergence of the Romanesque style, architecture had seen centuries of development originating when Christianity became a state religion in Rome, at which time an explosion of building took place to accommodate the needs of worship. Significant in this development was the modification of a Roman architectural plan, the basilica, which the Christians adapted to suit their own specific needs. Charlemagne's "renaissance" in the ninth century included architecture, and his palace chapel and standardized plan for monastery design were highly influential.

By the twelfth century the masculine concepts of feudalism were countered by a distinctly feminine view of ethics and personal conduct called chivalry or the courtly tradition. Its impact was significant in religion as well as philosophy, and changed perceptions of God from those of harsh and inflexible judgment to those of mercy. Christ the Saviour and Mary the compassionate Mother were focal points of faith. Amid the changing points of view rose a new and important middle class, filling the vacuum between nobility and peasant and drawing thousands into emerging towns and cities. The chaos and darkness of previous eras was being replaced by social stability and new intellectual activity. Universities were born. The Church and state were considered separate spheres of influence by the fourteenth century, and individual nations had arisen throughout Europe.

The pre-eminent artistic style in painting, sculpture, and architecture was the Gothic. In painting a new sense of three-dimensional

space and life prevailed. Spirituality, lyricism, and a new humanism (mercy versus irrevocable judgment) emerged. By the fifteenth century an "international gothic" style in painting, sculpture, music, and architecture united most of Europe. Sculpture reflected the same qualities of humanity and mercy, order, symmetry, and clarity, becoming more and more naturalistic as the period progressed. Increased worldliness reflected the increasing influence of secular interests. Slowly but surely sculpture grew less subordinate to architecture, gaining a new independence of form. The religious context of Gothic sculpture was didactic, highly symbolic, and complex.

Music, as well as painting, sculpture, and architecture, reflected qualities of relaxation, stability, and increased designed complexity. Standardized notation became widely used, and musical structure increased in formality. Conventions were established regarding rhythm, consonant harmony, and mode. Polyphony became a dominant texture. The *ars antiqua* of the twelfth and thirteenth centuries gave way in the fourteenth century to *ars nova*. Organum continued; *cantilena,* motets, and madrigals became prominent. The fourteenth century reflected greater diversity and freedom of rhythm; harmonic organization changed to emphasize specific progressions focusing on tonal centers. Secular music flourished and reflected the code of chivalry in ballads of love and honor.

Theatre dance found its rebirth in the courtly tradition. It was expressive and restrained and marked by spontaneity, although it increasingly conformed to specific rules. Professional dancers were utilized and the dancing master first appeared, beginning a role which later would become the ballet master and choreographer. As the Middle Ages progressed, drama associated with the Church followed the example of painting and included more and more Church-related material. Expanding from the trope, liturgical drama included mystery, miracle, and morality plays, and over the years production standards for the same plays changed drastically, with specific differences notable among various countries. Moving out of the sanctuary, dramas became more and more secularized. Audiences demanded greater realism and complexity, and the most popular of effects included elaborate, dragonlike depictions of Hellmouth. Like the other arts and society at large, drama moved from works designed to frighten to works showing greater humor and compassion.

Gothic style was most notable in architecture, and the pointed arch, symbolic of this style, expressed a synthesis of medieval intellect, spirituality, and engineering. Widespread throughout Europe, it was not uniform either in application or in date. Apparently developed from philosophies espoused by the Abbot Suger, the Gothic cathedral illustrated that harmony, the perfect relationship of parts, is the source of beauty, that "light divine" is a mystic revelation of God, and that space is symbolic of God's mystery.

The Middle Ages reflected the intellect versus emotion continuum we traced from classic, Periclean Athens to the Hellenistic Mediterranean world to Rome. This time the pendulum has appeared to reverse, moving from close, frenetic emotionalism in the earlier Middle Ages to a more relaxed and formal attitude in the Gothic. However, naturalism and complexity accompanied this return to form and order. In the movement from classic, Periclean Athens to Rome the opposite occurred.

Chapter 3

THE

RENAISSANCE

AND BAROQUE

- Humanism, Capitalism, Inquiry, and Reformation
- The Arts of the Early Renaissance
- Discord, Rationalism, Emotionalism, and Absolutism
- The Arts of the Late Renaissance and Baroque Style

HUMANISM, CAPITALISM, INQUIRY, AND REFORMATION

This chapter is a long and complicated one. The word *renaissance* means many things to many individuals. Its most literal translation is "rebirth," but, when referring to a specific epoch in history, a rebirth of what? Does "Renaissance," like "Gothic," imply one artistic style or many similar styles? Is it a historical term or a philosophical one? Or is it all of these? Was it a unified period of consistent philosophical and artistic reflections, or was it merely a natural extension of medieval forces that quickly dissipated into diverse reflections? Unfortunately no precise, or more importantly, no universally accepted answers to these questions exist. The details and definitions surrounding the Renaissance have been debated for centuries. Certainly, "Renaissance" reflects, in general, an attitude of self-awareness coined by individuals who had come to see themselves as no longer part of the Middle Ages; but where and how the Renaissance began and of what specifically it was comprised is as difficult to answer as is the question of where and how it ended—if it ended.

The approach in this work has been to use chronology loosely, as a touchstone, so that we can keep our historical bearings while we turn here and there amid politics and philosophy, attitudes, and the arts. The period of the Renaissance in this work will encompass roughly three hundred and fifty years, from approximately 1400 to about 1750. During this time diverse styles developed, including a major style called baroque, and a new way of viewing the world emerged, which brought humankind out of the Middle Ages and toward an industrialized, "modern" world. Within the rough boundaries of this period we will discover vestiges of eras past, like the Gothic, which ended in some places before starting in others, a renewed interest (rebirth?) in and influence of "classical" antiquity (often badly understood), new explorations and scientific discovery, dramatic changes in religion and philosophy, and revolutionary modifications in emerging artistic styles. Some of these styles we will call very specifically, "Renaissance" and "High Renaissance"; in such cases the term has a much more specific denotation than it has in the title of this chapter or in its historical and philosophical applications. We will call other artistic ventures within these historical parameters by other names such as "mannerism" or "baroque." Some of these labels are traditional, some are debatable, and some do not refer to separate styles, but rather to aberrations or refinements of a style. Whatever the circumstances, the "Renaissance" as an historical or philosophical concept can be applied, as we have applied it, very broadly to encompass an age whose horizons and enlightenment brought mankind to the threshold of a world view increasingly similar to our own.

Not unlike our own, the age of the Renaissance had a quickened pulse and a tumult of innovations in technology, science, politics, and economics as well as the arts. It was an age of conflict and inquisitiveness, vitality, and change. However, it is best not to stress comparisons with our own times, since compression of events occupying two or three centuries into an "age," from the vantage point of history, is significantly different from viewing our own time while we are still living in it. What, in fact, is our "age"? Is it the fifteen-, twenty-, thirty-, or sixty-year period since our birth? Does it expand backward to World War II, 1900, 1850? How far

into the future will it go? I offer these observations here mainly because many individuals are fond of comparing the Renaissance with the twentieth century, and also because, as I mentioned earlier, some individuals in the "Renaissance," as they themselves called it, saw themselves in a particularly favorable light in comparison with those who preceeded them in history. Rabelais, a French writer of the Renaissance Period, assessed his age thus: "Out of the sick Gothic night our eyes are opened to the glorious touch of the sun."

Our view of the Renaissance, because it encompasses all the arts, must be a very broad and flexible one, and more objective than Rabelais'. It must accommodate a fluid and three-dimensional mixture of time, places, attitudes, and objects. The epoch for our purposes, is somewhat amorphous in shape, roughly three and a half centuries in length; as with the Gothic, Renaissance ideas and activities spread and receded differently in different places, started and stopped in some arts in a way different from others. So the Renaissance, in our view, is thicker in the middle than at the edges, seeping into eras previous and eras ahead like the mixing of irregularly shaped pools of different colored water, as opposed to the smooth butt joining of two rectangular pieces of wood.

Probably the most significant attitude characteristic of the Renaissance is humanism. The roots of Humanism lay in the Gothic world of the fourteenth century in a slowly developing separation of religion and the state. Specifically, Humanism can be traced to the writings of Petrarch around the year 1341 in Italy, and it spread throughout the Western world thereafter. Humanism, as a philosophy, was not, nor is it, as some have ventured, a denial of God or faith, but rather an attempt to discover humankind's own earthly fulfillment. The Biblical injunction "O Adam, you may have whatever you shall

desire," became Humanism's liberating idea. The medieval view of life as a "vale of tears," the only purpose of which was a suffering preparation for salvation and the afterlife, was changed by the humanists to a view of humankind as men and women playing an important part in *this* world.

As we have seen previously, concern for humankind's diversity and individuality emerged in the late Middle Ages. Medieval Europe's expanding horizons and life's increasing detail and complexity caused a previously unneeded examination of man's responsibility for a stable moral order and for management of events. Such an examination yielded a philosophy, perfectly consistent with Christian principles, that focused on humanness, dignity, and intrinsic value of the individual. Humankind was characterized by goodness and perfectability and was capable of finding worldly fulfillment and intellectual satisfaction. Humanism, as an outgrowth of increasing distaste for intransigent dogma, embraced a figurative interpretation of the scriptures and an attitude of tolerance for all viewpoints.

As we move onward in this chapter we will discover that attitudes and events in the age of the Renaissance affected each other in very complex ways. The fact that certain aspects of society, politics, religion, and the arts are treated in separate paragraphs does not imply that any or all of these composite parts of existence may be isolated from each other. In fact they cannot. All of the characteristics found in any age and in its agencies and arts are very closely associated and interacting. Such is the manner in which the marvelous and complex drama of human existence unfolds.

The interest in antiquity normally associated with the Renaissance was not new in the sense that all interest in Greece and Rome had expired in the previous thousand years. Charlemagne rekindled interest in antiquity; the

German nun Hrosvitha had access to Terence whose works influenced her to use him as a prototype for her play. Aristotle was studied in the late Middle Ages. Nevertheless, in the fifteenth century, classical antiquity comprised a force and focus previously unknown. Certainly Renaissance men and women found a kindred spirit in the Greeks and Romans. They were, after all, interested in the things of this world. Renaissance scholars found a practical resourcefulness, especially in Rome, which helped in recreating their social order. Of special interest was Roman emphasis on civil responsibility and intellectual competence. Intellectual drive led to a desire to reinterpret ancient writings, which many believed to have been corrupted by bending to serve Church dogma.

As mentioned, the writings of the ancient, pagan world were not previously unknown; they were, however, approached from a different viewpoint. Aristotle provided an appealing balance of active living and sober reflection, and the Periclean Greeks yielded an idealized conception of humankind that could, for example, be reflected in painting and sculpture. Ideals of nobility, intellect, and physical perfection were stressed, and studies of classical art and philosophy led to new conceptions of what constituted beauty and proper proportion. In their pursuit of understanding classical art and architecture, in an age of new scientific inquiry, Renaissance scholars became enamored of measuring things: "True proportions" were believed to have been found when the Roman architect Vitruvius's treatise *De architectura* was discovered in 1414. Scientific curiosity and concern for detail led to a fascination with anatomy. Scientific investigation discovered a system of mechanical perspective. All this measuring and codifying spawned a set of rules of proportion and balance. In the arts unity, form, and perfect proportion were reduced to a set of laws.

Nevertheless, in the arts as in all society, the Renaissance placed new emphasis on the individual and on individual achievement. The rising middle classes with their new found wealth and power were not long in discovering that, salvation or not, life was a great deal more comfortable if one had a good house, good clothes, good food, and reasonable control over one's own existence. Such control and satisfaction was seen to be directly related to material wealth, and so amid all other facets of Renaissance life, and perfectly in tune with them, came a new economic system, that is, capitalism, or mercantilism. To a large degree capitalism pursued wealth and power as goals in and of themselves. In its broadest and perhaps lowest form, capitalism is a corporate pursuit with an insatiable goal. That is, the goal of a corporation, a superextension of the individual, is wealth; however, a corporation is not constrained by individual need or limitations concerning consumption of wealth; therefore, a corporation can never be satisfied, regardless of the amount of wealth it attains.

Capitalism in the Renaissance was not fully developed, but it did adhere to the basic tenets of pursuit of wealth and power as ends in themselves. In contrast to medieval agrarian feudalism, capitalism provided an individual reasonable freedom to pursue increased material standards of living—to the full extent one's wits and abilities would allow. As a result, Renaissance men and women were challenged to pursue their own individual goals, constrained only by what the traffic would bear. So, the general social order witnessed an explosion of goods and services previously unavailable or previously believed unnecessary.

Capitalism rests on creation of markets as well as supplying markets, in contrast with the guild system, which produced only what was desired. Capitalism, therefore, produced an increasing diversification of occupations

and social situations relying principally upon the urban setting for sustenance and essentially separating the home and workplace. Expansion of trade, capitalism, and commerce in the fourteenth and fifteenth centuries brought high prosperity especially to three locations: northern Italy, southern Germany and what we now call the Low Countries (Belgium and Holland), and Great Britain.

Further mixing and complication of the Renaissance social order came as a result of a thirst for new discovery—scientific, technological, and geographic. Great visions illuminated even the possibilities for human flight in Leonardo da Vinci's remarkable designs for complex, future-oriented machines. Renaissance scholars sought the answers to all questions and invested in the scientific quest and risk-taking required to unearth proof, not just faith and/or philosophy. As a result, conflicts between a forward-looking science and rearward-looking traditions and values occurred often in this era. Spirited and honest inquiry often raised more questions than it could answer, and often these questions and conflicts created unsettling and destabilizing effects.

Technology significantly changed the character of this era. The invention of the printing press, in 1445, spread humanistic writings and Greek and Roman literature rapidly and widely throughout Europe. Availability of textbooks at reasonable prices significantly affected education and influenced the rise of *scholas* (similar to our public schools), thereby bringing a higher level of education (required for full participation in an increasingly complex world) to nearly the full spectrum of society, not just to the aristocracy.

Technology, science, curiosity, and individual self-confidence took humankind to the furthest reaches of the planet. Renaissance explorers increased the worldview of the age to full global proportions. In 1486 Diaz broke the Mediterranean world's isolation by sailing down the coast of Africa; his efforts were superceded six years later when Columbus sailed to the West Indies. Seven years after Columbus, Vasco da Gama completed a two-year voyage around the horn of Africa to India. The sixteenth century began as Balboa discovered the Pacific Ocean. The full extent of a globular world crashed upon Renaissance men and women in 1522 with the completion of Magellan's three-year voyage around the world. It is easy for us to miss entirely or to minimize the impact of these events on the general view of reality held at the time, but the reality of an immense globular world in a heliocentric universe later proved catastrophic for many whose views of humanity and of God were compatible only with an earth-centered universe.

Many of the circumstances and events just noted, as well as the arts to be studied shortly, owed their shape also to the political circumstances of Europe's various regions. In the late Gothic period the Church had begun to lose its total authority over all social circumstances. Men and women were willing to render unto God that which they considered His, but they also wished to render a bit unto Caesar as well. The secular world began to drift toward national identity, although identities varied greatly. In Germany, feudalism continued, and in Flanders democracy began. France, England, and Spain moved toward governance by strong monarchies, for example, that of Ferdinand and Isabella of Spain (1474–1516). In Italy, whose geography is not unlike that of Greece, independent city-states had retained their autonomy, and, especially the seaports, had continued to grow and strengthen even during the Middle Ages. Great rivalries, warfare, and intrigue existed, but the expanded commerce of the early Renaissance reinforced the dominant positions of these localities. Capitalism brought indi-

vidual families to great wealth and power in most of the Italian port cities. The most important of these families, especially to the arts, was the Medici family under Lorenzo (the Magnificent) de Medici (1449–92).

The years at the end of the fifteenth century in Italy saw changes of significant impact on the arts. In Florence, which dominated Italian Renaissance culture during the fifteenth century, the Medici family proved patronistic and potent as well as tyrannical. But by 1498 Italy and Florence had seen the expulsion of the Medici's and the death of the reformer Savonarola. For a very brief time thereafter (but what a time!) the papacy again became a centralizing authority, champion of Italian nationalism, and great patron of the arts. Artists from diverse locations moved to Rome, schools of artists were established, and artistic production proliferated in Rome and spread throughout Europe. However, the merging of classicism and Humanism with Catholicism and inquiry proved a catalyst to events determined to unsettle the Western world for the last seventy years of the sixteenth century, and affect it irrevocably for all time.

Amidst the explosive cacophony of the Renaissance period came perhaps the most shattering and lasting blow the Christian Church has ever experienced, the Reformation. Our overview does not permit us great detail, but we can summarize by indicating that, like all other major turns of events, the Reformation was assisted by the peculiar circumstances of the times. We also must understand that it began not as an attempt to start a new branch of Christianity, but, rather, as a sincere attempt to reform what were perceived to be serious problems in the Roman Catholic Church at the time. The Roman Church had always been dominated by Italy, and, given the diverse and unique political climate of the Italian peninsula, the Catholic Church had responded to newly emerging

Renaissance ideas with an increasing worldliness and political intrigue that was of great concern to many, especially in Germany. The sale of indulgences was widespread, and such a practice of selling forgiveness was particularly repugnant to a monk named Martin Luther. In 1510 Luther summarized his contentions in his "95 Theses," which he tacked to the chapel door at Wittenberg, Germany. The resulting furor caused by the Church's response to Luther became a battle, public and royal, which eventually led to a complete break with the Roman Church and the founding of Lutheranism.

Clearly the Reformation at this stage was a political power struggle as well as a theological schism. Many individuals found church dogma indefensible, especially in the light of widely disseminated opposing views. Popular resentment of central ecclesiastical authority was widespread, and even in areas still essentially feudal, enough political stability existed to resist domination by Rome. Later, the Reformation saw further breaks from Catholicism. John Calvin's *Institutes of the Christian Religion* affected mid-sixteenth century Switzerland. Calvin's austere religious tenets later were carried to Scotland by John Knox. Finally a set of circumstances in which state advantage was gained from a break with Rome occurred in England under Henry VIII. The political rather than religious nature of King Henry's battles with Pope Clement VII are well known and resulted in the confiscation of all Roman Church property in the Act of Dissolution. Bloody conflicts between Protestants and Catholics *and* Protestants and Protestants gave English history a character, which, in something less than a century, drove a certain set of emigrants to the shores of North America.

Events in Germany and England reflected some of the Reformation's underlying economic, as well as spiritual and political, motivations. Throughout Roman Catholic Eu-

rope the huge body of clergy, through the sale of indulgences among other things, amassed significant wealth that was tax free. Secular governments and a growing number of their citizenry chafed under the economic burden such a condition presented. The injury was compounded by the fact that the civil sector, in return, was taxed by the Church.

The Reformation can be seen as a force that drastically affected artistic reflection from the second quarter of the sixteenth century onward. It marks a watershed of sorts, although a preoccupation with the relationship of reformation in the Church and emotional disarray in the visual arts overlooks the fact that secular and religious peace and stability were not necessarily the watchwords of life, especially in Italy, even in the fifteenth century. Nevertheless, the position of the Reformation, relative to the end of a significant style in the visual arts and the beginnings of Renaissance reflection in some of the performing arts, places it in position as a dividing point for this chapter.

The early Renaissance was a potpourri of thought and events that had very different artistic consequences in different locations. Therefore, we need to be alert to changes of chronology and location as we examine developments which occurred sometimes simultaneously. In the visual arts and architecture achievements in one or two locations were so profound that we will isolate our discussion on a limited area, whereas in other art disciplines our examination will be more far-ranging.

THE ARTS
OF THE EARLY RENAISSANCE

Two-Dimensional Art

In the north of Europe lies a tiny area known as the Low Countries. In the fifteenth century the Low Countries included Flanders, and amid a dominant atmosphere of late Gothic architecture and sculpture, Flemish painters and musicians forged new approaches, which departed significantly from the international Gothic style, formed a link with their contemporaries in northern Italy, and influenced European painters and musicians for the next century. Many scholars believe that early fifteenth century Flanders remained totally a part of the late Gothic style, but clearly the painters of this locale had significant contact with Italy, the heart of the early Renaissance in art; clearly, also, the Italians of this new Renaissance spirit admired Flemish painting.

Flemish painting of this time constituted a pictorial revolution. In Gothic art painters attempted to create realistic sensations of deep space. For all their ingenuity, essentially they retained a two-dimensional feeling and a lack of continuity or rationality in their perspective. Gothic works contain a certain childish or fairytale quality. Giotto (Fig. 2.12) attempted to bring us a three-dimensional world, but we are not for a moment convinced that his depiction is realistic. Flemish painters, however, achieved pictorial reality and rational perspective; and the sense of completeness and continuity found in Flemish works marked a new and clearly different style. Line, form, and color were painstakingly controlled to compose subtle, varied, three-dimensional, clear, and logically unified statements.

Part of the drastic change in Flemish painting stemmed from a new technical development, oil paint. Oil's versatile characteristics gave the Flemish painter new opportunities to vary surface texture and brilliance, and to create far greater subtlety of form. Oils allowed blending of color areas, because oil could be worked "wet" on the canvas, whereas egg tempera, the previous painting medium, dried almost immediately upon application. Gradual transitions between color areas made possible by oil paints allowed fifteenth century Flemish painters to enhance

use of atmospheric perspective, that is, the increasingly hazy appearance of objects furthest from the viewer, and thereby to control this most effective indicator of deep space. Blending between color areas also enhanced chiaroscuro (light and shade) by which all objects assume three-dimensionality: without highlight and shadow perceptible plasticity is lost. Early fifteenth century Flemish painters utilized sophisticated exploration of light and shade not only to enhance three-dimensionality of form, but also to achieve rational unity in their compositions. Pictures which do not exhibit consistent light sources or which omit natural shadows on surrounding objects stimulate very strange effects, even if their individual form depiction is high in verisimilitude; this new rational unity and realistic three-dimensionality separated fifteenth century Flanders from the Gothic style and tied it to the Renaissance.

Jan van Eyck's "The Arnolfini Marriage" or "Giovanni Arnolfini and His Bride" (Fig. 3.1) illustrates the qualities of Flemish painting, and also provides a marvelous range of aesthetic responses. Van Eyck utilized the full range of value from darkest darks to lightest lights and blended them with extreme subtlety to achieve a soft and realistic appearance. His colors are rich, varied, and predominantly warm in feeling. The only exception to the reds and red brown derivatives is the rich green gown of the bride. The highly atmospheric bedroom creates a sense of great depth. All forms achieve three-dimensionality through subtle color blending and softened shadow edges. Natural highlights and shadows emanate from obvious sources, such as the window, and tie the figures and objects together. However, as real as this painting appears, it is a selective portrayal of reality. It is an artist's vision of an event, a portrayal very clearly staged for pictorial purposes. The location of objects, the drape of fabric, and the nature of the figures themselves are

beyond reality. The man and woman are types, not individuals. Van Eyck's work achieves what much art does, that is, it gives the surface appearance of reality while revealing a deeper essence of the scene or the subject matter—in this case, man, woman, marriage, and their place within Christian philosophy.

The case has been made many times that this work comprises an elaborate symbolism commenting on van Eyck's view of marriage and the marriage ceremony.[1] Two people could execute a perfectly valid marriage without a priest. The painting depicts a young couple taking a marriage vow in the sanctity of the bridal chamber and thereby becomes a portrait and a marriage certificate. The artist has signed the painting in legal script above the mirror "Johannes de Eyck fuit hic. 1434" (Jan van Eyck was here. 1434). In fact, we can see the artist and another witness reflected in the mirror. The burning candle was required for taking an oath and also symbolized marriage; the dog was a symbol of marital faith; the statue of St. Margaret invoked the patron saint of childbirth. Considerable debate exists on the accuracy or appropriateness of all these symbols and on whether the bride is pregnant or not; most experts agree she is not; clothing design and posture of the period emphasized the stomach. Periodically one scholar or another refutes many previously accepted ideas about the painting.[2]

Every work of art tells a story to which we can respond at many levels. The more we know, the more we can discover of the messages and the human beings within the work; our fullest response requires investing a bit of

[1]See Erwin Panofsky, *The Burlington Magazine,* 1934 and *Early Netherlandish Painting,* 1953; in Alistair Smith, "The Arnolfini Marriage," The National Gallery, London, 1977.

[2]See Peter H. Schabacker, *The Art Quarterly,* vol. XXXV, no. 4, 1972 in Alistair Smith, "The Arnolfini Marriage," The National Gallery, London, 1977.

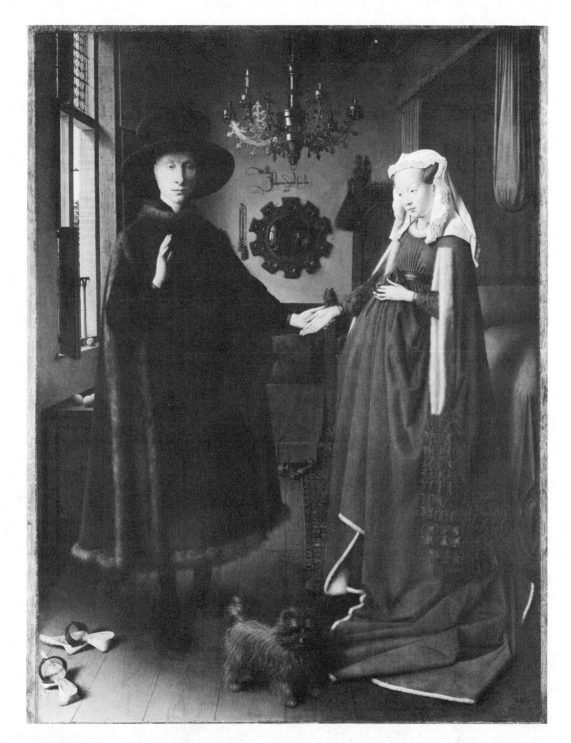

Fig. 3.1. Jan van Eyck. "The Arnolfini Marriage" ("Giovanni Arnolfini and His Bride"). 1434. Oil on panel 33″ × 22½″. Reproduced by courtesy of the Trustees, The National Gallery, London.

effort. If we had infinite time and space we could go into many times the detail we have just finished on every work of art mentioned in this text; however, these details must suffice to illustrate. The layers of discovery are there waiting for us to uncover.

Also illustrative of the same style, although slightly different from van Eyck, Rogier van der Weyden's deposition scene, "The Descent from the Cross" (Fig. 3.2) has softly shaded forms, rational three-dimensionality, and surface realism quite unlike the Gothic. Carefully controlled line and form create soft, undulating "S" curves around the borders and diagonally through the center. Colors explore the full range of the spectrum from reds and golds to blues and greens and the full extent of the value scale from dark to light. Composition, balance, and unity are extremely subtle. The figures are nearly statuary in depiction. Drapery folds are shallow and exhibit nervous, broken linearity.

However, the striking factor in this painting is its individualized human emotion. Dramatic power makes this work intensely appealing. Individualized character responses mark the people of this painting as they react to an emotion-charged situation. These figures are not types; they are human and individual and so fully and realistically portrayed that we might expect to encounter them on the street. Van der Weyden's linear style was particularly influential in the masterful woodcuts and engravings of Germany's Al-

Fig. 3.2. Rogier van der Weyden. "The Descent from the Cross." c. 1435. Oil on panel 7'2⅝" × 8'⅞". The Prado, Madrid. Alinari/Editorial Photocolor Archives.

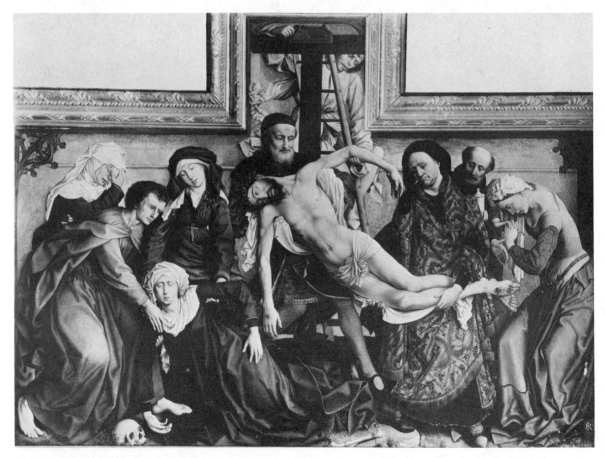

brecht Dürer. However, in contrast to van der Weyden and van Eyck, Dürer's works reflect the tensions present in northern Europe at the end of the fifteenth and in the early sixteenth centuries. The emotion of "The Four Horsemen of the Apocalypse" (Fig. 3.3), for example, and its medieval reflection of superstition, famine, fear, and death illustrate German art of this period.

The painting of fifteenth-century Flanders may be stylistically classified in several ways, but it had a character of its own that carried it beyond its predecessors and allied it in spirit with that of fifteenth century Italy. There the Renaissance, whatever connotations we attach to it, found its early spark and heart in about 1400 in Florence. Florence was a wealthy port and commercial center and, like Athens, leapt into her own golden age on a soaring spirit of victory as she successfully resisted the attempts of the Duke of Milan to subjugate the city. Under the patronage of the Medici family the outpouring of Florentine art made her the focal point of the early

Fig. 3.3. Albrecht Dürer. "The Four Horsemen of the Apocalypse." Woodcut. Courtesy, Museum of Fine Arts, Boston. Bequest of Francis Bullard.

Fig. 3.4. Botticelli. "Spring." Alinari/Editorial Photocolor Archives.

Italian Renaissance and an indicator of fif-teenth-century Renaissance characteristics.

Two general trends in Florentine painting developed in this period. The first, more or less a continuation of medieval tendencies, was lyrical[3] and decorative. Its adherents were the painters Fra Angelico, Fra Lippo Lippi, Benozzo Gozzoli, and Sandro Bot-ticelli. The decorative and lyrical tradition probably best expresses its humanism in the paintings of Sandro Botticelli. The linear quality of "Spring" (Fig. 3.4) indicates an art-ist apparently unconcerned with deep space or subtle plasticity in light and shade. Rather, forms emerge through outline. The composi-tion moves gently from side to side through a lyrical combination of undulating, curved lines, with focal areas in each grouping: Mercury, the Three Graces, Venus, Flora, Spring, and Zephyrus. Each part of this human, mythic (notice the non-Christian subject matter) portrait carries its own emo-tions, from contemplation to sadness to hap-piness. Beyond the immediate qualities exist deeper reflections of symbolism and emotion relating not only to the mythological figures, but also to the Medici family, the patron rulers of Florence.

Further, Botticelli's figures exhibit ana-tomical simplicity quite unlike the detailed muscular concerns we will find elsewhere in Florentine Renaissance painting. Although figures are rendered three-dimensionally and shaded subtly, they appear almost like bal-loons, floating in space, without anatomical definition.

The second tradition in Florentine and other Italian painting of this period is much

[3]Bernard S. Myers, *Art and Civilization* (New York: McGraw Hill Book Company, Inc., 1957), p. 378.

more clearly in the style of the Renaissance. Among the works of Masaccio, Uccello, Castagno, Veneziano, and Baldovinetti, exists a unifying monumentality, that is, works larger than, or giving the impression of larger than lifesize. When we compare Botticelli's "Spring" with the work of Masaccio (Fig. 3.5) and realize that both were fifteenth century Florentines, the differences between these two traditions strike us clearly. The "Tribute Money" illustrates concern for deep space and plasticity. Masaccio's emphasis on chiaroscuro creates dramatic contrasts, gives his figures solidity, and unifies the composition. He utilizes both atmospheric and linear perspective, and the building at the right exemplifies a new and significant scientific mechanization of single and multiple vanishing-point perspective (an invention that allowed the artist to plot foreshortened objects with photographic accuracy, thus enhancing deep, spatial realism). Masaccio's figures are very human, warm, strong, and detailed. At the same time his composition carefully subordinates parts to the whole. Unlike many excessively detailed paintings this work does not lose us in detail or cause us to be overly aware of detail to the detriment of the whole.

Perhaps the most breathtaking example of early Italian Renaissance monumentalism is Mantegna's "St. James Led to Execution" (Fig. 3.6). Here the forces of scale, chiaroscuro, perspective, detail, compositional unity and drama are overpowering. Much of the effect of this work is the artist's placement of horizon line (eye level of the viewer) below the lower border of the painting.

As important and revolutionary as the fifteenth century was, both in Flanders and Italy, the high point of the Renaissance came

Fig. 3.5. Masaccio. "Tribute Money." Santa Maria del Carmine, Florence. Photo courtesy of Heaton-Sessions Studio, New York.

Fig. 3.6. Mantegna. "St. James Led to Execution." c. 1455. Fresco. Ovetari Chapel, Church of the Eremitani, Padua (destroyed 1944). Alinari/Editorial Photocolor Archives.

in the early sixteenth century, as papal authority re-emerged and artists were called to Rome. Its importance as an apex of Renaissance style has led scholars to call this period in the visual arts the High Renaissance. (Let us recall that our uses of the term "Renaissance" are flexible in this chapter. At this point we are dealing with a style in the visual arts not with an historical era.) The High Renaissance comprised the titans and giants (terms most appropriate to their art as we shall see) of Western visual art: Leonardo Da Vinci, Michelangelo, Bramante, Raphael, Giorgione, and Titian.

Implicit in humanistic exploration of the individual's earthly potential and fulfillment is a concept of particular importance to our overview of visual art in the High Renaissance style. That concept is *genius*. In Italy between 1495 and 1520 everything in visual art was subordinate to the overwhelming genius of two men, Leonardo Da Vinci and Michelangelo Buonarroti. The great genius and impact of these two giants have led many to debate whether the High Renaissance of visual art was a culmination of earlier Renaissance style or a new departure. Scholars do not agree.

High Renaissance painting sought a universal ideal achieved through impressive art,

as opposed to overemphasis on tricks of perspective or on anatomy. Figures became types again, rather than naturalistically portrayed individuals: God-like human beings in the Greek classic tradition. Nevertheless, this carefully controlled human-centered attitude contained a certain artificiality and emotionalism reflective of the conflicts of the times. In addition, High Renaissance style departed from previous styles in its carefully controlled composition, based almost exclusively on geometric devices. Composition was closed; that is, line, color, and form or shape kept the viewer's eye continually redirected into the work, as opposed to leading the eye off the canvas. Organization centered upon a geometric shape—a central triangle or an oval, for example.

Leonardo's work contained an ethereal quality achieved by blending light and shadow (called *sfumato*). His figures hover between reality and illusion as form disappears into other form; only highlighted portions emerge. Leonardo's paintings are moody and gentle with an "unworldly" feeling caused by his use of *sfumato*. It is difficult to say which of Leonardo's paintings is the most popular or admired; certainly "The Last Supper" (Fig. 3.7) ranks among them. It captures the drama of Christ's prophecy "One of you shall betray me" at the moment the apostles respond with disbelief. Leonardo's medium proved most unfortunate because his own mixtures of oil, varnish, and pigments, as opposed to fresco, were unsuited to the damp wall; the painting began to flake and was reported to be perishing as early as 1517. Since then it has been clouded by retouching, defaced by a door cut through the wall at Christ's feet, and bombed during World War II. Miraculously, it survives.

In "The Last Supper" human figures, not architecture, take focus. The figure of Christ dominates the center of the painting, forming

Fig. 3.7. Leonardo da Vinci. "The Last Supper." c. 1495–98. Santa Maria della Grazie, Milan. Alinari/Editorial Photocolor Archives.

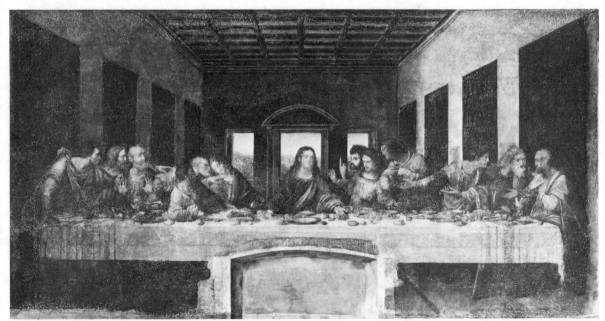

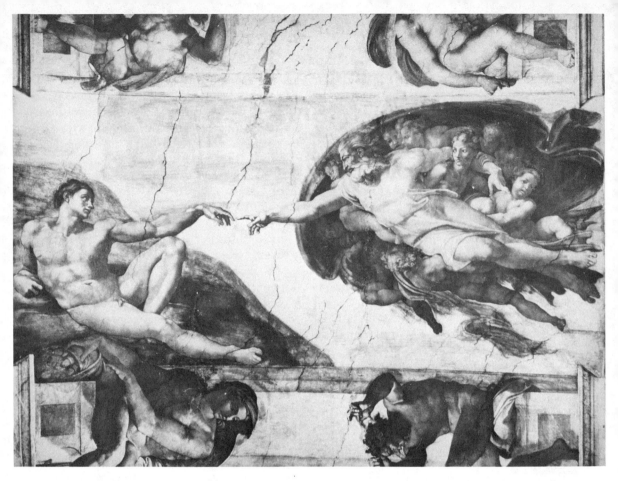

Fig. 3.8. Michelangelo. Sistine Chapel ceiling. Detail: "The Creation of Adam." The Vatican, Rome. Photo courtesy of Heaton-Sessions Studio, New York.

a stable, yet active, central triangle. All line, actual and implied, leads outward from the face of Christ, pauses at various subordinate focal areas, is directed back into the work, and returns to the central figure. Various postures, hand positions, and groupings of the Disciples direct the eye from point to point. Figures emerge from the gloomy architectural background in strongly accented relief; nothing anchors these objects to the floor of the room of which they are a part. Although not his strongest use of *sfumato,* the device is there. This typically geometric composition is amazing in the fact that so much drama can be expressed in such a mathematical format. Yet, despite the drama, the mood in this work and others is calm, belying the conflict

and turbulence of Leonardo's own life, personality, and times.

Michelangelo's Sistine Chapel ceiling (Fig. 3.8) reflects the ambition and genius associated with this era and its philosophies. Some scholars see in this monumental work a blending of Christian tradition and a neoplatonist view of the soul's progressive ascent through contemplation and desire. In each of the triangles along the sides of the chapel the ancestors of Christ await the Redeemer. Between them, amidst painted pillars, are the sages of antiquity. In the corners Michelangelo depicts various biblical stories, and across the center of the ceiling he unfolds the episodes of Genesis. The center of the ceiling captures, at the moment of fulfillment, the

Creation of Adam, and it does so in sculp-turesque human form and beautifully model-led anatomical detail. God, in human form, stretches outward from his matrix of angels to a reclining, but dynamic, Adam awaiting the divine infusion, the spark of the soul. The figures do not touch, and we are left with supreme anticipation of what we imagine will be the power and electricity of God's physical contact with mortal man.

Raphael, often considered along with Leonardo and Michelangelo as the third part of a High Renaissance triumvirate, did not reach the high level of genius and accomplish-ment of the other two. However, his work is illustrative of High Renaissance qualities. In the "Alba Madonna" (Fig. 3.9 color) the strong central triangle exists within the geo-metric parameters of a *tondo* (circular shape). The tendency of a circle to roll is counteracted by strong, parallel horizontal lines. The strong baseline of a central triangle is de-scribed by the leg of the child (left), the foot of the Christ child, the folds of the Madonna's robes, and the rock and shadow (right). The left side of the central triangle comprises the eyes of all three figures and carries along the back of the child to the border. The right side of the triangle moves down the edge of the Madonna's robe to join the horizontal shad-ow at the right border. Within this mechan-ical formula, nevertheless, exists a comfort-able, subtly and superbly modelled, and idealized Mary and Christ child. Textures are soft and warm. Raphael's treatment of flesh creates a tactile sensation of real flesh, with warm blood flowing beneath it, a characteris-tic relatively new to two-dimensional art. Raphael's figures express lively power, and his mastery of three-dimensional form and deep space is without peer.

Papal patronage had assembled great ge-nius in Rome at the turn of the sixteenth cen-tury and had ignited and supported a brilliant fire of human genius in the arts. The Spanish invasion and sack of Rome doused the flame of Italian art in 1527 and scattered its ashes to the far corners of Europe, contributing to the disillusionment and turmoil of religious and political strife that marked the next seventy years.

Sculpture

An attempt to capture the essence of Euro-pean sculpture in the early Renaissance can, again, best be served by fifteenth century Florence, where sculpture shared the patron-age of the Medici's. The early Renaissance sculptor attained the skills to create images of high verisimilitude. The goal, however, was not the same as the Greeks' with their ide-alized reality of human form. Rather, the Re-naissance sculptor found his ideal in Man as he *is*. The ideal was the glorious individual— even when faulty. Sculpture of this style showed an uncompromising and stark view of humankind: Complex, balanced, and full of action. Relief sculpture, like painting, re-vealed a new execution of deep space through systematic, scientific perspective. In addi-tion, free-standing statuary works, long ab-sent, returned to dominance. Scientific inqui-ry and interest in anatomy, witnessed in painting, were also reflected in sculpture. The nude, full of character and charged with ener-gy, made its first reappearance since ancient times. Human form became a body built layer by layer upon its skeletal and muscular framework. Even when clothed, fifteenth century sculpture revealed the body under the outward structure, quite unlike the decora-tive shell which often clothed medieval works.

Notable among fifteenth century Italian sculptors were Ghiberti, della Robbia, An-tonio Rosselino, Pollaiuolo, and Donatello. In Ghiberti's "Paradise Gates" (Figs. 3.10 color and 3.11 color), we see the same con-cern for rich detail, humanity, and feats of perspective we saw in Florentine painting.

The bold relief of these scenes took Ghiberti twenty-one years to complete.

However, the greatest masterpieces of fifteenth century Italian Renaissance sculpture came from the unsurpassed master of the age, Donatello. His magnificent "David" (Fig. 3.12) was the first free-standing nude since classical times. However, unlike classical nudes, David is partially clothed; his armor and helmet, along with bony elbows and ado-

lescent character, invest him with rich detail of a highly individualized nature. "David" exhibits a return to classical, *contrapposto* stance, but its carefully executed form carries a new humanity whose individual parts seem almost capable of movement.

Perhaps Donatello's most famous work is the "Equestrian Monument of Gattamelata." In this larger-than-lifesize monument to a deceased general is the influence of Roman

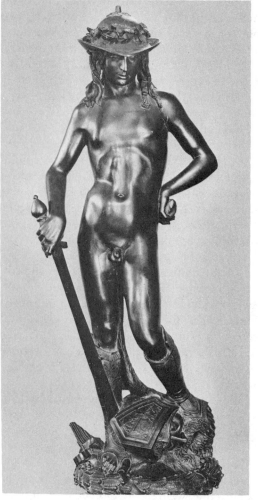

Fig. **3.12.** Donatello. "David." c. 1430–32. Bronze. 62¼". Museo Nationale del Bargello, Florence. Alinari/Editorial Photocolor Archives.

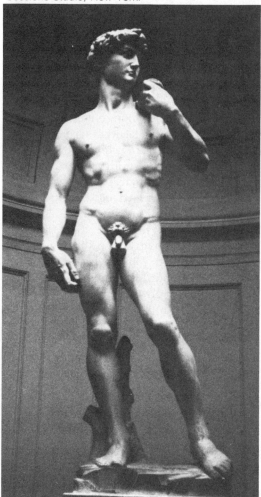

Fig. **3.13.** Michelangelo. "David." 1501–4. Marble. 13'5". Academy, Florence. Photo courtesy of Heaton-Sessions Studio, New York.

monumental statuary, probably the statue of "Marcus Aurelius on Horseback," but with a unique concentration of both human and animal anatomy. Donatello skillfully directs focus not to the powerful mass of the horse, but to the overpowering presence of the human astride it. His triangular composition previews the geometric approach of the High Renaissance.

The papal call to Rome gave impetus to a High Renaissance style in sculpture as well as painting. However, High Renaissance sculpture *was* Michelangelo Buonarroti. Michelangelo's ideal was the full realization of individualism—a reflection of his own unique genius. Such a view expressed itself in a quality called "terrabilità," or "terribleness," a quality of supreme confidence that allows a

man to accept no other authority but his own genius. We find that characteristic in Michelangelo's gigantic "David" (Fig. 3.13). In this nude champion is a pent-up energy again reflecting the artist's neoplatonistic philosophy of the body as an earthly prison of the soul. The upper body seems to move in opposition to the lower portion (again in *contrapposto* position); our eye is led downward through the right arm and left leg of the figure, and then upward along the left arm. The entire composition seeks to break free from its confinement through thrust and counterthrust. However, energy is contained and only potential.

In contrast is the quiet simplicity of the "Pieta" (Fig. 3.14). This is the only work Michelangelo ever signed, and it again reveals

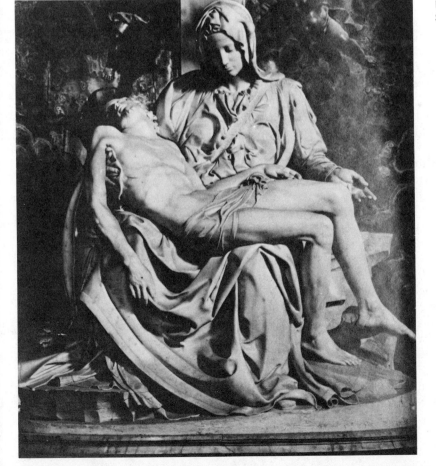

Fig. 3.14. Michelangelo. "Pieta." St. Peter's, Rome.

his neoplatonist viewpoint. Here High Renaissance triangularity of composition contrasts with what many believe to be a late medieval subject matter and figure treatment. The size of the Madonna compared to the figure of Jesus reflects an attitude of Mary-emphasis characteristic of the late medieval period. However, beyond these considerations lies the absolute perfection of surface texture in this work. Michelangelo has polished the marble to such a degree that it assumes a warmth of real human flesh. Skin becomes even more sensuous in its contrast to rough stone. Cloth has exquisite softness, and the expressive sway of drape reinforces the compositional line of the work. Emotion and energy are captured within the contrasting forces of form, line, and texture.

Music

The volatile courts of Renaissance northern Italy proved important patrons of the performing as well as the visual arts, but the *Ars Nova* of the fourteenth century found its most willing and significant successor in the Flemish school of composers, which developed parallel to the Flemish school of painters. Music historians are not of one mind in labeling the style of this locale and era. Some use the term "Franco–Flemish," others reserve that term for a later, sixteenth century development, preferring to call fifteenth century Flemish composers the "Burgundian School." Whatever the case, the Dukes of Burgundy equalled their Italian counterparts as active art patrons, and the painter Jan van Eyck, for example, benefited greatly from their patronage. As part of their courtly entourage the Dukes maintained a group of musicians to provide entertainment and chapel music. Musicians frequently were imported from other locales, serving, thus, both to enhance a cosmopolitan or "international" character in the Burgundian courts and to disseminate Burgundian influence throughout

Europe. So Flemish composers were widely educated and thoroughly aware of the world around them. Writers of Masses and motets, they made specific contributions in the development of four-part harmony and in the use of only one text, usually sacred, for all voices. Flemish composers gave greater independence to the lower voices; the bass part became independent for the first time and became a typical feature of this style of composition. All parts were separated and kept consistent, measured rhythm; they came together only at cadences. As a result, Flemish music contained, for the first time in musical history, a true four-part harmony.

Four composers illustrate this style: Guillaume Dufay (1400–1474), Johannes Ockeghem (1430–95), Jacob Obrecht (1430–1505), and Josquin des Prez (1450–1521), with Dufay and des Prez being the most prominent. Dufay had been a member of the Papal Chapel at Rome and Florence and had travelled extensively throughout Europe. So he brought to Flanders a wealth of knowledge and experience. Within his lifetime he was heralded as one of the great composers of his era. He was a prolific composer and we have a wealth of materials in modern editions. His style intended for each line to have a different timbre (tonal quality) with a separation of each of the parts clearly indicated. Dufay's sacred motets based on the chant, *Salve Regina,* formed the basis for numerous later polyphonic settings for the Mass.

Secular influence and patronage became stronger; the printing press made music, like the written word, more easily transmitted. More music than ever before was composed, and the individual identity and, in true humanistic spirit, the prestige of the composer became paramount. Composers strove to achieve an "ideal" sound. "Ideal" to them was four or more voice lines of similar and compatible timbres, as opposed to contrasting timbres in earlier works. Focus lay on

making the work a unified whole. So more concern was given to the relationship of music and text; clarity of communication became the purpose for music. According to the philosophy of the day, the ideal means of communication was an unaccompanied vocal ensemble. All of these characteristics peaked in the works of Josquin des Prez.

Like Dufay, Josquin was trained (among other places) in Milan, Rome, and Florence and brought to Flanders an equally rich but somewhat later Renaissance heritage. He was compared to Michelangelo and called the "father of musicians." He wrote secular music of a light, homophonic nature similar to that popular in Italy at the same time. However, his chief contribution came, like Dufay's, in the motet and in polyphonic development. Typically, his motets utilized individual musical motives (see Glossary) in each phrase of the text, and for the first time in musical history a consistent use of motival imitation occurred as the musical idea moved through each of the voices. Also typical and significant was a three-part form in which part one was recapitulated in part three, with those parts standing in contrast to part two (ABA form). Finally, as in all music of this school and era, there existed a sense of harmonic progression to "natural" cadence. (Natural cadence has both mathematical and cultural/conventional characteristics. Chordal resolution on the tonic chord is based both on the relative ease with which certain proportions of a string are set into sympathetic vibration by another vibrating string and also on purely cultural conditioning.)

In Germany early Renaissance spirit with its secular traditions, produced polyphonic German *lieder* (songs) in the mid-fifteenth century. These predominantly three-part, secular songs provided much of the melodic basis for the church hymns of Lutheranism after the Reformation. Heinrich Isaac (1450–1517) was probably the first and most notable German *lied* composer of this era. He was a prolific musician and he blended his diverse background, which included living at various times in Italy, the Netherlands, and France, into the most international output of any composer of his day. He and other composers of *lieder* took folk songs, essentially, and adapted them into polyphonic settings. The frequent usage and refashioning of this type of composition can be seen in one of Isaac's most famous works, "Innsbruck, I Must Leave Thee." Originally the song was a folk love song. Isaac notated the song into a polyphonic piece with words by the Emperor Maximilian. Later Isaac used the melody in his own sacred work, the *Missa Carminum*. The song then became widely known in another adaptation under the sacred title, "O World, I Now Must Leave Thee." Even Johann Sebastian Bach utilized the "Innsbruck Lied" in *The Passion According to St. Matthew*.

One final reference helps us to sense the quality of Renaissance music of the early fifteenth century. Referring to the English composer John Dunstable, a French poem of about 1440 comments on the "English countenance" that helped to make European music so "joyous and bright" with "marvelous pleasantness." Humankind had found a note of optimism in a period devoted to vital earthly living. Certainly there were troubles, but God and humankind had a fairly comfortable and comforting relationship.

Theatre

In the years corresponding to the Renaissance and High Renaissance in the visual arts, theatre maintained the characteristics it had developed in the Middle Ages, and there is little to add to the descriptions made previously. Secular adaptation and production of mysteries and moralities flourished. The *Confrèrie de la Passion,* under license from Charles VI, continued to produce mystery plays in France

through the fifteenth century. Their cycle of plays representing *Le Mystère du Vieil Testament* (*The Mystery of the Old Testament*) consisted of 44,325 verses and took twenty performances to complete. The *Mystère de Nouveau Testament* (New Testament) consisted of 34,574 verses. A third cycle, *Les Actes des Apôtres* (*The Acts of the Apostles*), rounded out the Confrèrie's repertoire and took forty days to present in its entirety.

But the French also developed a new secular form, the *sottie,* short theatrical entertainments woven into the yearly festivals of the *Feast of the Ass* and the *Feast of the Fools.* These festivals originated partly in pagan rites and were bawdy burlesques of the Roman Catholic Mass. A person called the Bishop, Archbishop, or Pope of Fools celebrated a mock Mass with a great deal of jumping around, buffoonery, and noise. Participants wore strange costumes (or nothing at all), and the entire affair was accompanied by much drinking. One of the most popular of the *sotties* written for the Feasts, Pierre Gringoire's *Jeu du Prince des Sots* (*Play of the Prince of the Fools*) was produced in Paris in 1512 at the request of King Louis XII to inflame the populace against Pope Julius II.

At the same time a more substantial French theatrical form also emerged: the farce. This genre was completely secular in its intent and fully developed as a play form; therefore, the farce saw full, independent production in contrast to the *sottie,* which was an *entr'acte* entertainment. The most famous of the French farces of this period was *Maître Pierre Pathélin* (1470). It is still stageworthy and is occasionally produced.

Midway through the fifteenth century the Turks conquered Constantinople causing a mass exodus of scholars, artisans, artists, and actors to Italy. The impact of that emigration had little effect on Italian theatre, stimulating little more than a few stilted imitations of Greek tragedy, some sentimental pastorals based on Virgil, and some bawdy comedies that debased even Plautus and Menander. However, in contrast to medieval drama, which tended to be a group effort, with its texts fairly well established by tradition and/or biblical source, Italy saw, in the late fifteenth century, a re-emergence of the individual playwright, whose themes characterized the humanistic and classical impetus of the period. These scholarly dramas in Latin included *Philoginia* by Ugolino Pisani, *Philodoxius* by Leon Battista Alberti, and *Polissena* by Leonardo Bruni. In 1471 or 1472 the Italian stage witnessed a production of Angelo Poliziano's *Orfeo,* a kind of *sacra rappresentazione* (Italian mystery play) with Christian elements changed into pagan mythology. *Orfeo* is significant for this era because it was written in vernacular Italian, rather than Latin.

We mentioned in passing that Italian early Renaissance painting tended not to reflect the discordant political cloak and dagger of its surroundings. The same may be said of Italian drama. Later, when the Renaissance found its way to England, English fascination with the Italian Renaissance and its historical context caused Shakespeare to reflect Italian attitudes and times in great tragedies. But Italian playwrights, living amidst it all, chose mostly to write tender sentimental pastoral comedies in a graceful, witty, and polished style similar to the tone of music suggested by the comments concerning John Dunstable. A few tragedies were written. The first Italian tragedy, *Sofonisba* by Giovanni Trissino was completed in 1515 and reflected the author's misconceptions of Aristotle's *Poetics* (a common occurrence in the Renaissance). However, the play was not produced until 1562, well into the next era.

For the most part, Italian drama was theatre of the aristocracy and was produced with elaborate trappings, usually at court, but sometimes in public squares under courtly

sponsorship. No permanent theatres existed at the time; surviving Roman theatre buildings were in such disrepair that they were not usable.

Theatre tends to be institutionally moribund. That is, its forms and conventions come together slowly and hang on tenaciously. Writing a play, the creative act of an individual playwright, does not have impact until that script is produced for a public. Since production involves a number of problems and judgments affecting individuals other than the playwright, theatre often takes longer to reflect social and stylistic changes than do other disciplines. Theatre in the early years of the Renaissance had changed somewhat from its medieval predecessors, but real fruition in the theatre had to wait until the middle of the sixteenth century.

Dance

Out of the same northern Italian courts that supported Renaissance painting and sculpture came the foundations of theatre dance. The point is well made that the visual and classical orientation of the Italian Renaissance was largely responsible for the primarily visual and geometric characteristics of dance as we know it. Line, form, repetition, and unity brought dance from a social to a theatrical circumstance as the Italians, especially in Florence, began to create patterns in body movements. As with all the arts, dance witnessed an increasing concern for "rules" and conventionalized vocabulary.

Mummeries, pageants, and other dance-related activities dating to the traveling pantomimes of the Middle Ages, emerged as formal dance in elaborate entertainments in the Italian courts of the fifteenth century. These entertainments were fashioned into spectacular displays although they remained more social than theatrical. The spirit of the Renaissance, nevertheless, moved dance closer to its emergence as an art form. Concern for perfection, for individual expression, dignity, and grace created a vocabulary for dance steps and a choreography of patterns and design. Courtly surroundings added refinement and restraint, and the dancing master mentioned earlier became a motivating force in coordinating and designing elegant movements. Dance, increasingly, was seen as something to be responded to as a visual display rather than to be experienced through participation.

Out of these slowly changing traditions emerged an important milestone in the journey toward a truly artistic, theatricalized form. Guglielmo Ebreo of Pesaro wrote one of the first compilations of dance description and theory in *De Praticha seu arte tripudii vulghare opusculum*. His attempts to record a complex and visually oriented art led him to stress memory as one of the essential ingredients of the dancer's art. His observation isolated the most critical element of dance tradition, one which even today is responsible for keeping the dance alive and transmitted from generation to generation of dancers. Film and labanotation (see Glossary) still have not replaced the personalized memory-form by which the traditions of dance are passed along. Guglielmo's work was a clear record of formal dance composition. He strove to bring dance out of the disrepute into which it had fallen in the bawdy pantomimes of previous eras. He sought to make the dance above criticism and fully acceptable from an aesthetic standpoint. For Guglielmo, dance was an art of grace and beauty.

In the fifteenth century, dance, in which grace, beauty, pattern, and form were predominant, left the floor of the courtly ballroom and moved to a stage to be watched by most and participated in by only a skillful few. Movement was carefully coordinated with music. A dancer's ability to keep time supposedly afforded pleasure and sharpened the intellect. Through the influences of the Medici family, the emerging traditions of

dance moved northward to France where, in the late Renaissance of the sixteenth century the *ballet de court,* the French version of the Italian court dance, became the *ballet.*

Architecture

Architecture of the early Renaissance centered itself in Florence and exhibited three significant departures from the medieval. First was its concern with replication of classical models along very mechanical lines. Ruins of Roman buildings were measured carefully and their proportions translated into Renaissance buildings. Rather than seeing Roman arches as limiting factors, Renaissance architects saw them as geometric devices by which a mechanically derived design could be composed. The second departure from the medieval was the application of decorative detail, that is, nonstructural ornamen-

tation, to the façade of the building. Third, and a manifestation of the second difference, was a radical departure from outward expression of structure. Previously, including in the Romanesque, the outward form of a building was closely related to its actual structural systems, that is, the structural support of the building, for example, post and lintel, masonry, and the arch. In the Renaissance, supporting elements were hidden from view so that external appearance need not be sacrificed to structural concerns.

Early architecture of the period, as exemplified by Brunelleschi's dome on the Cathedral of Florence (Fig. 3.15), was an imitation of classical forms appended to medieval structures. In this curious design, added in the fifteenth century to a fourteenth-century building, the soaring dome rises 180 feet into the air, and its height is apparent from both

Fig. 3.15. Brunelleschi. Dome. 1420–36. Cathedral of Florence.

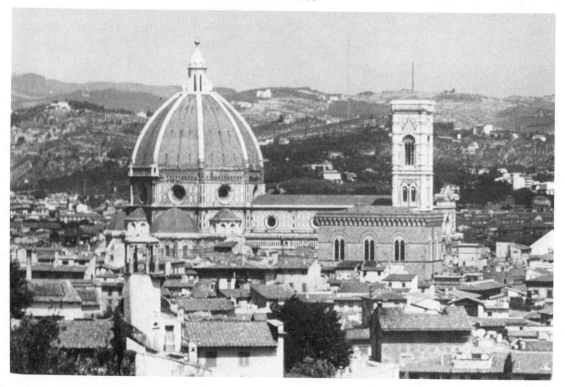

without and within. If we compare it with the Pantheon (Fig. 1.33) Brunelleschi's departure from traditional practice becomes clearer. The dome of the Pantheon is impressive only from the inside of the building because its exterior supporting structure is so massive that it clutters the visual experience. Brunelleschi's dome rises to a phenomenal height that is apparent on the exterior because the architect hid from view supporting elements such as stone and timber girdles and light-weight ribbings. As a result we experience an aesthetic statement whose visual appearance is foremost and whose structural considerations are subordinate.

The use of classical ornamentation can be seen in Brunelleschi's Pazzi Chapel (Fig. 3.16). Small in scale, its walls serve as a plain background for a wealth of surface decoration. Concern for proportion and geometric design are very clear, but the overall composition is not a slave to pure arithmetical considerations. Rather, the Pazzi Chapel re-flects Brunelleschi's *sense* of classical aesthetics. Brunelleschi's influence was profound in the first half of the fifteenth century, and he served as a model and inspiration for later Renaissance architects.

The second half of the fifteenth century was dominated by the Florentine scholar, writer, and humorist Leone Battista Alberti. His treatise *Concerning Architecture* was based on Vitruvius and provided a scholarly approach to architecture that influenced Western building for centuries. His scientific approach to sculpture and painting, as well as architecture, encompassed theories on Roman antiquity that typified the reduction of aesthetics to rules.

However, the problems of Renaissance architects were different from their predecessors. Faced with an expanding repertoire of building types, such as townhouses, hospitals, and business establishments, to which classical forms had to be adapted, the architect had to meet specific practical needs,

Fig. 3.16. Brunelleschi. Pazzi Chapel. 1430–33. Santa Croce, Florence.

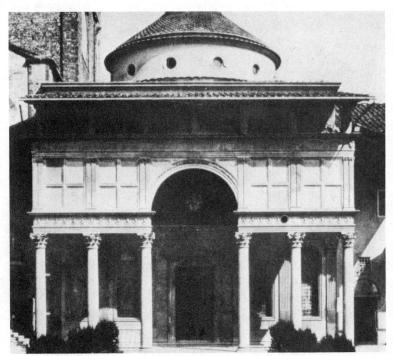

which, apparently, the ancients were not required to, or did not, accommodate. As a result, classical detail was applied to a wide range of forms and structures, many of which, like the Cathedral of Florence, were of nonclassical origin. In his well-known Palazzo Rucellai (Fig. 3.17), Alberti applied a detailed classical system to a nonclassical building. His design suggests the Roman Colosseum in its alternating arches and attached columns with upward progressing changes of order. However, the appearance, that is, the application of his systematic concept is rather academic, as opposed to individualistic.

As the fifteenth century progressed into the sixteenth, architecture witnessed a balancing of Christian and classical ideas and moved away from insistence and emphasis on decorative surface detail, to a greater concern for space and volume. The shift of patronage from local tyrant to the Roman Church, which brought the visual artist (painter, sculptor, and architect) to Rome, also changed the tone of architecture to a more formal, monumental, and serious style.

A perfect early example of High Renaissance architecture is Bramante's Tempietto (*little temple*). The purpose for churches for which the Tempietto (Fig. 3.18) is prototypical was the attempt of Pope Julius II to replace all Roman basilica-form churches with monuments so magnificent that they would overshadow all works by the Imperial Romans. The culmination of this style probably is Bramante's design for St. Peter's—later revised by Michelangelo and finished, still later, by Giacomo della Porta, (Fig. 3.19). St. Peter's was a geometrical and symmetrical design based on the circle and the square over which perched a tremendous dome surrounded by four lesser domes.

Fig. 3.17. Alberti. Rucellai Palace. 1446–51. Florence. Photo courtesy of Heaton-Sessions Studio, New York.

Fig. 3.18. Donato Bramante. The Tempietto. 1502. S. Pictro in Montorio, Rome. Photo courtesy of Heaton-Sessions Studio, New York.

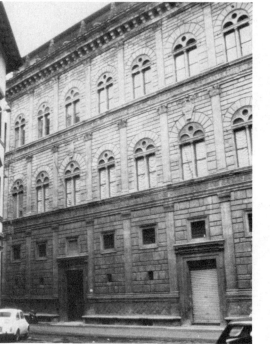

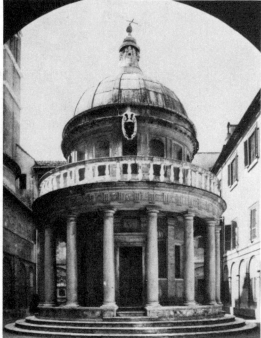

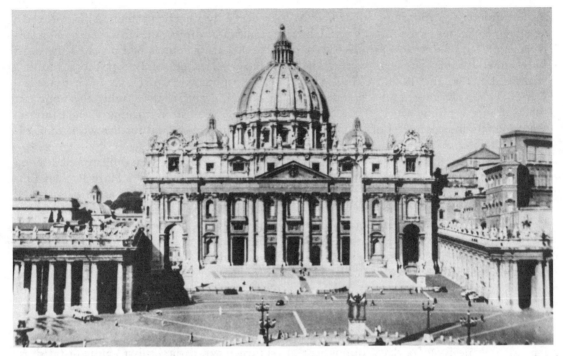

Fig. 3.19. St. Peter's, Rome. Original plan, Bramante (1506); alterations, Michelangelo (1546–64); dome completed by Giacomo della Porta (1590).

DISCORD, RATIONALISM, EMOTIONALISM, AND ABSOLUTISM

"Luther," wrote Erasmus, "arose and threw the apple of discord into the world." Nevertheless, the Reformation was a climax of centuries of sectarian agitation. In the fourteenth century English cries for reform and resentment of papal authority produced an English translation of the Scriptures, and caused John Wycliffe to pronounce that corrupt clergy and even the Pope were "the dammed limbs of Lucifer." But reform and separation are significant worlds apart. The Reformation's effects helped keep the Western world in a profound turmoil for the last three quarters of the sixteenth century.

The discord of religious rebellion ran rampant as various Protestant sects arose, some more dogmatic and intolerant than Roman Catholicism. Many of these sects had a significant effect on the arts. Zwingli, in Zurich,

modelled his church on the New Testament and decreed that music was to put babies to sleep, not to praise God. He also persuaded the Zurich city council, in 1524, to remove all works of art from the city's churches. Within Protestant sects persecution of other protestants arose, and radical groups such as the Anabaptists suffered at the hands of Protestants and Catholics alike. In Geneva, John Calvin's revolt gave birth to a church–city and to a Protestant sect that quickly spread throughout Europe and eventually to North America. Geneva had just overthrown the Dukes of Savoy, but had not joined the Swiss confederation. Calvin's zealots gained political power and passed religious laws in the city council; church attendance was mandatory, and heresy was punishable by death or life imprisonment. Interestingly, Calvin called for a capitalistic spirit based on unceasing labor in gainful pursuits for the glory of God. Schisms and intolerance brought war, sever-

ing of commercial relationships, and frenetic and intense religious conviction. Protestant Reformation led to Roman Catholic Counter-Reformation; religious wars were widespread, and in 1542 the Roman Catholic Inquisition began as an attempt literally to destroy all non-Catholic belief.

Into the religious upheaval of the Renaissance and its human-centered universe burst the frightening revelations of scientific discovery. The spirit of inquiry centered, especially, in astronomy. In 1530 Copernicus transformed the world and humankind's perception of itself, its universe, and its God by formulating a heliocentric (sun-centered) theory of the universe (Copernican Theory). Although not immediately accepted, such an insight was devastating to those whose view of reality saw humankind as the central and ultimate being in an earth-centered universe. Many concepts of a personal God could not adapt to or conceive of a deity omniscient enough to rule such a diverse universe. The visual arts, especially, reflected the changed perception of a universe of limitless, as opposed to tightly controlled, space.

Adding to the disturbance and disillusionment of the age was a new and critical approach to the basic questions of life. Montaigne in his *Essays* espoused that every man "carries in himself the entire form of the human state" and injected disillusionment by emphasizing doubt and the contradictory nature of truth. Nicolo Machiavelli's *The Prince,* written early in the century, extolled the virtue of double standards, ultimate pragmatism, and the fundamental wickedness of all men.

None of these considerations could be separated from political reality. In Paris on February 15, 1515, on the death of King Louis XII, Francis I assumed the French throne. Full of youthful vigor and power he and his army set out to conquer Milan. Bolstered by the Papacy, supported by Swiss mercenaries, and relieved by Venetian armies, Milan proved a significant combatant. However, by September 14, 1515 Francis had defeated the most renowned armies of Europe. As a result, a very frightened Pope Leo X made peace and granted Francis the right to nominate bishops, thus strengthening French monarchial nationalism and further weakening papal authority.

In 1519 Emperor Maximilian died, leaving vacant the throne of the Holy Roman Empire, a patchwork of kingdoms scattered across Europe. Three claimants sought the prize: Francis I, Charles (Carlos) I of Spain (then nineteen years old), and another young monarch, Henry VIII of England. The electors of the realm, who chose the Emperor, selected Carlos, who became Emperor Charles V; his ascension began a bitter struggle among the three monarchs that tore at Europe for a generation. Meanwhile, Francis I turned sympathetically to humanistic ideas. He saw the Protestant revolt as a threat to his own authority, a preoccupation with which he held fanatically. He bolstered the strong tradition of Renaissance art and humanism in France. Leonardo spent his last years in Francis's court, and, later, Italian artists brought there a changing Italian art.

By the mid-sixteenth century Italy had been invaded not only by the French, but by the Spanish as well. Rome was sacked in 1527, and that date essentially marks the close of an era in the visual arts, which had seen under Papal patronage a remarkable, if brief, outpouring called the High Renaissance. Visual art, especially, then turned in a different direction to express the spiritual and political turmoil of its age.

The Roman Catholic response to Protestantism was the Council of Trent (1545–63) and the Counter-Reformation. Although little could be done to assuage the conflict and its social effects, conditions within the Catholic Church stabilized in a decided attempt at

least to keep the Reformation from spreading. Of extreme significance for the arts was the Council's decision to undertake a policy of attracting worshippers to the Church through art. That momentous decision, humanitarian voices of restraint, and general fatigue closed the sixteenth century with a series of edicts of toleration and an impetus for a new, emotional art called baroque that gave the seventeenth and early eighteenth centuries a quality unknown before or since.

Renaissance inquiry and exploration continued in a new framework. Magellan's global circumnavigation opened man's horizons fully. "The New World" was explored and pillaged, filling to overflowing the coffers of strengthened, independent European states, and to a large degree underwriting the cost of expensive artistic production. Colonialism and trade produced a growing and powerful middle class of wealthy merchants. Their wealth stimulated a desire for magnificence as insatiable as, if less extravagant than, that of the absolute monarchs of the age. Often the wealthy middle classes became enthusiastic patrons of the arts, desirous of artistic works reflecting their perception of their own opulence.

The scientific inquiry of Copernicus was only the beginning of concern for orderly systems. Giordano Bruno (1548–1600) speculated upon a universe of infinite size, comprised of numerous solar systems and universes. As a reward for his trouble he was burned at the stake. Kepler (1571–1630) postulated the laws of planetary motion; Galileo (1564–1642) invented the telescope and anticipated the laws of motion. Sir Francis Bacon (1561–1626) proposed his *Novum Organum,* in which he established inductive reasoning as the basis for scientific inquiry; René Descartes (1596–1650) formulated scientific philosophy; and Isaac Newton (1642–1727) discovered the laws of gravity. The effect of such inquiry and exploration was an irrever-

sibly broadened understanding of the universe and humanity's place within it. That understanding permeated every aspect of Western culture. Its underlying philosophy was systematic rationalism, that is, a seeking after logical, systematic order based on an intricate, moving, and changing universe subject to natural laws, and, therefore, relatively predictable. The artistic reflection of that philosophy was a widespread style called baroque. Consistent with their time, baroque arts sought rational order in intricate relationships and, like science and philosophy, held firmly in place by a Renaissance spirit, lifted branches into an atmosphere of emotional and unrestrained action.

Finally, an important aspect of seventeenth and early eighteenth century life was absolutism. Although some democratic ideals existed, the basic underlying force in European life and art was the absolute monarch, who received his mandate from God ("the divine right of kings"). Strong dynasties of rulers controlled Europe. England passed its crown through the Tudors from Henry VIII to Elizabeth I (r. 1558–1603). England would experience its own turmoil as Charles I and the monarchy were toppled by Cromwell, but in short order the Restoration and Charles II would return the country to continental European style and elegance. Style, elegance, and opulence, the last of which, at least, was an undebatable characteristic of the age, were exemplified and personified by France's Louis XIV, "The Sun King" (1638–1715). His court and its splendors amplified Roman Catholic infusion of artistic development, and heightened further the character of the artistic age.

Humankind, as a result of Renaissance inquiry, may have lost its ordinal role in the universe but, after a nervously shaken early reaction, gained a new confidence in its interdependence with a far-flung and perhaps infinite universe.

THE ARTS
OF THE LATE RENAISSANCE
AND BAROQUE STYLE

Two-Dimensional Art

The turmoil of the last three-quarters of the sixteenth century sought a reflection and an outlet in painting. Considerable question exists regarding the nature of the period between the clearly developed style of the High Renaissance and baroque style. The prevalent view today is a positive one, which regards this era in painting as a reflection of the conflicts of its time and not as a decadent and affected imitation of the High Renaissance. The name attached to the most significant *trend,* if not style, of the period is mannerism. The term originates from the mannered or affected appearance of the subjects in the paintings. These works are coldly formal and inward looking. Their misproportioned forms, icy stares, and subjective viewpoint can be puzzling and intriguing to us if we respond to them without understanding the context from which they came. Nevertheless, we find an appealing "modernism" in their emotional, sensitive, subtle, and elegant content and reflection. At the same time, mannerism contains an intellectualism that distorts reality, alters space, and makes vague, cultural references. Anticlassical emotionalism, abandonment of classic balance and form, conflict with its High Renaissance predecessors, and clear underpinnings of formality and geometry epitomize the troubled sense of mannerism's style and times.

Bronzino's "Portrait of a Young Man" (Fig. 3.20) illustrates. A strong High Renais-

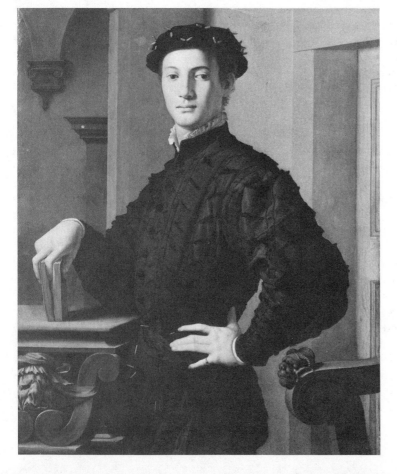

Fig. 3.20. Bronzino. "Portrait of a Young Man." The Metropolitan Museum of Art. Bequest of Mrs. H. O. Havemeyer, 1929. The H. O. Havemeyer Collection. All rights reserved. The Metropolitan Museum of Art.

sance central triangle dominates the basic composition of this work. However, line has a nervous and unstable quality; incongruous, juxtaposed rectilinear and curvilinear forms create an unstable and emotional feeling. The colors of the painting are very cold (greens and blacks), and the starkness of the background adds to the painting's discomfort. Shadows are harsh, and skin quality is cold and stonelike. Although light and shade create some dimension, lack of atmospheric or linear perspective brings graphically clear background objects forcefully into the forward plane of the picture. The pose and affected stare of the young man are typical of the "mannered" artificiality that gave this movement its name. Finally, although less obvious in this work than in El Greco's "St. Jerome" (Fig. 3.21 color), the human form is attenuated and disproportionate. The young man's head is entirely too small for his body and particularly for his hands.

El Greco (1541–1614), a Spanish painter born in Crete (hence the name El Greco, "the Greek"), exemplified the strong, inward-looking subjectivity of his time. In "St. Jerome" we find alternation and compression of space. Forms are piled on top of each other in two-dimensional, as opposed to deep space. Also, rather than the closed composition of the High Renaissance, composition here, as in the Bronzino, escapes the frame, a comment on the disturbed centrality of humankind in its universe. Emotional disturbance is further heightened by the attenuated form of St. Jerome himself. In strictly a color sense, El Greco's work is not cold; the predominantly monochromatic shades of red–brown in this painting belong to the "warm" end of the color spectrum. However, the artist's characteristic use of strongly highlighted forms (the highlight is pure white, as opposed to a higher value of the base hue) sharpens contrasts and intensifies the emotional tone of the work. This nonverisimilar treatment (brushstroke is obvious in many places) al-

lows the viewer to look beyond the surface reality of the painting to a "special truth" within.

The characteristics noted in these two works are typical. The tendencies of mannerism can be found in other artists, such as Parmigianino, Tintoretto, and Pontormo (Italy), Morales (Spain), Clouet (France), Holbein the Younger (Germany), Nabuse and Breughel the Elder (Flanders).

As noted earlier, relative stability accompanied the seventeenth century. With that stability came an age of intellectual, spiritual, and physical *action*. Above it all stood wealth and strong personal emotion. Along with the new age came a new style, the baroque, which reflected the characteristics and concerns of its age, and did so in forms that acknowledged the presence of middle-class patronage as an addition to the Church and the nobility. Painting appealed to emotions and desires for magnificence through opulent ornamentation, but it also adopted a systemized and rational composition in which ornamentation was unified through variation on a single theme. Realism replaced beauty as an object for painting. Color and grandeur were emphasized, as was dramatic use of light and shade. In all baroque art a sophisticated organizational scheme subordinated a multitude of single parts to the whole and carefully merged one part into the next to create an exceedingly complex but highly unified design. The expansive universe humankind was now coming to know saw *open composition* as a symbol of that broadened worldview. The viewer's eye traveled off the canvas to a wider reality. Man, as an object or focus in painting, could be monumental in full Renaissance fashion, but he also now could be a minuscule figure in a landscape, part of, but subordinate to, an overwhelming universe. Above all, baroque style reflected intensely active compositions that emphasized feeling rather than form; emotion rather than the intellect.

Baroque painting was diverse in applica-

tion, although fairly easily identifiable as a general style. It reflected the Church and religious sentiment—both Catholic and Protestant; it portrayed the magnificence of secular wealth—both noble and common; it spread throughout Europe, with examples in every corner.

Peter Paul Rubens (1577–1640) pursued baroque style with overwhelming, museum-sized paintings and fleshy feminine nudes. He also illustrated the use of art as religious propaganda. In "The Assumption of the Virgin" (Fig. 3.22 color) Rubens presents a swirling and complex composition full of lively action, color, and curvilinear repetition. Typical of Rubens are corpulent cupids and women whose flesh stimulates a sense of softness and warmth we find in few other artists. Rubens's colors here are warm and predominantly limited to the red end of the spectrum. A diagonal sweep of green pulls through the figures in the upper left, but it, like all the low-value colors in this painting, is subdued in brilliance. As a result the composition shows a strong contrast in light and dark and in lively and subdued tones. This work swirls actively, and yet comfortably, through its uniformly curvilinear line. Detail is richly naturalistic, but each finely rendered part is subordinate to the whole. Rubens leads our eyes around the painting, upward, downward, inward, and outward, occasionally escaping the frame entirely. Nevertheless, he maintains a High Renaissance central triangle beneath his complexity, thus holding the broad base of the painting solidly in place and leading the eye upward to an apex, the lovely face of the Virgin. The overall feeling inspired by this painting is richness, glamour, decorativeness, and emotional optimism. Religious and artistic appeal is to worldly emotion and not to intellectualism or mystical asceticism.

Rubens not only was an artist, but he also was a man of his time. He produced works at a prolific rate, primarily because he ran a painting "factory." He employed hundreds of artists and apprentices to assist in his work. He sold his paintings on the basis of their size and on the basis of how much actual work he, personally, did on them. We need not be overly disturbed by such a fact, especially when we consider the unique qualities and concepts Rubens's work expresses. His unique baroque style emerges from every painting, and even an unsophisticated observer can recognize his works with relative ease. Clearly artistic value here lies in the concept, not merely in the handiwork.

Rembrandt van Rijn (1606–69), in contrast to Rubens, could be called a "middle-class" artist. His genius lay not in glamorous and extravagant propaganda pieces, but rather in dramatically delivering the depths of human emotion and psychology. In contrast to Rubens, for example, Rembrandt suggests rather than depicts great detail. After all, the human spirit is intangible; it cannot be detailed, only alluded to. In Rembrandt we find atmosphere and shadow, implication and emotion. As in most baroque art, the viewer is invited to share in a feeling, to enter into an experience rather than to observe as an impartial witness.

Rembrandt's deposition scene "Descent from the Cross," (Fig. 3.23 color) is at the opposite end of the emotional spectrum from Rubens's ascension scene, but it still embraces a warm expression. Colors are exclusively reds, golds, and red–browns. With the exception of the robe of the figure pressing into Christ's body, the painting is nearly monochromatic. Contrasts are provided and forms are revealed through changes in value. In typically open composition, line escapes the frame at the left arm of the cross and in the half forms at the lower right border. Although subtly, the horizontal line of a darkened sky carries off the canvas, middle right. However, a strong central triangle

holds the composition together, growing from a darkly shadowed base, which runs the full width of the lower border, traveling upward along the highlighted form (lower right) and the ladder (lower left). Christ's upstretched arm completes the apex of the triangle as it meets an implied extension of the ladder behind the cross. Drapery folds lead the eye downward and then outward in a gentle sweeping curve. The experience is involving and deeply moving.

Rembrandt's emotions probably were difficult for most collectors to cope with. More reflective of the new, general marketplace and interests of the times were the emerging landscape painters. Jacob van Ruisdael's

"The Cemetery" (Fig. 3.24) reflects another emotional experience of rich detail, atmosphere, light and shade, and grandiose scale. This painting is nearly five feet high and more than six feet wide. The graveyard and medieval ruins cast a spell of imagination and melancholy over the work. Humankind, by physical absence, at least in living form, is totally subordinated to the universe; the ruins suggest that even the physical effects of our presence shall pass away. Highlight and shadow lead the eye around the composition, but the path of travel is broken, or at least disturbed, by changes of direction, for example, in the tree trunk across the stream and in the stark tree limbs. Nature broods above the

Fig. 3.24. Jacob van Ruisdael. "The Cemetery." c. 1655. Canvas. 56 × 74½". The Detroit Institute of Arts. Gift of Julius H. Haass, in memory of his brother Dr. Ernest W. Haass.

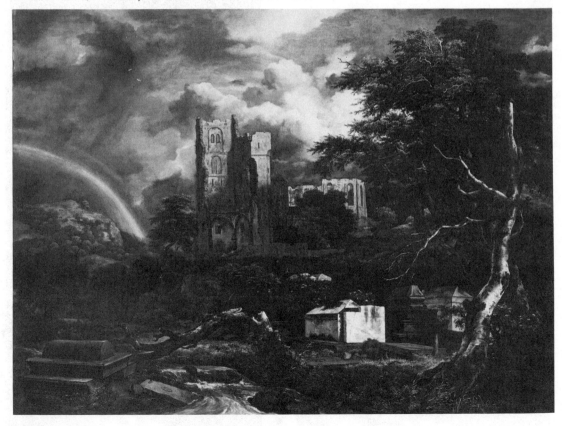

scene and we are led, again, outside the frame to an even wider, more diverse universe.

Baroque style was nearly universal in the period from 1600–1725, and further examples can be found in the paintings of Caravaggio, Franz Hals, Diego Velázquez, Carracci, Van Dyck, Heda, Steen, Vermeer, Poussin, and Lorrain. Two-dimensional art stood in the doorway of entrance to the modern era.

Sculpture

The late sixteenth century witnessed very little sculpture production. However, the twisting, elongated form of Giovanni da Bologna's (1529–1608) "Mercury" (Fig. 3.25) would be equivalent to the mannerist tendencies in painting of the same era. Affec-

tation of pose, upward-striving line, linear emphasis, and nearly total detachment from earth suggest tension and nervous energy. Mercury races through the air seeking escape from the world and is supported by a puff of breath from a mask symbolizing the wind. "The Rape of the Sabine Woman" (Fig. 3.26) twists with frenetic fury. Line and form fly off into space, violating Michelangelo's self-contained philosophies at every turn.

The splendor of the baroque was particularly noticeable in sculpture. Form and space

Fig. 3.26. Giovanni Da Bologna. "The Rape of the Sabine Woman." 1583. Marble. Height: 13'6". Loggi del Lanzi. Piazza della Signoria, Florence. Alinari/Editorial Photocolor Archives.

Fig. 3.25. Giovanni da Bologna, "Mercury." 1567. Photo courtesy of Heaton-Sessions Studio, New York.

were charged with energy, which carried beyond the limits of actual physical confines in the same sense as did Bologna's work. As did painting, sculpture appealed to the emotions through an inward-directed vision that invited participation rather than neutral observation. *Feeling* was the focus. In addition, baroque sculpture treated space pictorially, almost like a painting, to describe action scenes rather than single sculptural forms. The best examples we can draw upon are those of the sculptor Gianlorenzo Bernini (1598–1680).

"David" (Fig. 3.27) exudes dynamic power, action, and emotion as he curls to unleash his stone at a Goliath standing some-

where outside the statue's frame. Our eyes sweep upward along a diagonally curved line and are propelled outward by the concentrated emotion of David's expression. A wealth of detail occupies the composition; detail is part of the work, elegant in nature, but ornamental in character. Repetition of the curvilinear theme carries throughout the work in deep, rich, and fully contoured form. Again, the viewer participates in an emotional sense, feels the drama, and responds to the sensuous contours of dramatically articulated muscles. Bernini's "David" flexes and contracts in action, rather than repressing pent-up energy as did Michelangelo's giant-slayer.

"Apollo and Daphne" (Fig. 3.28) is almost

Fig. 3.27. Gianlorenzo Bernini. "David." 1623. Marble. Life-size. Borghese Gallery, Rome. Photo courtesy of Heaton-Sessions Studio, New York.

Fig. 3.28. Gianlorenzo Bernini. "Apollo and Daphne." 1622. Borghese Gallery, Rome.

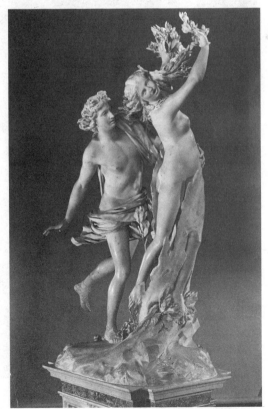

whimsical or melodramatic by contrast to "David"; nevertheless, the work exhibits the same active, diagonally moving upward curvature of line and ornamented detail. Every part of this complex sculpture is clearly articulated, but each part subordinates itself to the single theme of the overall work. Although statuary, "Apollo and Daphne" exudes motion, carrying itself beyond the confines of its actual form. Figures are frozen mid-stride; the next instant would carry them elsewhere.

Daphne's hair flies in response to her twisting movement. Flesh is rendered sensuously. This work is a pictorial description; more exists here than in previous works, whose forms barely emerge from their marble blocks.

Finally, "The Ecstasy of St. Theresa" (Fig. 3.29) is a fully developed "painting" in sculptural form. It pictorializes a statement by St. Theresa (one of the saints of the Counter-Reformation), describing how an angel had

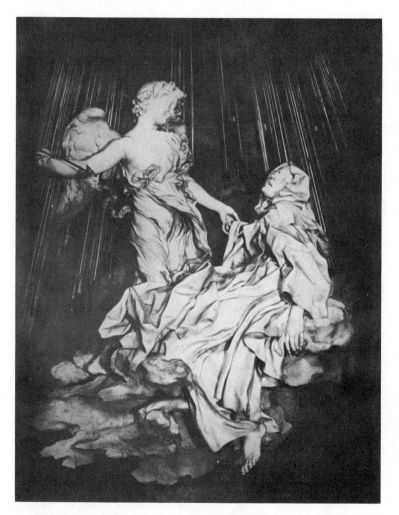

Fig. 3.29. Gianlorenzo Bernini. "The Ecstacy of St. Theresa." 1645–52. Marble. Life-size. Sta. Maria della Vittoria, Rome. Photo courtesy of Heaton-Sessions Studio, New York.

pierced her heart with a golden, flaming arrow: "The pain was so great that I screamed aloud; but at the same time I felt such infinite sweetness that I wished the pain to last forever."[4] Amid richly opulent detail, accentuated by golden rays, the composition cries with the emotion of St. Theresa's ecstasy. Typical of baroque sculptural design, line swirls diagonally to create circular movement. Each detail merges easily into the next in an unbroken chain, however complex. Every aspect of the work is in motion. Figures float upward and draperies billow from an imaginary wind. Deep recesses and contours establish strong highlights and shadows, further heightening dramatic contrasts, in comparison with baroque painting and music, among parts. The drama of the "picture" forces involvement. Its intent is to overwhelm with an emotional and religious experience.

Music

The character of music in a given period derives not only from how melody, texture, and rhythm are utilized, but also from the tonal qualities (timbres) of the voices and instruments used to produce musical sounds. Even the human voice has a diverse variety of "colors," and the emotional or intellectual quality of sound can be enhanced or reduced by how the singer employs vocal color and presentation. Musical instruments, while having a more limited range of timbres, likewise have their own individual tonal qualities. A violin and a trumpet sound nothing alike, and the same music played by a brass choir, as opposed to a string ensemble, is considerably different in its appeal to the listener's senses. We can only imagine, unless

we have access to ancient instruments, the actual quality of musical sound in the baroque or any, nonmodern era. In the Renaissance, instruments still adhered to the medieval concept of "loud" or "soft" instruments, basically the differences between the flute (recorder) and the violin (viol). Large ensembles such as orchestras, as we know them, were unheard of. So music sounded much "thinner" and less overwhelming then.

In the courtly life of the sixteenth century dancing was widespread, and much instrumental music was composed with the dance in mind. Such works had clearly developed and consistent rhythmical patterns and contrasts between dance pieces were important. Dance music also developed a theme and variation pattern. Often a slow dance in duple meter preceded a fast dance in triple meter, both built on the same tune. Dance-related themes later would be developed to a peak by J. S. Bach in independent compositions called *suites.* In the latter part of the sixteenth century dance music for lute, keyboard instruments, and ensembles became increasingly popular. The introduction of the ballet of the French court (see the section on "Dance" later in this chapter) brought forward a new outlet for musical composition.

In the same vein that occurred in Renaissance *commedia dell'arte* (see "Theatre" section), improvisation was a popular and common occurrence in sixteenth-century music. Improvisation usually took one of two forms; either the performer improvised ornamentation on a specific melody, or he improvised a contrapuntal melody in harmony with an existing melody. Principal among improvised keyboard pieces was the *toccata* (see Glossary), a specialty of Venetian composers.

The Reformation brought many changes to church music, from its complete absence in the services of sects such as Calvin's, to new forms in Lutheranism. Even after the separa-

[4] H. W. Jansen, *A Basic History of Art,* 2nd ed. (Englewood Cliffs, N.J.: Prentice–Hall, Inc., 1981), p. 244.

tion, Lutheran music maintained many of its Roman Catholic characteristics, including Latin texts and plainsong chants. The most important contribution of the Lutheran Reformation was the *chorale*. Contemporary hymns, many of which date to Martin Luther for both text and tune, illustrate this form. However, our four-part harmonies are of later modification, although the recent edition of the Lutheran Book of Worship attempts to return to the early chorale form. Originally the chorale was a single melody, stemming from the chant or folk song, and a text. Congregational singing was in unison and without accompaniment.

Lutheranism also contributed a considerable body of polyphonic choral settings, many from Luther's principal collaborator Johann Walter (1496–1574). These settings vary tremendously in style and source. Some were based on German *lieder,* and some, on Flemish motets. However, polyphony, a complex texture, is not well suited for congregational singing, and polyphonic settings were uniformly reserved for the choir. By the end of the sixteenth century Lutheran congregational singing changed again, with the organ assuming an expanded role. Rather than singing unaccompanied, the congregation was supported by the organ, which played harmonic parts while the congregation sang the melody.

The Council of Trent and the Counter Reformation also influenced music, fostering perhaps the most significant musical figure to emerge from the turbulent years of the late sixteenth century. Giovanni Pierluigi da Palestrina (1524–94) was choirmaster of St. Peter's in Rome, and, in response to the Council's opinion that sacred music had become corrupted by overly complex polyphonic textures, his compositions returned Roman church music to more simplified constructions. His works have great beauty and a certain simplicity but still retain polyphony as a basic compositional device. In Palestrina's works the text took primary focus. He was successful in eliminating what the Council considered to be objectionable displays of virtuosity. He maintained the imitative qualities of his predecessors and provided clearly articulated sections marked by strong cadences.

In contrast to the purity and reduced complexity of Roman church music and the martial solidity of Lutheran hymnody, secular music of the sixteenth century showed bawdiness, irreverence, and a celebration of physical love; often, the same composers who wrote for the church also wrote secular music. Probably more reflection of the nervous conflict of the age exists in such a dichotomy than first meets the eye. Illustrative of sixteenth-century secular music is the Italian madrigal, which also found its way to England, France, and Germany in slightly altered forms. The madrigal was an elaborate composition, usually in five parts, polyphonic, imitative, intense, and often closely linked to a text by *word painting,* which attempted to equate musical sound with a literal interpretation. For example, *water* might be indicated by an undulating, wavelike melody.

In England the madrigal, by composers such as Thomas Morley (1557–1603), was called by a variety of names: song, sonnet, canzonet, and ayre. In France, by composers Clement Jannequin and Prince Certon, the madrigal was called a *chanson,* and Jannequin's "Chant des Oiseaux" ("*Song of the Birds*") used word painting as singers imitated bird sounds. The frivolousness of such characteristics suggests an attitude not entirely unlike mannerism in the visual arts.

The word "baroque" originally meant a large, irregularly shaped pearl, and baroque music of the period from 1600 to 1750 was the full complement of the ornate, complex, and emotionally appealing style of its performing and visual sisters and brothers. The general characteristics used to describe baroque

painting and sculpture are applicable in a non-visual sense to music. Reflective of its era's systematic rationalism, baroque music stressed a refined systemizing of harmonic progression around tonal centers and led to tonal concepts of harmonic progression and major and minor keys that were basic to Western music for the next three hundred years.

Baroque composers also began to write specifically for particular instruments or voices, in contrast to previous practices of writing music that might be sung or played. They also brought to their music implicit forces of action and tension, for example, strong and immediate contrasts in tonal color or volume, and rhythmic strictness played against improvisatory freedom. The Baroque Era produced great geniuses in music: Monteverdi, Bach, Handel, Vivaldi, Scarlatti, Rameau, and others. The period also produced some new ideas, new instruments, and, most significantly, an entire new form, *opera.*

In many ways opera exemplifies baroque spirit. Whether one considers it music with theatre or theatre with music, opera is the systematizing of complex forms into one big, ornate, and even more complex design in which the component parts (the art forms it comprises) are subordinate to the whole. Some go so far as to call opera a perfect synthesis of all the arts; in it exist music, drama, dance, visual art (both two- and three-dimensional), and architecture (since an opera house is a unique architectural entity). Likewise, in true baroque character, opera primarily is an overwhelming, emotional experience.

Opera was a natural elaboration of late fifteenth-century madrigals. Many of these madrigals, some called madrigal comedies, and some called *intermedi,* written to be performed between acts of a theatre production, had a fairly dramatic character, including pastoral scenes and subjects, narrative reflec-

tions, and amorous adventures. Out of these circumstances came a new style of solo singing, as opposed to ensemble singing put to dramatic purposes. In 1600 two Italian singer-composers, Jacopo Peri (1561–1633) and Giulio Caccini (c. 1546–1618) each set to music a pastoral-mythological drama, *Eurydice,* by the playwright Ottavio Rinuccini (1562–1621). Peri's work became our first surviving opera. Peri's work was somewhat on the thin order, consisting primarily of recitative (sung dialogue) over a slow-moving bass. Musically and theatrically deficient, Peri's *opera* required a firmer hand to allow the new form to prosper.

That hand came from Claudio Monteverdi. In *Orfeo* (1607) Monteverdi expanded the same mythological subject matter of *Eurydice* into a full, five-act structure (five acts being considered classically "correct") and gave its music a richer, more substantial quality. Emotionalism was much stronger in *Orfeo.* The mood swung widely through contrasting passages of louds and softs (throughout baroque music is found the musical equivalent of strongly contrasted light and shade in painting and sculpture; almost instantaneous shifts from loud to soft, from activity to passivity, and from pleasure to pain, typify the baroque). Monteverdi added solos (airs and arias), duets, ensemble singing, and dances. *Orfeo's* melodic lines were highly embellished with ornamental notation. The orchestra contained approximately forty instruments, including bass, woodwinds, strings, and continuo.[5] Grandiose and spectacular staging marked the production; the scenic designs of the great Bibiena family, one of

[5]*Continuo* was an important characteristic of baroque music. Instruments such as the harpsichord played a continuing bass line on which harmonies were improvised from symbols provided in the notation. This system of symbols was called "figured bass" or "thorough-bass."

which is illustrated in Figure 3.30, suggests the treatment given to this and other baroque operas. Monteverdi's innovative and expansive treatment created the dramatic prototype of what we experience today, and he rightly is called "the father of opera."

By the second half of the seventeenth century opera had become an important art form, especially in Italy, but also in France, England, and Germany. A French National Opera was established under the patronage of Louis XIV. French opera also included colorful and rich ballet and strong literary traditions utilizing the dramatic talents of playwrights such as Pierre Corneille and Jean Racine. In England the court masques of the late sixteenth century led to fledgling opera during the suspension of the monarchy in the period of the Commonwealth. English opera probably stemmed more from a desire to circumvent the prohibition of stage plays than of anything else. Spurred by a strong Italian influence, opera in the courts of Germany fostered a strong tradition of native German composers; German tradition, thus established, led to one of opera's most astonishing eras in the mid-nineteenth century.

Another important new musical form to emerge in the late seventeenth century was the Italian *cantata*. It, as did opera, developed from *monody,* solo singing with the vocal line predominant and centering on a text to which the music was subservient; it consisted of many short, contrasting sections. Its proportions and performance were far less spectacular than opera, and it was designed to be per-

Fig. 3.30. Fernando Bibiena. Design for a stage set for a shrine of Diana. The Metropolitan Museum of Art, Harris Brisbane Dick Fund, 1931.

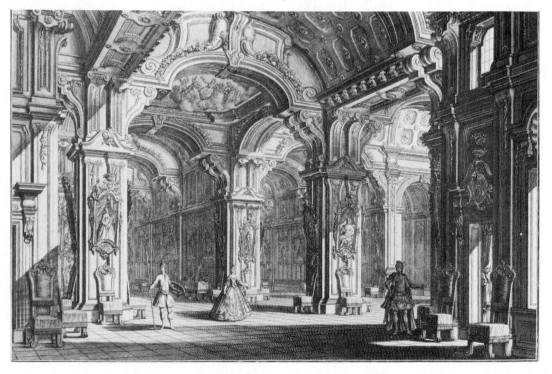

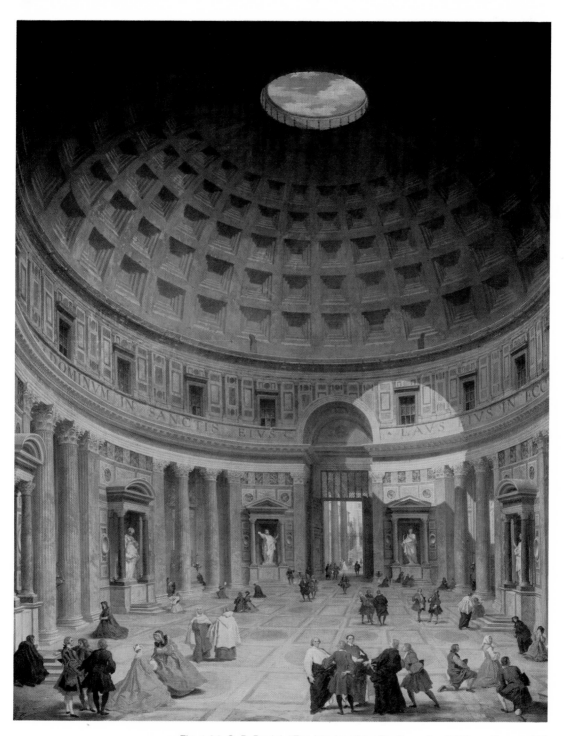

Fig. 1.34. G. P. Panini. "The Interior of the Pantheon." c. 1740 A.D. Canvas. $50\frac{1}{2}$ × 39″. National Gallery of Art, Washington, D.C. Samuel H. Kress Collection, 1939.

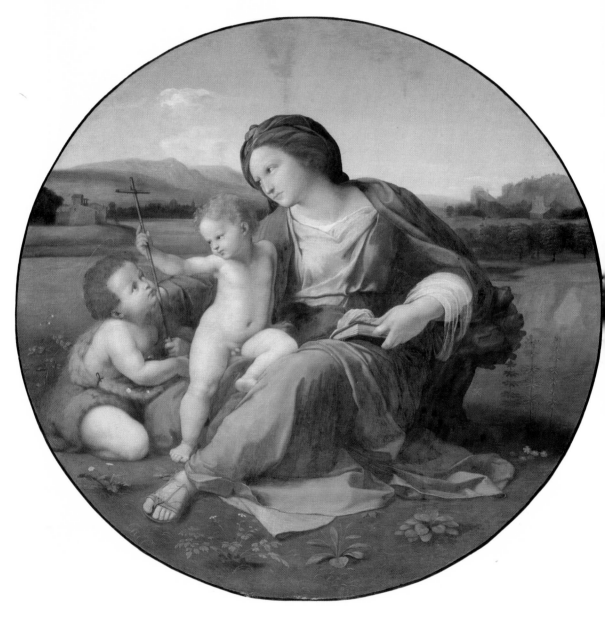

Fig. 3.9. Raphael. ''The Alba Madonna.'' National Gallery of Art, Washington, D.C. Andrew W. Mellon Collection.

Fig. 3.10. *RIGHT.* Ghiberti. "Paradise Gates." Baptistry of the Cathedral of Florence. c. 1435.

Fig. 3.11. *BELOW.* Ghiberti. "Paradise Gates." Detail: The Story of Jacob and Esan. Baptistry of the Cathedral of Florence.

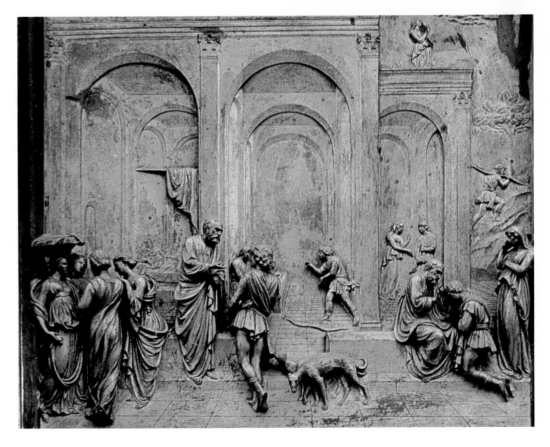

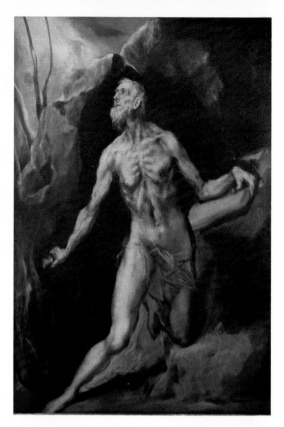

Fig. 3.21. *LEFT.* El Greco (Domenikos The-
otokopoulos). "St. Jerome." c. 1595. Canvas. 66¼ ×
43½". National Gallery of Art, Washington, D.C.
Chester Dale Collection, 1943.

Fig. 3.22. *BELOW LEFT.* Peter Paul Rubens. "The
Assumption of the Virgin." c. 1626. Wood. 49⅜ ×
37⅛". National Gallery of Art, Washington, D.C. Sam-
uel H. Kress Collection, 1961.

Fig. 3.23. *BELOW.* Rembrandt van Rijn. "The De-
scent from the Cross." Canvas. 56¼ × 43¾". National
Gallery of Art, Washington, D.C. Widener Collec-
tion, 1942.

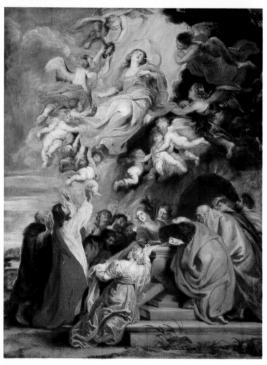

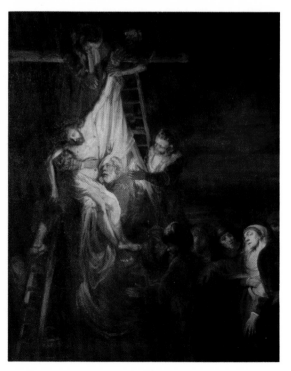

formed without costumes or scenery. The high point of Italian cantata composition came in the works of Alessandro Scarlatti (1660–1725). Scarlatti composed more than six hundred cantatas. Typically, these begin with a short *arioso* section, somewhat slower in tempo and less highly organized, less rhythmically regular, and less emotional than an aria; a *recitative* (sung dialogue) follows, then a full *aria,* a second recitative, and a final aria in the opening key. Scarlatti's moods tended to be melancholic and tender, and his composition, elegant and refined. Most cantatas were written for solo soprano voice, although many utilized other voices and groups of voices. In Germany the cantata grew from the Lutheran chorale and found its most accomplished composers in Johann Sebastian Bach (1685–1750) and Dietrich Buxtehude (c. 1637–1707). Bach, during parts of his career, was under professional obligation, as a choirmaster, to compose a new cantata weekly. Between 1704 and 1740 he composed more than 300. His cantatas were primarily contrapuntal in texture, usually written for four soloists and four-part chorus, and often illustrative of the word-painting techniques mentioned earlier.

A third major development in the same vein was the *oratorio.* Broad in scale like an opera, it utilized a sacred subject with a poetic text, and, like the cantata, was designed for concert performances, without scenery or costume. Many oratorios could be staged and have highly developed dramatic content with soloists portraying specific characters. Oratorio began, principally, in Italy in the early seventeenth century, but all other oratorio accomplishments pale in comparison with the works of its greatest master, George Frederick Handel (1685–1759). Although Handel was German by birth, he lived in England and wrote his oratorios in English. His works continue to enjoy wide popularity, and each year his *Messiah* has thousands of performances around the world. Most of Handel's oratorios are highly dramatic in structure and contain exposition, conflict or complication, and *denouement* or resolution sections. Many could be staged in full operatic tradition (except for two outstanding examples, *Israel in Egypt* and the *Messiah*). Woven carefully into the complex structure of Handel's oratorios was a strong reliance on the chorus. His choral sections (as well as his arias and recitatives) are carefully developed and often juxtapose complex polyphonic sections against homophonic sections. Each choral movement has its own internal structure, which, like the oratorio itself, rises to a climax and resolves to a conclusion. Most of the solo and choral sections of Handel's oratorios can stand on their own as performance pieces apart from the larger work. Nevertheless, as superb and individual as these may be, they fit magnificently together in a systematic development, losing their separate importance to the overall composition of the whole.

Judas Maccabaeus, for example, tells the story of the Maccabaean wars between the Jews and the Syrians. Seven characters, Judas Maccabaeus, an Israelitish Man, two Israelitish Women, Simon the High Priest, an Israelitish Messenger, and a Priest, as well as a chorus of "The People of Israel" comprise the cast. In *Part I* the Jews lament the death of Mattathias, the father of Judas Maccabaeus and Simon, who had resisted attempts by the Syrian King to repress Jewish religion and liberties. They invoke divine favor and recognize Judas as leader; Judas appeals to the people's patriotism in the following air for tenor:

Sound an Alarm

Sound an alarm, your silver trumpets sound,
And call the brave, and only brave around!
Who listeth, follow:—to the field again!
Justice, with courage, is a thousand men.

The people respond; all acknowledge the value of liberty and prepare for war with pious trust in God and a heroic resolve to conquer or die. Part I ends on that high dramatic and emotional tone. Part II begins in celebration of recent victories under Judas' valorous leadership. However, news of a renewed war with Syrian armies out of Egypt brings despondency to the Israelites. Again Judas rouses their failing courage and sets out to battle while those who remain at home utter their detestation of the "heathen idolatries," by which the temple of Jerusalem had been desecrated. They resolve to worship only the God of Israel. Part III brings the work to triumphal climax amid the Feast of the Dedication of Jerusalem, recaptured and restored by Judas, with full liberties returned to the people of Israel. Finally, Judas returns in triumph from his final victory over his enemies. The oratorio is a powerful and complex emotional work of full baroque character.

As baroque composers began to write specifically for individual voices and instruments, instrumental music assumed a new importance in contrast to its previous role as accompaniment for vocal music. Significant achievement occurred in exploration of the full range of possibilities for individual instruments and also in technical development of the instruments themselves. Of particular significance was the need to create flexibility so that instruments could play in any key. For example, although we take *equal temperament* for granted, prior to the Baroque Era an instrument such as the harpsichord needed to be retuned virtually each time a piece in a new key was played. As a result, *equal temperament* established the convention we accept without question, that each half-step in a musical scale is equidistant from the one preceding or following. Such an advancement was not perceived immediately as advantageous, and J. S. Bach composed a series of two sets of preludes and fugues in all possible keys ("The

Well-Tempered Clavier," Part I, 1722; Part II, 1740) to illustrate the attributes of the new system.

Perhaps the most significant outgrowth of focus on instruments and equal temperament was the wealth of keyboard music in this era. Most expressive of the complexity, ornamentation, and virtuosity of such an outgrowth was the *fugue* (see Glossary). Representing the highest point of the development in keyboard fugal music was J. S. Bach, and nothing represents Bach better than the collection of twenty fugues and canons, *The Art of the Fugue,* published after his death.

Two other compositional forms added to baroque contribution to Western musical traditions: the *concerto grosso* (also the *solo concerto*) and the *sonata*. The master of the *concerto grosso* was Antonio Vivaldi (1669–1741). As was true not only of composers, but of baroque playwrights as well, Vivaldi composed for specific occasions and usually for a specific company of performers. Also, like his performing arts contemporaries, he was prolific. He wrote approximately 450 concertos, 23 sinfonias, 75 sonatas, 49 operas, and numerous cantatas, motets, and oratorios. About two-thirds of his concertos are for *solo instrument and orchestra,* in contrast to *concerto grosso,* which uses a small *ensemble* playing as a solo instrument. Probably his most familiar solo concerto is *Primavera (Spring)*, one of four works in Opus 8 (1725) representing the *Seasons. The Seasons* is *program music,* written to describe a text, in contrast to *absolute music,* which presents purely musical ideas. *Primavera* displays an interlocking development of interestingly shaped, individual pieces joined to form an ornate whole. In the first movement (allegro) Vivaldi alternates an opening theme (A) with sections musically depicting "The birds' song," "the flowing brook," "the storm," and "the birds' return" (ABACADAEA). This expanding and alternating pattern is called *ritornello.* Within this

clear, but complex structure exist ornamental melodic developments. For example, in a simple ascending scale of five notes, *do, re, mi, fa, sol,* the composer wrote additional notation near in pitch and surrounding each of the five tones; the resulting ascending scale comprises a melodic pattern of perhaps as many as twenty tones—a musical equivalent of the complex ornamental visual detail of painting, sculpture, and architecture.

The sonata in the Baroque Era often consisted of several movements (sections) of contrasting tempos and textures. It was written for a small ensemble of instruments, usually two to four, with a *basso continuo.* Considerable diversity existed in sonata composition, many sonatas greatly vary from the definition just given. The trio sonatas of Archangelo Corelli (1653–1713) probably best illustrate the form. Corelli treated his instrument, usually the violin, as if it were a human voice—indeed the tonal and lyrical qualities are similar. In treating the violin like the human voice, Corelli did not explore the instrument's full range of technical possibilities, but he did create extremely diverse and sophisticated devices. He usually alternated four contrasting movements, in the same key, in slow–fast–slow–fast tempi. Corelli utilized essentially independent single themes that unfolded subtly, in a manner characteristic of the late Baroque Period.

Corelli's dependence and focus on the violin draws our attention to this major instrument, which saw great development in the era. The violin was fully explored as a solo instrument and also was perfected as a physical entity. From the late seventeenth and early eighteenth centuries came the greatest violins ever constructed, the *Stradivari.* Made of maple, pine, and ebony by Antonio Stradivari (1644–1737) these remarkable instruments are priceless today, and despite the best scientific attempts of our age, have never been matched in their superb qualities, the secrets to which died with Maestro Stradivari. Not only is a violin similar to the human voice in timbre, but a well-made violin actually has an individual personality: It assumes certain qualities of its environment and of the performer. Its delicate nature responds like a human to external factors, and its most expressive utilization depends upon tender care and love from its owner.

The Baroque Age in music was a magnificent one. For all intents and purposes baroque music began our contemporary musical age, and remains a far more integral part of contemporary experience than does any of its stylistic contemporaries.

Theatre

Given time, the theatre of the late Renaissance era caught the Renaissance spirit. When it finally arrived it developed characteristics so profound that it made a significant impact in every part of Europe. Interestingly, as ephemeral as theatre can be and often is, we have as clear a picture of its diverse character throughout Europe as we have of every other art discipline. At some time during the Renaissance significant theatre occurred in Italy, England, France, and Spain.

In Italy where Renaissance emphasis was visual, two important and influential developments emerged. One was a new form of theatre building, and the other was painted scenery. Both contributed to changed aesthetics and style in formal theatre production. Vitruvius, Roman architect and historian, was the source of Italian plans for a new physical theatre, but Renaissance scholars were quite inaccurate in their antiquarian enterprises. Nevertheless, Italian modifications of medieval mansion stages into compact, carefully designed theatres created a theatre form basic to twentieth-century theatres. Palladio's *Teatro Olympico* (Figs. 3.31 and 3.32) was once thought to be the prototype for modern theatres, but scholars now believe

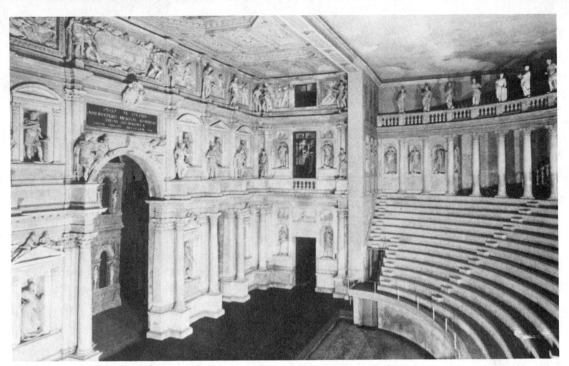

Fig. 3.31. Teatro Olympico. Interior. c. 1580. Vicenza. Photo courtesy of Heaton-Sessions Studio, New York.

Fig. 3.32. Teatro Olympico. Stage. Vicenza. Photo courtesy of Heaton-Sessions Studio, New York.

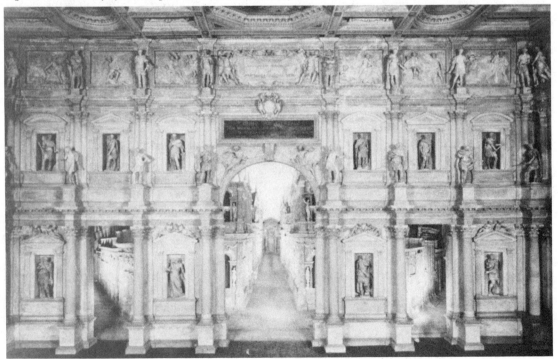

our theatre derived from the *Teatro Farnese* at Parma. The most significant change in the theatre in this era was a move to encapsulate dramatic action within a "picture frame" or *proscenium,* so that the audience sat on only one side of the stage, watching the action through a rectangular or arched opening. The term "picture frame" stage is particularly appropriate both in terms of its visual effect and the painting traditions of the era, which the theatre attempted to adopt.

The discovery of scientific, mechanical perspective found its way into the theatre in the sixteenth century, and the designs of Sebastian Serlio (Fig. 3.33) illustrate the new painted scenery. The visual and historical effect of these designs is impressive. What we may not realize is the fact that these designs achieve their visual effect from falsified perspective "tricks" (just as did early Renaissance paintings) based on scientific, mechanical principles. From a point slightly upstage of the actual playing area, the size of the scenery physically diminishes to an imaginary vanishing point. The effect stimulates a sense of great depth when, in actuality, the set re-

Fig. 3.33. Sebastian Serlio. Stage setting from *De Architettura.* 1545.

cedes only a few feet. Of course, the actors were restricted to a narrow playing area adjacent to the full-sized downstage wings. Were the actors to move upstage, they would have towered over the buildings. Stage settings became more and more elaborate, and a new "opening" usually brought out an audience to see not a new play, but, rather, the new accomplishments of the set designer. No end of magical devices existed. Cities enveloped in flames, water and waves, scenery moving in and out, up and down, revolving stages, moving clouds, trapdoors, rolling platforms, palaces and ships all captured the audience's fancy.

Stage and costume designs provided the major quality and attraction of theatre in sixteenth-century Italy, far outstripping the meager plays of the period. The comedies of Ariosto, Cardinal Bibiena's *Calandria,* Machiavelli's *Mandragola,* Tasso's *Aminta,* and Bruno's *Il Candelaio* represent the undistinguished playwriting of the age. However, theatrical concerns were directed to opera, as we have seen, and the conflicting interests of that art form along with the visual orientation of the sixteenth century may be responsible for the literary vacuum on the Italian stage.

Competing, additionally, for public attention was Italy's unique *commedia dell'arte. Commedia* developed parallel to the traditions just examined, enjoyed tremendous popular support, and featured the actor, not the script. *Commedia dell'arte* could be identified by four specific characteristics. The first was improvisation. Even though full-fledged productions had plots and subplots, dialogue was completely improvised, depending only upon a plot outline or scenario. A few *commedia* works were serious, and some pastoral, but most were comic. We assume from information available that the acting style was highly naturalistic, calling for good entrance and exit lines as well as *repartee.* The second

characteristic was the use of stock characters, for example, young lovers, old fathers, braggart soldiers, and comic servants (*zanni*). All wore stock costumes, which the audience easily could identify. (We have seen these character types previously in Roman comedy.) Actors portraying these roles required great skill, physical dexterity, and timing (still an important comic attribute), since much of the action was visual. The famous Scaramouche (Tiberio Fiorilli) apparently still could box another actor's ears with his foot at age eighty-three. Actors in the *commedia* also depended upon skills in dancing, singing, and acrobatics. Somersaulting without spilling a glass of wine apparently gained an actor great adulation. A third characteristic was the use of mime and pantomime. Masks were worn by all roles except the lovers and the servingmaid, and attitudes were communicated through gesture.

Commedia dell'arte also comprised a fourth characteristic. Actors travelled in companies, and each member of the company played the same role over and over again. The practice was so pervasive and popular that actors often lost their own individuality to the role they played; many actors changed their original names to that of the stage personage they portrayed. From the mid-sixteenth to the mid-seventeenth centuries troupes of *commedia* actors travelled throughout Europe. Their influence and popularity were tremendous, but *commedia* remained an Italian form, although its characters and situations found their way into the theatre of other nations. By the end of the seventeenth century, *commedia* had, for all intents and purposes, disappeared. One final fact must be noted; *commedia dell'arte* introduced women into the theatre as equals. Their roles were as important as, and often more important than, men's.

While late Renaissance Italy prepared the way for our modern theatre building and certain acting techniques, sixteenth-century England created a new theatre of convention and history's foremost playwright. In August, 1588, a regal, red-haired, virgin Queen sat astride a horse amid some six thousand troops and proclaimed her resolve to rule among her subjects, to don armor and fight, if necessary, lest any "dishonor grow by me." The Queen was Elizabeth I, and under her aegis the British Empire and the English stage would rise to pre-eminence.

We always must be careful when we try to draw conclusions concerning why the arts developed as they did within a particular historical context. While Italy and France saw the arts prosper under varying forms of extravagant patronage, England saw a theatre of great literary consequence and conventional nature prosper under a monarch who loved the theatre only as long as it did not impose upon her financially. In other words, Elizabeth I encouraged the arts not by patronage of the kind provided by the Medicis, the Church, or King's Francis I or Louis XIV, but, rather, by benign neglect.

England's drama in the mid- to late-sixteenth century was national in character, influenced undoubtedly by the severance of church and state under Henry VIII and by the brief reign of the Catholic Mary, Queen of Scots. Nevertheless, literary influences in England in the sixteenth century were strongly Italian, and the theatre reflected these influences.

The Elizabethans had a seemingly insatiable appetite for drama, and the theatres of London saw prince and commoner together among its audiences. They sought and found, usually in the same play, action, spectacle, comedy, character, and intellectual stimulation so deeply reflective of the human condition that Elizabethan plays have found universal appeal through the centuries since their first production.

Shakespeare, of course, was the pre-eminent Elizabethan playwright, and his and

English sensitivity to and appreciation of the Italian Renaissance can be seen in the Renaissance Italian settings of many of his plays: *Romeo and Juliet, Othello, Two Gentlemen of Verona, The Merchant of Venice,* and so on. In true Renaissance expansiveness, Shakespeare took his audiences back into history, both British and otherwise, from *Henry VI* to *Hamlet,* from *Antony and Cleopatra* to *Richard II,* and far beyond, to the fantasy world of Caliban in *The Tempest.* We gain perspective on Renaissance humankind's perception of their own or their fellows' condition when we compare the placid, composed reflections of Italian painting with Shakespeare's tragic portraits of Renaissance Italian intrigue.

Shakespeare, like most playwrights of his age, wrote for a specific professional company (of which he became a partial owner). The need for new plays to keep the company alive from season to season provided much of the impetus for his prolific writing, in the same sense that a required weekly cantata stimulated Bach and Scarlatti. A robust quality exists in Shakespeare's plays. His ideas have universal appeal because of his understanding of human motivation and character and his ability to probe deeply into emotion. He provided insights dramatically equivalent to Rembrandt's visual probings. Shakespeare's plays reflect life and love, action and nationalism; and they present those qualities in a magnificent poetry that explores the English language in unrivalled fashion. Shakespeare's use of tone, color, and complex or new word meanings gives his plays a musical as well as dramatic quality, which appeals to every generation. Late Renaissance word painting in music found a masterly peer in Shakespeare's use of musical sound in language. His characters can be as alive today as they were in his time, and the teenage troubles of Romeo and Juliet so capture the complexities of life that even the most sophisticated audience members can be moved to tears by each new performance of a play they may have seen a dozen times or more.

However, Shakespeare was not the only significant playwright of the English Renaissance stage, and the plays of Christopher Marlowe (1564–93), of Ben Jonson (1573–1637), and of Francis Beaumont (1584–1616) and William Fletcher (1579–1625) still captivate theatre audiences. Marlowe's *Tamburlaine the Great* rivalled even Shakespeare and surges with a mighty use of language in blank verse. Marlowe's love of sound permeates his works, and if his character development is weak, his heroic grandeur carries the classic qualities of Aeschylus and Sophocles. Ben Jonson's comedy stands in contrast to Marlowe's heroic tragedy. *Everyman in his Humor* documents the lives of a group of Elizabethan eccentrics. Jonson's wit and pen were sharp, and his tolerance was low. His plays were quarrelsome in nature and often were vicious caricatures of contemporary individuals. Even Shakespeare was a target; Jonson disparagingly referred to Shakespeare's "Small Latin and less Greek." Jonson's eyes were on Renaissance ideas, however, and on Italian influences in particular. His most frequently produced comedy, *Volpone,* is set in Venice and satirically attacks the greed Jonson found throughout the world around him.

Most of us are at least vaguely familiar with the nature of Elizabethan theatre buildings, even though our documentation of their characteristics is fairly sketchy. In general we assume that the audience surrounded the stage on three sides, an inheritance from earlier times when stages were erected in the enclosed courtyards of inns. By 1576 professional theatre buildings existed in London. These were circular in shape ("This wooden O," according to Shakespeare's *King Henry V*), and their performances were witnessed by a cross section of society from commoners in the "pit," the standing area around the stage, to nobility in the galleries, a sitting area

under a roof. The stage, situated against one wall of the circular building, may or may not have been protected by a canopy, but the great spectacle of Elizabethan and Shakespearean drama was an "outdoor" event. Theatres were constructed of wood, and fire was a constant threat. Johannes de Witt, from whose accounts of a trip to London in 1596 we derive nearly all our knowledge of the physical theatre of the era, claimed that the Swan Theatre could seat three thousand spectators.

The scenic simplicity of Elizabethan theatre (no locales were depicted; all acting was done in front of an unchanging architectural façade) stood in strong contrast to the opulent spectaculars of English Court masques during the reign of Charles I in the early years of the seventeenth century. Essentially the court masque was a toy for the nobility, an indoor extravagance which had developed earlier in the sixteenth century, probably influenced by its visually resplendent cousins in Italy. Short on literary merit, the English masque, nevertheless, was a dramatic spectacle *par excellence* and reflected monarchial splendor.

Banqueting halls in palaces often were redesigned to accommodate scenic complexities of the masques. Stages often exceeded thirty-five feet in width and twenty-five feet in depth. Six feet high in front and seven feet high at the rear, these stages allowed manipulation of scenery from below and utilized a form of staging called forestage–façade, in which the actors played on a protruding area in front of (as opposed to amid) drops and wings. What is important about the English court masque is its direct tie to the scenic style of Palladio and Serilo in Italy. Inigo Jones (1573–1652), the most influential English stage designer of the time, freely imitated Italian perspective, using elaborate stage machines and effects, including the *periaktoi*, a three-sided, scene-changing device utilized by the Greeks.

This baroque equivalent in English theatre was broken by the dissolution of the monarchy by Cromwell's zealots in 1642. Theatres were closed and production forbidden (at least publicly) until restoration of the Stuarts under Charles II in 1660. Opera provided a handsome substitute, however. When Charles returned from exile in France he brought to the English theatre the continental style current to the French Court. One result was a sophisticated comedy of manners called English Restoration Comedy. It was an era of great English acting and a period of refinement in the forestage–façade style of physical theatre.

The Restoration theatre produced Nell Gwynn, Thomas Betterton, Elizabeth Barry, and Anne Bracegirdle, actors and actresses of fundamental importance in the furtherance of a modern tradition in comic acting style. Playwrights such as John Dryden, William Wycherly, Sir George Etherege, *Love in a Tub* (1664), and William Congreve *Love for Love* (1695), to name only a few, brought England and Western culture a comedy of high style and fashion.

Spain also shared a Renaissance, a golden age during the late sixteenth and early seventeenth century. Spanish Renaissance theatre developed parallel to the Elizabethan; many playhouses were remarkably similar, notwithstanding the fact that there appears to have been little contact between the two countries. The greatest influence on Spanish theatre, however, came from Italy. The invasion of Italy by Charles V in 1527 brought Italian influence to Spain. Spanish Renaissance comedies played against street scenes similar to those of Serlio's. Spanish Theatre also was influenced by Italian *commedia dell'arte,* both in acting standards and in staging conventions.

Among those who wrote for an emerging Spanish classical or Renaissance theatre was Miguel de Cervantes (1547–1616). However,

it was Lope de Vega (1562–1635) who brought Spanish drama to the fore. A Renaissance personality of intense vigor, he reportedly wrote over twelve hundred plays. Perhaps the most outstanding is *Fuente Ovejuna* (*The Sheep's Well*), which tells the poignant story of a peasant uprising against a tyrannical nobleman. Lope's contemporaries, Tirso de Molina, Juan Ruiz Alarćon, and Calderón de la Barca reflected the lyricism and Renaissance probing of individual human psychology we have seen so often in this era and gave Spain a brilliant moment in Western arts history.

The years from 1550–1720 in France parallel the years in Italian and English theatre just examined, and these years witnessed travelling *commedia* troupes and a cross-pollenizing of theatre influences from France to England and *vice versa,* as exemplified by the English Restoration period. Within her own borders, France, like her sister countries, developed a unique and significant theatrical tradition scholars have called *French neoclassicism.* We must remember that labels are sometimes confusing; French neoclassicism is a part of the late Renaissance period and related, especially in its later years, to the baroque style in music and visual art. "Classicism" and "neoclassicism," as stylistic labels, will occur later in both music and the visual arts, and we must not let the differences from the periods of their original development confuse us.

Earlier we noted the Renaissance ideas and artistic encouragement of Francis I. Despite these facts French theatre remained essentially medieval until after his death in 1547. France lay in the midst of Catholic/Papal conflicts stemming from Francis's battles with Rome and his invasion of Italy; France also lay in the middle of the Protestant rebellion. The country was not under the thumb of Rome but was essentially Catholic. So the Reformation and Counter-Reformation found France geographically and philosophically in the middle. The ascension of Henry II to the throne of France in 1547–48 brought with it Henry's wife Catherine de Medici. Her influence was significant in bringing late Renaissance Italian ideas to the French Court and was especially profound in the development of ballet.

Medieval religious drama had continued its strong traditions under the royal monopoly granted to the Confrèrie de la Passion, as we noted in the previous section. However, in 1548 a strange combination of Protestant and Catholic attitudes caused the legal suppression of all religious drama. Secular drama, freed from its religious competition, turned to Renaissance classicism. French rediscovery of Sophocles, Euripides, Aristophanes, and Menander provided a new impetus. As we have seen before in the arts, this turning back to the ancients had a tendency to foster specific "rules" for "acceptable" works of art. In the French theatre such attitudes forced plays to fit a structural and spatial mold called "the unities." As a result, the spirit and substance of classical drama was lost in attempts to bend it into artificial confines. The "unities" of time and space became the masters of drama. No play was found acceptable by the academies unless it conformed to action occurring in a single location and encompassing no greater time span than twenty-four hours. Of course, had French antiquarians bothered to study actual classic Greek dramas, they would have discovered many violations of the unities. As a result of all this historically inspired rule making, French tragedy achieved little of consequence. As in Italy and England (in the masque), this period witnessed scenic invention and extravagance. Under the arbitrary conventions of misinterpreted classicism, Pierre Corneille (1606–84) managed to conform and to produce a few plays. In 1635 he produced a masterpiece, *Le Cid*. His characterizations were original; his themes, grand and heroic;

and his language, richly poetic. However, he violated the unities, and Cardinal Richelieu, France's official arbiter of taste, and his subservient Académie Française condemned the play. Corneille continued to write, and his late work *Andromède* was produced as a vehicle to spotlight Italian scenery and machinery imported by Torelli. Corneille's tragedies established a form and quality that strongly influenced a second important playwright of this era, Jean Racine (1639–99). *Phèdre*, perhaps his best work, illustrates the lyrical poetry, subtle psychology, and carefully developed plots that mark the best examples of French Renaissance (neoclassic) drama.

However, French tragedy was bound to play second fiddle to her great comedy and her greatest playwright, Molière (1622–73). Early in his career he joined a professional company, a family of actors named Béjart. His earliest productions took place in what has come to be known as a *tennis court* theatre, because the shape and size of the indoor tennis courts of the time made them easily and acceptably adaptable to theatre. For over thirteen years the Béjarts and Molière toured France as an itinerant company. A fateful appearance before Louis XIV launched his career as a playwright, combining it with work as an actor and manager. *Tartuffe, Le Misanthrope*, and *Le Bourgeois Gentilhomme* brought French comedy to new esteem and equal to tragedy. For comedy to be so esteemed is a rare occasion in the history of the theatre. Molière's instincts for penetrating human psychology, fast-paced action, crisp language, and gentle but nonetheless effective puncturing of human foibles earned him a foremost place in theatre history. Molière's comedies were not only dramatic masterpieces; they also stood up to the potentially overpowering baroque scenic conventions of Versailles. *Andromède* and *Psyché* challenged the painted backgrounds and elaborate machinery of Italian scene designers and emerged dominant.

Dance

European, indoor court entertainments of the early and mid-sixteenth century often took the form of "dinner ballets." These entertainments were long and lavish and consisted of danced interludes called *entrées* between courses. Often the mythological characters of these *entrées* would correspond to the dishes served in the meal. Poseidon, god of the sea, for example, would accompany the fish course. In addition to mythology, danced depictions of battles in the Crusades, called *moresche* or *moresca*, were popular. Henry VIII of England found the tales of Robin Hood to his liking, and English Court masques of the early sixteenth century often dealt with that folk theme. Theatre dance was closely connected, still, with social dancing, and social dances such as the *pavane, galliard, allemande, courante, sarabande, gigue*, and *minuet* played an important role not only in influencing theatre dance but also in influencing music, as we noted earlier. Purcell, Bach, Handel, and Couperin and, much later, Ravel, Schoenberg, Debussy, Respighi, and Prokofieff found inspiration in the dances of this era.

Courtly dancing in Europe, and especially in Italy, became more and more professional in the late sixteenth century. Skilled professionals performed on a raised stage and then would leave the stage to perform in the center of the banquet hall to be joined by members of court. During this period dancing technique improved and more complicated rhythms were introduced. All of these changes were faithfully recorded by Fabritio Caroso in *Il Ballerino* (1581) and Cesare Negri in *Nuove Inventioni di Balli* (1604).

Formal ballet came of age as an art form under the aegis of Catherine de Medici (1519–89), great-granddaughter of Lorenzo

the Magnificent. Catherine had left Italy for France to marry the Duc d'Orleans. However, on the death of Francis I she became queen of France when her husband was crowned Henry II. Her Medici blood apparently endowed her with a love of pageantry and spectacle, and her political acumen understood the usefulness of such pageantry in the affairs of state. After her husband's accidental death in 1559 (he was pierced through the eye at a tournament) she ruled France through her sons for the succeeding thirty years. Love of spectacle permeated the French Court, and lavish entertainments, some of which nearly bankrupted the shaky French treasury, marked important events such as the marriage of Catherine's eldest son, Francis II, to Mary, Queen of Scots. Although sources vary in attributing the specific development of these spectaculars into a balletic artform, we can be sure that either *Le Ballet des Polonais* (1572) or the *Ballet Comique de la Reine* (1581) marked the real beginning of formal Western ballet tradition.

Le Ballet de Polonais (The Polish Ballet) was produced in the great hall of the Palace of the Tuilleries on a temporary stage with steps leading to the hall floor. The audience surrounded three sides of the stage and joined the dancers at the end of the performance in "general dancing." Music composed by Orlando di Lasso was played by thirty viols, and a text glorifying the King and Catherine was written by the poet Pierre Ronsard. Oversight of the entire production fell to Catherine's *valet de chambre,* Balthasar de Beaujoyeulx, an Italian who also produced the *Ballet Comique de la Reine.* This extravaganza was a mixture of Biblical and mythological sources. It had original music, poetry, and song, and employed typically Italian Renaissance scenic devices to overwhelm the audience with fountains and aquatic machines. Over 10,000 spectators witnessed this costly

(c. 3.5 million francs) "event," which ran from ten P.M. to four A.M. Probably the most significant aspect of the *Ballet Comique,* and one that leads some scholars to mark it as the "first" ballet, was its use of a single dramatic theme throughout. Whatever the case, these ballets made France the center of theatrical dance for the next centuries. We can sense the Renaissance concept of this work from Beaujoyeulx' descriptions of ballet as "a *geometric combination* of several persons dancing together."

Especially at the turn of the seventeenth century dancing also formed a part of the court masques of England. However, given the presence of writers of the calibre of Ben Jonson and designers such as Inigo Jones, dance was a minor factor in these primarily theatrical productions. Newly emerging formal dance also provided part of the spectacle slowly becoming known in Italy as opera. But these were minor, peripheral episodes. The roots of theatre dance grew strong and deep in France.

During the reign of Henry IV (1589–1610) over eighty ballets were performed at the French Court. In a ballet in 1615 "thirty genii, suspended in the air heralded the coming of Minerva, the Queen of Spain. . . . Forty persons were on the stage at once, thirty high in the air, and six suspended in mid-air; all of these dancing and singing at the same time."[6] Later, under Louis XIII, a fairly typical ballet of the period, *The Mountain Ballet,* had five great allegorical mountains on stage: the Windy, the Resounding, the Luminous, the Shadowy, and the Alps. A character, Fame, disguised as an old woman, explained the story, and then "quadrilles of dancers" in flesh-colored costume with windmills on their

[6]Père Menestrier, in Gaston Vuillier, *A History of Dance* (New York: D. Appleton and Co., 1897), p. 90.

heads (representing the winds) competed with other allegorical characters for the "Field of Glory." Such a work typically consisted of a series of dances dramatizing a common theme.

By the late seventeenth century baroque art had centralized in the court of Louis XIV. A great patron of painting, sculpture, theatre, and architecture, Louis also brought ballet into the full splendor of the era. Louis himself was an avid dancer, and studied for over twenty years with the dancing master Pierre Beauchamps, who is credited with inventing the five basic dance positions. Louis' title *Le Roi Soleil* (The Sun King) was certainly appropriate to his absolutist philosophies, but it actually derived from his favorite childhood role, that of Apollo the Sun god in *Le Ballet de la Nuit,* which he danced at age fourteen. Mazarin, Louis' First Minister, utilized the splendiferous role to promote the young monarch and to establish Louis' supremacy.

Louis employed a team of professional artists to produce ballet and opera at court, and the musician Jean-Baptiste Lully and the playwright Molière were active in these grand collaborative efforts. Usually the plots for French ballets came from classical mythology and the works themselves comprised a series of verses, music, and dance. The style of the dancing, at least in these works, appears to have been fairly simple, noble, and controlled. Gestures were symmetrical and harmonious. The theatrical trappings were elegant and opulent. Probably no conflict exists here even though we have described the baroque style as emotional in emphasis. An appeal to the emotion does not preclude formality, nor intricacy or restraint. One must also bear in mind that the costume of the era included absurdly elaborate wigs. Anything other than restrained movement, such as befitted the demeanor of a king, probably was impossible.

Finally, ballet became formally institutionalized when Louis XIV founded the Academie Royale de Danse in 1661. Thirteen dancing masters were appointed to the *academie* to "re-establish the art in its perfection." Ten years later the *Academie Royale de Danse* was merged with a newly established *Academie Royale de Musique.* Both schools were given the use of the theatre of the Palais Royal, which had been occupied by Molière's company. Its proscenium stage altered forever the aesthetic relationship of ballet and its audience. Choreography designed for an audience on one side only was developed and focused on the "open" position, which is still basic to formal ballet.

Establishment of the Academy of Dance led to prescribed "rules" for positions and movements. It also led to a fully professionalized artform in which women as *ballerinas* (career professionals) first took the stage in 1681. The stage of the Palais Royal, which allowed no access to the auditorium, placed the final barricade between the professional artist and the "noble amateur" of the previous eras. As the Baroque Era came to a close in the early eighteenth century, ballet as a formal art discipline had its foundations firmly in place.

Architecture

The late sixteenth century in architecture evidenced mannerist tendencies especially in France under Francis I. The Lescot wing of the Louvre (Fig. 3.34) exhibits a discomforting design of superficial detail and unusual proportions, with strange juxtaposing of curvilinear and rectilinear line. If we compare this building with previous works from the Renaissance, we find a continuation of decorative detail applied to exterior wall surfaces. However, careful mathematical proportions are replaced by a flattened dome and dissimilar treatments of shallow arches. The helmet-like dome stands in awkward contrast to the pediment of the central section and wears a

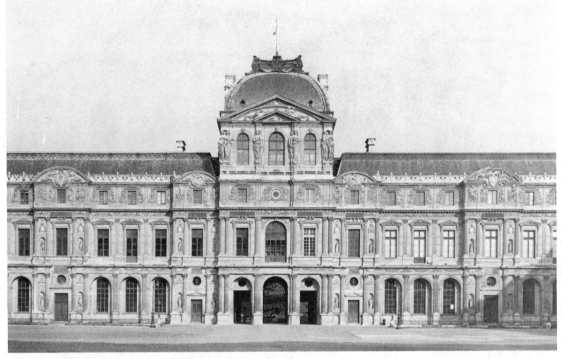

Fig. 3.34. Pierre Lescot. Louvre: The Lescot Wing. 1541–48. Paris. The Louvre.

crown perched nervously on its top. The relief sculptures of the top level of the central section are far too large to be comfortable in their architectural context.

In this same period existed architecture of significant influence in later eras, but clearly of a different feeling from Lescot's. Andrea Palladio (1518–80) designed villas and palaces, which reflected his clients' individualism and desire for worldly possessions. Villa Rotunda in Vicenza (Fig. 3.35) shows strong classical influence, combining Greek and Roman details. The porticos carry freestanding Ionic columns, and the dome is reminiscent of the Pantheon. The rooms of the villa are arranged symmetrically around the central rotunda. Palladio's mathematical combination of cubes and circles is High Renaissance, but he has cleansed the exterior surfaces of detail, placing his decorative sculpture above,

in anticipation of baroque treatments. Palladio explained his theories in *Four Books on Architecture,* which were highly influential in establishing canons utilized later in various "revival" periods, for example, in America in Thomas Jefferson's Monticello.

In the seventeenth century baroque style emphasized the same qualities of light and shade, action, intricacy, opulence, ornamentation, and emotion exhibited in the other visual and performing arts. Architecture reflected all those qualities, but because of its scale, it did so with amazing, dramatic spectacle. There were many excellent baroque architects, among them Giacomo della Porta (Figs. 3.36 and 3.37), Francesco Borromini (Sant' Agnese and S. Carlo alle Quattro Fontane), Bernini (St. Peter's Plaza), Claude Perrault (East Front, the Louvre). Later, German baroque combined with the lightness and del-

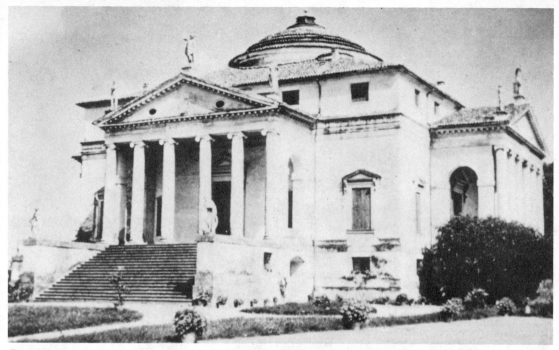

Fig. 3.35. Palladio. Villa Rotunda. 1550. Vicenza.

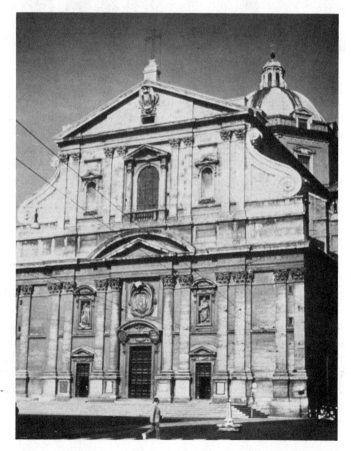

Fig. 3.36. Giacomo della Porta. Il Gesu. Exterior. 1568–84.

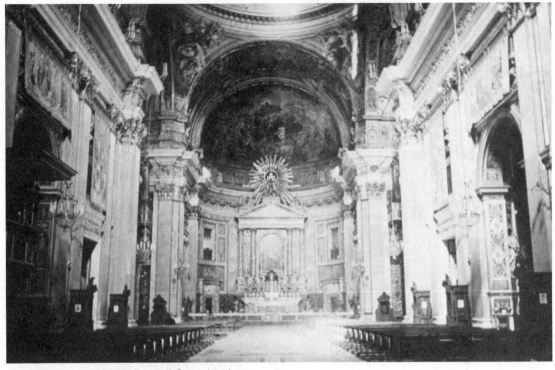

Fig. 3.37. Giacomo della Porta. Il Gesu. Interior.

icacy of rococo in the works of Balthasar Neuman (Figs. 3.38 and 3.39). One certain summation of baroque style and its absolutist, imperial reflections is the Versailles Palace (Figs. 3.40 and 3.41), of King Louis XIV of France. In a very real sense the expanding nature of the baroque universe carried into the thousands of acres which surround the Palace and which, in their intricately related designs, comprise a monumental and complex architectural extravaganza. The palace itself becomes the central jewel in this elaborate, but nonetheless precise, setting. It would be somewhat repetitious to develop an elaborate analysis of either the exterior or interior of the palace. However, the properties of opulence, ornamentation, subordination of detail to the whole, highlight, shadow, and emotion are all implicit; all are baroque in the same sense noted in the other arts and also present in the immediately preceding examples.

The Restoration of the monarchy under Charles II brought the baroque influence of the court of Louis XIV to England. Over a period of fifty years London witnessed numerous significant building projects directed by her most notable architect, Christopher Wren. Two of them, St. Paul's Cathedral and Hampton Court, illustrate the intricate but restrained complexity of English baroque style. The impact of Wren's genius, obvious in his designs, is attested to in an inscription in the crypt beneath St. Paul's: "Beneath is laid the builder of this church and city, Christopher Wren, who lived not for himself but for the good of the state." That statement gives us an important insight into nationalistic tendencies that were particularly prevalent in Protestant countries.

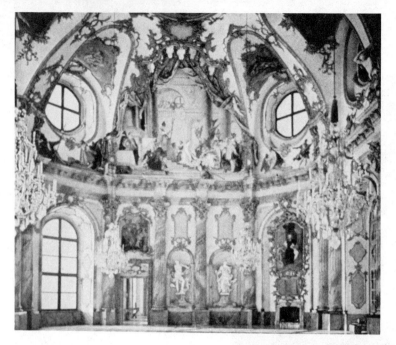

Fig. 3.38. Balthasar Neumann. The Kaiseraal. 1719–44. Episcopal Palace, Wurzburg.

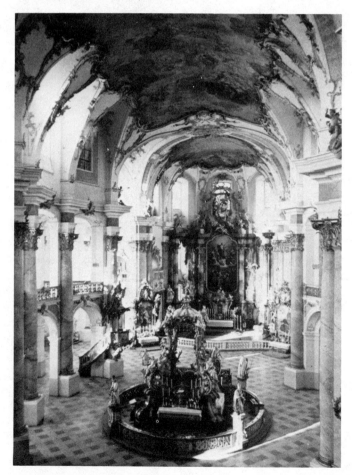

Fig. 3.39. Balthasar Neumann. Vierzehnheiligen. 1743–72.

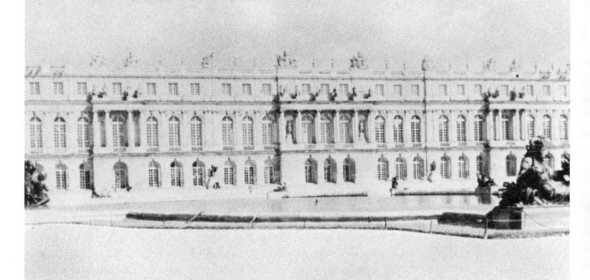

Fig. 3.40. Louis Le Vau and Jules Hardouin-Mansart. Palace of Versailles. 1669–85. France.

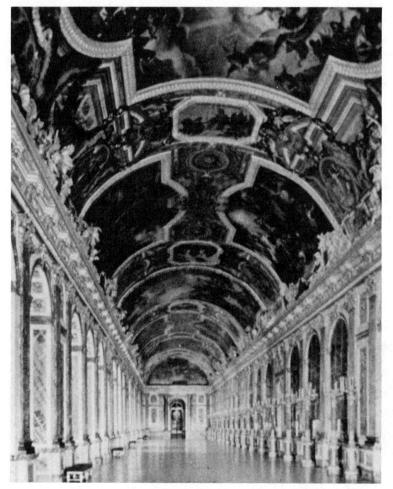

Fig. 3.41. Jules Hardouin-Mansart and Charles Le Brun. Palace of Versailles. Hall of Mirrors. 1680.

The influence of Renaissance geometric design and Greek and Roman detail mark St. Paul's Cathedral (Fig. 3.42). The central area under the expansive dome is surrounded by auxiliary spaces. Wren's plan takes the shape of a Greek rather than a Latin cross, which helps to unify the design under the dome. The shorter arms and body of the Greek cross also eliminated the long nave of churches built on the plan of a Latin cross and had the practical effect of bringing worshippers closer to the altar and pulpit area. That concept is significant in Protestant worship, which places great emphasis on the sermon. Subtle elegance in the exterior façade keeps ornate detail in balance, without overstatement or clutter. Yet, at the same time, the awesomeness of the dome and the overall scale of the building is an overpowering emotional experience. The dome rises 275 feet above the ground and in

Fig. 3.42. Christopher Wren. St. Paul's Cathedral. 1675–1710. London.

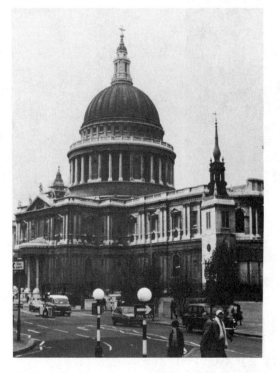

Renaissance fashion hides its structural components within a double sheaf of brick and timber coated with lead. On the top of the dome, to satisfy the clergy's call for a spire to dominate the city's skyline, rises a 90-foot lantern tower. The entire composition is a complex interaction of forces and details in which one part flows smoothly into another, losing itself in the overwhelming expression of the fully unified, total design.

On a smaller scale, but equally English baroque in expression, is Wren's garden façade for Hampton Court Palace (Fig. 3.43), commissioned in the reign of William and Mary in 1689. With careful perception we can see how the seemingly straightforward overall design of this façade is a sophisticated and complex interrelationship of merging patterns and details. For example, in the center of the building are four attached columns surrounding three windows. The middle window forms the exact center of the design, with mirror-image repetition on each side. Now note that above the main windows is a series of relief sculptures, pediments (triangular casings), and circular windows. Now, return to the main row of windows at the left border of the photo and count toward the center. The outer wing contains three windows; then seven windows; then the central three; then seven; and finally the three of the unseen outer wing. Wren has established a pattern of three in the outer wing, repeated it at the center, and then repeated it within each of the seven-window groups to create three additional patterns of three! How is it possible to create three patterns of three with only seven windows? First, locate the center window of the seven. It has a pediment and a relief sculpture above it. On each side of this window are three windows (a total of six) without pediments. So, we have *two* groupings of three windows each. Above each of the outside four windows is a circular window. The window on each side of the center window does not have

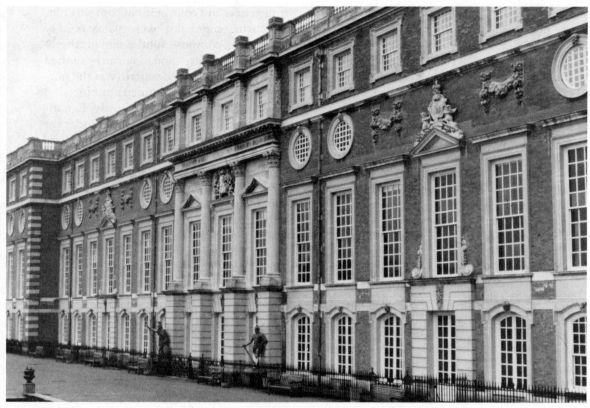

Fig. 3.43. Christopher Wren. Hampton Court Palace. Garden Façade. 1689. England.

a circular window above it. Rather, it has a relief sculpture, the presence of which joins these two windows with the center window to create a third grouping of three. Line, repetition, and balance in this façade form a marvelous perceptual exercise and experience.[7]

Summary

Broadly and flexibly applied, the term "Renaissance" can encompass several hundred years and diverse activities and styles, including a major style called baroque. In the

[7]Dennis J. Sporre, *Perceiving the Arts* (Englewood Cliffs, N.J.: Prentice–Hall, Inc., 1981), p. 189.

Renaissance a new way of viewing the world emerged which brought humankind out of the Middle Ages and toward an industrialized, modern world. The Renaissance had a quickened pulse and a tumult of innovations and discoveries in technology, science, politics, and economics as well as the arts. To the Renaissance scholar the world had emerged "Out of the sick Gothic night . . . to the glorious touch of the sun."

Probably the most significant movement of the Renaissance was Humanism. The medieval view of life as a "vale of tears" was changed by the humanists to a view of humankind as men and women very much a part of the scheme of *this* world. Fully consistent with Christian principles, Humanism saw humankind as characterized by goodness

and perfectability. Also typical of the Renaissance was an interest in antiquity focused with a force previously unknown. Renaissance men and women found a kindred spirit in the Greeks and Romans, who also were interested in things of this world. A rising middle class, capitalism, discovery both technological and geographic, and a search for proof rather than faith or philosophy were all witnessed. An important advance amid all of this was the invention of the printing press in 1445, making possible the spread of humanistic writings and Greek and Roman literature throughout Europe.

Many of the circumstances and events of the Renaissance owed their shape also to the political environment of Europe's various regions. The Church had begun to lose its total authority over all social circumstances. The secular world began to drift toward national identities. The merging of classicism and humanism with Catholicism and inquiry proved a catalyst to the shattering occurrences of the Reformation, a political power struggle as well as a theological schism.

The early Renaissance was a potpourri of thoughts and events that had different artistic consequences in different locations. Study of the Periclean Greeks yielded an idealized conception of humanity that could, for example, be reflected in painting and sculpture. Studies of classical art and philosophy led to new conceptions of "beauty" and a penchant for measuring and codifying, which spawned rules of proportion and balance. However, emphasis was on the individual and on individual achievement.

In the early fifteenth century Flanders contributed a pictorial revolution to painting. Partially through techniques made possible by a technological advance, the invention of oil paints, Flemish painters, such as van Eyck and van der Weyden, achieved pictorial reality, rational perspective, and a new sense of completeness and continuity in composition. Line, form, and color were painstakingly controlled to compose subtle, varied, three-dimensional, clear, and logically unified statements. Especially dramatic was the portrayal of individualized human emotion.

Undoubtedly the heart of early Renaissance painting was Florence, Italy, under the patronage of the Medici family. Two general trends of Florentine painting developed. One, illustrated by Sandro Botticelli and others, was a lyrical and decorative trend, more or less a continuation of medieval tendencies. Symbolism, emotion, limited three-dimensionality, and anatomical simplicity prevailed. The second trend was much more clearly "Renaissance." Including the works of Masaccio, this tendency was toward monumentality, concern for deep space and plasticity, and the scientific mechanization of single and multiple vanishing point perspective. Parts were subordinated to the whole and figures were warm, human, strong, and anatomically detailed.

Early in the sixteenth century papal authority re-emerged, and artists were called to Rome. The next twenty-five years in Italy produced a style called High Renaissance, which comprised the titans of Western art: Leonardo Da Vinci and Michelangelo Buonarroti. High Renaissance painting sought a universal ideal achieved through impressive art. Figures became types again, godlike human beings in the Greek classic tradition. High Renaissance painting comprised a carefully controlled, human-centered attitude with carefully controlled composition based almost exclusively on geometric devices. Leonardo's *sfumato,* Michelangelo's neoplatonism, and Raphael's rendering of flesh exemplified the style.

Early Renaissance sculpture also centered in Florence, where sculptors attained the skills to create images of high verisimilitude.

Unlike the Greeks, the early Renaissance sculptor found his ideal in Man as he is, the glorious individual. The nude reappeared for the first time since ancient times, and Ghiberti and Donatello illustrate the era's concern for rich detail and humanity. Sculpture also shared the High Renaissance, but High Renaissance sculpture *was* Michelangelo, who expressed his viewpoint in a quality called "terrabilità," a supreme confidence that allows a man to accept no other authority but his own genius. In Michelangelo's sculptures, pent-up energy remained contained, with the body the earthly prison of the soul. Yet Michelangelo also could exhibit simplicity and emotion as well as energy, capturing these qualities within contrasting forces of line, form, and texture.

In music Flanders, again, contributed significantly to the early Renaissance. Widely educated Flemish composers, such as Dufay and des Prez, composed Masses and motets. Flemish composers gave greater independence to the lower voices; the bass part became independent. All parts were separated, kept consistent, measured rhythm, and came together only at cadences—a true four-part harmony. Secular influences and patronage became stronger; the printing press made music more easily transmitted. In true humanistic spirit the prestige of the composer became paramount. Focus lay on making a work a unified whole. So more concern was given to the relationship of music and text; clarity of communication became the purpose for music. Harmonic progression to natural cadence was universal. The mid-fifteenth century also witnessed the development of *lieder* in Germany, and European music, aided by an "English countenance," was "joyous and bright" with "marvelous pleasantness."

In the years corresponding to the Renaissance and High Renaissance in the visual arts, theatre maintained the characteristics it had developed in the Middle Ages. New secular forms, however, were emerging in the *sottie* and the French farce. Italy saw, in the late fifteenth century, a re-emergence of the individual playwright and the revival of themes characterizing the humanistic and classical impetus of the period. However, the real "renaissance" in the theatre had to wait until the middle of the sixteenth century.

The foundations of theatre dance emerged from the same northern Italian courts that supported Renaissance painting and sculpture. The classical orientation of the Italian Renaissance was largely responsible for the primarily visual and geometric characteristics of dance, that is ballet, as we know it. Dance witnessed an increasing concern for rules and conventionalized vocabulary. Courtly surroundings added refinement and restraint, and the dancing master became a motivating force in coordinating and designing elegant movements. Dance description and theory emerged in the writings of Guglielmo Ebreo of Pesaro. In the fifteenth century, dance, in which grace, beauty, pattern, and form were predominant, left the floor of the courtly ballroom and moved to a stage to be watched by most and participated in by only a few.

Architecture of the early Renaissance centered itself also in Florence and exhibited three significant departures from the medieval. First was its concern with replication of classical models along very mechanical lines. Second was the application of decorative detail to the façade of the building. Third was a radical departure from outward expression of structure. In the Renaissance, supporting elements were hidden from view so that external appearance need not be sacrificed to structural concerns. As the fifteenth century progressed into the sixteenth, architecture witnessed a balancing of Christian and classical ideas and moved away from insistence and emphasis on

decorative surface detail to a greater concern for space and volume. Papal patronage in Rome changed the tone of architecture to a more formal, monumental, and serious style.

The Reformation's effects helped keep the Western world in a profound turmoil for the last three-quarters of the sixteenth century. This was further heightened by the revelations of scientific discovery, which, especially regarding Copernicus's theory of a heliocentric universe, altered the comfortable human-centered universe of the early Renaissance. Exploration confirmed a global world, and political turmoil and warfare had special impact when the Spanish invaded Rome in 1527, abruptly ending the visual arts style known as High Renaissance.

To counteract the Reformation, the Roman Catholic Church instituted its Counter-Reformation, significant in which was the use of art to attract worshippers to the Church. That decision helped to create an impetus for a new, emotional art called baroque that gave the seventeenth and early eighteenth centuries a quality unknown before or since. Reinforcing the impetus was absolutism, that is, the absolute monarch, and none exemplified that spirit better than France's Louis XIV, whose court and its splendors amplified Roman Catholic infusion of artistic development and heightened further the character of the artistic age.

The turmoil of the last three-quarters of the sixteenth century sought a reflection and an outlet in painting. The most significant of the trends in that period was mannerism, which was typified by anticlassical emotionalism and abandonment of classical balance and form juxtaposed against cold formality and geometry. Among those usually associated with mannerism, Bronzino and El Greco were illustrative.

With the stability of the seventeenth century came an age of intellectual, spiritual, and physical action, wealth and strong personal emotion. These characteristics were reflected in a new style called baroque, which in painting centered on systematized and rational composition in which opulent ornamentation was unified through variation on a single theme. Deep emotion, color, grandeur, dramatic use of light and shade, and sophisticated organization were pre-eminent. To symbolize an expansive universe composition became open, allowing the eye to leave the frame to a wider world outside the canvas. Humankind as a subject could be central or peripheral. The works of Peter Paul Rubens and Rembrandt van Rijn exemplified this style.

Mannerism in painting found a cousin in sculpture in twisting, elongated forms, affectation of pose, and nervous energy. However, the late sixteenth century in sculpture was a period of little output. Such was not the case regarding the baroque. Production was prolific. Form and space were charged with energy, which carried beyond the limits of actual physical confines. Feeling was the focus, and Giovanni Lorenzo Bernini was the master.

In the courtly life of the sixteenth century dancing was widespread, and much instrumental music was composed with the dance in mind. Consistent rhythmical patterns, contrasts, theme and variation, and improvisation were important characteristics. Secular music was bawdy and irreverent. The Reformation brought many changes to church music including the chorale, Lutheran hymns, and many polyphonic choral settings. The Catholic Counter-Reformation turned to Giovanni Palestrina who returned what was believed to be overly complex, polyphonic texture to more simplified constructions.

Reflective of its era's systematic rationalism, baroque music stressed harmonic progression around tonal centers. Action, ten-

sion, and strong contrasts in the works of J. S. Bach, Handel, Vivaldi, and others were the musical equivalents of the same characteristics in visual art. However, the new spirit of the age found reflection in a new art form, opera, which spread throughout Europe from its cradle in Italy. Cantata and oratorio also developed; concertos, fugues, and sonatas gained focus. Technical achievements produced equal temperament and full perfection of the violin. The baroque era in music, from approximately 1600 to 1750, was a magnificent one, which for all intents and purposes began our contemporary musical age.

By the late sixteenth century theatre had caught the Renaissance spirit, revealed in different ways throughout Europe. In Italy emphasis was visual with a new form of proscenium theatre and painted scenery emerging. Italy also witnessed the *commedia dell'arte* with its improvisation, stock characters, mime and pantomime, and widely travelled troupes. In England a national spirit and conventionalized physical theatre placed emphasis on plays of great literary merit in the works of William Shakespeare and others. The baroque equivalent in English theatre developed in the court masques of the aristocracy and in the theatre of the Restoration period after 1660. Spain, at the same time, showed a remarkable Renaissance theatre very similar to that of the Shakespearean. Playwrights, such as Lope de Vega, produced a Golden Age.

Neoclassicism comprised French theatrical output during the late sixteenth to early eighteenth centuries. Hampered by academic "rules," neoclassic tragedy, although pursued by such playwrights as Racine and Corneille, could not match the comedy of Molière. Superimposed on some French neoclassicism were baroque scenic conventions fostered by Louis XIV and imported from Italy.

Courtly dancing became more and more professional in the late sixteenth century. Formal ballet came of age as an art form in France under the aegis of Catherine de Medici, great-granddaughter of Lorenzo the Magnificent. Court spectaculars became balletic art in the *Ballets Comique* of Balthazar de Beaujoyeulx, who described ballet as "a geometric combination of several persons dancing together." By the late seventeenth century much of baroque art, including the dance, had centralized in the court of Louis XIV of France, who himself was an avid dancer. Ballet style, however, seems to have been fairly simple, noble, and controlled. Gestures were harmonious and symmetrical. The theatrical trappings were elegant and opulent, and the overall appeal was to the emotions. Ballet became formally institutionalized when Louis XIV founded the Academie Royale de Danse in 1616; as a result rules were prescribed for positions and movements, and women took the stage as career professionals (ballerinas).

The late sixteenth century in architecture evidenced mannerist tendencies especially in France under Francis I. In the same period in Italy existed significant architecture by Andrea Palladio of a clearly different feeling, reflecting his clients' individualism and desire for worldly possessions. In the seventeenth century baroque style emphasized the same qualities of light and shade, action, intricacy, opulence, ornamentation, and emotion exhibited in the other visual and performing arts. There were many excellent baroque architects, and a significant diversity of approaches existed, from the more classically restrained works of England's Christopher Wren to the absolutist, imperial reflections of Louis XIV's Versaille Palace.

The very broad time span we just have examined highlights many of the problems inherent in a study of the history of the arts

when generalized labels and summary qualities are attempted. Wide diversities existed, and even such a seemingly clear style as the baroque had numerous variants and occupied a time frame into which nonbaroque qualities in some arts intruded. Nevertheless, we have seen the continuing interaction between intellect and emotion, between classicism and anticlassicism. The many complicated reflections which existed in the Renaissance and baroque years should indicate to us the varying degrees of "form" and "feeling" and that an emphasis on one need not mean, and usually does not mean, an absence of the other.

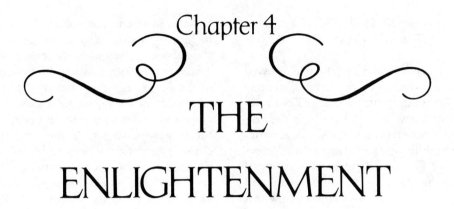

Chapter 4

THE

ENLIGHTENMENT

- Progress, Revolution, Aesthetics, and Nature
- The Arts of the Enlightenment

PROGRESS, REVOLUTION, AESTHETICS, AND NATURE

Contemporary Western society was brewed in a cauldron comprising the last half to three quarters of the eighteenth century. The ingredients of the brew grew in Europe in the preceding century; nevertheless, our social structures are so different from the world of James II or Louis XIV that we must stand in awe of the forces that coalesced so quickly and laid the cornerstones for the social milieu in which we live today.

The eighteenth century often has been called *The Age of Enlightenment,* but we already have witnessed too much shifting and sliding of styles, philosophies, and politics to take very seriously any arbitrary parameters, such as a century mark, regarding matters either of history or of art. In fact, we already have wandered freely in the early years of, and in some cases nearly half-way through, the eighteenth century without tripping over any natural barricades (Bach lived until 1750). Like all "centuries" the eighteenth century did encompass one hundred years, and it generally can be called an age of enlightenment. However, that enlightenment came as a natural continuation of seventeenth century events and philosophies, which, like Gothic art or the "Renaissance," made differing inroads at differing times in different places.

Seventeenth- and eighteenth-century thought held essentially that humankind consisted of rational beings in a universe governed by natural law. Some believed that law to be an extension of the law of God, and others, more secular in spirit, held that natural law stood by itself. Natural law extended to include international law. International accords were formulated in which sovereign nations, bound by no higher authority, could work together for a common good.

Faith in science, in natural human rights, in human reason, and in progress, formed touchstones for eighteenth-century thought. The idea of progress rode the undercurrents of the age, suggesting that conditions of life get better as time progresses and that each generation contributes to an even better life for those following. Some scholars ("ancients") held that works of the Greeks and Romans had never been surpassed, while others ("moderns") held that science, art, literature, and inventions of their own age were better since they built upon the achievements of their predecessors. Most people of the eighteenth century probably were moderns, assuming that progress would never cease and that the natural faculties of the human mind could overcome skepticism and superstition.

Enlightenment, reason, and progress made the age one of secularism. Intellectual, social, and economic conditions combined to place politics and business outside religion and to wrestle leadership and prestige away from the church—of whatever denomination. Toleration of differences spread; persecution and imposition of inhumane corporal punishment for religious, political, and/or criminal offenses became less common as the era progressed—especially in Germany and Austria.

The rapid increase in scientific interest and discovery that followed Newton gave birth to numerous specialties. Physics, astronomy, and mathematics continued primary, but frenetic activity was replaced by quiet categorizing. The vast body of information surging from the late Renaissance needed codifying. As a result, new disciplines of mineralogy, botany, and zoology developed. First came classification of fossils; then came classification of rocks, minerals, and plants. Linnaeus, the botanist, and Buffon, the zoologist, gave

brilliant illumination to their fields, laying foundations unsurpassed for generations. Chemistry struggled amid mistaken theories of combustion, but with the isolation of hydrogen and oxygen, the Frenchman Lavoisier propelled chemistry into its place as a science, first by correctly explaining the process of combustion and then by separating water into its two component elements. Finally, he postulated that although matter may alter its state, its mass always remains the same.

Science went hand in hand with technology. Telescopes and microscopes were improved; barometers and thermometers were invented, as were the air pump and the steam engine. By 1769 James Watt had patented a steam engine so reliable that it could drive a machine. Perhaps more than any other catalyst in our history, the steam engine caused an acceleration in invention of machines, which brought the Industrial Revolution to fruition at the end of the century.

To understand the philosophy of the eighteenth century in a bit more detail than was indicated in the opening paragraph of this chapter, we must retrace our steps to the Middle Ages. Then, philosophy was closely connected to theology. In the seventeenth century Descartes broke philosophy away from theology and allied it with the natural sciences and mathematics. Reason was supreme, and Descartes called for rejection of everything that could not be proved. Descartes' philosophy is called Cartesianism, and it leans fully on the contention that human reason can solve every problem facing humankind.

Such rational philosophy was championed by Spinoza and Leibnitz, but late in the seventeenth century John Locke argued that knowledge derives first from the senses. Locke's challenge to Cartesianism redirected philosophic energies from the vast metaphysical systems of pure rationalism to a more practical, earthbound emphasis. Locke's philosophy was rationalistic; but because he stressed sensations and experience as the primary sources of knowledge, he is known as a sensualist or empiricist.

Empiricism became the predominant philosophy of the late eighteenth century, although it was not without its critics. Locke's approach formed the primary basis for the later philosophic thought of Hume and Kant. David Hume (1711–76), a Scotsman, differed from Locke by asserting that the mind is incapable of building up from sensations. Rather, he held that we live in a world of mere probabilities. Hume's philosophy was skeptical for the most part and maintained that not only philosophy, but also natural science, existed in a cloud of doubt; only mathematics was a true and valid science.

Although Hume was not the only skeptic of the age (we shortly shall examine Rousseau and Voltaire), his philosophy might have ended in futility were it not for the German philosopher Immanuel Kant (1724–1804). Kant's major contribution to late eighteenth-century thought was the separation of science from philosophy and the ascribing of separate functions and techniques to each. For Kant, science was concerned with the phenomenal world, the world of appearances, which it describes by general propositions and laws. Science must not go beyond the world of appearances to concern itself with the reality beyond appearances; that reality, the nominal world, was the realm of philosophy. Kant's division of science and philosophy succeeded in giving a much-needed justification and assurance to both philosophy and science and allowed them to move forward in their missions.

Had the "Enlightenment" comprised nothing but philosophy and invention, we undoubtedly would live in a vastly different world today. But enlightened thought led to active desire, called humanitarianism, to raise humankind from the low social circumstances into which superstition and tyranny had cast it. Men and women had a right, as

rational creatures, to dignity and happiness. Such a desire to elevate humankind's social circumstances led to significant examination and questioning of political, judicial, economic, and ecclesiastical institutions.

The ideas of the Enlightenment spread largely through the efforts of the *philosophes.* Although the word appears to relate to philosophy, the *philosophes* were not philosophers in the usual sense of the word. Rather, they were popularizers or publicists. "Men of Letters," they read the great books, which most individuals did not read and put the essences of these thoughts into terms the average individual in a greatly expanded, literate public, could understand. The most serious of all *philosophe* enterprises was the *Encyclopedia,* edited by Denis Diderot. The *Encyclopedia,* incorporating seventeen volumes of a compendium of scientific, technical, and historical knowledge, including a good deal of social criticism, numbered Voltaire, Montesquieu, Rousseau, and others among its contributors and took twenty-one years (1751–72) to complete.

No *philosophe* undertook so vocal or so universal an attack on contemporary institutions as did Voltaire. However, before we discuss Voltaire, we must return briefly to John Locke and the seventeenth century. In 1649 Charles I was deposed and beheaded by Cromwell's Commonwealth, and in 1660 Charles II was returned to England to re-establish the monarchy. Both Charles II and his successor, James II, attempted to rule in the absolutist manner of Louis XIV. However, the British Parliament intervened and in the "Glorious Revolution" of 1688 removed James II and invited William of Orange and his wife, Mary, to assume the throne as joint monarchs. However, the monarchs were forced as a condition of rule to accept a Bill of Rights, which later served as a basis for the United States Constitution. Immediately following the Glorious Revolution Locke wrote several treatises on government, asserting that the power of a nation came from its people as a whole; in that social contract, the people had the right to withdraw their support from the government whenever government used its power against the general will.

Voltaire (1697–1778) took Locke's ideas to France, and extolled them amidst his aggressive and vociferous skepticism. It is easy to cast Voltaire in the role of curmudgeonly negativist who had nothing positive to offer as a substitute for the ills he found in everything. However, his championship of deism did much to bring about religious toleration. His stinging wit broadened awareness of and reaction to witch-burnings, torture, and similar abuses. Without question his popularizing of knowledge and broad program of social reform helped to bring about the French Revolution, which cast out the old order of absolutism once and for all.

Another figure of significant influence in the mid-eighteenth century was Jean Jacques Rousseau (1712–78), who largely superseded Locke by propounding a theory of government so purely rationalistic that it had no connection whatever with the experience of history. To Rousseau, humans essentially were unhappy, feeble, frustrated, and trapped in a social environment of their own making. He believed humankind could be happy and free only in a community small and simple enough to be within their grasp. Such a philosophy stands completely in contrast to another important eighteenth-century thinker, Diderot, who held that only accumulated knowledge would liberate mankind. Indeed, it was an age of contrasts. Rousseau was an anarchist, disbelieving in government of any kind. He wrote on politics, therefore, not because he believed in government, but because he lived in an age of political speculation and believed he had the power to deal with every

problem. His *Social Contract* (1762) was fully rationalistic and reasserted Locke's propositions of contract, people's sovereignty, and the right of revolution. More importantly, however, he took Locke's concept of primitive man and converted him into a *Noble Savage* who had been subjected to progressive degradation by an advancing civilization. So, amidst an age turning to rational, intellectual classicism, Rousseau sowed the seeds of romanticism, which were to flower in the next century. In addition, he sounded the call for revolution. The opening sentence of the *Social Contract* reads, "Man is born free and everywhere he is in chains."

In previous chapters we traced the development of trade and capitalism (often called mercantilism in those eras). The spirit of challenge and questioning adhering to other aspects of society also applied to economics. Critics of mercantilistic government regulation and control were called *physiocrats* (from the Greek *physis,* meaning nature), since their philosophy held that the single source of all wealth was nature. That being the case, the physiocrats emphasized agriculture, forestry, and mining. Manufacturing occupied a secondary status. In addition physiocratic theory maintained that production and distribution were best handled without government interference (*laissez-faire:* hands off!). Government supervision should be abandoned so that nature and enterprising individuals could cooperate to produce the greatest wealth possible. General physiocratic ideas were systematized and altered in Adam Smith's *Wealth of Nations* (1776). Smith, a Scotsman, argued that the basic factor in production was not nature, but human labor. He believed that enlightened self-interest without government intervention would be sufficient to allow individuals to produce wealth on an unheard of scale.

On the political scene, the German states (as seemed always to be the case) were in turmoil and flux in the eighteenth century. In 1701 Frederick I became King *in* Prussia (the word *in* rather than *of* was used to avoid criticism from Poland, which occupied West Prussia). Actually Frederick's major political stronghold was the small area called Brandenburg. However, Frederick's House of Hohenzollern soon dominated the entirety of Prussia. Frederick's son, King Frederick William I (r. 1713–40) perfected the army and the German civil service, and went on, following Russia's defeat of Sweden in 1709, to occupy Swedish Pomerania, thus further expanding Prussian dominance. Frederick William had some strange eccentricities, one of which compelled any man the king suspected of being wealthy to build a fine residence to improve the appearance of the city. He also had a craze for tall soldiers whom he recruited from all over Europe, thereby making his palace guard a cadre of coddled giants. His severe conflicts with his son resulted in an uneasy truce calling for his son's rigorous training in the army and civil service.

So when Frederick II (the Great) assumed the throne on his father's death in 1740, he brought to it a thorough knowledge of every detail of the Prussian service and an intense love of arts and literature. He also brought to the throne an intense ambition, which very quickly turned toward neighboring Austria. Austria's house of Hapsburg was ruled by Charles VI, who also died in 1740. His daughter, the Archduchess Maria Theresa, thereby assumed the rule of all Hapsburg territories, many of which carried disputed claims of possession. Smelling opportunity and a supposedly weak, feminine foe, Frederick II of Prussia promptly marched into the Austrian territory of Silesia. What followed was a tug of war and peace between Austria and Prussia (and also between Austria and France, Saxony, and Bavaria over Bohemia).

Lest the incessant warfare of the German states take undue space, we need to leave this tack in order to note what is important to our overview: Austria and Prussia emerged strong and socially stable; both countries became centers of artistic, literary, and intellectual activity in the second half of the eighteenth century.

Frederick the Great was an "enlightened" and humanitarian ruler (a benevolent despot); he championed thinkers throughout Europe and reformed German institutions so they were better able to render service to all classes of society, especially the poor and oppressed (in strong contrast to Louis' XV and XVI of France). When he died in 1786 he left behind a strong and famous Prussia.

Austria and the Hapsburgs, likewise, emerged strong and stable; constant warfare did not interfere with internal order and enlightened reform. Maria Theresa's husband became Emperor Francis I in 1745, followed in 1765 by his son, Joseph II. Ruling jointly with his mother from 1765 to 1780 and alone until his death in 1790, Joseph II was a typical enlightened monarch; through reform he unified and centralized the Hapsburg dominions and brought them into harmony with the economic and intellectual conditions of the day.

Meanwhile, George III, King of England (1760–1820), and Louis XV (1715–74) and his grandson, Louis XVI (along with Marie Antoinette), 1774–89, led England and France into revolution. We should already be familiar with the events and ramifications of the American Revolution; the complexities of the French Revolution (1789), which must remain outside the scope of our examination, led to wars throughout Europe, to a Second Revolution (1792), an "Emergency Republic," the "Terror," the Directorate, to Napoleon's *coup d'etat* in 1799, and a new and explosive century for Europe.

However, in order to set the stage for our discussion of the arts, we need to turn back a bit for some additional information. The death of Louis XIV in 1715 brought to a close a magnificent French courtly tradition that had come to signify academic baroque art (German baroque continued well into the eighteenth century). The French court and aristocracy moved to more modest surroundings, such as intimate, elegant townhouses and salons, which reflected an entirely different milieu from the vastness and opulence of the Palace of Versailles. Charm, manners, and finesse replaced previous standards for social behavior. If the Enlightenment sought refinement of humankind, its society sought refinement of detail and decor, and delicacy in everything. "Sociability" became the credo of early eighteenth-century France and elsewhere.

Classical influences dating from the Renaissance continued strong, principally because a "classical education" was considered essential for all members of the upper classes. So when the ruins of the Roman city of Pompeii were excavated, virtually intact, in 1748, a new excitement about antiquity burst forth. Partial excavation of the ancient city of Herculaneum had occurred in 1738. "Back to antiquity" was the watchword. Amid this excitement came Gottlieb Baumgarten's significant book, *Aesthetica* (1750–58). Here for the very first time occurred the word *aesthetics:* the study of beauty and theory of art. Then, in 1764 came Johann Winklemann's *History of Ancient Art,* in which the author described the essential qualities of Greek art as "a noble simplicity and tranquil loftiness . . . a beautiful proportion, order, and harmony."

Refinement, grace, and delicacy brought the eighteenth century and its arts out of the baroque era; Pompeii, Herculaneum, aesthetic theory, and a return to antiquity, that is, "noble simplicity" (which was uniformly in-

terpreted to mean nature) closed a century marked by war and revolution, rationalism, and skepticism.

THE ARTS
OF THE ENLIGHTENMENT

Two-Dimensional Art

The change from grand baroque courtly life to that of the small salon and intimate townhouse was reflected in a new style in painting called rococo. Often rococo is described as a "small, inconsequential version of baroque." Certainly there is some basis for such a relatively derogatory description when we examine paintings of this style and find fussy detail, complex composition, and a certain superficiality. However, to dismiss early eighteenth century works with nothing more than that is a serious error. Rococo probably is a mirror of its time, most notably the declining importance of the aristocracy. Rococo art is, essentially, decorous and nonfunctional like the nobility it represented. Its intimate grace, charm, and delicate superficiality reflect the social ideals and manners of the age.

Informality replaced formality in life and in painting. The logic and academic character of the baroque of Louis XIV was found lacking in feeling and sensitivity. Its overwhelming scale and grandeur were *too* ponderous. So deeply dramatic action faded, mostly, into lively effervescence and melodrama. Love, sentiment, pleasure, and sincerity became predominant themes. None of these characteristics conflict significantly with the general qualities and thrusts of the Enlightenment, whose major goal was the refinement of man. The arts of the period dignified the human spirit through social consciousness and bourgeois social morality, as well as through graceful gamesmanship of love. Delicacy, informality, lack of grandeur, and lack of action did not always imply superficiality or limp sentimentality.

The transitional quandry of the aristocracy can be seen in the rococo paintings of Antoine Watteau (1683–1721). Although largely sentimental, much of Watteau's work refrains from gaiety or frivolousness. "Embarkation for Cythera" (Fig. 4.1) illustrates idealized concepts of aristocratic social graces. Cythera

Fig. 4.1. Antoine Watteau. "Embarkation for Cythera." The Louvre, Paris.

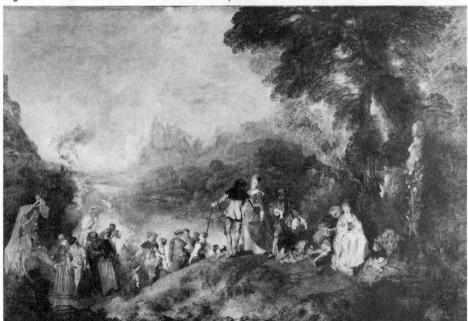

is a mythological land of enchantment, the island of Venus, and Watteau portrays aristocrats as they await departure for that faraway place idling away their time in amorous pursuits. Fantasy qualities in the landscape emerge through fuzzy color areas and hazy atmosphere. A soft, undulating line underscores the human figures, all posed in slightly affected attitudes. Watteau's fussy details and decorative treatment of clothing stand in contrast to the diffused quality of the background. Each grouping of couples engages in graceful conversation and love games typical of the age. Delicacy pervades the scene, over which an armless bust of Venus presides. Underlying this dreamlike fantasy lies a deep, poetic melancholy. These doll-like figurines,

which are only symbols, engage in sophisticated and elegant pleasure, but the work's softness and affectation counterbalances gaiety with languid sorrow.

The slightly later work of François Boucher (1703–70) continues the rococo tradition and gives us a taste of the decorative, mundane, and slightly erotic painting popular in the early and mid-eighteenth century. As a protégé of Madame Pompadour, mistress of King Louis XV, Boucher enjoyed great popularity. His work has a highly decorous surface detail and portrays pastoral and mythological settings such as "The Toilet of Venus" (Fig. 4.2). The consistency of Boucher's style easily can be seen by comparing "Toilet of Venus" with "Venus Consol-

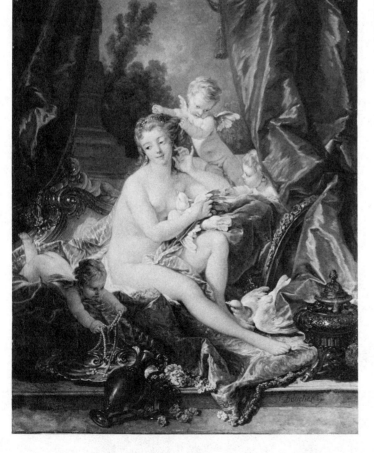

Fig. 4.2. François Boucher. "The Toilet of Venus." The Metropolitan Museum of Art. Bequest of William K. Vanderbilt, 1920.

ing Love" (Fig. 4.3 color). Boucher's figures almost always appear amidst exquisitely detailed drapery. His rendering technique is nearly flawless, and his displays of painterly virtuosity provide fussily pretty works whose main subjects compete with their decorous backgrounds for our attention. In comparison with the power and sweep of the baroque, Boucher emerges gentle and shallow. The intricate formal design of the baroque, in which sophisticated ornateness created smooth articulation of parts is lost here in intricate and delicate details each of which takes on a separate focus of its own and leads the eye first in one direction, and then in an opposite, nearly without control.

In strong contrast to the aristocratic frivolity of rococo style was the biting satire and social comment of enlightened humanitarians such as William Hogarth in England in the 1730's. Hogarth portrayed dramatic scenes on moral subjects, and his "Rake's Progress" and "Harlot's Progress" series attempt to teach solid middle-class values. He attacked the foppery of the aristocracy, drunkenness, and social cruelty. In the "Harlot's Progress" series (Fig. 4.4) the harlot is a victim of circumstances. She arrives in London, is seduced by her employer, and ends up in Bridewell Prison. However, Hogarth portrays her final fate less as a punishment for her sins than as a comment on humankind's general cruel-

Fig. 4.4. William Hogarth. "The Harlot's Progress: Arrival in London." The Metropolitan Museum of Art, Harris Brisbane Dick Fund, 1932. All rights reserved. The Metropolitan Museum of Art.

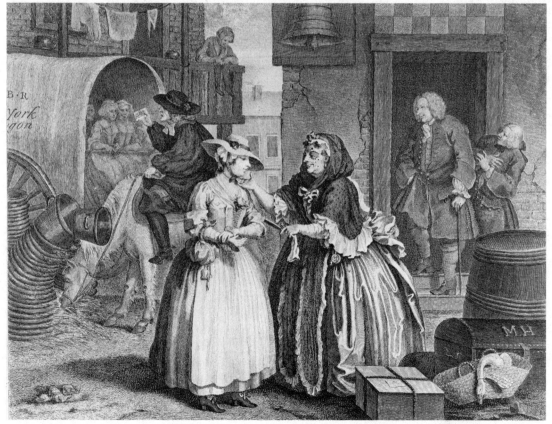

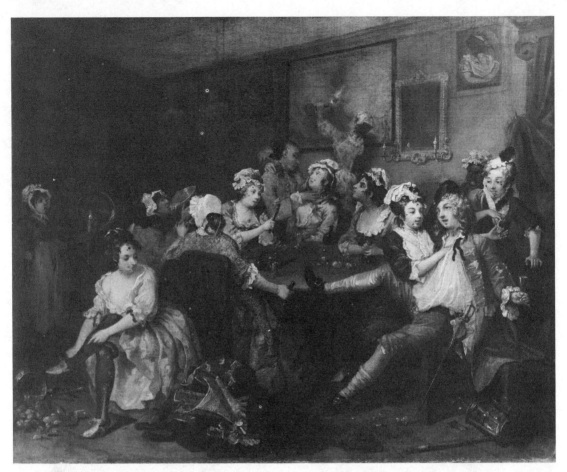

Fig. 4.5. William Hogarth. "The Rake's Progress: The Orgy." The Trustees of Sir John Soane's Museum.

ty. The same may be said for the "Rake's Progress" series, which portrays the unfortunate downfall of a foolish young man from comfortable circumstances. This series moves through several unusual and exciting incidents (Fig. 4.5) to a final fate in Bedlam insane asylum. Hogarth's concern for and criticism of social conditions are voiced in his paintings and represent incitement to action characteristic of eighteenth-century humanitarianism. The fact that his paintings were made into engravings and sold successfully as prints to the general populace illustrates the popularity of attacks on social institutions of the day.

The eighteenth century also witnessed an increase in portraiture, as exemplified by Sir Joshua Reynolds in England, John Copely and Gilbert Stuart in America, and Rigaud, Latour, and the rococo portraitist Nattier in France. The spirit of sentimentality could be found in the paintings of Fragonard and Greuze. Italy's Tiepolo furthered rococo through unique palettes of blues, pinks, and yellows, while Canaletto and Guardi painted scenes of spectacle and architecture. A new bourgeois flavor could be found in the mundane (genre) subjects of France's Jean-Baptiste Chardin (Figs. 4.6 color and 4.7) and Italy's Pietro Longhi. In a nearly separate category exist the works of Thomas Gainsborough of England (1727–88), whose land-

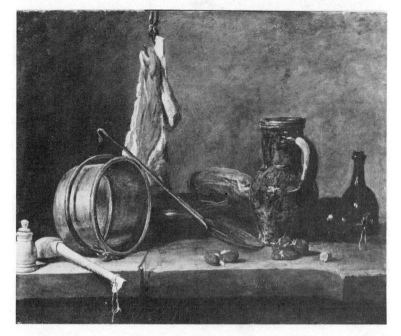

Fig. 4.7. Jean Chardin. "Still Life Menu de Gras." The Louvre, Paris.

scapes represent almost a direct bridge from baroque to romantic, and whose portraits range from rococo to sensitive elegance.

Discovery of the ruins of Pompeii, Winckelmann's interpretation of Greek classicism, Rousseau's Noble Savage, and Baumgarten's aesthetics sent the late eighteenth century whirling back to antiquity in general and to nature, in specific. A principal proponent of neoclassicism in painting was Jacques Louis David; his works illustrate the newly perceived grandeur of antiquity and its reflection in subject matter, composition, depiction, and historical accuracy. Although propagandistic in tone (he sought to inspire patriotism and democracy), his neoclassical works show a Roman two-dimensionality and a strong, simple compositional unity. Accurate historical detail and antiquarian subject matter complete the works. In both "The Oath of the Horatii" (Fig. 4.8) and "The Death of Socrates" (Fig. 4.9) David exploits his political ideas amidst Greek and Roman themes. In both cases he implies a devo-

tion to ideals so strong that one should be prepared to die in their defense. David's belief in a rational and ordered existence is reinforced by his sparse and classically simple composition. However, we must recognize that David's and others' neoclassicism is not confined to copying ancient works. Classical detail and principles are built upon by employing selectivity and adaptation. "The Oath of the Horatii," inspired by Corneille's play *Horace,* captures a directness and intensity of expression that would play an important role in romanticism. But the starkness of linear color edges, triangular arrangements parallel to the picture plane (like classical relief sculpture), strong, geometric composition (juxtaposing straight line in the men and curved line in the women), and smooth color areas and gradations hold it to the more formal, classical tradition. Curiously, David's work was admired and purchased by King Louis XVI, against whom David's revolutionary cries were directed and whom David, as a member of the French Revolutionary

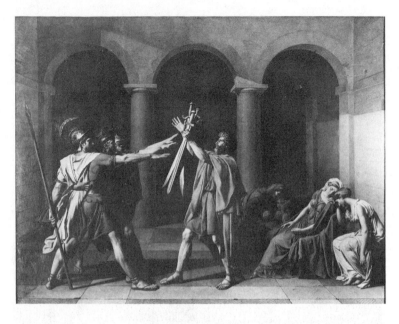

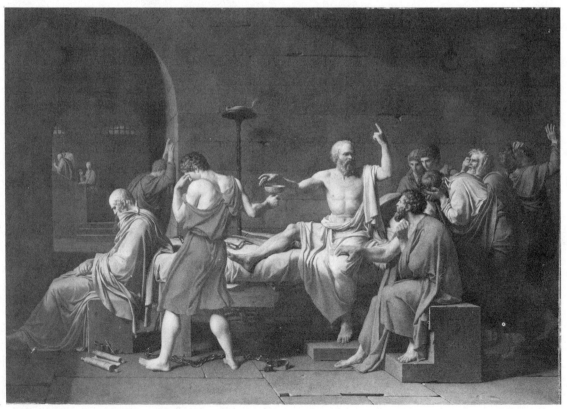

Convention, would sentence to death. David's career flourished; neoclassicism in painting increased in popularity and continued beyond the Revolution to the rise of Napoleon and into the nineteenth century.

Sculpture

Sculpture struggled in the eighteenth century. The Academy of Sculpture and the French Academy in Rome emphasized copying antique sculpture, and resisted changes reflective of the change in eras. Lack of originality and continuation of the baroque predominated. Rococo style did find expression in Falconet (1716–91), Pajou (1730–1809), and Clodion (1738–1814). In their works are the myriad of decorous cupids, nymphs, and so on, which occurred throughout painting in this style. Venus appears frequently, often depicted in the thinly disguised form of a prominent lady of the day. Madame de Pompadour, who epitomized love, charm, grace, and delicacy for the French, appears often as a subject in sculpture as well as in painting. Rococo sculpture was not of the monumental scale of its predecessors. Rather, in the spirit of decoration that marked the era, sculpture often took the form of delicate and graceful porcelain and metal figurines. Falconet's "Madame de Pompadour as the Venus of the Doves" (Fig. 4.10 color) fully captures the erotic sensuality, delicacy, lively intelligence, and charm of the rococo heritage. The unpretentious nudity found here indicates the complete comfort and naturalness the eighteenth century found in love and affairs of the flesh. Beyond reflections of the time, rococo sculpture exhibits masterful technique. Its surface textures, detail, and line all comprise superb delicacy and control of the medium. If this style and the "society" it exemplifies can be found wanting in its profundity, it must be admired for its technical achievement.

In a more serious vein than much of eighteenth-century sculpture is the work of Jean Antoine Houdon (1741–1828) from the years just prior to the revolution. His portrait busts, such as those of Alexandre and Louise Brongniard (Figs. 4.11 and 4.12), exhibit penetrating psychological analysis coupled with delicate and accurate technical execution. Houdon's works marvelously express the personality of his subjects, and his portraits of American Revolutionary figures such as Washington, Jefferson, John Paul Jones, and Benjamin Franklin are masterful projections of their characters. Probably (al-

Fig. 4.11. Jean Antoine Houdon. "Alexandre Brongniard." National Gallery of Art, Washington, Widener Collection, 1942.

Fig. 4.12. Jean Antoine Houton. "Louise Brongniard." National Gallery of Art, Washington, Widener Collection.

though transitions and exact delineations are difficult to ascribe) we should consider the work of Houdon as a part of the emerging eighteenth-century neoclassic style. The "realistic truth" Houdon expresses in individual character is much more akin to the ideals of neoclassicism than to those of the rococo. Sculpture, like society in the eighteenth century, was in transition. Academically rooted in the baroque, attempting to reflect the age of the rococo, and shadowing the aesthetic and antiquarian impetus of the last third of the century, sculpture slowly moved toward the nineteenth century and yet another stylistic shift.

Music

Rejection of French Court society and its baroque arts brought ornamentation, delicacy, prettiness, and pleasant artificiality to a rococo style in music as well as painting and sculpture. Musicians improvised "decorations" in their performances, and the practice was so common that many composers purposely left their melodic lines bare in order to allow performers the opportunity for playful improvisation. The purpose of music was to entertain and to charm.

François Couperin (1668–1733), more than any other composer, captured the musical spirit of his time, but he also managed to retain his baroque roots sufficiently to avoid excessive sentimentality or completely artificial decoration. Nevertheless, his works contain refinement suitable to the *salon* performance and avoid the emotional effects of his baroque predecessors. His compositions show a pleasant blending of logic and rationality with emotion and delicacy. He pursued allegory and mythological allusion in true rococo arts fashion.

Couperin was part of a uniquely French school of organ music from which came settings of popular airs and compositions similar to the overtures and recitatives of French opera. Many of Couperin's works were designed specifically to explore the tonal color possibilities of the organ, and his "Masses," which comprised verses and interludes to be played in the Mass, exhibit ornamentation that can be associated with both baroque and rococo. His *passacaglias* and *chaconnes* (for example, the *Passacaille ou Chaconne* from the *First Suite for Viols,* 1728) show the same indefinitely repeated four- or eight-measure harmonic pattern found in music of the seventeenth century. However, his trio sonatas mark the earliest development in France of this musical form, which was to assume such an important role in the Classical Period to follow.

A second style of music, paralleling

rococo, also acted as a transition between baroque and classic. This "expressive style" (more literally, "sensitive style"), or *Empfindsamer Stil,* came from Germany and permitted a freer expression of emotions than the baroque, largely by allowing a variety of moods to occur within a single movement. Polyphonic complexities were reduced, and different themes with harmonic and rhythmic changes were introduced. "Expressive style," therefore, was simple, and also highly original. Composers had the freedom to utilize new dynamic expressions, rhythmic contrasts, and original melodies. Yet the goal was a carefully proportioned, logical, unified whole, whose parts were clear and articulated to provide a definite demarcation between one part and the next.

The principal exponent of *empfindsamer stil* was C.P.E. (Carl Philipp Emanuel) Bach (1714–88), son of J. S. Bach. His influence and position between baroque and classical styles caused many scholars to call him the "founder" of classical style. Although he wrote many different kinds of works, his most important compositions were for clavichord. The clavichord's soft, intimate tonal characteristics were well suited to C.P.E. Bach's delicate, dynamic shadings. His ornamentations stayed within the proportions of his melodic passages, lending assistance to his desire to keep strong unity of modal and melodic materials. C.P.E. Bach's works often employ the element of surprise, with dramatic and swift changes in dynamics, harmonies, key, texture, and so on. Not the least of C.P.E. Bach's contributions to Western music was his *Essay on the True Way to Play Keyboard Instruments* (1753–62), which contains important information on ornamentation, musical thought, and practice in the era.

Interestingly, this "expressive" departure from the polyphonic emotionalism of the baroque was labeled as "romantic" at the time. What to some now appears sensible and restrained, witty and graceful, logical and reasoned, was thought then to be sentimental and whimsical. In less than a century the real romantics would rebel against this tradition, as it later developed, finding it too restrained and formal. All of which goes to emphasize our earlier discussion concerning the relative convenience of using labels to define or describe works of art.

In 1785 Michel Paul de Chabanon wrote, "Today there is but one music in all of Europe." The cause of such a statement was music composed to appeal not only to the aristocracy but to the broad middle classes as well. Egalitarian tendencies and popularizing of ideas typical of the *philosophes* had also influenced artists, turning them toward a larger audience. Pleasure became a legitimate artistic purpose. Eighteenth-century rationalism regarded astonishment by excessive ornamentation and puzzlement by excessive complexity (both baroque characteristics) contrary to meeting a wide audience on its own terms. Those sentiments coupled with the discoveries of Pompeii and the works of Winckelmann and Baumgarten orchestrated a logical step to order, simplicity, and focus on form as opposed to feeling. We call this style in music "classical" (the term was not applied until the nineteenth century) rather than "neoclassical" or "classical revival" because although the other arts returned (more or less) to Greek and Roman prototypes, music had no known classical antecedents to "revive," despite a rather detailed understanding of Greek music theory. So, for the first time in history, music existed and was maintained, which turned to classical *ideals,* though not to classical *models.*

One very clear characteristic of classical style was a definitely articulated structure. Each piece was organized into short statements called phrases, which recurred regularly and clearly. The most frequently cited example of such a practice is Mozart's *Symphony No. 40 in G Minor,* whose opening movement

is based on a three-note rhythmic pattern or motive (♩♪ ♪) organized into two contrasting phrases. These phrases then are grouped into *themes,* which, finally, comprise sections in the movement. In contrast, for example, with the opening movement of Vivaldi's *Spring,* which we characterized as having an ABACADAEA structure, *Symphony No. 40,* typical of classical works, utilizes an AABA structure. Although it is in a much longer composition than Vivaldi's, it is much simpler and more clearly expressed. Second, classical music avoided polyphony, depending instead upon a single, unobscured, melodic line that could be shaped into clear and expressive contours and brought to a definite cadence (conclusion).

A third change from the baroque lay in rhythmic patterns. Baroque's numerous ornamented parts flowing together in complex design fostered essentially unchanging rhythmic patterns. Classical phrase structure and melodic linearity allowed far more opportunity for rhythmic variety and also for rhythmic contrasts among or between lines. For example, the featured upper melodic line could carry one rhythmic impulse while the chordal supporting lines could carry another. Usually the chordal voices had more regular rhythms than the independent voice. Classical style also changed harmonic relationships, including more frequent use of modulation (key change).

Major musical forms such as the opera, oratorio, and concerto changed according to classical priorities. For example, Mozart's *The Marriage of Figaro* (1786), a comic opera on the theme of love and marriage, with a fast-paced plot, subplot, and dramatic conflicts, shows concern for simplicity and clarity. Haydn's oratorio, *The Creation,* reflects the Enlightenment's concepts of God and nature, reason and benevolence. *The Creation* also exhibits concern for simplicity and clear form. Operas and oratorios continued in

popularity, but for the most part instrumental music became the dominant force. The concerto adapted smoothly from its baroque configurations into classical form and style. Chamber music also rose in popular appeal; its small ensemble format was perfect for performance *en chambre,* in the small rooms of the eighteenth-century salon.

However, the most important forms in the period were the symphony and the sonata. Sonatas were composed for virtually every instrument, and composers varied in their approach. Haydn, for example, utilized a sonata–rondo form: rondo was a classical variation of ritornello. The classical sonata, sometimes called sonata cycle, is a work of three or four movements, each of which consists of a specific structure. The most important structural configuration of the sonata (and the only one we will discuss) is the typical configuration of the first movement. This structure is so important and specific that it is called *sonata form* or *sonata–allegro form.* It is utilized heavily not only in the first movement of sonatas, but also in the first movement of symphonies and chamber music as well. Using the traditional structural alphabet we would characterize sonata form as AABA.

The (A) section begins with a thematic statement in the tonic key, followed by transitional materials called a *bridge;* a restatement of the opening theme or additional themes is then developed in a different key—usually the key of the dominant or the relative minor. The *A* section, called the *exposition,* closes with a strong cadence; usually the entire exposition section is repeated (AA). In the next section (B), called the *development section,* the thematic material of the exposition undergoes numerous alterations called *variations.* The composer would restate thematic material in different rhythmic, harmonic, melodic, dynamic, and key configurations. Usually the composer strove to increase dynamic tension in the development section. Finally, ten-

sion is resolved in a *recapitulation* section (A). Although called a recapitulation section, it is not usually a strict repeat of the exposition. For example, in the recapitulation section of the allegro movement in *Symphony No. 40,* Mozart restated the opening theme in the original key to let the listener know he has finished the development section, but then he proceeded to finish the movement with a bridge and an extended *coda.* Not all classical sonatas, symphonies, or chamber music fit the textbook mold, but the characteristics just mentioned provide a fairly accurate guide for understanding classical sonata form.

The symphony, which utilized sonata–allegro form in its opening movement, also played an important part in the classical music tradition. Composers such as Stamitz, Cannabich, Wagenseil, Graun, C.P.E. and J. C. Bach, Gossec, and Boyce, in addition to the giants we will examine shortly, all contributed significantly to the development of this most important form. By the last quarter of the eighteenth century the symphony, as well as other forms of instrumental ensemble music, had largely eliminated use of *basso continuo,* and, thereby, the harpsichord. Primary focus, then, fell on the violin section, and classical symphonic compositions reflect that new focus. By the turn of the nineteenth century other sections, such as the woodwinds, were given more important, independent material.

The timbre of an orchestra was fairly close to what we know today, the size, and, therefore, the overall "amount" of sound was not. The largest orchestra of the mid-eighteenth century, the Mannheim Orchestra, consisted of forty-five players, mostly strings, with six woodwinds, five brasses, and two timpani. Haydn's orchestra between 1760 and 1785 rarely exceeded twenty-five players, and the Vienna orchestras of the 1790's averaged thirty-five players.

The most illustrative symphonic literature of the classical style came from the minds and pens of Haydn, Mozart, and Beethoven (in his early years). Austrian born Franz Joseph Haydn (1732–1809) pioneered the development of the symphony from a short, simple work into a longer, more sophisticated one. Haydn's symphonies are diverse and numerous (some sources indicate that he wrote more than one hundred and four). Some are light and simple; others are serious and sophisticated. Many of his early symphonies utilize pre-classical, three-movement form. These usually consist of an opening allegro movement, followed by an andante movement in a related key, and closed with a rapid minuet or giguelike movement in triple meter. Other early works utilize four movements, the first of which is in a slow tempo. In contrast, *Symphony No. 3 in G Major* (c. 1762) has a typical four-movement structure beginning with a fast tempo: I. allegro; II. andante moderato; III. minuet and trio; IV. allegro. *Symphony No. 3* emphasizes polyphony more than homophony, in contrast to the general classical trend, and the opening allegro movement does not utilize sonata–allegro form. The third movement, minuet and trio, is found in nearly every classical symphony and always has a two-part form. Haydn's minuets contain very charming music, emphasizing harmonic invention and instrumental color.

Haydn's middle symphonies from the early 1770's exhibit imaginative emotion and a larger scale than those previous. Exposition sections explore broadly expressed themes followed by contrasting ideas and restatement; the development sections are dramatic and employ sudden and unexpected changes of dynamics; slow movements contain great warmth and emotion. Haydn frequently drew on Austrian folk songs and baroque dance music, and his modulations and changes of tonality contain great dramatic power.

Among his late works is his most famous: *Symphony No. 94 in G Major* (1792), com-

monly known as the "Surprise Symphony." Its second movement contains a charming theme and the dramatic "surprise" which gave the work its popular name. The tempo of the second movement is andante, and the orchestra begins with a very soft, clear statement of the theme. After presenting the quiet theme, Haydn inserts a tremendous, fortissimo chord. Its effect on those who are not familiar with the work is very amusing. This simple theme, constructed of triads, carries throughout the movement in a series of delightful variations. Melodies are disjunct, and phrase structure, highly symmetrical.

Wolfgang Amadeus Mozart (1756–91), also an Austrian, had performed, at age six, at the court of Empress Maria Theresa. As was the case throughout the classical period, aristocratic patronage was essential for musicians to earn a living, although the middle classes provided a progressively larger portion of commissions, pupil fees, and concert attendance. Mozart's short career (he died at age thirty-five) was marked by financial insecurity.

His early symphonies were simple and relatively short, like Haydn's; his later works, longer, and more complex. His last three symphonies generally are regarded as his greatest masterpieces, and *Symphony No. 40 in G Minor* often is referred to as *the* typical classical symphony. This work and Nos. 39 and 41 have clear order and restraint and yet exhibit tremendous emotional urgency, which many musicians cite as the beginning of the romantic style. The opening movement of *Symphony No. 40* is cast in sonata–allegro form, and built, as we mentioned earlier, on a three-note motif. The second movement (andante) also is in sonata form. It begins with a comfortable motive in the viola section; shortly, however, tension clouds the melody. The moderate tempo continues, but the rhythm changes from calm to agitated. The development section is very sombre and

intense, and, as in the opening movement, the recapitulation returns subtly and creatively to the opening theme. The third movement explores the standard minuet and trio, and the fourth movement (allegro) closes the work in sonata form.

Ludwig van Beethoven (1770–1827) often is considered apart from the Classical Period and treated as a singular transitional figure between classicism and romanticism. Beethoven desired to expand the classical symphonic form in order for it to accommodate greater emotional character. The typical classical symphony moves through contrasting movements; Beethoven changed that to accommodate a single thematic development throughout, and thereby achieved a unified, emotional work.

Beethoven's works are significantly different from Haydn's and Mozart's. They are more dramatic and utilize changing dynamics for emotional effects; silence occurs as a device in pursuit of dramatic and structural ends. In addition, Beethoven's works are longer than his predecessors'. He lengthened the development section of sonata–allegro form and did the same to his codas, many of which take on characteristics of a second development section. He also changed traditional thematic relationships among movements, especially in the Sixth Symphony, which has no break between the fourth and fifth movements; in the Fifth Symphony no break occurs between movements three and four. In his four-movement works he changed the traditional third movement trio to a scherzo and trio of significantly different character. His symphonies draw heavily on imagery, for example, heroism in *Symphony No. 3* and pastoral settings in *Symphony No. 6*. *Symphony No. 5 in C Minor* begins with a motive even the nonmusician knows well and which Beethoven described as "fate knocking at the door." The first movement (allegro con brio) develops according to typical sona-

ta– allegro form; the second and contrasting movement (andante con moto) is in theme and variation form; the third movement (allegro) is, as noted, a *scherzo* in triple meter. Movement number four returns to allegro and to sonata form. Beethoven's nine symphonies become progressively more and more romantic, and the Ninth Symphony is a gigantic work of tremendous power. Its finale includes a chorus singing the text of Schiller's "Ode to Joy."

Although classical style exemplified a simpler character and utilized a more symmetrical structure than baroque, it did not sacrifice dynamic qualities in that pursuit. In the same sense that the simple qualities of Greek architecture, for example, did not lose their sophistication and interest in a slavish pursuit of apparently mathematical form and symmetry, so classical music maintained its dynamic and sophisticated character in its pursuit of form and reason. As classical style was shaped by its advocates it moved as comfortably toward romanticism as it had from baroque.

Theatre

If there was only one music throughout Europe in the last half of the eighteenth century, the same may not be said of theatre, which during the Enlightenment increased in nationalism and separation. In order to continue our story of theatre's history in this period we have no option but to continue to break it into its national components. England, France, Germany, Italy, and the United States each contributed to eighteenth-century dramatic traditions.

We must remember that Britain preceded France in eliminating absolutism. The Restoration and its theatre, which began a new style in the late seventeenth century, carried England into the early eighteenth century. However, like the rest of Europe, although earlier, the character of English audiences was changing; its theatre changed accordingly.

Queen Anne cared little for the theatre, and George I, being German and not speaking English well, could not understand it; audiences in England tended more and more to be well-to-do, middle-class tradesmen. The effect of this change in audience character caused Restoration comedy to shift its emphasis toward sentiment. Witty dialogue persisted, and English comedy in the Augustan age (in deference to George I) is well illustrated in the works of Colley Cibber (1671–1757).

Moderately clever plays such as *Love's Last Shift; or the Fool in Fashion* (1696), *She Wou'd and She Wou'd Not; or the Kind Imposter* (1702), and *The Careless Husband* (1704) delighted London audiences. *The Non-Juror* (1717) portrayed an English Catholic priest fomenting rebellion against the king, and it fomented its own furor among the Catholic community while earning Cibber the pleasure of the king. Cibber's final contribution to the theatre was a delightful and sharp-witted analysis of English acting called *An Apology for the Life of Colley Cibber, Comedian . . . with an Historical View of the Stage during His Own Time* (1740). English comedy closed the century in high style with the plays of Oliver Goldsmith and Richard Brinsley Sheridan (1751–1816). Goldsmith's works, especially *She Stoops to Conquer* (1773), exhibit excellent humor and exceptionally well-drawn characters. Sheridan, probably the most famous British playwright of the period, created two masterpieces, *The Rivals* (1775) and the most brilliant comedy of the English stage, the *School for Scandal* (1777), a biting satire with crisp, fast-paced dialogue.

Tragedy had been virtually nonexistent in England since 1640 when all public theatres were closed by the Commonwealth. However, by the early eighteenth century the neoclassical traditions of seventeenth-century France and the pseudoclassical theories of essayist, critic, and poet Alexander Pope

(1688–1744) made some inroads into British tragedy. A number of plays and playwrights followed these precepts; the most successful was James Thompson (1700–1748) with *Sophonisba* (1729) and *Edward and Eleanora* (c. 1735).

Undoubtedly the most popular theatre form in early eighteenth-century London was the ballad opera, and the best of these unquestionably was John Gay's *The Beggar's Opera* (1728). It caricatured the bribery of Sir Robert Walpole and created a social scandal. *The Beggar's Opera* was not the only theatrical piece to burlesque the corruption of Walpole, and as a result of these theatrical attacks, Walpole successfully convinced Parliament to institute the Licensing Act of 1737, which limited legal theatrical production to three theatres, Drury Lane, Covent Garden, and Haymarket, and gave the Lord Chamberlain the right to censor any play.

Production style remained controlled, however, and as a result the physical theatre in London retained its elegant but intimate scale, in contrast to the mammoth opera houses that flourished elsewhere. The playing area consisted of a forestage, the sides of which contained doorways for entrances and exits by the actors, and over which were located boxes for spectators. Wing and drop scenery was placed upstage, behind a proscenium arch, and consisted of flat, painted pieces utilized strictly as a background. Lighting consisted of wax candles in chandeliers over the audience. As might be expected, fire was a constant danger, and smoke from the candles, an irritating nuisance.

The entire eighteenth century in England, but especially the second half, was an age of actors—not playwrights; the greatest of these, indeed the greatest theatre figure to emerge in this time, was David Garrick (1717–79). His genius significantly changed the style of English theatre and, as a result, that of America as well. Garrick began as an actor, attaining great fame after a sensational debut performance in *Lethe; or Aesop in the Shades* (1740). He followed that with a fantastic success in Shakespeare's *Richard III*. However, he and his rival for acting supremacy, Macklin, changed the course of theatre history not by their acting, but by introducing antiquarian-inspired costume to the English stage. Macklin began by appearing in a costume described as "Old Caledonian habit," to which Garrick responded by playing King Lear in his own idea of "Old English" costume.

Earlier, by briefly mentioning Gilbert Stuart, the American painter, we finally acknowledged notable artistic enterprise in America. The arts, and theatre especially, bumped squarely against unbending Puritan austerity. However, sometime between 1699 and 1702 Richard Hunter gained permission from the acting Governor of the Province of New York to present plays in the city of New York. In 1703 an English actor named Anthony Ashton landed at Charlestowne, South Carolina; he was "full of Lice, Shame, Poverty, Nakedness, and Hunger," and to survive became "Player and Poet." Eventually he found his way to New York where he spent the winter "acting, writing, courting, and fighting." Perhaps as a consequence, the Province, in 1709, forbade "play acting and other forms of disreputable entertainment." Notwithstanding an inauspicious start, American theatre struggled forward. The first recorded theatre was built in Williamsburg, Virginia, in 1716 and housed a performing company for the next several years. For the most part theatre in America was merely an extension of the British stage, and English touring companies provided most of the fare. Theatres themselves appear to have been small and closely modelled upon provincial English theatres with their raked stages, proscenium arches, painted scenery, and apron forestages flanked by entrance

doors. Four hundred seats seems about average. The front curtain rose and fell at the beginning and end of each act; numerous scene changes within the acts were executed in full view of the audience.

Companies from London, usually comedy troupes, came to Williamsburg annually for an eleven-month season. By 1766 touring British companies played the entire eastern seaboard from New York, Philadelphia, and Annapolis to Charleston. A milestone was passed on April 24, 1767 when the British *American Company* presented Thomas Godfrey's *The Prince of Parthia,* the first play written by an American to receive a professional production. As the American Company prepared for its 1774–75 season, the Continental Congress passed a resolution discouraging (among other things) "exhibitions of shows, plays, and other expensive diversions and entertainments."

Numerous American plays were written during the years of the American Revolution, most of which were never performed. Their titles, however, reflect the current of thought and the loyalist/rebel dichotomy: *The Americans Roused in a Cure for the Spleen* (1775), *Battle of Brooklyn* (1776), and *The Blockade* (1775). All of the former were loyalist satires against the revolutionary cause. On the other side of the question were *The Adulateur* (1773), *The Group* (1775), and *The Blockheads* (1776), all aimed at the Tories, as well as *The Battle of Bunker's Hill* (1776), *The Fall of British Tyranny* (1776), and *The Patriots* (1776). Since there were no American professional actors, and since all the British professionals had fled back to England, the war years saw a flurry of amateur production throughout the colonies, including performances staged by the American troops themselves under the countenance of George Washington.

The century closed with eighteen postwar years of production by the American Company, which returned from England in 1782.

In 1787 Royal Tyler's *The Contrast* successfully launched a firm tradition of American theatre. Tyler was a Boston lawyer and American army officer, who had seen his first play only a few weeks before writing *The Contrast.* He gave a lively picture of New York society, with facile dialogue and well-drawn characters. The play satirizes Dimple, a young New Yorker who has turned into a fop by his admiration of all things British. Although engaged to Charlotte, the daughter of a wealthy merchant, Dimple considers himself a European rake and makes advances to two of his fiancé's friends. One of the friends has a brother, Colonel Manly, the epitome of American plain manners, high principles, and patriotism. Manly falls in love with Charlotte, exposes Dimple, saves both Charlotte and his own sister from Dimple's duplicity, and ends up united with Charlotte. In the midst of this delightful comedy are two additional characters of extreme importance; they are Jessemy, Dimple's servant, every inch the mirror of his master, and Jonathan, Manly's servant, the prototypical "country bumpkin." The subplot of scenes between these two provides hilarious fun even for contemporary audiences.

As successful as *The Contrast* was, however, the title of first major American playwright must go to British-trained William Dunlap, especially for *The Father, or American Shandyism* (1789), which combined sentiment, wit, comic humor, and "the finer feelings of the human heart."

In 1794 the focus of American theatre turned to Philadelphia with the opening of the Chestnut Street Theatre. It had a handsome interior with boxes set in a semiellipse; total seating capacity was either 1,200 or 2,000 (sources vary). The auditorium was grey with gold trim, including elegant gilt railings. The orchestra pit held thirty musicians, and the large forestage was flanked by walls representing the façades of handsome

Mr. JEFFERSON Mr. BLISSETT.
in the Charaters of Dr. Smugface & Dr. Doblancour in the Budget of Blunders

Dr. Dab. ___ La Fleur _ Patrick _ sieze him, knock him down.
Engraved for Mirror of Taste.

Fig. 4.13. Joseph Jefferson I (left) and Francis Blissett in the farce "A Budget of Blunders" at the John Street Theatre c. 1796. Courtesy of the Theatre Collection, New York Public Library.

buildings. The large stage was lit by oil lamps, whereas the auditorium was lit by candles. A French traveler, whose descriptions detailed the theatre, indicated that "between the acts the pit is noisy and even indecent. . . . [T]he women turn their backs on the pit during intermission."[1]

Ripples of the comic style of Molière and the neoclassicism of Racine extended well into the eighteenth century, but, essentially, the theatre of France underwent a barren period after Molière died. The recently established Comédie-Française produced fine actors and actresses in both comedy and tragedy, but its management appeared overly

aware of its state patronage and held a backward-looking philosophy of production that stifled new directions. The Comédie-Française slipped into tragedies that were sentimental and melodramatic, and comedies caught up in contemporary triviality. A rival company at the Hôtel de Bourgogne called themselves the Comédie-Italiènne, so as to distinguish themselves from the Comédie-Française and to reflect the Italian nationality of the actors (although they played in French). Success for this company had begun in the closing years of the seventeenth century with productions of the playwrights Jean Francois Régnard (1655–1710) and Charles Rivière Dufresny (1654–1724). After a brief exile for slighting Mme. de Maintenon, the Comédie-Italiènne returned to successful seasons, after the death of Louis XIV in 1715.

[1]Barnard Hewitt, *Theatre U.S.A.* (New York: McGraw–Hill Book Company, 1959), p. 40.

Plays of the early years of the century often show a combination of neoclassicism, popularization, and rococo niceties. Tearful comedies called *comédies larmoyantes* satisfied the tastes of the *salon* set as well as an ever-increasing, middle-class audience, which demanded emotional plays in recognizably contemporary situations. The Enlightenment's egalitarianism brought tragedy to a curious state; the increasing numbers of women in theatre audiences seemed to demand to cry, even in comedies, and they flocked to the well-equipped theatres in pursuit of such release. By the Revolution, serious drama had become *drames bourgeois*, middle-class drama, of melodramatic proportion.

A few undistinguished tragedies of neoclassical bent were written, only to fall justifiably to the wayside. Of interest in such a vein are the works of Jolyot de Crébillon (1674–1762) who wrote popular horror plays. His intention was to move an audience to pity and terror (cf. Aristotle) and never to offend their refinement or propriety. The plots of Crebillon's plays speak for themselves: a father kills his son (*Idoménée*, 1705); a father drinks his son's blood (*Atrée et Thyeste*, 1707); a man kills his mother (*Electra*, 1709). Crébillon continued to write tragedies well into the middle of the century, and his last two plays, *Catalina* (1742) and *Le Triumvirate* (1754), were written to compete with the individual who dominated the first three-quarters of the eighteenth century, Voltaire.

The shifting character of French drama of the first half of the century also can be seen in the plays of Pierre Mariveaux (1688–1763). Mariveaux' style was a bit unclassifiable, but seems to be fairly consistent with the rococo tendencies of his day. His plays are charming, sentimental, and meticulously written. *Les Fausses Confidences* (1732) described the efforts of a poor but handsome young man who sets out to make his rich mistress fall in love with and marry him. The questionable

morality of his duplicity is assuaged when, in the end, the young man actually falls in love himself. Although Mariveaux' tone is eighteenth century, he still had his eye on the neoclassical "unities." The entire action of the play occupies less than a day.

Perhaps nothing summarizes the first three quarters of the eighteenth century better than the theatrical ventures of its most dominant personality, François Marie Arouet, called Voltaire (1694–1778). His plays were diverse in style and genre. Curiously, given his critical, antiestablishment propensities, Voltaire's early plays, such as *Oedipe,* reflect the neat rules of the French Academy (*Oedipe* is, in fact, a slavish imitation of Racine). An admirer of Shakespeare, Voltaire once called him an "inspired barbarian" because Shakespeare's dramatic structures were far too untidy for neoclassical tastes. In *Mérope* (1741) Voltaire declared that he had returned to "first Greek" principles, although most critics agree that what he meant by such a statement was that he had eliminated any love scenes. His last play, *Nanine* (1778), had a gala premiere with most of the royal family in attendance, and when he died two months later, he had been given the greatest acclaim ever bestowed on anyone in the French theatre.

French drama had one final blaze of brilliance before the Revolution, in the plays of Beaumarchais. His two most famous plays, *The Barber of Seville* (1775) and *The Marriage of Figaro* (1784), are entertaining comedies built upon the traditions of neoclassicism dating back to *Le Cid*. In fact, at the last moment Beaumarchais expanded *The Barber of Seville* into a neoclassic five-act structure, an act that only added ponderousness to a fine play. Opening night criticism caused him to rewrite it into a four-act structure, which restored the sparkle and brilliance. Both *The Barber of Seville* and *The Marriage of Figaro* foretold the coming Revolution, and the nine

years between the works saw a dramatically changed audience perception of the forecast. *The Barber of Seville* was enjoyed and received calmly, but by 1784 France was well aware of its circumstances. The criticisms directed within the play to its main personage, Figaro, were taken seriously as an indictment of society as a whole. The horrors and chaos of the Revolution left the French stage barren for all intents and purposes during the final ten years of the eighteenth century. Its revival came only after the ascension of Napoleon.

The mid-eighteenth century in Germany marked a determined attempt to develop a significant national theatre, even if the political concept of "Germany" remained a somewhat nebulous entity. Chaos and a lack of any stable national boundaries or capital cities to act as cultural centers had previously mitigated against any strong national theatre such as England, France, Italy, or even Spain had enjoyed. However, as we have seen, the late eighteenth century in both Germany and Austria altered previous political circumstances.

Seeds planted by touring English, French, and Italian companies, nevertheless, had created a cross-pollinized environment ready to grow into a "German" theatre. Instrumental in the attempt were the efforts of Johann Christoph Gottsched (1700–1766), who began a small literary renaissance at the University of Leipzig by translating numerous French neoclassical plays (some of dubious quality) into German. Gottsched turned from literary to production efforts primarily because of the acting talents of Carolina Neuber (1697–1760). In 1724 the troupe of which Neuber was a part came to the attention of Gottsched, and he joined forces with her. Their later collaborations to reform the theatre of Germany did much to improve circumstances and establish traditions. Konrad Ekhof (1720–78) followed Neuber's tradition

with an acting style of "earnestness, sincerity, and honest restraint" that set the production standard of the era.

The literary values prominent in German theatre in the mid-eighteenth century were strengthened by a playwright of superb credentials, Gotthold Ephraim Lessing (1729–81). Lessing and Ekhof became part of the newly established Hamburg National Theatre. Lessing was offered the position of "stage poet," whose responsibilities included writing new plays, making translations, and composing prologues and epilogues for special occasions. Lessing refused the position, indicating that he could not complete plays as frequently as required for such a position (recall the requirements for Bach and others to compose weekly cantatas as part of their employment conditions). Nevertheless, the Hamburg National Theatre was so eager to have Lessing associated with them that he was hired.

Lessing's first tragedy, written before his association with the Hamburg National Theatre, was *Miss Sara Sampson* (1755), a rehash of the Medea story in a middle-class English setting. A typical *tragedie bourgeoise,* it had great influence in Germany; in essence it replaced French neoclassic drama as a standard. His most remembered play, *Minna von Barnhelm* (1767) often is called the first German contemporary drama. It is a tender, serious comedy about womanhood. Lessing's final, and perhaps best play was *Nathan the Wise* (1779), which preached religious toleration, introduced blank verse, and utilized strong symbolism. *Nathan the Wise* exemplified enlightened thought. In addition to his plays Lessing provided important theoretical advancement in German theatre. In his *Hamburgische Dramaturgie* and other works, he argued that all art is but a *reflection of nature;* and pseudoclassic rules interfering with that perception were false. Lessing considered Soph-

ocles and Shakespeare as the dramatic models by which all playwrights should be measured.

Finally, Lessing made another contribution of consequence to German and Western theatre. He wrote plays that allowed for scene changes at the act break rather than between scenes so as not to impede the movement of the action. Such an accomplishment is a significant one. In a theatre utilizing depictive scenic background, as opposed to theatre of scenic convention, such as the Greek or Elizabethan, pauses at any point in the dramatic action break the rhythmic and emotional flow of the production. Elaborate scenic changes within an act, therefore, break the audience's involvement and attention. The fact that Lessing's plays were written to accommodate such circumstances provided an important aesthetic influence for future German playwrights. Clearly Lessing was a playwright of the theatre for which he wrote; his plays were written *for* the stage with *theatre* aesthetics in mind.

Probably we should break our examination of German theatre at 1770, because the years that follow introduced the Romantic Movement, which was to dominate the nineteenth century. Lessing's interest in Shakespeare and also his concern for unbroken action were shared by Johann Wolfgang von Goethe. For reasons that will become apparent in the next chapter, Goethe and others in Germany turned to Shakespeare, chivalry, and Elizabethanism. In 1771 Goethe produced his *Goetz von Berlichingen,* a Shakespearean historical drama in German thought and concept. Complete with typically Shakespearean comic interludes amid the tragedy, *Goetz von Berlichingen* told the story of a Robin Hood-like robber-knight of the sixteenth century. Four years after this play, Goethe helped change the course of the next century with two monumental works, the novel *Die Leiden des Jungen Werther* (*The Sorrows of Young Werther*) and the first draft of the play *Faust.* These two works and Frederick von Klinger's play *Sturm und Drang* (1776) began a new revolt against classicism. *Sturm und Drang* (*Storm and Stress*) drew much of its inspiration from the American Revolution and became the name associated with a movement attracting young and free spirits everywhere, which also included Goethe; it is *Faust* that draws most attention as the masterwork of the age.

Part I of *Faust* actually is the theatrical masterpiece. Goethe began and partially completed it around 1774–75 but continued to rework the play until 1801. *Part II* occupied the remaining thirty years of his life and was not actually published until 1833, the year after he died. The Faust story was not original to Goethe, but he treated it in an unconventional manner. Some consideration must, in fact, be given to whether Goethe even intended *Part I* to be a stage presentation, as opposed to a dramatic poem. It begins with a poetic dedication, followed by a "Prelude in the Theatre" and a "Prologue in Heaven." What follows then is a series of twenty-six "scenes" ranging from Faust's study to a final "Prison Scene." Nowhere does Goethe enumerate the scenes or give a list of characters. He does not even indicate passage of time. Rather, he provides absorbing speeches illustrating the struggles in Faust's mind and his commentary on life. The work is a dramatic mixture of passion and wisdom. *Part II* reflects idealism removed from the "conflict of conscience and love" of *Part I. Part II* is so formless that it is virtually impossible to stage. Goethe's Faust was a poet–dreamer and idealist, seeking the divine and the ability to understand the workings of nature and the mystery of life. He is the prototypical romantic "hero" of such significance in the years to come.

Italian theatre in the eighteenth century is little more than a footnote compared to what we have just examined, but it had some important aspects. First was its interaction with the French theatre. The traditions of France and Italy crossed in the presence of the Comédie-Italiènne in Paris and also in the presence of plays by the Italian dramatist Goldoni, who wrote both in Italian and French. Goldoni settled in Paris in 1761, having made in Italy a significant but unsuccessful attempt to revive the *commedia dell' arte* by providing its actors with written texts. His plays reflect a mingling of styles (eclecticism) apparent, for example, in *Servant of Two Masters* (1740) and *La Locandiera* (*The Mistress of the Inn,* 1751). In contrast to the more spectacular works of Gozzi, Goldini's plays are intimate comedies very much like Molière's, which served as Goldoni's models.

A second important aspect of Italian theatre in the eighteenth century was its operatic production and specifically its magnificent scenic designs. Several schools of scenic design existed in Italy, and each followed a different tradition. Venice produced a school of light and graceful designs. Bologna, Parma, and Pisa, on the other hand, continued the opulent traditions of the baroque, especially through the work of the influential Galli-Bibiena family.

Dance

"The only way to make ballet more popular is to lengthen the dances and shorten the *danseuses'* skirts." Such was the opinion attributed to the composer Campra. One of the most significant obstacles to the development of the ballerina was costume. Floorlength skirts were not conducive to freedom of movement, and as a simple result, *danseurs* (male dancers) played the prominent roles as dance turned the corner of the eighteenth century and left behind the courtly splendor of Louis XIV's Versailles. In 1730 one of those

curious accidents of history occurred, which helped to change the course of ballet and bring the ballerina into pre-eminence.

Marie Anne Cupis de Camargo (1710–70) was a brilliant dancer, so much so that her mentor Mlle. Prevost (then "Ballerina") tried to keep her hidden among the *corps de ballet.* However, during one performance a male dancer failed to make his entrance, and Camargo quickly stepped forward to dance the role in his place. Her performance was superb and in a style that revealed ease, brilliance, and gaiety. Her footwork was so dazzling that, in order to feature it more fully, she raised her skirts to a discreet inch or two above the ankle! Her forte was the *entrechat,* a movement in which the dancer jumps straight up and rapidly crosses the legs while in the air. The move is still a technical achievement especially favored by male dancers. Voltaire indicated that Camargo was the first woman to dance like a man, that is, the first ballerina to acquire the technical skills and brilliance previously associated only with *danseurs.*

Another significant stylistic change came about also via the individual accomplishments of a ballerina, Marie Sallé. Her studies in mime and drama led her to believe that the style prevalent in Paris was overly formal and repetitious. So in the early 1730's she broke her contract with the Paris Opera (an act punishable by imprisonment), and took residence in London. Her style was one of expressiveness, as opposed to "leaps and frolics," and in 1734, in her famous *Pygmalian,* she wore simple draperies rather than the traditional *panniers;* her hair flowed freely in contrast to the usual custom of piling it tightly on the top of the head. The contrasts between the apparent styles of Camargo and Sallé indicate the almost immediate ebb and flow characteristic of ballet. A sterile emphasis on flashy technique can be quickly countered by emphasis on emotion and ex-

pressiveness. When emotion and expressiveness become melodramatic the pendulum can swing back to technique. However, certain schools or companies traditionally feature athletic technique while others feature expressiveness; still others try to blend the two. So at any given time any or all of these contrasting styles may find expression on the stage.

We have no way of knowing the actual characteristics of eighteenth century ballet, but its mythological subjects in the first half of the century appear fully consistent with those of painting, sculpture, and music: *Les Indes Galantes* (1735), *Pygmalian* (1734), *The Loves of Mars and Venus* (1717), *Orpheus and Eurydice* (1718), *Perseus and Andromeda* (1726), and *The Judgement of Paris* (1732). Significant in the previous works, most of which were produced in London by the dancing master John Weaver, was the use of movement to communicate the story. These early attempts to integrate movement and dramatic content brought forth *ballet d'action* in the last half of the century.

The popularity of the *ballet d'action* helped to separate this form from the sprawling *ballet à entrée* and gain ballet's independence from the opera and drama. *Ballet d'action* contained an evolving classical concern for unity. Its emphasis on drama stood in contrast to *ballet à entrée's* focus on display. The primary moving force in this new form was Jean George Noverre (1727–1810); his influential *Letters on Dancing and Ballets* (1760) contended that ballets should be unified artworks in which all elements contribute to the main theme. For Noverre ballet was a dramatic spectacle, literally a play without words, whose content was communicated through expressive movement. Technical virtuosity for the purpose of display was objectionable. He advocated music "written to fit each phrase and thought." In perfect harmony with Baumgarten and Winklemann, Noverre insisted that ballet

should study other arts and draw upon natural forms of movement, in order to be "a faithful likeness of beautiful Nature." He also argued for costumes that enhanced rather than impeded movement, and his ballets were considered excellent examples of "psychological realism."

Salvatore Vigano (1769–1821), another major figure of the period, followed Noverre's theories somewhat. Vigano's works moved from early choreography inspired by Shakespeare (specifically *Coriolanus*) to elaborate mime–dramas displaying neoclassic formulas. His *The Creatures of Prometheus* (1801) had music by Beethoven. Vigano was highly influenced by the neoclassical painters Jacques Louis David and Jean Dominique Ingres, the latter of whom we have yet to examine. His ballets comprise a transition between classicism and romanticism, emphasizing heroic qualities. Works such as *Richard The Lion Hearted* and *Joan of Arc* were called *choreodrammi* and differ from *ballet d'action* in fervor and scale. Poses and groupings of solo dancers suggested classical sculpture and were used in contrast to sweeping ensemble movement.

Popularizing of ballet occurred along with other arts and philosophy, and by 1789 ballet themes, as did painting, began to include subjects beyond mythology. Ordinary country life (like Chardin's *genre* painting) served as the topics for rustic ballets. However, these "realistic portraits" undoubtedly left much "realism" to be desired. They do serve, however, to illustrate trends toward egalitarianism in France and England, especially. Jean Dauberval (1742–1816), a student of Noverre, followed his teacher's example and accepted theories about nature as an inspiration for the dance and its gestures. Dauberval's *La Fille Mal Gardée,* for example, showed ordinary folk in real situations.

Nevertheless, mythology persisted. A rare glimpse of late eighteenth-century choreog-

raphy and mythic subject matter is available through the unbroken traditions of the Royal Danish Ballet, which still dances a fairly accurate production of Vincenzo Galeotti's *The Whims of Cupid and the Ballet Master* (1786).

As the eighteenth century came to a close, Charles Didelot (1767–1837) changed the course of ballet forever. First, he simplified the line and form of dance costume by utilizing tights. Next, he set the ballet world on its ear by attaching ballerinas to wires in *Zephyr and Flora* (1796) and flying them in and out of the scene. According to some sources, Didelot's wires allowed ballerinas to pause, resting effortlessly on the tips of their toes. As we well know, the line and form of the body created by that single effect constitutes a dramatic change in the aesthetic tone of a dance. That change was as obvious then as it is now, and very soon ballerinas were dancing *en pointe* without using wires, and an entirely new age in the dance had begun.

Architecture

Unlike most previous architectural styles, rococo was principally a style of interior design. Its refinement and decorousness applied to furniture and decor more than to exterior structure or even detail. Even the aristocracy lived in attached row houses. Townhouses, simply, had virtually no exteriors to design. So focus and reflection of current taste turned to interiors, and there the difference between opulence and delicacy was apparent. Figure 4.14 shows a polygonal music room characteristic of German rococo. Broken wall surfaces made possible stucco decoration of floral branches in a pseudonaturalistic effect. In Venice curved leg furniture, cornices, and guilded carvings were *à la mode*. French designer François de Cuvilliés (1695–1768) combined refinement, lightness, and reduced scale to produce a pleasant atmosphere of grace and propriety (Fig. 4.15).

Fig. 4.14. German music room. Thüringer Museum, Eisenach.

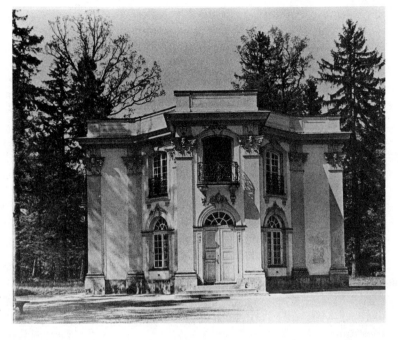

Fig. 4.15. François de Cuvilliés. The Pagodenburg. c. 1722. Schloss Nymphenburg, Munich.

English architecture of the early eighteenth century shared rococo refinement but in many ways was different from its continental cousin. The very late seventeenth and early eighteenth centuries in England produced a so-called "Georgian style" (referring to the Kings George I, II, III, whose reigns it partially encompassed). Essentially, Georgian style (which some sources do not use at all) was a baroque manifestation. Its relationship to rococo stems from its refinement and delicacy. Georgian architecture emerged from the English baroque of Christopher Wren, which was much more restrained and classical than the florid baroque style of the continent.

In the mid-eighteenth century architecture changed its viewpoint entirely and embraced the complex philosophical concerns of the Enlightenment. The result, in architecture, was a series of styles and substyles broadly referred to as "neoclassical." Excavations at Herculaneum and Pompeii, philosophical concepts of "progress," the aesthetics of

Baumgarten, and the writings of Winklemann combined to produce a new view of antiquity. "Neoclassicism," as a result, was really a new spirit of examination of the past. Rather than seeing the past as a single, continuous cultural stream broken by a medieval collapse of classical values, theoreticians of the eighteenth century saw history as a series of "compartments," for example, "Antiquity," "Middle Ages," "Renaissance," and so on.

Three important concepts emerged as a result of this change in viewpoint. First was the archeological concept, which viewed the present as continually enriched by persistent inquiry into the past (progress). Second was the eclectic, which allowed the artist to choose among styles, or, more important, to combine elements of various styles. The third concept was the modernist, which viewed the present as unique and, therefore, possible of expression in its own terms. These three concepts profoundly influenced eighteenth-century architecture, had important bearing on

the other arts and fundamentally changed the basic premises of art from that time forward.

"Neoclassicism," as applied to architecture, encompasses those three concepts and reflects a variety of treatment and terminology. Basic to it, of course, are the identifiable forms of Greece and Rome. Neoclassicism in architecture took considerable impetus from the *Essai sur l'architecture* by the Abbé Laugier (Paris 1753). Laugier's work was strictly rationalistic and expressed neoclassicism in a nutshell. He discarded architectural language developed since the Renaissance. Rather, he urged the architect to seek truth in principles demonstrated in the architecture of the ancient world and to use those principles to design modern buildings that expressed the same logical limitations as the classic temple. Laugier's classicism went directly to the Greeks, with only "midling obligations to the Romans."

In Italy, the architect Giambattista Piranesi (1720–78) was incensed by Laugier's arguments, which placed Greece above Rome, and he retaliated with an overwhelmingly detailed work that professed to prove (perhaps by sheer weight of evidence) the superiority of Rome over Greece. Both Piranesi (*Della Magnificenza ed Architettura dei Romani*) and Laugier proved instrumental to the neoclassical tradition. The revival of classicism in architecture was seen in many quarters as a revolt against the frivolity of the rococo with an art that was serious and moral. In America neoclassicism had special meaning as the colonies struggled to rid themselves of the monarchial rule of England's George III. For revolutionary Americans classicism meant "Greek," and "Greek" meant democracy. The designs of colonial architect Thomas Jefferson (Figs. 4.16 and 4.17) reflect the complex interrelationships of this period.

Fig. 4.16. Thomas Jefferson. Rotunda of the University of Virginia. 1806. Charlottesville, Virginia. Photography Division of Printing Services, University of Virginia.

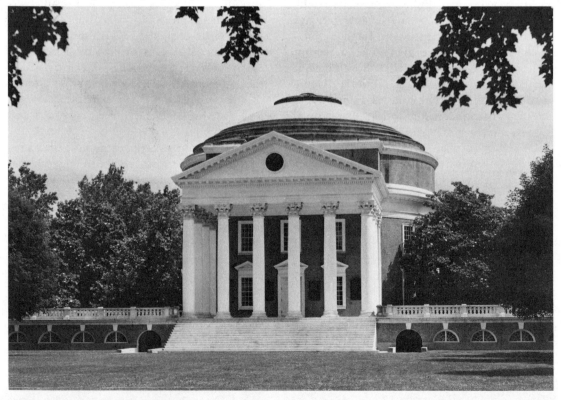

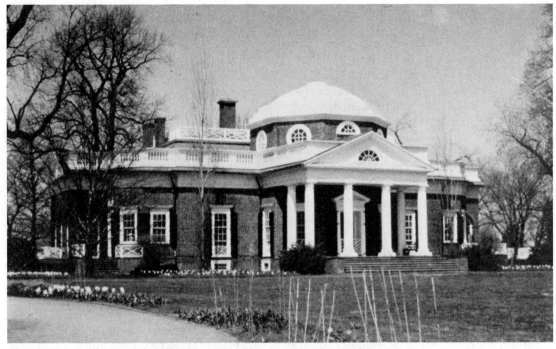

Fig. 4.17. Thomas Jefferson. Monticello. 1770–84, 1796–1806. Charlottesville, Virginia.

Jefferson was highly influenced by Palladio, who enjoyed popularity in a significant revival in English villa architecture between 1710 and 1750. Jefferson, in a uniquely eighteenth-century way, considered architecture objectively within the framework of contemporary thought. His philosophy of architecture, of which Monticello and the Rotunda are illustrative, was founded on a belief that the architecture of antiquity embodied indisputable "natural principles." He was strongly influenced by Lockean thought, "natural law," and, as noted, found Palladian reconstruction of the Roman temple a foundation on which a theory of architecture could be built. Monticello contains a center with superimposed Doric and Ionic porticos (porches) and short, low wings attached to the center by continuing Doric entablatures. The simplicity and refinement of Jefferson's statement here goes beyond reconstruction of classical prototypes and appeals directly to the intellect.

Summary

Contemporary Western society was brewed largely in a cauldron comprising the first one half to three quarters of the eighteenth century, called the Age of Enlightenment. Seventeenth and eighteenth century thought held essentially that humankind consisted of rational beings in a universe governed by natural law, whether the law of God or of something else. Faith in science, in natural human rights, in human reason, and in progress formed touchstones for eighteenth-century thought. Enlightenment, reason, and progress made the age one of secularism. Toleration of differences spread. The rapid increase in scientific interest and discovery that followed Newton gave birth to numerous specialties such as mineralogy, botany, and zoology. Frenetic scientific activity of the previous century was replaced by quiet categorizing.

Empiricism became the predominant philosophy of the late eighteenth century, fol-

lowing Locke's rationalistic emphasis on sensations and experience as the sources of knowledge. The skeptical philosophy of Hume was refined by Kant into a system which separated philosophy from science, allowing them to move forward separately. However, the Enlightenment went beyond philosophy to action with humanitarianism, a desire to raise humankind from the low social circumstances into which superstition and tyranny had cast it. The ideas of the Enlightenment in France spread largely through the efforts of *philosophes* such as Voltaire. Voltaire and the social critic Rousseau were instrumental in bringing absolutism to its knees in the French Revolution. Rousseau's *Social Contract* was fully rationalistic and included the preromantic conception of the Noble Savage.

The political scene witnessed the reigns of enlightened despots in Prussia and Austria, leading to strong and stable social orders. England and France, on the other hand, were led into revolutions. The former's was in America; the latter's, at home, gave rise to years of turmoil and the eventual *coup d'état* of Napoleon.

Classical influences dating to the early Renaissance continued strong and were, in fact, heightened by the excavations in Herculaneum and Pompeii. "Back to antiquity" was the watchword when Baumgarten's *Aesthetica* and Winklemann's *History of Ancient Art* redefined artistic qualities and concepts. Refinement, grace, and delicacy had brought the eighteenth century and its arts out of the baroque era; Pompeii, Herculaneum, aesthetic theory, and a return to antiquity ("noble simplicity") closed a century marked by war and revolution, rationalism and skepticism.

The change from grand baroque courtly life to that of the small salon and intimate townhouse was reflected in a new style called rococo. Probably a mirror of its time and the declining influence of the nobility, rococo was decorous, nonfunctional, intimate, graceful, charming, and delicately superficial. The arts throughout the century dignified the human spirit whether through social consciousness, bourgeois social morality, or the graceful gamesmanship of love. The paintings of Boucher and Watteau typified rococo; Hogarth represented social criticism and humanitarianism; Reynolds and Stuart, among others, reflected individualism through portraiture.

Although sculpture struggled in the eighteenth century, with lack of originality and continuation of the baroque predominating, rococo found expression in Falconet and others. Intimate in scale, rococo sculpture often took the form of delicate and graceful porcelain and metal figurines and reflected masterful technique. In a more serious vein than much of eighteenth-century sculpture is work such as that by Jean Antoine Houdon, whose portrait busts show penetrating psychological analysis coupled with delicate and accurate technical execution.

Rejection of French Court society and its baroque arts brought ornamentation, delicacy, prettiness, and pleasant artificiality to a rococo style in music as well as painting and sculpture. Francois Couperin, more than any other composer, captured the musical spirit of his time, but he also managed to retain his baroque roots sufficiently to avoid excessive sentimentality or completely artificial decoration. Couperin was part of a uniquely French school of organ music from which came settings of popular airs and compositions similar to the overtures and recitatives of French opera. A second style of music, paralleling rococo, also acted as a transition between baroque and classic. This style was called *Empfindsamer Stil,* and its principal exponent was C. P. E. Bach.

Unlike most previous architectural styles,

rococo was principally a style of interior design. However, in the mid-eighteenth century architecture changed its viewpoint entirely and embraced the complex philosophical concerns of the Enlightenment. One result was a series of styles and substyles broadly referred to as neoclassical, which encompassed a new spirit of examination of the past. Emerging from this viewpoint were archeological, eclectic, and modernist concepts. The revival of classicism was seen in many quarters as a revolt against the frivolity of the rococo with an art that was serious and moral. In America "classicism" meant "Greek," and "Greek" meant "democracy." The complex designs of Thomas Jefferson, based on Palladio, illustrate the tendencies of the style. In painting neoclassicism's principal proponent was Jacques Louis David. Propagandistic in tone, his works show a Roman two-dimensionality and a strong, simple compositional unity as well as accurate historical detail and antiquarian subject matter.

By 1785 many believed there to exist "but one music in all of Europe." Music was composed to appeal to the aristocracy and to the middle classes. Egalitarian tendencies and popularizing of ideas typical of the *philosophes* had also influenced artists, turning them to a larger audience. Eighteenth-century rationalism led to greater simplicity, order, and focus on form which has come to be known as classical style. Characteristic also of this style was a definitely articulated structure, avoidance of polyphony, rhythmic variety and contrast, and changed harmonic relationships. The most important forms in the period were the symphony and sonata. Many composers were important, but Haydn and Mozart stand out among them, with Beethoven providing a transition from classical style to its successor, the romantic.

Theatre during the Enlightenment increased in nationalism and separation. In England, Restoration comedy shifted toward sentimentalism. Neoclassical tragedies emerged in the early eighteenth century after a long hiatus, but the most popular form in England was the ballad opera. Production style remained elegant but intimate. Essentially, the eighteenth century in England was an age of actors, but the introduction of antiquarian philosophies had a profound effect on theatre style from that time forward.

In America, theatre, maintained by travelling troupes of English actors, was slowly building its foundations. Interrupted by the American Revolution, these European companies eventually led to an indigenous American theatre, with American playwrights and American actors. In France the neoclassicism of Racine extended well into the eighteenth century, but, essentially, the theatre of France underwent a barren period after Molière's death. The early eighteenth century produced tearful comedies called *comedies larmoyantes,* and the Enlightenment's egalitarianism led to a melodramatic, middle-class drama called *drames bourgeois.* The most typical attitude and theatrical work came from the era's most dominant personality, Voltaire, and French drama had one final blaze before the Revolution in the works of Beaumarchais.

The mid-eighteenth century in Germany marked a determined effort to develop a significant national theatre. The literary values prominent in German theatre in the mid-eighteenth century were strengthened by a playwright of superb credentials, Gotthold Lessing. He also helped change production style by writing plays that allowed for scene changes at the act breaks rather than between scenes, so as not to impede the movement of the action. The century ended with the beginnings of a revolt against classicism in the *Sturm und Drang* movement and the works of Goethe.

Italian theatre had two aspects of impor-

tance. One was its interaction with the French theatre through the Comédie-Italiènne and the works of Goldoni; the second was operatic production and its magnificent scenic designs.

The shortening of ballerinas' skirts and the resultant freedom of movement brought the female dancer into primary focus in the eighteenth century, and dance was changed from that point onward. Style in some quarters also changed to one of expressiveness as opposed to emphasis on technique. Subject matter remained essentially mythological and consistent with painting, sculpture, and music. Attempts to integrate movement and dramatic content led to *ballet d'action* and an emphasis on classical unity in the last half of the century. In perfect harmony with the writings of Winklemann and Baumgarten, the choreographer Noverre believed that ballet should study other arts and draw upon natural forms of movement, in order to be "a faithful likeness of beautiful nature." Popularizing of ballet occurred along with other arts and philosophy, and by 1789 ballet themes began, as did painting, to include subjects beyond mythology, such as in rustic ballets. As the eighteenth century came to a close, line and form in dancing was irrevocably changed by the introduction of dancing *en pointe*.

So in the eighteenth century a modern world was emerging, and the artistic pendulum returned to emphasis on form and intellect, in neoclassicism and classicism, and away from the sweeping emotion of the baroque and rococo. However, before the pendulum in some areas had reached its maximum arc, a shift back to emotion had begun. Beethoven infused the classical style in music with new emotion. While David, and later, Ingres, were forging neoclassical directions in painting, the romantics of the *Sturm und Drang* movement, Goethe in particular, had already emerged into prominence in literature and the theatre.

Chapter 5

THE
AGE
OF INDUSTRY

- Industrialization, Evolution, "Isms," and Subjectivity
- The Arts of the Age of Industry

INDUSTRIALIZATION, EVOLUTION, "ISMS," AND SUBJECTIVITY

The major result of social development since the Middle Ages was the rise of the middle class. Until the French Revolution it was in England that the middle class had reaped the greatest benefit from the changing circumstances. Capitalism had replaced the guild system, and individual initiative flourished and stimulated a spirit of invention. The first major industry to feel the thrust of invention was the textile industry, an industry absolutely basic to society. Cumulative inventions revolutionized the English textile industry with the result that one man, with a machine, could do as much work in a day as four or five men previously accomplished. Machines meant more cotton could be planted in the southern United States, and more cotton could be processed. Eli Whitney's cotton gin could do the work of a dozen slaves.

Watt's steam engine (1769) had sown the seeds for further invention both in the textile industry and elsewhere. In 1807 Robert Fulton built the first practical steamboat, and in 1825 an Englishman, George Stephenson, built a steam locomotive, which led to the first English railroad. Such an explosion of steamboats and railroads followed, that by the middle of the nineteenth century the world's entire transportation system had undergone a complete revolution.

Soon steam engines ran sawmills, printing presses, pumping stations, and hundreds of other kinds of machinery, and further revolutions followed on the heels of steam. Electricity was recognized as a source of power, and before the century was over electricity further mechanized a mechanizing world. In the meantime electricity spawned the telegraph (1832), which spanned continents and, in 1866, joined continents via the first trans-Atlantic cable. The telephone interrupted Western society in 1876, and by 1895 radio-telegraphy foreshadowed the twentieth century.

The Industrial Revolution, as these changes have been called, began in England and, as soon as the Napoleonic wars concluded, spread to France and the rest of Europe, gaining momentum as it spread, and irrevocably altering the fabric of civilization. By 1871, which witnessed the unification of Germany, the major industrial centers of Europe had been forged.

As industrialization strengthened, coal and iron became the measuring rods of supremacy in the machine age. These raw materials gave Great Britain, Germany, France, and Belgium the European lead in industry. However, vast resources in coal, iron, and other raw materials, exceeding the cumulative totals of all of Europe, soon propelled the United States into a position of dominance. The consequences of industrialization increased wealth enormously, concentrated heavy industrial centers near raw materials and transportation routes, and increased colonial expansion to provide world markets for new goods. Capitalism as an economic system came to absolute supremacy, spreading wealth through investment throughout the social strata but mostly centralizing economic control in the hands of a relatively restricted class of capitalists. Populations grew, probably because of increased quality of life and a diminished mortality rate among infants and the elderly. A new class of machine workers, blue-collar workers, entered the social structure.

Drawn from preindustrial home industries and farms, the new machine-worker class

was cast into absolutely deplorable conditions, reduced from being their own masters to virtually a slave status. They were nearly helpless, subject to severe organizing restrictions, hampered by lack of education, and threatened constantly by the prospect of unemployment. Slums, tenements, and frightening living conditions completed the degrading existence of this new class of workers, for whom the middle classes, caught in their own aspirations to wealth and political power, cared little.

Middle-class interests and outlook turned toward Liberalism, which was a political program with three goals: 1) to reduce the authority of a dominant church through religious toleration; 2) to reduce the power of a king and/or aristocracy through constitutionalism; and 3) to remove economic barriers of a provincial nature through nationalism. In other words, the goal of Liberalism was to put into a concrete political program those things that would enhance middle-class power. For the most part, Liberalism succeeded and became the political watchword of the age. Part of middle-class politics was *laissez-faire* economics. The middle classes were so successful that states, effectively, became spectators to middle-class control.

That control was coupled with a specific code of morality that stressed individual freedom and deliverance from bondage. The *free man* was the goal of human endeavor. Men and women were to stand on their own feet, create their own destiny, and realize their own inherent dignity. In such a philosophy individual freedom resulted from struggle and survival, in which the unfit perished and the fittest survived. Rugged individuals, that is, those who had been tried and tested, were the selected few; the degraded masses did not count.

The degraded masses, however, wanted to count. In order for them to do so, two conditions had to be met. First, they needed a basic education; second, they needed basic self-confidence. Only in Prussia did there exist a public school system designed for mass education. Great Britain and France were delinquent in this regard until the 1870's and 1880's respectively. In the United States public education for the working classes had some localized impetus as early as the 1820's, but even the concept of mass education did not take root until mid-century; compulsary elementary education took hold only near the end of the nineteenth century.

Gradually workers acquired the right to form unions, which right was often bloody in achievement and sometimes lost and then regained. Not until the second half of the nineteenth century did laborers become free to unionize, and, thereby, to promote their own interests. Of course, the working class problem saw a number of theoretical and proposed solutions: philanthropy, utopianism, and above all, the socialism of Karl Marx (1818–83).

In the realm of science, interest turned to investigation of the atom and theories of evolution. Evolution as a unifying concept in science dated to the Greeks. However, Sir Charles Lyell became the first to coordinate earth studies, and his *Principles of Geology* (1830) provided an important base for evolutionary thinking. In 1859 Charles Darwin offered "natural selection" as the explanation of species development in his *Origin of the Species*. Darwinism was further modified by Gregor Mendel in 1866. By the end of the nineteenth century evolution comprised the framework for modern knowledge of the universe.

The inevitable clash between evolution and Christianity occurred. However, many Protestant denominations, after an initial rejection, were able to come to grips with evolution. Such an accommodation was easier in Protestantism than in Roman Catholicism because, essentially, Protestants recognized the right of private judgement, as opposed to doctrinal control. At the same time that evo-

lutionary doctrine arose, some Protestant scholarship acknowledged the human elements of the Bible, that is, the Bible as a compilation of human writings over a period of time and written under special circumstances. Of course, such Biblical scholarship was (and still is) seen as equally diabolical as Darwinism by some Christian sects. Nevertheless, Protestantism, in general, gradually reconciled both doctrines to a modern outlook. Catholicism could not accommodate such an outlook, and continued its rejection, stating its position in Pope Pius IX's *Syllabus of Errors* (1864). Papal infallibility was declared by the Vatican Council of 1870 and continued its intransigence on the subject of evolution throughout the papacy of Leo XIII (1878–1903).

In the late eighteenth century, as noted, Immanuel Kant tried to reconcile philosophical extremes through a dualism that distinguished between a knowable world of sense perceptions and an unknowable world of essences. His reconciliation led to a nineteenth century philosophy which centered on the emotions. Such an idealistic appeal to faith was called romanticism, and this reaction against eighteenth century rationalism permeated philosophy and the arts. Other German idealism, as evidenced by Fichte and Shelling, basically rejected Kant's dualism, and developed an absolute system based on emotion that asserted the oneness of God and nature. However, nineteenth century idealism (romanticism) culminated in Hegel, who believed that both God and humankind possessed unfolding and expanding energy. Hegelian philosophy combined German idealism with evolutionary science and saw the universe from an optimistic viewpoint.

Such optimism was challenged by Schopenhauer, who saw the world as a gigantic machine operating under unchanging law. Schopenhauer recognized no Creator, no benevolent Father, only a tyrannical and unfathomable First Cause. If Hegel was an optimist, Schopenhauer was a pessimist of the highest order.

Following Schopenhauer came Nietzsche, a poet and philosopher. Nietzsche accepted humankind's helplessness in a mechanical world operating under eternal law, but he did not accept Schopenhauer's pessimism. Rather, he preached courage in the face of the unknown and found in courage humankind's highest attribute. Courage would produce, after a long selective process, a race of supermen and women.

Unlike the Germans, who were intent on coping with transcendental issues, the English and French focused upon philosophical explanation of the emerging, mechanized world. What was *beyond* was beyond knowledge and, therefore, inconsequential. For such philosophers as the Frenchman Comte, the nineteenth century was an era of science and, as such, needed to go about the work of sorting out numerous factual details of worldly existence, rather than trying to solve the riddles of the unknown universe. Comte's philosophy was called positivism, and his approach formed the basis for sociology or social science. Across the channel the Englishman Herbert Spencer (1820–1903) expounded a philosophy of evolutionary materialism in which evolution was the framework. He also believed that a "struggle for existence" and survival of the fittest were fundamental, and the human mind, ethics, social organization, and economics were "exactly what they ought to be."

Philosophy and mechanization, especially in transportation and communication, made the nineteenth century an age of internationalism and social study. Humankind, especially in Europe, sought to examine itself in as nearly a scientific, if social scientific, manner as possible. As humankind sought to un-

derstand itself, it also continued to strive for nationalistic power. Communications networks destroyed distances, and increasing numbers of international agreements, coupled with those communication networks, created a global communication unit. All this was set against a fierce and imperialistic competition for raw materials and marketplaces. To secure it all, the Western world depended upon armaments. The dangers were not unknown, and led, in the late nineteenth century, to various pragmatic alliances and treaties, which in the guise of cooperation cast the die for war.

War was an eternal specter in European existence. At the close of the eighteenth century, as France struggled to emerge from the chaos of its revolution, skillful maneuvering brought Napoleon Bonaparte to power. He slowly, but cunningly, moved from first consul to dictator, at first behind the screen of hand-picked legislators. War with England and Austria still persisted, and Napoleon set about to rectify things in France's favor. The battle of Morengo (1800) gave France all of Italy and crushed the Austrians in a single stroke.

The Peace of Amiens with Great Britain in 1802 left Napoleon free to concentrate on rebuilding France. Again, space and scope prohibit us from pursuing Napoleonic endeavors, which included the Napoleonic Code and a system of education. Nor can we detail the renewal of the Franco–British War (1803), Napoleon's ascension to emperor (1804), his great sweep across Europe, or America's war with Britain in 1812.

After Napoleon's defeat at Waterloo in 1815 the Act of the Congress of Vienna, controlled by factions of the old aristocracy, attempted to arrange the affairs of Europe. In essence, the congress gave legitimacy to restoration of dynasties displaced by the revolution and returned Europe to boundaries that existed prior to it. However, more war and revolution swept through France and Europe in 1820, 1830, and 1848. A new Napoleon emerged in 1849—Louis, later Emperor Napoleon III. War raged around the edges of Europe in 1854, and returned to its heart in 1859.

The United States tore itself apart in civil war in the early 1860's as Europe continued its perennial fratricide. The Treaty of Versailles in 1871 brought hostilities to a halt for the time being, unified Germany, and ceded Alsace and Lorraine from France to Germany. Throughout all of this, Great Britain and Ireland were at each other's throats, while the British Empire encircled the globe. The Western world spent the nineteenth century coping with industrialism, militarism, Liberalism, radicalism, Republicanism, socialism, idealism, nationalism, Conservatism, monarchism, and a faint glow of humanitarianism, while the arts set about throwing off classicism, bathing in the intense subjectivity of romanticism, nurturing realism, and returning to subjectivity in impressionism and postimpressionism.

The tenor of the times created moods of turbulence and frustration. France, for example, had an entire generation of young men raised in an era of patriotic and military fervor under Napoleon; after his defeat they were left to vegetate in a country ruined by war and controlled by a weak, Conservative government. Feelings of isolation and alienation increased. Suffering, downtrodden youth such as Goethe's Werther became romantic "heroes." Curiosity with the supernatural ran rampant. "Escape" to Utopia became a common goal. A desire to "return to nature" fostered nature both as the ultimate source of reason, and also, conversely, as an unbounded, whimsical entity in which emotionalism could run freely. Freely running emotionalism formed the heart of the wide-

ranging attitude called romanticism, whose philosophic bases were just mentioned, and whose remaining characteristics will unfold as this chapter proceeds. Outside the visual and performing arts romanticism permeated literature in the works of Blake, Byron, Wordsworth, Keats, Shelley, and Coleridge, among others.

The role of the artist changed significantly in the nineteenth century. For the first time art existed without significant aristocratic, as well as religious, commissions or patronage. In fact, patronage not only shrank, it was resisted as an undesirable limitation of individual expression. Artists occupied a place in the social order they had not occupied previously. Much of art became individualistic and increasingly critical of society and its institutions. The conflict between rebellious individual expression and established values, whether the values of a critic or of the public at large, created a chasm, which drove some artists into increasingly personal and experimental techniques. In many cases artists, particularly visual artists, were separated from

the world they viewed, reacted to, and needed to communicate with. They were prohibited from exhibition either by those with traditional standards, who controlled formal exhibitions, or by the vogue of public consumption, which controlled commercial galleries. As a result, artists became social outcasts, romantic heroes, and starving individualists and entered public legend.

THE ARTS
OF THE AGE OF INDUSTRY

Two-Dimensional Art

The neoclassical traditions of the eighteenth century continued into the nineteenth, especially in France, and pursuit of physical and intellectual perfection progressed from David to Jean-Auguste Dominique Ingres. However, Ingres, and perhaps David as well, illustrates the confusing relationships and conflicts that surrounded the neoclassic and romantic traditions in painting. Ingres' "Odalisque," or "Harem Girl," (Fig. 5.1) has

Fig. 5.1. Jean-Auguste Dominique Ingres. "Odalisque." 1814. Oil on canvas, 35¼ × 63¼". The Louvre, Paris.

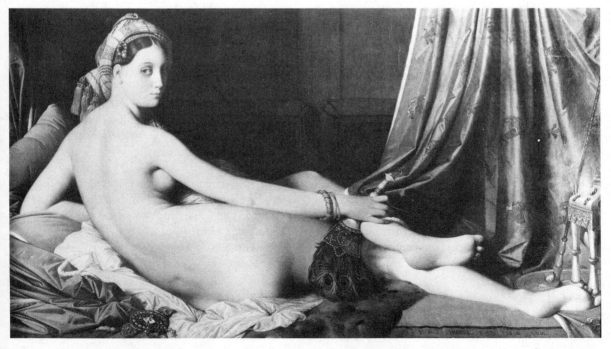

been called both neoclassic and romantic, and in many ways represents both. Ingres professed to despise romanticism, and yet his proportions and subject exude romantic individualism and escape to the "far away and long ago," to the exotic. His sensuous textures appear emotional, not intellectual. At the same time, his line is simple; his palette, cool; and his spatial effects, geometric. The linear rhythms of this painting are very precise and calculated and, therefore, classically intellectual in appeal.

If Ingres believed himself to be a neoclassicist and not a romantic, there were those who willingly championed the banner of romanticism. The romantic style was diverse. It comprised an emotional appeal; it tended toward the picturesque, nature, the Gothic, and, often, the macabre. Romanticism sought to break the geometric compositional principles of classicism. Compositions moved toward fragmentation of images. The intent was to dramatize, to personalize, and to escape into imagination. Romantic painting reflected a striving for freedom from social and artistic rules, a subordination of formal content to expressive intent, and an intense introversion. As the writer Zola put it, relative to romantic naturalism, "A work of art is part of the universe as seen through a temperament." Closely connected with the critic and writer Beaudelaire, romanticism dwelt upon the capacity of color and line to affect the viewer independently of subject matter.

Many romantic painters are worthy of note, for example, Delacroix, Daumier, Constable, Friedrich, Bingham, Gros, and Blake. However, Géricault, Goya, Turner, and Corot will suffice for our overview. Géricault's "Raft of the Medusa" (Fig. 5.2)

Fig. 5.2. Theodore Géricault. "The Raft of the Medusa." 1818–19. The Louvre, Paris.

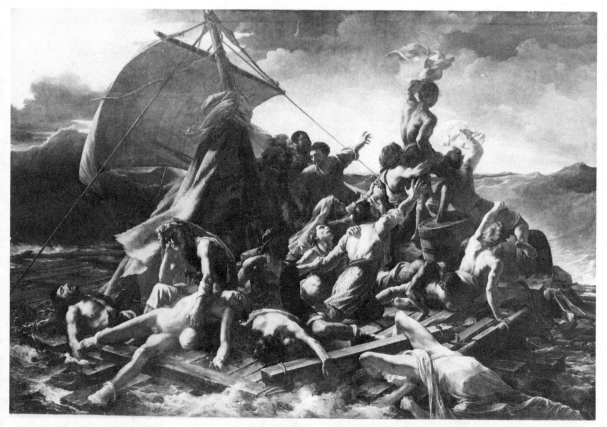

illustrates both an emerging rebellion against classicism and criticism of social institutions. The painting tells a story about governmental incompetence, which resulted in tragedy. In 1816 the French government allowed the ship Medusa to leave port in an unsafe condition. As a result, it was wrecked. The survivors, aboard a makeshift raft, endured tremendous suffering, including cannibalism. Géricault captured that ordeal in his painting, and he did so in a manner that illustrates romantic style, as well as Géricault's classical and even High Renaissance training. Géricault was a pupil of David, and like David he achieved here a firm modelling of flesh, realism of figure depiction, and a very precise play of light and shade. Also present is powerful and expressive musculature reminiscent of Michelangelo. However, in contrast to David's two-dimensional, relieflike paintings, Géricault created complex three-dimensional patterns and a fragmented and disorderly compositional structure. Rather than a strong central triangle, Géricault draws two triangles. One, which sweeps to the left and up the makeshift mast, signifies the death and despair of the Medusa; the other, moving up to the right to the figure waving the fabric, signifies hope as a rescue ship appears, faintly, on the crest of a wave at the right border. The turbulence of the composition has a dramatic and climactic sense, fully charged with unbridled emotionalism, which extols the individual heroism of the survivors.

The Spanish painter and printmaker Francisco Goya (1746–1828) attacked abuses of government both Spanish and French. His highly imaginative and nightmarish works reveal subjective emotionalism in humanity and nature, often at their malevolent worst. "Execution of the Citizens of Madrid, May 3, 1808" (Fig. 5.3) also tells a story of an actual

Fig. 5.3. "Execution of the Citizens of Madrid, May 3, 1808." The Prado, Madrid. Alinari/Editorial Photocolor Archives.

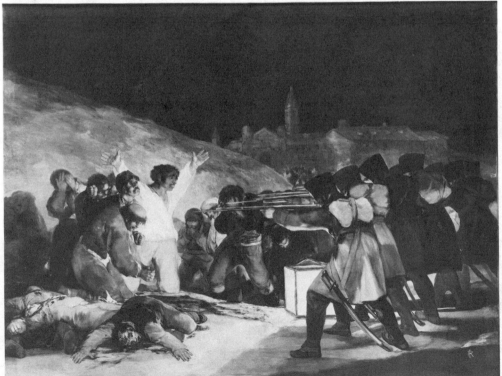

THE AGE OF INDUSTRY

event. On May 3, 1808, the citizens of Madrid rebelled against the invading army of Napoleon. As a result, individuals were arbitrarily arrested and summarily executed. Goya captured a dramatic and climactic moment in the story and did so with a composition even more fragmented than Géricault's. It is impossible to escape the focal attraction of the man in white, about to die. Goya's strong value contrasts force the eye to the victim; only the lantern behind the soldiers keeps the composition in balance. However, Goya leads us beyond the death of individuals, because these figures are not individuals; they are not realistically depicted. Rather, Goya gives a powerful social and emotional statement. Napoleon's soldiers are not even human types. Their faces are hidden, and their rigid, repeated forms become a line of subhuman automatons. The murky quality of the background further charges the

emotional drama of the scene and further strengthens value contrasts. Color areas have hard edges, and a stark line running diagonally from the oversized lantern to the lower border irrevocably separates executioners and victims. Goya has no sympathy for French soldiers as human beings in an ugly situation, perhaps only following orders. His subjectivity fills the painting; his portrayal is as emotional as the irrationality he wished to condemn.

The Englishman William Turner (1775–1851) reflected subjectivity perhaps even beyond his romantic contemporaries and foreshadowed the dissolving image of twentieth-century painting. The romantic painter John Constable called Turner's works "Airy visions painted with tinted steam." "The Slave Ship" (Fig. 5.4) visualizes a passage in James Thompson's poem "The Seasons," which describes how sharks follow a slave ship in a

Fig. **5.4.** William Turner. "The Slave Ship." 1839. Canvas, 35¾ × 48″. Courtesy, Museum of Fine Arts, Boston. Purchased, Henry Lillie Pierce Fund.

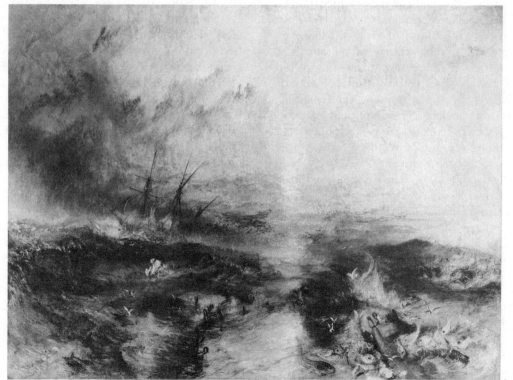

storm: "Lured by the scent of steaming crowds of rank disease, and death." This, too, was based on an actual occurrence, wherein the captain of a slave ship had dumped his human cargo into the sea when disease had broken out below decks. Turner's work further illustrates the elements of romanticism we already have discussed. He employs disjointed diagonals, which contribute to an overall fragmentation of the composition. His space is deeply three-dimensional. The turbulence of the occasion is reflected in the turbulence of painting technique. The sea and sky are transparent, and brushstroke reflects energetic spontaneity. Form and content are subordinate to expressive intent; a sense of doom prevails.

Camille Corot approached romantic goals through a modification often called *romantic naturalism*. Corot was among the first to execute finished paintings out of doors, as opposed to in a studio. His objective was to capture the full luminosity of nature and to capture the natural effect of the perceptual experience, that is, how the eye focuses relative to detail and peripheral vision. His works strive for truthfulness of visual effect by reducing the graphic clarity of all details in favor of clarity of central objects (just as our eyes perceive clearly only those objects on which we focus in a moment; the remaining objects in our field of vision remain relatively out of focus). Corot's works are spontaneous and subjective, but he retains a formal order to balance that spontaneity. "A View Near Volterra" (Fig. 5.5 color) is indicative of this movement in the romantic tradition.

The mid-nineteenth century in painting also witnessed the rise of a painting style called *realism*. The term realism occurs in varying contexts in various sources. Some refer to "social realism," and include painters such as Daumier. Social realism describes various styles which emphasize the contemporary scene, usually from a left-wing point of view and always with a strong thematic emphasis on the pressure of society on human beings. Others extend "realism" to include Manet. For others, the term appears to apply only to Courbet. Whatever the case, the term "reality" in the nineteenth century came to have special significance because the camera, a machine to record events, people, and locations, thrust itself upon part of what previously had been considered the painter's role. The style referred to as realism ran through the 1840's, 1850's, and 1860's, and its central figure was Gustav Courbet, who "sought to translate the customs, the ideas, the appearances of my epoch." He depicted everyday life and was closely tied to the innovations of Corot relative to the play of light on surfaces (Fig. 5.6). Also a social realist, Courbet was more intent on social message than on meditative reaction and so was less dramatic and nostalgic than other romantics. Edouard Manet (1832–83) followed in the realistic tradition, although he often is seen as an impressionist (an association he denied). He strove to paint "only what the eye can see." Yet his works go beyond a mere reflection of photographic reality to encompass an artistic reality, telling us that a painting has an internal logic different from the logic of "familiar" reality. Manet liberated the canvas from competition with the camera (Fig. 5.7). His searching for spontaneity, harmonious colors, subjects from everyday life, and faithfulness to observed lighting and atmospheric effects led to a style encompassing a small group of painters in the 1860's called (in 1874 by a hostile critic), *impressionists*.

Impressionism was as collective a style as any we have seen thus far. In an age as individualistic as the nineteenth century this style centered on the common concerns of a relatively small group of artists who met together frequently and even held joint exhibitions. As

Fig. 5.6. Gustav Courbet. "The Stone Breakers." Photo Deutsche Fotothek Dresden.

Fig. 5.7. Edouard Manet. "Luncheon on the Grass." The Louvre, Paris.

a result, this painting style had marked characteristics, which applied to all its adherents. Impressionism definitely suggested a new way of looking at things. Paintings of the style suggest an "on the spot" immediacy. They are impressions: of landscapes, rivers, streets, cafés, theatres, and so on. Claude Monet's "The River" (Fig. 5.8) illustrates the concerns of the impressionists. It suggests a pleasant picture of the times, an optimistic reflection, in contrast to the often pessimistic viewpoint of the romantics. In addition, it suggests a fragmentary and fleeting image: a new tone in a new era. The tempo increases;

life's pace is more rapid. Monet, along with Degas, Renoir, and Mary Cassatt, among others, formed the nucleus of this style.

In the last two decades of the nineteenth century impressionism evolved gently into a collection of rather disparate styles called, simply, postimpressionism. In subject matter the postimpressionists were similar to the impressionists—landscapes, familiar portraits, groups, and café and nightclub scenes. However, the postimpressionists gave their subject matter a complex and profoundly personal significance. George Seurat (1859–91), often called a neoimpressionist (he called his

Fig. 5.8. Claude Monet. "The River." 1868. Canvas, 32 × 39½". Courtesy of The Art Institute of Chicago. Potter Palmer Collection.

approach and technique divisionism), departed radically from existing painting technique in experiments in optics and color theory. His patient and systematic application of specks of paint is called pointillism, because paint is applied with the point of the brush, one small dot at a time. He applied paint in accordance with his theory of color perception, and "A Sunday Afternoon on the Grande Jatte" (Fig. 5.9) illustrates his concern for accurately suggesting light and colorations of objects. The composition of this work shows attention to perspective, and yet it willfully avoids three-dimensionality. As was the case in much of postimpressionism, a Japanese influence is present, that is, color areas are fairly uniform, figures are flattened,

and outlining is continuous. Throughout the work we find conscious systematizing. The painting is broken into proportions of 3/8's and 1/2's, which Seurat believed to represent true harmony. He also selected his colors by formula. Physical reality for Seurat was a pretext for the artist's search for a superior harmony, for an abstract perfection.

Postimpressionism in painting called for a return to form and structure, characteristics the postimpressionists believed requisite to art and lacking in the works of the impressionists. So, utilizing the evanescent light qualities of the impressionists, Gauguin, Seurat, Van Gogh, and Cézanne brought formal patterning to their canvases, utilized clean color areas, and casually applied color in

Fig. 5.9. George Seurat. "A Sunday Afternoon on the Grande Jatte." 1884–86. Oil on canvas, 6' 9¼" × 10'. Courtesy of The Art Institute of Chicago. Helen Birch Bartlett Memorial Collection.

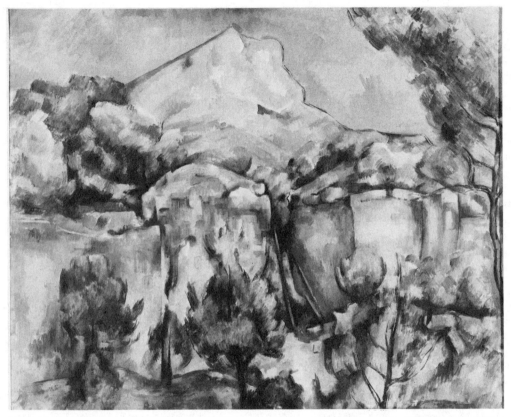

Fig. 5.10. Paul Cézanne. "Mt. Sainte-Victoire Seen from Bibemus Quarry." c. 1898–1900. Canvas, 25½ × 32". The Baltimore Museum of Art. The Cone Collection.

a systematic and nearly scientific manner. The postimpressionists sought to return painting to traditional goals while, at the same time, retaining the clean palette of the impressionists.

Paul Cézanne, thought by many to be the father of modern art, illustrates concern for formal design, and his "Mt. Sainte-Victoire" (Fig. 5.10) shows a nearly geometric configuration and balance. Foreground and background are tied together in a systematic manner so that both join in the foreground to create two-dimensional patterns. Shapes are simplified and outlining is used throughout. Cézanne believed that all forms in nature were based on geometric shapes: the cone, the sphere, the cylinder. Utilizing such forms, he sought to reveal the permanent reality that lay beneath surface appearance.

A highly imaginative approach to postimpressionist goals came from Paul Gauguin (1848–1903). An artist without formal training, and a nomad who believed that all European society and its works were "sick," Gauguin devoted his life to art and wandering, spending many years in rural Brittany and the end of his life in Tahiti and the Marquesas Islands. His work shows his insistence on form, his resistance to naturalistic effects, and a strong influence of non-Western art, including archaic and "primitive" styles. "Vision after the Sermon" (Fig.

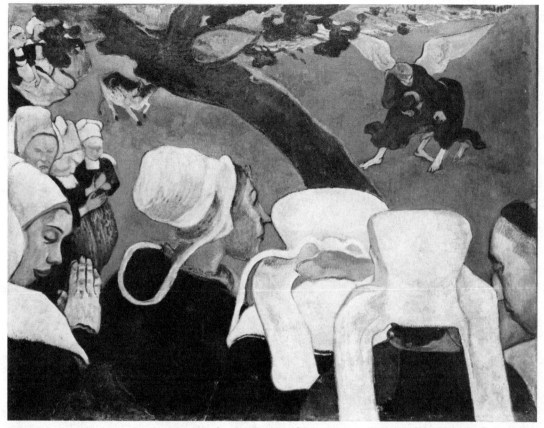

Fig. 5.11. Paul Gauguin. "Vision after the Sermon." 1888. Oil on canvas. 28¾ × 36¼". National Galleries of Scotland.

5.11) has Gauguin's typically flat, outlined figures, simple forms, and the symbolism for which he and his followers were known: "Symbolists" or "Nabis" (from the Hebrew word for prophet). In the background of this painting Jacob wrestles with the Angel while, in the foreground, a priest, nuns, and women in Breton costume pray. The intense reds of this work are typical of Gauguin's symbolic and unnatural use of color, used here to portray the powerful sensations of a Breton folk festival.

A final approach to postimpressionism was that of Vincent Van Gogh (1853–90), whose emotionalism in the pursuit of form

was absolutely unique. Although we have not dealt in much detail with biographical information concerning the art and artists we have examined, we must take note of Van Gogh's turbulent life, which included numerous shortlived careers, impossible love affairs, a tempestuous friendship with Gauguin, and, finally, serious mental illness. Biography here is essential because Van Gogh gives us one of the most personal and subjective artistic viewpoints in the history of Western art. Works such as "The Starry Night" (Fig. 5.12) explode with frenetic energy manifested in Van Gogh's brushwork. Flattened forms and outlining reflect Japanese influ-

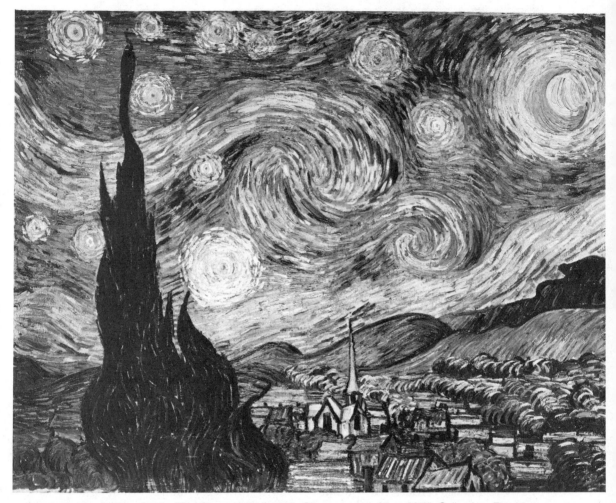

Fig. 5.12. Vincent Van Gogh. "The Starry Night." 1889. Oil on canvas, 29 × 36¼". Collection, The Museum of Modern Art, New York. Acquired through the Lillie P. Bliss Bequest.

ence. Tremendous power and controlled focal areas exist, and we can sense the dynamic, personal energy and mental turmoil present in Van Gogh's art.

Sculpture

Neoclassic sculpture occupied the early years of the nineteenth century and consisted predominantly of a reproduction of classic works rather than a revising of them, as occurred in architecture. In France neoclassi-

cism served its commemorative and idealizing functions as the political tool of Napoleon, who was glorified in various Greek and Roman settings, sometimes garbed in a toga and sometimes in the nude, as if to grant him the status of a Greek god. Perhaps no style is free from outside influences, and nineteenth century neoclassic sculpture often reveals tendencies toward rococo, baroque, and romantic.

Antonio Canova (1757–1822) is recog-

nized as the ablest of neoclassic sculptors, and his works illustrate not only this style, but also influences of the rococo tradition. "Venus Victrix" (Fig. 5.13), for which Napoleon's sister was the model, presents classical pose and proportions, similar in many ways to Ingres' "Odalisque." Line, costume, and hairstyle reflect the ancients, but sensuous texture, individualized expression, and realistic and fussy detail suggest other approaches. At the same time, this work presents a two-dimensional viewpoint. Canova appears unconcerned with the work when seen from any angle other than the front.

The Danish sculptor Bertel Trovaldsen (1768–1844) also pursued classic goals. His best known work, "The Lion of Lucerne" (1818–25) is carved out of the rock in a grotto near Lucerne and memorializes the Swiss Guards who died at Tuilleries in 1792. The associations and implications of this monument, as well as the emotionalism, which appears in the depiction itself, reflect romanticism nearly as much as they do classicism.

Romantic sculpture as a style seems never to have emerged. Those works not clearly of the traditions we have just mentioned show a generally eclectic spirit and a uniformly undistinguished character. There may be a reasonable explanation for such a phenomenon in that romantic idealism, whose strivings after nature and the far away and the long ago really do not translate well into sculptural expression; certainly nineteenth century devotion to landscapes does not. Of course, the term romantic often is applied to almost anything of the nineteenth century, and so it is the case with this era's most remarkable sculptor, Auguste Rodin.

Fig. 5.13. Antonio Canova. "Venus Victrix" (Pauline Bonaparte Borghese as Venus). 1808. Marble, life-size. Borghese Gallery, Rome. Alinari/Editorial Photocolor Archives.

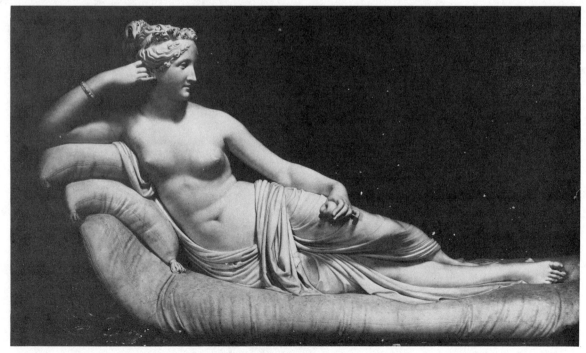

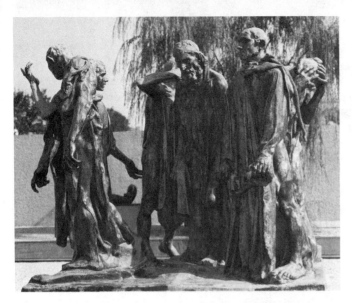

Fig. 5.14. Auguste Rodin. "The Burghers of Calais." 1884–86. Bronze, 82½ × 95 × 78". Hirshhorn Museum and Sculpture Garden, Smithsonian Institution.

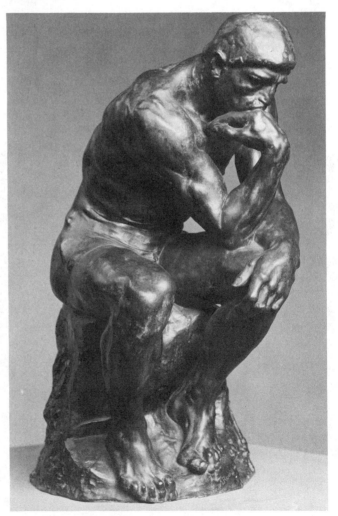

Fig. 5.15. Auguste Rodin. "The Thinker." 1879–89. Bronze. Height: 27½". The Metropolitan Museum of Art, Gift of Thomas F. Ryan, 1910. All rights reserved. The Metropolitan Museum of Art.

One can find ample room to apply idealism and social comment in Rodin's "Burghers of Calais" (Fig. 5.14), which celebrates the noble, if humiliating surrender of the city. However, Rodin's textures, more than anything else, reflect impressionism; his surfaces appear to shimmer as light plays on their irregular features. "The Thinker" (Fig. 5.15) provides a familiar example and shows the difficulty in attempting to put into sculptural form what Monet, for example, tried to do with color and texture in painting. Rodin's textures, however, are more than reflective surfaces; they give his works dynamic and dramatic qualities. Although Rodin utilized a fair degree of verisimilitude, he nevertheless presented a subjective reality beyond the surface, a subjective viewpoint seen even more clearly and dramatically in "Balzac" (Fig. 5.16). Rodin's style is of the nineteenth century, but it nearly defies description except by the term "modern."

Sculpture in the late nineteenth and early twentieth century sought a return to form combined with expressive emotional content. The works of Aristide Maillol point to these concerns and occasionally are classified as classical; such a label would be appropriate in terms of the mythological sense and clear concern for formal composition. However, many scholars draw comparisons between Maillol and the postimpressionist painters, because he shared their desire, not only for structure, but also for capturing emotional qualities. Maillol believed that a statue should exhibit rest and self-containment, and that

Fig. 5.16. Auguste Rodin. "Balzac." 1892–97. Height: 9′ 10″. Rodin Museum. The Philadelphia Museum of Art.

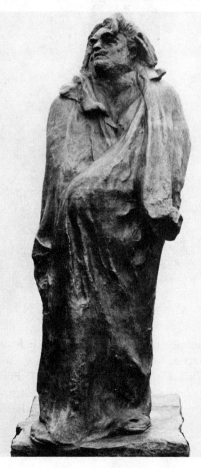

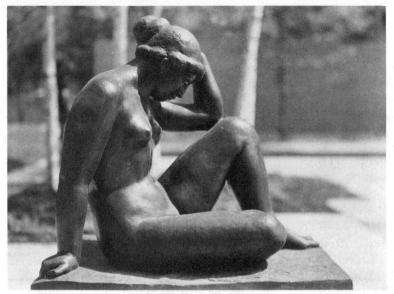

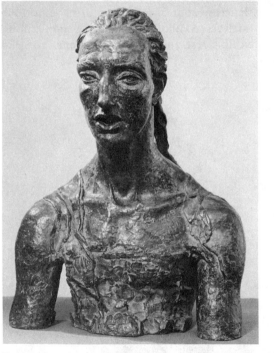

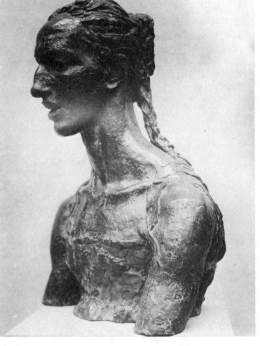

Fig. 5.17. Aristide Maillol. "Méditerranée." Collection, The Museum of Modern Art, New York. Gift of Stephen C. Clark.

Figs. 5.18 and 5.19. Jacob Epstein. "Selina." The Brooklyn Museum.

belief emerged clearly in works such as "Méditerranée" (Fig. 5.17). Finally, the poignant work of Jacob Epstein (Figs. 5.18 and 5.19) suggests postimpressionistic, emotive energy and subjective qualities similar to the work of Van Gogh.

Music

Richard Strauss claimed that by purely musical means he could convey to an audience the amount of water in a drinking glass. In an era of subjectivity music provided an artistic me-

dium in which many found an unrivalled opportunity for expression of emotion. All of the arts were closely related in the romantic period and drew inspiration from each other. Painting and poetry provided strong impetus, but each art discipline offered its own unique qualities. Music was exceptionally appealing, offering, without words or pictures, deep expression of human emotion.

In pursuit of that expression, romantic music made stylistic changes from its classical predecessors. However, unlike some art disciplines, whose romantic tendencies could be called a "rebellion," music's romanticism was a more gradual change and natural extension of classical principles. The classic–romantic antithesis, that is, the form versus feeling or the intellect versus emotion conflict, simply cannot be applied neatly to music of the eighteenth and nineteenth centuries. Nonetheless, subjectivity and emotion played a more important role in romanticism, and even if classicism sought sustenance in nature and antiquity, romanticism imbued nature and the far away and long ago with a strangeness that went far beyond classical inspirations. How much or how little space existed between classicism and romanticism on the form/feeling continuum is the stuff of which scholarly debates are made, and we need not engage in such hair-splitting. Utopia, whether in the past or the future, and nature, whether malevolent or benevolent, were as obvious and influential in nineteenth century music as in any other art discipline.

As in painting, spontaneity replaced control; but the primary emphasis of music in the era was on beautiful, lyrical, and expressive melody. Phrases became longer, more irregular, and more complex than in classical music. Melodic development nearly always had individual performance virtuosity as its object.

Rhythm in this style varied from simple to complex. Much romantic rhythm was strictly traditional, but experiments produced new meters and patterns. Emotional conflict often was suggested by juxtaposing duple and triple meters, and rhythmic irregularity became increasingly common as the century progressed.

Harmony and tone color were significantly different in music of this era. Harmony was seen as a means of expression, and any logic or restriction regarding key relationships submerged below the need to achieve striking emotional effects. Form was clearly subordinate to feeling. Harmonic procedures became increasingly complex, and traditional outlines of major and minor keys were blurred in chromatic harmonies, complicated chords, and modulations to distant keys. In fact, key changes became so frequent in some composers' works that their compositions comprised virtually nothing but tonal whirls of continuous modulation. Chromaticism, that is the altering of normal whole- and half-tone relationships in a scale, gained increasing importance as composers sought to disrupt previously logical expectations. The result was a sense of uncertainty and of the bizarre. More and more dissonance occurred, changing in its role from that of a passing dissettlement leading to resolution to that of a principal focus. That is, dissonance was explored for its own sake, as a stimulant of emotional response, as opposed to its utilization merely as a device in traditional harmonic progression to resolution on the tonic. By the end of the romantic period, exploration (and exhaustion) of chromatics and dissonance led to a search for a wholly different tonal system.

Exploration of "color" as a response stimulant was as important to the romantic musician as it was to the painter. Interest in tonal color, that is, timbre, led to great diversity in vocal and instrumental performance. The technical and emotional limits of every aspect of music were probed with enthusiasm, and music literature abounds with solo works and

a tremendous increase in the size and diversity of the orchestra. In order to find our way through this complex era, we need to isolate some basic musical forms and explore them, their individual artworks, and their composers in relation to the general characteristics we have just described.

In many ways "art songs" or shall we say, *lieder,* since many of its important composers were German, characterized romantic music. A solo voice with piano accompaniment and poetry for a text allowed a variety of lyrical and dramatic expressions and tied music directly to literature, from which romanticism sprang. German lyric poetry provided the cornerstones for feelings in the period, and the burst of German romantic poetry encouraged the growth of *lieder.* The linkage of poetry and music allowed one artform, in effect, to enhance another. Literary nuances affected music, and music allowed for deeper emotional implications for the poem. Such a partnership led to diverse results; some *lieder* were complex; others were simple. Some were structured and strophic; others, freely composed. The pieces themselves depended upon an integral relationship between the piano and the voice. In many ways the piano was an inseparable part of the experience; certainly it was more than accompaniment. The piano explored mood and established rhythmic and thematic material; occasionally it had solo passages of its own, fully rounding out the interdependency basic to *lieder.*

The earliest, and perhaps the most important composer of *lieder* was Franz Schubert (1797–1828), whose troubled life epitomized the romantic view of the artist's desperate and isolated condition. Known only among a close circle of friends and musicians, Schubert's nearly 1000 compositions (from symphonies to sonatas and operas, to masses, choral compositions, and *lieder*) did not see a public concert until the year of his death. His songs utilized a wide variety of poetry and

poets, and he composed in strophic and through-composed form. Melodic contours, harmonies, rhythms, and structure were all determined by the poem. Schubert's "Die Forelle" ("The Trout") is a well-known and frequently sung *lied,* which clearly evidences romantic concern for nature.

The Trout[1]

In a limpid brooklet
Merrily speeding.
A playful trout
Shot past like an arrow.
I stood on the bank,
Watching with happy ease
The lively fish
Swimming in the clear brook.

A fisherman with his rod
Was standing there on the bank,
Cold-bloodedly watching
The fish dart to and fro . . .
"So long as the water remains clear,"
I thought, "He will not
Catch that trout
With his rod."

But at last the thief
Could wait no more.
With guile he made the water muddy.
And, ere I could guess it,
His rod jerked,
The fish was floundering on it,
And my blood boiled
As I saw the betrayed one.

The first two verses share a simple melody and harmonic accompaniment. The mood is cheerful and calm. The third verse is excited and backed by a chromatic and agitated accompaniment. The song closes with a restate-

[1]Gerard Mackworth–Young, trans., *Schubert: 200 Songs Vol. I.* (New York: International Music Company), pp. xxi–xxii.

ment of the opening melody. The popularity of *lieder* or art songs cannot be underestimated, and drew such composers as Brahms, Wagner, Wolf, Mahler, Richard Strauss, Berlioz, and Fauré.

The growth of *lieder* as an artform depended in no small manner upon nineteenth-century innovations and improvements in the piano. The instrument for which Schubert wrote had a much warmer and richer tone than earlier pianos. Improvements in pedal technique made sustained tones possible and thus gave the instrument greater lyrical potential. Such flexibility made the piano perfect for accompaniment, and, more importantly, gave it enhanced properties as a solo instrument. As a result, new works were composed solely for the piano, and these ranged from short, intimate pieces similar to *lieder* to larger works designed to exhibit great virtuosity in performance. Franz Schubert also excelled in piano compositions, as did Felix Mendelssohn and Franz Liszt. Liszt, influenced by the great violin virtuoso, Paganini, tried to bring to the piano the dazzling virtuosity of Paganini's violin. Liszt's performances and the demands of his compositions exhibited and encouraged theatricality, although less so than others, whose primary purpose was to impress audiences with flashy technical presentation. More restrained were the compositions of Frederic Chopin.

Frederic Chopin (1810–49), born in Warsaw of a Polish mother and French father, wrote almost exclusively for the piano. Each of his *études,* or technical studies, explored a single technical problem, usually around a single motive. More than simple exercises, these works explored the possibilities of the instrument and became short tone poems in their own right. A second group of compositions included short, intimate works such as preludes, nocturnes, and impromptus and dances such as waltzes, polonaises, and mazurkas. Polish folk dance tunes were particularly influential. A final class of compositions comprised larger works such as scherzos, ballades, and fantasies. Chopin's compositions were highly individualized; many were without precedent. His style was completely opposed to classicism, almost totally without standard form and having little sense of balance or structure. His melodies were lyrical, and his moods varied from melancholy to exaltation.

The close relationship of musical composition to a text, such as occurred in *lieder,* also surfaced in another area. When classical forms were not utilized, especially in longer works, significant problems arose in keeping compositions unified. As a result, romantic composers turned to building their works around a nonmusical idea. When the idea was utilized in a general way, the music was called descriptive. When the idea was more specific and applied closely throughout, the music was called programmatic or program music. These techniques were not new to the romantic period, but they did offer a flexibility and variation, which the romantics found particularly attractive and utilized with great gusto. A nonmusical idea allowed the composer to rid himself of formal structure altogether. Of course, actual practice among composers varied tremendously; some utilized programmatic material as the sole structuring device; others continued to subordinate program idea to formal structure. Nevertheless, the romantic period has become known as the "age of program music." Among the best known composers of program music were Hector Berlioz (1803–69) and Richard Strauss (1864–1949).

Berlioz' *Symphony Fantastique* (1830) employed a single motive, called an *idée fixe,* to tie the five movements of the work together. The text begins with an introduction, which familiarizes the audience with a hero who has poisoned himself because of unrequited love. However, the drug only sends him into semi-

consciousness, in which he has visions, occurring as musical images and ideas. Throughout his visions is the recurrent musical theme symbolizing his beloved (the *idée fixe*). The first movement consists of "Reveries" and "Passions." Movement two represents "A Ball." "In the Country," the third movement, he imagines a pastoral scene. In the fourth movement, "March to the Scaffold," he dreams he has killed his beloved and is about to be executed. The *idée fixe* returns at the end of the movement and is abruptly shattered by the fall of the axe. The final movement describes a "Dream of a Witches' Sabbath" in grotesque and orgiastic imagery.

Not all program music depends for its meaning or interest upon understanding its text. Berlioz believed that the audience did not have to know the text; the work could be self-sufficient without it. We, certainly, can enjoy and respond to most programmatic works, for example, Mussorgsky's *Pictures at an Exhibition,* Tchaikovsky's *Romeo and Juliet,* or Brahms's *Academic Festival Overture,* without knowing the idea or text to which they refer; but our response is even greater if we do.

However, many believe that the tone poems (or symphonic poems) of Richard Strauss require an understanding of the program. His *Don Juan, Till Eulenspiegel,* and *Don Quixote* draw such detailed materials from specific legends that program explanations and comments are integral to the works and help to give them coherence. In *Till Eulenspiegels Lustige Streiche* (Till Eulenspiegel's Merry Pranks) Strauss tells the legendary German story of Till Eulenspiegel and his practical jokes. Till is traced through three escapades, all musically identifiable. Then he is confronted by his critics and finally executed. The musical references are so specific that it is difficult to imagine any meaningful relationship with the work apart from its pro-

gram. Other program music encompasses concert overtures and incidental music and includes composers such as Bizet, Grieg, and Mendelssohn.

At the same time as these relatively innovative directions were being pursued by romantic composers, a traditional direction continued in the romantic symphony and concerto. This direction, while employing the lyrical melodic tendencies of the period, retained classical form, and produced symphonic works based solely on musical information. That is, these symphonic works are built upon musical ideas such as motives, themes, and phrases, and maintain their unity through structure as opposed to nonmusical ideas or texts. These works are known as abstract or absolute music. Their melodies, rhythms, and timbres reflect the characteristics we noted at the beginning of the chapter, and include an increasingly dense texture and greatly expanded dynamic range. Although their form maintains tradition, their effect is emotional; the listener is bathed in an overwhelmingly sensual experience. Contrasts in dynamics and timbre are stressed, and, as in painting, form, although maintained, is subordinated to expressive intent. Nonetheless, to a large degree a synthesis of classic tradition and romantic spirit has occurred, and that synthesis is quite clear in the works of Johannes Brahms, and present also in the compositions of Tchaikovsky, Mendelssohn, and Schumann.

During the romantic period there emerged, also, a new nationalism in music, much akin to the nationalistic trends in theatre during the eighteenth century. Again, the roots of such movements went deep into the past, but the political circumstances of the century served as a significant catalyst. Folk tunes and themes dominated this tendency, and localized experimentation with rhythms and harmonics created qualities, which, while still within romantic pa-

rameters, are easily associated with national identities. Such, especially, was the case in Russia, which for the most part has remained outside our examination of Western art, and with the Russian composers Glinka, Balakirev, Cui, Borodin, Mussorgsky, Rimsky–Korsakov, Rubenstein, and, of course, Tchaikovsky. These conditions also appeared in Bohemia (Czechoslovakia) with the music of Smetana and Dvořák; in Spain with Albeniz and Falla; in England with Elgar and Vaughan Williams; also in Scandinavia with Grieg; and in Germany with Wagner and Mahler.

If instrumental music ranged from single solo instrument to massive ensemble works, so did choral music, and the emotional tenets of romanticism were well served by the potential for diverse timbres and lyricism in the human voice. Nearly every major composer of the era wrote some form of choral music, which ranged from small pieces to huge ensemble works utilizing soloists, massive choruses, and full orchestras. Franz Schubert is remembered for his Masses, the most notable of which was the *Mass in A Flat Major*. Felix Mendelssohn's *Elijah* stands beside Handel's *Messiah* and Haydn's *Creation* as a masterpiece of oratorio. Hector Berlioz marshalled full romantic power for his *Requiem,* which called for 210 voices, a large orchestra, and four brass bands.

Undoubtedly, the most enduring choral work of the Romantic Period, however, was Johannes Brahms's *Ein Deutsches Requiem (A German Requiem)*. Based on selected texts from the Lutheran Bible, in contrast with the Latin of traditional requiems, Brahms's work is not a Mass for the dead as much as it is a consolation for the living. This is principally a choral work; the solos are minimal, two for baritone and one for soprano. Tonal colors in chorus and orchestra are very expressive. Melodic lines and harmonies weave highly pictorial textures. After the chorus sings "All

mortal flesh is as the grass," the orchestra elicits strong feelings of fields of grass moving in the wind. The lyrical "How Lovely Is Thy Dwelling Place" remains one of the favorite and most moving choral pieces ever written—for both performers and audience alike. An important factor in Brahms's music is its lyricism and its vocal beauty. That is, Brahms's explored the human voice as a human voice; his parts are written and his words chosen so that, while technically demanding, no voice is required to do what lies outside its tessitural or technical capacity. Such a fact is in strong contrast to many composers who treat the voice (and specific instruments for that matter) as if it were a mechanism unaffected by any restrictions. Brahms's *Requiem* begins and ends with moving passages aimed directly at the living: "Blest are They That Mourn." Hope and consolation underlie the entire work.

Finally, romanticism, its spirit, style, and time for many is summed up in the perfect synthesis of all the arts—opera. "I have written the opera with clenched fists, like my spirit! Do not look for melody; do not look for culture: in Marat there is only blood!" Such was the defiant statement of Pietro Mascagni describing his new opera *Il Piccolo Marat* in 1921. Mascagni's tantrum was the final burst of the end of an era. The preceding century and two decades produced nearly our entire contemporary operatic repertoire. In the service of that development three centers dominated: France (principally Paris), Italy, and Germany.

Paris occupied an important position in romantic opera during the first half of the nineteenth century. The spectacular quality of opera and the size of its auditoriums had made it an effective vehicle for propaganda during the revolution. As an artform opera enjoyed great popular appeal among the rising and influential middle classes. A new type of op-

era called "grand opera" emerged early in the nineteenth century, principally due to the efforts of Louis Veron, a businessman, Eugene Scribe, playwright and librettist, and Giacomo Meyerbeer, composer. Breaking away from classical themes and subject matter, these three produced spectacular productions with crowd scenes, ballets, choruses, and fantastic scenery, written around medieval and contemporary events and themes. Meyerbeer, a German Jew, studied Italian opera in Venice and produced French opera in Paris. *Robert The Devil* (1831) and *The Huguenots* typified Meyerbeer's extravagant style and achieved great popular success, although Schumann called *The Huguenots* "a conglomeration of monstrosities." More musical and controlled, as well as classically based, was Berlioz's *The Trojans* (*Les Troyans*), written in the late 1850's. At the same time Jacques Offenbach (1819–80) brought to the stage a lighter style, which mixed spoken dialogue amidst the music. Called "opera comique" this type of opera is serious in intent despite what the French word "comique" might suggest. It is a satirical and light form of opera, utilizing vaudeville humor to satirize other operas, popular events, and so forth. In between Meyerbeer and Offenbach existed a third form of romantic opera called "lyric opera." Works of Ambroise Thomas (1811–96) and Charles Gounod (1818–93) exemplified lyric opera; the composers turned to romantic drama and fantasy for their plots. Thomas's *Mignon* contains highly lyrical passages, and Gounod's *Faust,* based on Goethe's play, stresses melodic beauty.

Early romantic opera in Italy featured the *bel canto* style, which emphasizes beauty of sound. Illustrative of this substyle of romanticism were Donizetti (1797–1848), Bellini (1801–35), and, especially, Rossini (1792–1868). Rossini's *The Barber of Seville* takes melodic singing to tremendous heights and

quality. His songs are light, ornamented, and very appealing; his drama is exciting. Donizetti (*Lucia di Lammermoor*) and Bellini (*The Sleepwalker*) are much akin to Rossini in pursuit of lyrical and expressive melodies.

Often great artists stand apart from or astride general stylistic trends, exploring on their own a unique or dominant theme. Such is the case with the Italian composer Giuseppi Verdi (1813–1901). Verdi combined earthy emotions and clear expression within a nationalistic philosophy. He refined opera into a human drama consisting of simple, beautiful melody.

His long career experienced different phases. The early phase saw works such as *Rigoletto* (1851), *La Traviata* (1853), and *Il Trovatore* (1853). In these works Verdi focused upon logic and structure, using recurring themes to provide unity. Out of the second phase came *Aida* (1871), a grand opera of spectacular proportion built upon a tightly woven dramatic structure. Finally, a third phase produced operas based on Shakespearean plays. *Othello* (1887) and *Falstaff* (1893) contrast tragedy (*Othello*) and "*opera buffa*" (*Falstaff*). Both explore subtle balance among voices and orchestra, in concert with strong melodic development.

Nothing, however, represents romantic opera better than the works of Richard Wagner (1813–83) in Germany. At the heart of Wagner's prolific artistry lay a philosophy which was to affect the world of the musical and legitimate stage from the mid-nineteenth century to the present day. His ideas were laid out principally in two books: *Art and Revolution* (1849) and *Opera and Drama* (1851). Wagner's philosophy centered on the *gesamtkunstwerk,* a comprehensive work of art in which music, poetry, and scenery are all subservient to the central generating idea. For Wagner the total unity of all elements reigned supreme. Fully expressive of German roman-

tic philosophy, which confers upon music supremacy over all other arts, Wagner's operas placed music in the predominant role. Dramatic meaning unfolded through the use of *leitmotif*, for which Wagner is famous, although he did not invent it. A *leitmotif* ties a musical theme to ideas, persons, or objects; whenever those ideas, persons, or objects appear or occupy thought, the theme is played. Juxtaposing *leitmotifs* can suggest relationships between their subjects for the audience. These themes also provide the composer with building blocks, which can be utilized for development, recapitulation, and unification.

Wagner's operas are legendary. Beginning with *Die Feen* (*The Fairies*) and *Das Liebesverbot* (*The Ban on Love*), he rose to his first original, major grand opera, *Rienzi*. In 1843 he produced *Der fliegende Holländer* (*The Flying Dutchman*), followed by *Tannhäuser* (1845). *Lohengrin, Tristan und Isolde* (1857–59), and *The Ring Cycle* (1852–74), consisting of *Das Reingold, Die Walküre, Siegfried,* and *Die Götterdämmerung,* round out Wagner's operas. Each of these, and every work we have so casually treated, deserves detailed attention. However, whatever we might say by way of description or analysis would be insignificant compared to the dramatic power these works exhibit in full production. The music alone, on a recording, cannot approach the tremendous effect of these works in full production in an opera house, nor can the minuscule approximations which appear on television.

Romanticism in the arts encountered many counterreactions and opposing directions. The late nineteenth century in opera was no exception. In France an antiromantic movement, called naturalism, developed. It opposed stylization and freely presented brute force and immorality, although it maintained exotic settings. Undoubtedly the best operatic example of this movement was Georges Bizet's *Carmen* (1875), which tells the exotic story of a gypsy girl and her tragic love (Fig. 5.20). In contrast to earlier romantic works, the text for *Carmen* is in prose, rather than poetry. Set in Spain, its scenes are highly realistic, and its music, colorful and concise. Bizet's naturalism was similar to the operatic style alluded to at the beginning of this section, Italian *verismo* opera, which closed the nineteenth and began the twentieth century.

The spirit of *verismo* (cf. verisimilitude or "true to life"), is a hot-blooded, slice-of-life

Fig. 5.20. Georges Bizet. *Carmen.* Opera Company of Philadelphia. Composite photo by Trudy Cohen.

virility well characterized by Mascagni's earlier statement. The works of Mascagni, Puccini (Fig. 5.21), Leoncavallo, Giordano, Refice, and others exemplify this tradition, which comprises a type of music drama that deals exclusively with the violent passions and common experiences of everyday people. Adultery, revenge, and murder are common themes. Mascagni's *Cavalleria Rusticana* and Leoncavallo's *Il Pagliacci* are the best known examples of this melodramatic form.

Elsewhere in music the antiromantic spirit produced a style analogous to that of the impressionist painters. Even among the romantics a free use of chromatics marked later nineteenth-century style. However, a parting of the ways occurred, whose effects still permeate contemporary musical experience. On one hand free use of chromatics and key shifts stayed within the parameters of traditional major–minor tonality. On the other hand, traditional tonality was rejected completely, and a new *atonal* harmonic expression occurred. Rejection of traditional tonality gave birth to impressionism in music, a movement international in scope, but limited in quantity and quality. There was some influence from the impressionist painters, but mostly impressionism in music turned to the symbolist poets for inspiration.

Even though impressionist music was international, it is difficult, principally for want of significance or quality, to go beyond its primary champion, Claude Debussy, to find its substance. However, Debussy did not like to be called an impressionist, which is not surprising considering the fact that the label was coined by a severe critic of the painters and was applied in extremely derogatory fashion. He maintained, "I am an old romantic who has thrown the worries of success out the window," and he sought no association with the painters. However, similar motifs and characteristics can be seen. His use of tone

Fig. 5.21. Giacomo Puccini. *Manon Lescaux.* Opera Company of Philadelphia. Photo by Trudy Cohen.

color has been described as "wedges of color" applied in the same manner that the painters employed individual brushstrokes. Oriental influence also is apparent, especially in Debussy's use of the Asian five-tone scale. He wished above all to return French music to fundamental sources in nature and away from the heaviness of the German tradition. He delighted in natural scenes, as did the impressionist painters, and sought to capture the effects of shimmering light.

In contrast to his predecessors, Debussy reduced melodic development to short motives of limited range and removed chordal harmony from traditional progression. That act was perhaps his greatest break with tradition. For Debussy, and impressionists in general, a chord was considered strictly on the merits of its expressive capabilities and apart from any context of tonal progression. As a result, *gliding chords* (repetition of a chord up and down the scale) have become a hallmark of musical impressionism. Dissonance and irregular rhythm and meter further distinguish Debussy's works. Here, again, form and content are subordinate to expressive intent. His works propose to suggest, rather than to state, to leave the listener with ambiguity, with an impression, in contrast to an answer. Freedom, flexibility, and nontraditional timbres mark his compositions, the most famous of which is *Prélude à l'après-midi d'un faune,* based on a poem by Malarmé. The piece utilizes a large orchestra, with emphasis on the woodwinds, most notably in the haunting theme running throughout. Although freely ranging in an irregular $\frac{9}{8}$ meter and having virtually no tonal centers, *Prélude* has a basically traditional ABA structure.

Theatre

"The playgoing world of the West-end is at this moment occupied in rubbing its eyes, that it may recover completely from the dazzle of Thursday last, when, amid the ac-clamations of Queen Victoria's subjects, King Richard the Second was enthroned at the Princess's Theatre." Thus began the reviewer's comments in *The Spectator,* March 14, 1857. The dazzle of scenery, revivals, and a potpourri of uncertain accomplishments helped a stumbling theatre to keep up with its romantic brethren through the early years of the nineteenth century.

Romanticism as a philosophy was its own worst enemy in the theatre. Artists sought new forms to express great truths and strove to free themselves from neoclassical rules and restraints. To reiterate, form was subordinate to expression. Significantly, Shakespeare was seen as exemplary of new ideals and symbolized freedom from structural confinement. Intuition reigned, and genius, being apart from everyday humankind, placed its holder above or beyond normal constraints. As a result, the romantic writer had no use for any guide but his own imagination. Unfortunately the theatre operates within some rather specific limits. So many nineteenth-century playwrights penned scripts that were totally unstageable and/or unplayable, that the era justly gained its reputation for dramatic barrenness. It seemed that great writers could not constrain themselves to the practicalities of the stage, and the hacks, yielding to popular taste, could not restrain themselves from overindulgence in phony romantic emotionalism, melodrama, and stage gimmickery. As a result, the best romantic theatre came from the pen of William Shakespeare, brought out of his Elizabethan "theatre of convention" into nineteenth-century antiquarianism. Be that as it may, the romantic period succeeded in shaking loose the arbitrary "rules" of neoclassicism, thus paving the way for a new era in the later years of the century.

The audiences of the nineteenth century played a significant role in what took the stage. Royal patronage was gone, and what

was to be staged required box office receipts to pay its bills. A rising middle class swelled the eighteenth-century audience, changing its character. The nineteenth century witnessed the addition of the lower classes to its houses. The Industrial Revolution, as we noted, brought about larger urban populations, expanded public education to a degree, and sent feelings of egalitarianism throughout European and American social orders. All this swelled theatre audiences, and, literally, caused an explosion of theatre building. Audience diversity and capitalistic entrepreneurship caused theatre managers to program to the popular as well as sophisticated taste. In order to offer something to everyone, an evening's theatre program might contain several types of fare and last upwards of five hours. The consequence was predictable. Fewer and fewer sophisticated patrons chose to attend, and quality declined in direct proportion.

However, by 1850 a semblance of order returned, and specialization occurred so that certain theatres offered certain types of fare, thus returning the sophisticated playgoer to the theatre with quality to suit that level of expectation. Nevertheless, the multiproduction evening remained a typical one until nearly the turn of the twentieth century. In any case, audience demand was high, and theatre continued to expand. Continental Europe, especially, witnessed problems during the Napoleonic Wars and the depression which followed, but by 1840 prosperity enhanced the state of the Western theatre immensely.

In our first look at theatre in Athens in Chapter One, I mentioned that a playwright is always a man of his theatre. Given the comments just made, perhaps we should modify that statement to say that a successful playwright is always a man of his theatre. In the early nineteenth century the theatre of which the playwright needed to be a part consisted of several characteristics. First of all was the repertory company. The company comprised a set group of actors, including "stars," that is, leading actors and actresses, and arranged its performances around a "season." Each season consisted of several productions. (That is quite unlike our contemporary professional theatre in which each play is produced and cast independently and runs for as long as it shows a profit.) Gradually, better known actors began to capitalize on their reputations (and sometimes were exploited by the same), and began to tour, starring in local productions and featuring their most famous roles. A virtual craze for visiting stars developed and "'round-the-world" tours became a habit for the most famous. With the increase in touring stars also came an increase in touring companies, and in the United States, especially, these companies, including star attractions and complete sets of costumes and scenery, were a regular feature of the landscape. By 1886 America boasted 282 touring companies. At the same time local resident companies decreased appreciably, except in Germany whose nationalism produced a series of local, state-run theatres.

The theatres in which all this took place consisted of a diverse lot, although several generalities can be drawn. Principally the changes in nineteenth-century stages and staging came about as a result of increased interest in historical accuracy and popular demand for depiction rather than convention. Prior to the eighteenth century, history was considered irrelevant to art. However, knowledge of antiquity through archeological excavation in Pompeii, as we noted, aroused curiosity; romantic desire to escape to the "far away and long ago" decreed that the stage picture represent those places and represent them in a "real" sense. At first such detail was utilized only inconsistently, but by 1823 claims were made to the "completely historical" nature of the entire production. Historical accuracy occurred as early as 1801

in the Berlin production of Schiller's *The Maid of Orleans,* and Victor Hugo and Alexandre Dumas, *père,* insisted on historically accurate settings and costumes in France in the early years of the century. However, it remained for Charles Kean and London in the 1850's to bring the spectacle of antiquarianism fully to fruition (Figs. 5.22 color and 5.23 color).

The onset of realism as a standard for production led to three-dimensionality in settings and then, away from drop and wing scenery to the box set. The stage floor was leveled (since the Renaissance it had been *raked,* that is sloping upward slightly from downstage to upstage). New methods of shifting and rigging were devised to meet specific staging problems. Over a period of years all elements of the production were integrated into a total aesthetic unity, much in the spirit of Wagner's *gesamtkunstwerk.* The distraction of scene changes (which were numerous) was alleviated by closing the curtain to hide stage hands.

Stage space itself became clearly defined and separated from the audience. Rather than playing on the forestage between audience-occupied stage boxes, the actors moved upstage, within the confines of the scenery. Inventions in the use of gaslight made control of light possible; the audience area was darkened and stage light, controlled. An isolated and self-contained stage world was created.

All of the foregoing comprised the "theatre" of which playwrights were or were not a part, and there were many of the latter variety. Goethe's *Faust Part I* was basic to romantic drama as discussed in the last chapter. It also was virtually unstageable. In romantic philosophy art and literature were linked inextricably. Plays often were seen and studied as "literature." The theatre-literature link of the nineteenth century brought writers to the theatre who were not of the theatre; their inexperience was complicated by romantic disregard for practicality, and the result was problematic to say the least.

Victor Hugo occupied the position of nearly a god in the artistic community of Paris. After two aborted attempts (one at the hands of the state censor), he finally succeeded in producing on his third attempt, the play *Hernani.* An earlier diatribe against the neoclassicists succeeded in filling his audience with revenge-seekers who were determined that *Hernani* would fail. The production was a shambles. However, beyond the turmoil of the time, *Hernani,* though written by a master writer, is not a very good play. Characters violate their own integrity; "honor" is carried to ridiculous extremes; and the ending is totally contrived. Nonetheless, the poetry is lyrical and charming, and Hugo's brave assault on the bastions of French neoclassicism did open a few doors for romantic dramatists, not the least of whom was the novelist Alexandre Dumas, *père* (1802–70). His prose work *Henry III et sa cour* (1829) enjoyed success at the *Comédie-Française,* and it did much to popularize the romantic movement through its introduction of justified illicit love.

In England revivals of Shakespearean plays enjoyed more success than contemporary works. The Romantic poets Coleridge, Wordsworth, Byron, Keats, and Shelley attempted playwrighting. A few of their works were produced, but all suffered from the maladies noted previously. James Sheridan Knowles (1784–1862), an actor, enjoyed some success as a playwright, mingling Shakespearean verse with melodramatic stories in *Virginius* (1820), *William Tell* (1825), and the *Hunchback* (1832).

Heinrich von Kleist (1777–1811) carried the German theatre into the nineteenth century along with Goethe and Schiller. His *Prince of Hamburg* (1811) tells the story of a young officer so desirous of fame that he defies orders in order to win a victory. His suc-

cess does not excuse his endangering the entire army, and so he is condemned to death. Only after realizing that his ego must be subordinate to service and the good of all is he spared. Another German playwright, Georg Buchner (1818–37), in *Danton's Death* (1835) illustrates the pessimistic side of romanticism. The dashing of hopes resulting from Napoleon's despotism and defeat is reflected in this story of idealism crushed by pettiness. *Woyzek* also expresses disillusionment, but it does so in a remarkably modern psychological study.

The popular side of theatre production in the nineteenth century gave birth to a romantically exaggerated form called *melodrama*. Typically this form or *genre* is characterized by sensationalism and sentimentality. Characters tend to be stereotyped; problems, solutions, and people tend to be all good or all evil. Plots are sentimental and the action, exaggerated. A strict moral code must be observed, as well. Regardless of circumstances, good must be rewarded and evil, punished. Often melodrama employs some form of comic relief, usually through a minor character. Action progresses at the whim of the villain, and the hero is forced to endure episode after episode of superhuman trial. Suspense is imperative and reversal at the end, obligatory. The term *melodrama* implies music and drama, and in the nineteenth century these plays were accompanied by a musical score tailored to the emotional or dynamic character of the scene. Actual practice was very similar to the use of contemporary movie and television scores, but melodrama's music also often included incidental songs and dances used as "curtain raisers" and "entr'acte" entertainment.

Melodrama was popular throughout Europe and the United States, and playwrights such as Kotzebue and Pixérécourt enjoyed great success. In the United States, *Uncle Tom's Cabin,* based on the novel by Harriet Beecher Stowe (1852), took the stage by storm. The stage version was opposed by Mrs. Stowe, but copyright laws did not exist to protect her. Nevertheless, the play, in a number of versions, represents the same complex themes of slavery, religion, and love. The action involves a number of episodes, some of which are rather loosely connected. Characteristic of melodrama, *Uncle Tom's Cabin* places considerable emphasis on spectacle, the most popular of which at the time was Eliza's crossing the ice with mules, horses, and bloodhounds in pursuit.

In line with trends in philosophy and the other arts, a conscious movement toward realism in the theatre emerged around the middle of the century. Such a movement brought significant change, and by 1860 one could find in dramatic literature a striving for verisimilitude, that is, a truthful portrayal of the real world. Objectivity was stressed, and knowledge of the real world was seen as possible only through direct observation. Corot's approach to painting showed a similar viewpoint. As a result, contemporary life, that is, life with which the playwright was directly familiar, became the subject matter of drama. Insight turned from the utopian past and exotic places to an investigation, and, to a large extent, idealization of human motives. Exposure to current and mundane topics on the stage was not particularly pleasant for many playgoers, and objection to turning the theatre into a "sewer or a tavern" came from many quarters. Playwrights responded that the way to avoid such ugly depiction on the stage was to change it in society; the fault lay in the model, and not in the messenger.

Translating contemporary life realistically into dramatic form required a thorough knowledge of theatre practicality and presentation. A workable solution to that problem, which had plagued the romantics, came from Eugene Scribe (1791–1861). Scribe was a

master of plot manipulation, and as a play-wright was better able to mold a dramatic structure than the vague romantics. His early success came through well-plotted comedies of intrigue, and although his characterizations were very weak, his ability to put together a comprehensible action gave him great influence in his time and later. Scribe perfected a form known as the "well-made play," and his formularized approach to play-wrighting allowed him and his "factory" of collaborators to turn out plays in great numbers. His formula was straightforward: present a clear exposition of the situation; carefully prepare events that will happen in the future; provide unexpected but logical reversals; build suspense continuously; bring the action to a logical and believable resolution. The crux of the well-made play was logic and cause-to-effect relationships.

The realistic movement in nineteenth century theatre found followers in Alexandre Dumas, *fils* (1824–95), and Émile Augier (1820–89), both of whom were greatly concerned with social problems. The former's *The Lady of the Camellias,* also known as *Camille,* was dramatized from his novel in 1849 (though not produced until 1852) and achieved phenomenal worldwide popularity. Its central character grew to legendary status. *Camille* is the story of a courtesan with a heart of gold who comes to a cruel fate. Although Dumas probably was only interested in painting a picture of French society, not in creating sentimentality, the play is sentimental, romantic, and tearful. It is a sincere portrayal of youthful passion, and, unlike most melodrama, it contains no rescue at the end; Camille dies in her lover's arms.

Another well-known, late nineteenth-century Romantic amid the realists was Edmond Rostand (1868–1918). Rostand wrote with excitement and passion, and his *Cyrano de Bergerac* has challenged the leading actors of the last century. Cyrano is a dashing, literate

romantic, whose courage is unequalled, as is his one great flaw, his grotesque nose. Cyrano's death scene rivals any in the annals of theatre for passion, and for length!

However, the acknowledged master of realistic drama was Norway's Henrik Ibsen. Ibsen took the format of Scribe's well-made play, eliminated many of its devices, and built powerful, realistic problem–dramas around careful selection of detail and plausible character-to-action motivations. His exposition usually is meticulous, and the play itself tends to bring to conclusion events that began well in the past. Ibsen's concern for realistic detail carries to the *mise en scène,* and his plays contain detailed descriptions of settings and properties, all of which are essential to the action.

Many of Ibsen's plays were controversial. Most still present pertinent and significant questions concerning social and moral issues and personal relationships. *The Pillars of Society, A Doll's House* (1879), *Ghosts* (1881), *An Enemy of the People* (1882), *The Wild Duck* (1884), *Rosmersholm* (1886), *Hedda Gabler* (1890), *The Master Builder* (1892), and *When We Dead Awaken* (1899) all speak to a realistic philosophy and form a cornerstone for contemporary drama.

Realism spread throughout the world, finding excellent reflections in the works of Arthur Wing Pinero (1855–1934), Henry Jones (1851–1929), John Galsworthy (1867–1933), and Anton Chekhov (1860–1904), although Chekhov frequently departs from realism, as Ibsen occasionally did, to incorporate significant symbolism in his works. Anton Chekhov is regarded by many critics as fundamental to modern realism. His themes and subject matter were drawn from Russian daily life, and they are realistic portrayals of frustration and the depressing qualities of mundane existence. His structures flow in the same apparently aimless manner as do the lives of his characters. The-

atricalism and compact structure are noticeably absent. Nonetheless, his plays are skillfully constructed so as to give the appearance of reality.

The spirit of realism in England can have no better representative than George Bernard Shaw (1856–1950), whose wit, cleverness, and brilliance are without equal. Shaw's career overlapped the nineteenth and twentieth centuries, and illustrates how difficult it is adequately to categorize, even chronologically, the works and ideas of great artists. However, this great artist was above all a humanitarian; his beliefs (if they may be called that) were shocking to Victorian society. Considered a heretic and a subversive (because of his devotion to Fabian socialism), his trust and faith lay in humanity and its infinite potential.

Shaw's plays exhibit originality and the unexpected, and often appear contradictory and inconsistent in characterization and structure. His favorite device was the construction of a pompous notion only to destroy it. For example, in *Man and Superman* a respectable Victorian family learns that their daughter is pregnant, to which they react with predictable indignation. To the girl's defense comes a character who obviously speaks for the playwright. He attacks the family's hypocrisy and defends the girl. However, the girl explodes in anger, not against her family, but against her defender. She has been secretly married all the time; and as the most respectable of the lot, she abjure's her defender's free-thinking (and that of the audience who thought they had comprehended the playwright's point of view).

Shaw opposed "art for art's sake" and insisted that art should have utility. For example, a play was, for Shaw, a more effective means of transmitting social messages than were speaker's platforms and pamphlets. His pursuit of message through dramatic device is exceptionally skillful, and he succeeds, often despite weak characterizations, in pointing out life's problems through a chosen character in each play who acts as the playwright's mouthpiece. But he does more than sermonize. His plays show deep insight and understanding. His characters probe the depths of the human condition and often discover themselves through crisis, all in a logical, reasonable, and realistic portrayal of life.

A style closely related to realism, that is naturalism, occurred in the same period and is illustrated in the writings of Émile Zola, who was more a theoretician and novelist than he was a playwright. The essential differences between realism and naturalism often are debated. Both insisted on truthful depiction of life; naturalism went on to insist on scientific methodology in the pursuit of art and adherence to demonstrating that behavior is determined by heredity and environment (behaviorism). Absolute objectivity, not personal point of view, dominated the naturalistic viewpoint.

Late in the nineteenth century, and for the most part disappearing shortly thereafter, came an antirealistic movement called symbolism also appearing as neoromanticism, idealism, or impressionism. It erupted briefly in France, and has recurred occasionally throughout the twentieth century; it held that truth can be grasped only by intuition, not through the five senses or rational thought. Ultimate truth could be suggested only through symbols, which evoke various states of mind corresponding vaguely with the playwright's feelings. A principal dramatic symbolist, Maurice Maeterlinck (1862–1949) believed that every play contains a second level of dialogue, which seems superficial, but which actually speaks to the soul. He believed that great drama contains verbal beauty, contemplation, and passionate portrayal of nature and our sentiments, and an idea which the poet forms of the unknown. Therefore, plays (which contain human ac-

tions) only suggest, through symbols, higher truths gained through intuition. The symbolists did not follow the realists' path in dealing with social problems. Rather they turned to the past, and, like the neoclassicists, tried to suggest universal truths independent of time and place. Maeterlinck's *Pelléas and Mélisande* (1892) and *The Blue Bird* (1911) are excellent examples of symbolist plays.

The curtain fell on nineteenth century theatre with two significant developments. First was the emergence of production unity as a principal aesthetic concern. To that end the production director was assigned the overriding responsibility to control unity. That consideration remains fundamental to modern theatre practice and owes its emergence principally to Georg II, Duke of Saxe–Meiningen (1826–1914). The second development was the emergence of the independent theatre movement in Europe, from which came France's *Théâtre Libre,* and Berlin's *Freie Bühne,* both champions of realism and naturalism, London's Independent Theatre, organized to produce theatre of "literary and artistic rather than commercial value," and the Moscow Art Theatre, founded by Constantin Stanislavsky, the most influential figure in acting and actor-training in the twentieth century. The significance of these theatres lay in the fact that they were private theatres, open only to members. As a result, they were free of the censorship that dominated public theatre. Consequently, they nurtured free experimentation and artistic development, which gave birth to a truly modern twentieth-century theatre.

Dance

In a totally unrehearsed move, a ballerina leaped from the tomb on which she was posed and narrowly escaped a piece of falling scenery. That and other disasters plagued the opening night performance of Meyerbeer's *Robert the Devil* in 1831. However, the novelty of tenors falling into trapdoors, and falling stagelights and scenery was eclipsed by the startling novelty of the choreography for this opera. Romantic ballet was at hand. To one degree or another, opinion in all the arts turned against the often cold formality of classicism and neoclassicism; the subjective, not the objective viewpoint, feeling, rather than reason, sought release.

Since we cannot hold even part of an artwork up for examination in this discipline, we need to rely on other materials to gain an understanding of romantic ballet. Two sources are helpful: the writings of Theophile Gautier and Carlo Blasis. Gautier was a poet and critic, and his aesthetic principles held first of all that beauty was truth: a central romantic conception. He rejected Noverre and Vigano, who believed that every gesture should express meaning. Rather, Gautier believed that dance was visual stimulation to show "beautiful forms in graceful attitudes." "The true, the unique, the external subject of ballet is dancing."[2] No deeper meaning was allowed; passion was limited to love. Dancing for Gautier was like a living painting or sculpture—"physical pleasure and feminine beauty." Whether admirable, helpful, or not, his unbridled desire to focus on ballerinas placed sensual enjoyment and eroticism squarely at the center of his aesthetics. Gautier's influence was significant, and from his philosophy emerged the central role of the ballerina in romantic ballet. Male dancers were relegated to the background, strength being the only grace permissible to them. Gautier and his philosophy proved important as the inspiration for an 1841 work, *Giselle,* often called the greatest achievement in romantic ballet. *Giselle,* however, is a bit ahead of us.

[2]Walter Sorrell, *Dance through the Ages* (New York: Grosset and Dunlap; 1967), p. 138.

The second general premise for romantic ballet was similar to Gautier's and came from *Code of Terpsichore* by Carlo Blasis. He found Noverre and Vigano too experimental, revolutionary, and in "bad taste." Much more systematic and specific than Gautier (Blasis was a former dancer) his principles enveloped training, structure, and positioning. All matters of ballet required a beginning, a middle, and an ending, and the basic "attitude" in dance (modelled on Bologna's statue "Mercury," Fig. 3.25) was that of standing on one leg with the other brought up behind at a ninety-degree angle with the knee bent . The dancer needed to display the figure with taste and elegance. To achieve the ends of ballet and to achieve proper position, the dancer was required to train each part of the body; the result was grace without affectation. From Blasis came the fundamental "turned-

Fig. 5.24. From "The Art of Dancing" by Carlo Blasis. Courtesy, Dance Collection, New York Public Library, Cia Fornaroli Collection.

out position," which rules ballet today (Figs. 5.24 and 5.25). In contrast to Gautier's thinking, gesture and pantomime were seen as the "very soul and support" of ballet. Finally, Blasis, like Gautier, placed the female at the center of ballet, removing the male to the background. These broad principles, then, provided the framework and to a great extent a summary of objectives for romantic ballet: delicate ballerinas, lightly poised, sweetly gracious, costumed in soft tulle, and moving *en pointe,* with elegant grace.

Robert the Devil, mentioned earlier, probably was the first truly romantic ballet. It told the story of Duke Robert of Normandy, his love for a princess, and an encounter with the devil. The ballet contains ghosts, baccanalian dancing, and a spectral figure who was danced by Marie Taglione.

Taglione went on to star in perhaps the

most famous of all romantic ballets, *La Sylphide* (1832). Here the plot centered on the tragic impossibility of love between a mortal and a supernatural being. A spirit of the air, a sylph, falls in love with a young Scot on his wedding day. Torn between his real fiancée and the ideal, the sylph, he deserts his fiancée to run off with the spirit. A witch gives him a scarf, and, unaware that it is enchanted, he ties it around the spirit's waist. Immediately her wings fall off, and she dies. The sylph drifts away to some sylphidic Heaven, and the young man is left disconsolate and alone as his fiancée passes in the distance with a new lover on the way to her wedding. The setting in Scotland was exotic, at least to Parisians. Gaslight provided a ghostly and moonlit mood enhanced by a darkened auditorium. Taglione's dancing of the role of La Sylphide proved unbelievably light and delicate, "a creature of mist drifting over the stage" (assisted by "flying" machinery). Taglione's lightness, poetic delicacy, and modest grace established the standard for romantic style in dancing. The story, exotic design, and modal lighting completed the production style, which was to triumph for the next forty years: "moonbeams and gossamer," as some have described the era.

Choreographers of romantic ballet sought magic and escape in fantasies and legends. Ballets about elves and nymphs enjoyed great popularity, as did those about madness, sleepwalking, and opium dreams. Fascinating subject matter came to the fore, for example, harem wives revolting against their oppressors with the help of the "Spirit of Womankind," in Filippo Taglione's *The Revolt in the Harem* (possibly the first ballet about the emancipation of women). Not only did women come to prominence as ballerinas and in subject matter, but also as choreographers.

Romantic staging, especially in ballet, was aided significantly by improvements in stage machinery and lighting. Flickering gloom

Fig. 5.25. Basic "turned out" or "open" position. Dancer: Kathleen Cantwell. Photographer: Wayne Upchurch.

and controlled darkness and shadows added greatly to the mystery of stage scenes, achievements previously impossible when candles provided sources of light. Gaslight, however, proved a mixed blessing. Its volatility and open flame made fire a constant danger, and the gauzy *tutus,* characteristic of the period and style, undoubtedly consisted of the most flammable material ever invented. During a performance of *The Revolt in the Harem,* a ballerina brushed an oil burner. Her dress caught fire, and she rushed around the stage in a blaze of flame. By the time a stagehand could extinguish the fire, she was fatally burned and died two days later. Ironically, in rehearsal for *Le Papillon* (*The Butterfly*), another grotesque incident occurred. The story concerns a heroine, changed into a magic butterfly, who darts toward a torch until the flame shrivels her wings. The ballerina playing the role brushed against a gaslight fixture, her costume burst into flame, and she lingered in agony for eight months before dying of her burns. Only a day before, the management had insisted that the dancers dip their costumes in a flame-proofing solution; she had refused, insisting that the solution made her *tutu* look dingy.

With reference to the earlier comment concerning Gautier's influence on *Giselle* (1841), this ballet marks the height of romantic achievement. Adolphe Adam, known for his piece "O Holy Night," composed the score; Heinrich Heine, the German poet, provided the legend—via a scenario by Gautier and a libretto by Vernoy de Saint-Georges. The prima ballerina was Carlotta Grisi. The choreography was created by Jean Coralli, ballet master at the Paris Opera, although, apparently, Jules Perrot, Carlotta's teacher, choreographed all of her dances, and in them lies the essence of the ballet.

The ballet contrasts two typically romantic acts: one in sunlight (Act I) and one in moonlight (Act II). In a Rhineland village during a vine festival Giselle, a frail peasant girl in love with a mysterious young man, discovers that he is Albrecht, Count of Silesia. Albrecht already is engaged to a noblewoman. Giselle is shattered. In madness she turns from her deceitful lover, tries to commit suicide, swoons, and falls dead. In Act Two Giselle is summoned from her grave, deep in the forest, by Myrtle, Queen of the Wilis (spirits of women who, having died unhappy in love, are condemned to lead men to destruction. The word "wili" comes from a Slavic word for "vampire"). When a repentant Albrecht comes to bring flowers to Giselle's grave, Myrtle orders her to dance him to his death. Rather, Giselle protects Albrecht until the first rays of dawn break Myrtle's power.

Giselle contains many fine dancing roles for women and men and has been a favorite of ballet companies since its first production. Carlotta Grisi was acclaimed for her "tender melancholy."

Jules Perrot's characterizations and choreography often spread focus among the corps. His ballets generally had skillfully drawn characterizations, which encompassed all social classes. His heroes frequently were men of humble birth, and he continued to provide male dancers good parts even in an era dominated by Gautier's disdain for the *danseur.* One of Perrot's major accomplishments was the choreography for *Pas de Quatre* (1845) at Her Majesty's Theatre, London. In an awesome gamble he brought together the four major ballerinas of the day, Taglione, Cerrito, Grisi, and Grahn. His purpose was to allow each star to shine—without permitting any one to upstage the others! A decision that the dancers would perform in order of age, with the oldest last, defused a raging conflict over who would perform in the place of honor (the last solo), and the ballet went forward to earn plaudits from Queen Victoria and London at large.

Fig. 4.3. *RIGHT.* François Boucher. "Venus Consoling Love." Canvas. 42⅛ × 33⅜". National Gallery of Art, Washington, D.C. Chester Dale Collection, 1943.

Fig. 4.6. *BELOW.* Jean Chardin. "The Young Governess." Canvas. 22⅞ × 29⅛". National Gallery of Art, Washington, D.C. Andrew W. Mellon Collection, 1937.

Fig. 4.10. *LEFT.* Etienne Maurice Falconet. "Madame de Pompadour as the Venus of the Doves." Marble. $29\frac{1}{4}$ × 28 × 18. National Gallery of Art, Washington, D.C. Samuel H. Kress Collection, 1952.

Fig. 5.5. *BELOW.* Camille Corot. "A View Near Volterra." Canvas. $27\frac{3}{8}$ × $37\frac{1}{2}$". National Gallery of Art, Washington, D.C. Chester Dale Collection, 1962.

Fig. 5.22. Shakespeare's Richard II. Charles Kean's production. London, 1857. Between Acts III and IV. Entry of Bolingbroke into London. Courtesy Victoria and Albert Museum, London.

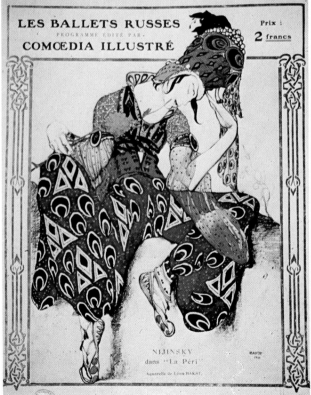

Fig. 5.23. *ABOVE.* Shakespeare's Richard II. Charles Kean's production. London, 1857. Act II, scene 2. Entrance into St. Stephen's Chapel. Courtesy Victoria and Albert Museum, London.

Fig. 6.26. *LEFT.* Costume design by Alexandre Bakst. 1911. Crown copyright the Victoria and Albert Museum, London.

Russian composers and playwrights entered our discussion in this chapter. Traditionally Eastern in orientation, Russia had opened up to the West tentatively in the seventeenth and eighteenth centuries. By the nineteenth century the country had turned attention consciously toward the rest of Europe and Russian artists, thereby, emerged as part of the tradition of Western arts. This was certainly true in dance. In St. Petersburg in 1862 an English ballet called *The Daughter of Pharoah,* choreographed by Marius Petipa, sent Russian audiences into rapture. Nonetheless, Russian ballet was not new. As early as 1766 Catherine II had established the Directorate of the Imperial Theatres to supervise ballet, opera, and dance.

Petipa had come to Russia from France in 1842, and he remained a central force in Russian ballet for almost sixty years. By the middle of the nineteenth century, ballet companies flourished in Moscow and St. Petersburg; dancers occupied positions of high esteem in Russia, in strong contrast to their lot in the rest of Europe. Petipa's influence carried Russia forward in a quasi-romantic style. He shared the sentimental taste of his time, but his ballets often consisted of very strange elements and numerous anachronisms. Minor characters might wear costumes suggesting period or locale, but the stars wore conventionalized garb, often of classical derivation. Prima ballerinas often appeared in stylish contemporary coiffures and jewels, even if playing the role of a slave. *Divertissements* often were inserted into a ballet; lyrical and sustained movements predominated. Petipa included many different kinds of dance in his ballets: classical, character, folk, and demi-character dance. Mime played an important role as well. The inclusion of all these various elements in a panoramic display gave Petipa's Russian choreography a variety and richness that was interesting and attractive. His creative approach and reliance on convention more than compensated for his anachronisms. As some have said on his behalf, "No one criticized Shakespeare for having Anthony and Cleopatra speak in blank verse."

Petipa and his ballets demanded excellent dancers, and so the Imperial School grew to include outstanding teachers, who produced outstanding pupils. From this close collaboration grew a Russian style, which contained elements of French, Danish, and Italian traditions. Also from this Russian school, and choreographed by Petipa's associate Lev Ivanov, came the ever-popular *The Nutcracker* and *Swan Lake* (partially choreographed by Petipa), the scores for both of which were composed by Tchaikovsky. *Swan Lake* was first produced in 1877 by the Moscow Bolshoi, and *The Nutcracker,* in 1892. *Swan Lake* popularized the *fouetté* (a whipping turn), introduced by the ballerina Pierina Legnani in Petipa's *Cinderella* and incorporated for her in *Swan Lake.* She danced thirty-two consecutive *fouetté's,* and to this day that number is mandatory; balletomanes carefully count to be sure the ballerina executes the required number. Russian ballet emphasized technique; strong, athletic movements remain characteristic of its productions today.

Late in the century ballet declined in quality although not necessarily in popularity; but middle-class popularizing had a stultifying effect and also turned dance efforts in a new, hedonistic direction. (Given Gautier's barely submerged eroticism, however, the direction probably was not all that new). The same sensual desires that brought many to the ballet also took them to the dance hall, of which the *Moulin Rouge* was the most famous and the *cancan,* the object. The posters of Toulouse Lautrec and Seurat capture the spirit of this age and fascination remarkably (Fig. 5.26). It also was the age of the *Folies-Bergère* to which a young American named Loie Full-

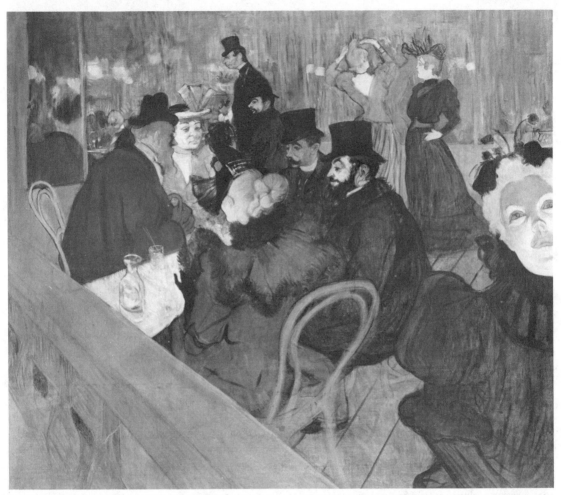

Fig. 5.26. Toulouse Lautrec. "At the Moulon Rouge." Courtesy of The Art Institute of Chicago. Helen Birch Bartlett Memorial Collection.

er came in 1892. Probably not much of a dancer (she had only a few lessons), and certainly not a ballerina, nevertheless Miss Fuller created, in her "Butterfly Dance," "White Dance," "Violet Dance," and "Fire Dance," a "new" thrust and experimentation in theatre dance that was later to break the bonds of a sterile ballet and point toward a new century of dance, which we know as "modern."

Architecture

The nineteenth century was an age of increased individualism and subjective view-

point. However, what is possible by way of experimentation for the painter, sculptor, musician, choreographer, and to some degree, the playwright, is not always possible for the architect. An architect's work involves a client who must be satisfied, and its results are public and permanent.

The use of Greek and Roman forms after 1750 has been called classical revival or neoclassicism. Basically this revival can be broken into two general periods—Roman prior to 1815 and Greek from then on. Often the plethora of terms describing this period can

be confusing, and not the least of these is the term romantic classicism. However, such a label is not as contradictory as one might suspect if one considers "classical" as a description of architectural detail and "romantic" as a philosophy of individualized, intuitive creation, emphasizing, among other things, "the far away and long ago," which, of course, Greece and Rome were. Other confusing terms occurring in relation to this era include "federal style," which, essentially is a specific substyle of the romantic era's resurrection of ancient prototypes.

Benjamin H. Latrobe's Catholic cathedral in Baltimore (Fig. 5.27) can illustrate many of the principles at issue here. In this view the Ionic orders of Athens are visible in the alcove behind the altar, while a Roman dome, like the Pantheon's, dominates the nave. However, these basically "classical" forms are modified significantly and added to with numerous individualized details. Traditional Roman semicircular arches flank the central opening above the altar; yet that arch and its complements are flattened and also broken by cantilevered balconies. Whimsical, starlike decoration marks the dome, and a misty panorama of painted scenes winds over and through the modified pendentives.

Romanticism, however, also focused on other eras and produced a vast array of build-

Fig. 5.27. Benjamin H. Latrobe. Basilica of the Assumption. 1805–18. Baltimore, Maryland. Photo by Joseph F. Siwak, courtesy of The Catholic Review.

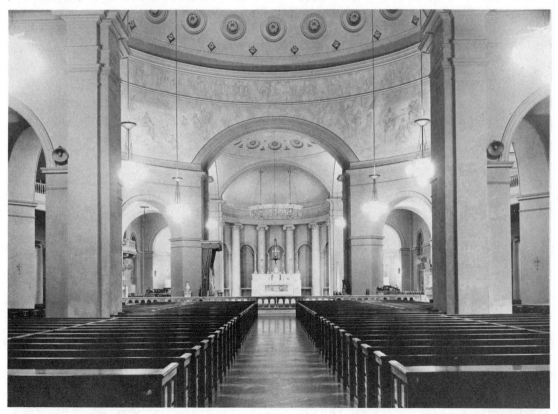

ings reviving Gothic motifs and reflecting fantasy, which has come to be known as "picturesque." Eastern influence and whimsy abounded in John Nash's Royal Pavilion in Brighton, England (Fig. 5.28). "Picturesque" also applies to the most famous example of romantic architecture, the Houses of Parliament (Fig. 5.29). The Houses of Parliament imply more than an escape into fantasy, however. A significant concept has been reflected in this building, which embodies a modern tendency in architectural design. The exterior walls function as a screen. They reflect nothing of structure or of interior design and utilization. What we find inside has absolutely no spatial relationship to the outside. Significant also is the strong contrast of forms and totally asymmetrical balance.

The nineteenth century was, as we have seen, an age of industry, of experimentation and new materials. In architecture steel and glass came to the fore. However, at first it took courage for an architect actually to show structural honesty by allowing support materials to be seen as part of the design itself. England's Crystal Palace exemplified the nineteenth century fascination with new materials and concepts. Built for the Great Exhibition of 1851, this mammoth structure was completed in the space of nine months. Space was defined by a three-dimensional grid of iron stanchions and girders, designed specifically for mass production and rapid assembly (in this case, disassembly as well: The entire structure was disassembled and rebuilt in 1852–54 at Sydenham). Like its cousin, the Houses of Parliament, the Crystal Palace was an outgrowth of the growing dichotomy between the function of a building as reflected in the arrangement of the interior spaces, its sur-

Fig. 5.28. John Nash. Royal Pavilion, Brighton, as remodeled, 1815–23.

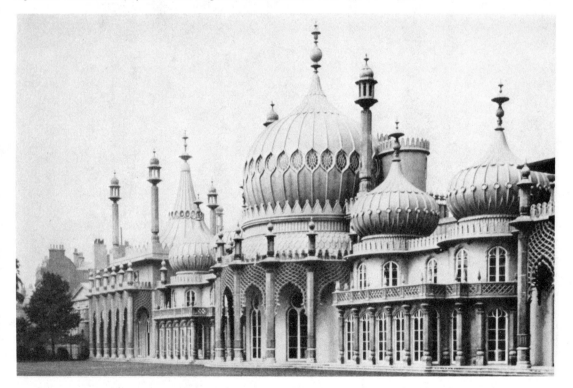

Fig. 5.29. Sir Charles Berry. Houses of Parliament. 1840–65. London.

face decoration, and its structure. A new style of building had arrived.

A new age of experimentation also took nineteenth-century architects in a different direction—upward. Late in the period the skyscraper emerged, a solution for the need to create commercial space on limited property in burgeoning urban areas. Burnham and Root's Monadnock building in Chicago (Fig. 5.30) was an early example. Although this prototypical "skyscraper" is all masonry, that is, built completely of brick and requiring increasingly thick supportive walls toward its base, it continued the movement to combine design, materials, and new concepts of architectural space. When all these elements were finally combined, the skyscraper emerged—almost exclusively in America. Architects were able to erect buildings of unprecedented height without increasing the thickness of lower walls by erecting struc-

tural frameworks (first of iron, later of steel) and by treating walls as independent partitions. Each story was supported on horizontal girders. Reflective of the close interrelationship of forces in the age of industry, none of these concepts or practicalities could be brought to completion until a man named Otis invented a safe and reliable elevator.

Most influential in the development of the skyscraper and philosophies of modern architecture was Louis Sullivan, the first truly "modern" architect. Working in Chicago, then the most rapidly developing metropolis in the world, in the last decade of the nineteenth century, Sullivan designed buildings characterized by dignity, simplicity, and strength. Most importantly, he created a rubric for modern architecture by combining form and function into a theory in which the former flowed from the latter. As Sullivan illustrated to an observer of the Carson, Pirie,

Fig. 5.30. Burnham and Root. Monadnock Building. 1891. Chicago.

Fig. 5.31. Louis H. Sullivan. Carson, Pirie, and Scott Department Store. 1899–1901, 1903–4. Chicago.

and Scott Building (Fig. 5.31), "It is evident that we are looking at a department store. Its purpose is clearly set forth in its general aspect, and the form follows the function in a simple, straightforward way."

The final years of the nineteenth century introduced a new style of architectural decoration called *art nouveau*. It is not primarily an architectural mode, but, like rococo, which it resembles, it provides a decorative surface (closely associated with graphic art) that imparts a unique character to the buildings it serves. These pages are not the place to argue *art nouveau*'s heritage or significance. Rather they serve only to familiarize the reader with its easily recognized characteristics—charac-

teristics which formed a part of Western artistic tradition. *Art nouveau* is connected in some ways to the doctrines of nineteenth-century artistic symbolism, and its unique characteristic is the lively, serpentine curve, known as "whiplash" (Fig. 5.32). The style evokes, particularly and aptly, a fascination for plant and animal life and organic growth. Japanese art, whose influences were common late in the nineteenth century, is evident in the undulating curves. *Art nouveau* incorporates organic and often symbolic motifs, usually languid-looking flowers and animals, and usually treats them in a very linear, relieflike manner (Fig. 5.33). The twentieth century had arrived.

Fig. 5.32. Baron Victor Horta. Tassel House. 1892–93. Brussels.

Fig. 5.33. Frantz Jourdain. Samartine Department Stores. 1905. Paris.

Summary

The major result of social development since the Middle Ages was the rise of the middle class. Capitalism had replaced the guild system, and individual initiative flourished and stimulated a spirit of invention. The result was the Industrial Revolution, which increased wealth enormously, concentrated heavy industrial centers near raw materials and transportation routes, and increased colonial expansion to provide world markets for new goods. The new machine-worker class was cast into absolutely deplorable conditions, which bordered on slavery. Meanwhile, middle-class interests and outlook turned toward the political program of Liberalism. Class conflicts were inevitable.

Science turned to investigation of the atom and to theories of evolution. By the end of the nineteenth century evolution comprised the framework for modern knowledge of the universe. In other venues Kant's eighteenth-century philosophic reconciliations created a dualism that distinguished between a knowable world of sense perceptions and an unknowable world of essences. His reconciliation led to a nineteenth-century philosophy centering on the emotions and called romanticism. This idealistic appeal to faith and reaction against rationalism permeated philosophy and the arts.

Philosophy and mechanization made the century one of internationalism, nationalistic power, and imperialistic competition. War was an eternal specter in European existence, while in the United States the Civil War tore the nation apart. The tenor of the times created moods of turbulence and frustration. "Escape" to utopias became a common goal. Freely running emotionalism formed the heart of the wide-ranging attitude called romanticism.

The role of the artist changed significantly in the nineteenth century as significant artistocratic commissions or patronage not only shrank, but were viewed as undesirable limitations of individual expression. Much of art became individualistic and increasingly critical of society and its institutions.

The neoclassical tradition of the eighteenth century continued into the nineteenth, especially in France, and pursuit of physical and intellectual perfection progressed from David to Ingres in painting and was typified by Canova and Torvaldsen in sculpture, although both of the latter reflected other qualities as well.

The romantic style is diverse. Intrinsic to it is an emotional appeal and tendencies toward the picturesque, nature, the Gothic, and, often, the macabre. Romanticism sought to break the geometric compositional principles of classicism. Composition moved toward fragmentation of images. The intent was to dramatize, to personalize, and to escape into imagination. Romantic painting reflects a striving for freedom from social and artistic rules, a subordination of formal content to expressive intent, and an intense introversion. Romantic sculpture as a style seems never to have emerged. Those works not of classical derivation show a generally eclectic spirit.

All of the arts were closely related in the Romantic Period and drew inspiration from each other. Music was especially appealing to the romantic, offering deep expression of human emotion without words or pictures. Music's romanticism was introduced more gradually and was a natural extension of classical principles than occurred in the other arts. Nonetheless, subjectivity and emotion played a more important role in romantic music, and even if classicism sought sustenance in nature and antiquity, romanticism imbued nature and "the far-away and long-ago" with a strangeness that went far beyond classical inspiration. As in painting, spontaneity replaced control, but the primary emphasis of music in the era was on beautiful, lyrical, and expressive melody. Rhythm varied from simple to complex; harmony and tone color were significantly different in this era and were seen as means of expression, above all, to achieve striking emotional effects. Form was clearly subordinate to feeling.

In many ways art songs or *lieder* characterized romantic music and depended to a large degree on innovation and improvements in the piano. Romantic composers also turned to building their works around nonmusical ideas such as in descriptive and/or program music. At the same time a more traditional direction continued in the romantic symphony and concerto. A new nationalism in music emerged, especially in Russia. Choral music also flourished; the romantic spirit, style, and age meant opera. Grand opera, *opera comique,* and lyric opera solidified as forms.

Romanticism as a philosophy was it own worst enemy in the theatre. Admitting to no guide but one's own imagination the romantic playwright often ignored the practical necessities of the stage and wrote plays that were unproducible. Increasing mass audiences were catered to by emotionalism, melodrama, and stage gimmickery. As a result, the best romantic theatre came from the pen of William Shakespeare, brought out of his Eliz-

abethan theatre of convention into nine-teenth-century antiquarianism. However, the Romantic Period succeeded in shaking loose the arbitrary rules of neoclassicism, thus paving the way for a new era in the later stages of the century.

Dance also broke the bonds of the often cold formality of classicism and neoclassi-cism; the subjective, not the objective view-point sought release. Dance aesthetics changed to show "beautiful forms in graceful attitudes." Dancing was like a living painting or sculpture—"physical pleasure in feminine beauty." New principles enveloped training, structure, and positioning. The dancer needed to display the figure with taste and elegance: to achieve grace without affecta-tion. Romantic staging was aided signifi-cantly by improvements in stage machinery and lighting. Flickering gloom and con-trolled darkness and shadows added greatly to the mystery of stage scenes.

The nineteenth century was an age of in-creased individualism and subjective view-point, but such individualism was not always possible for the architect. Nonetheless, the attitudes of the nineteenth century carried into architecture in results often called "ro-mantic classicism." Romantic adaptation of classical and Renaissance prototypes to suit contemporary interest was widespread. Ar-chitecture included the "picturesque," Gothic motifs, and fantasy. Most signifi-cantly, the exterior of a building came to be seen as a screen, reflecting little of the struc-ture or of interior design and utilization. New materials such as steel and glass became com-monplace. Finally, the skyscraper took archi-tecture upward as far as practical concerns would allow; Louis Sullivan emerged as the first "modern architect." The final years of the century witnessed a new style called "art nouveau," which carried the Age of Industry into the twentieth century.

The Romantic viewpoint did not survive unchallenged, however. The mid-nineteenth century witnessed the rise of realism. In painting attempts to portray everyday life, ideas, and customs emerged. Social message replaced meditative reaction. Yet the desire to go beyond a mere reflection of photographic reality opened an explicit artistic reality, tell-ing us that a painting has an internal logic different from the logic of "familiar" reality. Searches for spontaneity, harmonious colors, subjects from everyday life, and faithfulness to observed lighting led to impressionism, a new way of looking at things. Impressionism evolved gently into a disparate set of styles called "postimpressionism," which called for a return to form and structure, while main-taining the evanescent light qualities of the impressionists.

Sculpture continued its curious ways. Of the nineteenth century but defying descrip-tion was the scuptural work of Auguste Rodin. Presenting a subjective reality beyond the surface, he can only be described perhaps as "modern." His works have been associ-ated with the impressionists; others, such as those of Maillol, have been classified both as classical and postimpressionistic.

Nonromantic tendencies also occurred in music, encompassing the impressionism of Debussy and the realism or naturalism of ver-ismo opera. The onset of realism as a standard for production in theatre led to three-dimen-sionality in settings and the "box set." Stage space was clearly defined and separated from the audience. However, translating contem-porary life realistically into dramatic form was a task most romantic playwrights were not equipped to handle. Eugène Scribe per-fected a form known as the "well-made play" and opened the door further for the realistic movement, whose masters included Ibsen, Shaw, and Chekhov.

A related movement, naturalism, also

evolved late in the nineteenth century, insisting on scientific methodology in pursuit of art. Later came a turn against realism in symbolism, which also has been called neoromanticism, idealism, or impressionism. The nineteenth century closed with two significant developments. First was the emergence of the concept of production unity as a principal aesthetic concern. The second was the development of Europe's independent theatre movement, which freed theatre from state-imposed censorship.

Individualism, parallel development and existence of styles, and quickly rising and falling movements ushered the nineteenth century into the twentieth, where nearly all that has gone before moves forward with the developments of the day and the expectations of tomorrow.

Chapter 6

TO
THE
PRESENT DAY

- Entr'acte
- Wars, Depression, and Annihilation
- The Arts of the
 Early Twentieth Century
- Toward Another Millennium
- The Arts of Our Time

ENTR'ACTE

How do we approach the world of our own century? Can we see it in a historical perspective, or are our observations obstructed like those of a tourist trying to gain a view of a large city while standing on a street corner surrounded by skyscrapers? Where does history end and first-hand personal involvement begin? How does one choose illustrations of trends and styles still in formation? Had this book been written as few as two years ago the second half of this chapter would be significantly different in some areas, because what appeared, then, as potentially significant in many cases has already died, leaving only a fleeting image. Such is the danger of attempting to pull history too close to one's own doorsteps, and why histories often stop at some convenient date safely well in the past. History has a way of culling the insignificant, an act vitally important for a brief overview such as this. In addition, our century has produced more art than all the centuries preceding it combined. Our society and its people seem to crave works of art, and artistic expression permeates our existence. So this final chapter is difficult to deal with, but we shall try to be as objective as possible and to treat circumstances right up to the day this book goes to press.

WARS, DEPRESSION, AND ANNIHILATION

As Western culture approaches a new millennium the potential for cataclysmic demise hangs as heavily over us as it did over our predecessors in the tenth century. Our civilization has emerged from small, medieval beginnings to global applications of commerce, economics, and government, and to global conflicts between capitalism and socialism, nationalism and imperialism, and Christianity and innumerable other philosophies and religions.

Somewhere before 1914 Europe and the rest of the Western world went astray. Societies believed themselves headed toward mountaintop experiences, toward the best that "progress" in science and invention could offer, and toward an era in which even competitive struggle would produce desirable, positive results. 1914 and the World War that defied logic changed all that.

Philosophy had lost credit in the nineteenth century. Compared to their former colleagues in the sciences, philosophers appeared to be a useless appendage to social progress. Greater and greater numbers of men and women began to believe that sensory and intellectual powers were not sufficient to solve the problems posed by philosophy. Although not entirely abandoned, philosophical questions, inherited from theology and relevant to humankind's relationship to the universe, slipped into an atmosphere of irrelevance.

Early in the twentieth century a reorientation occurred. Called "pragmatism," a new philosophy emerged in America and found as its champion no less a figure than John Dewey. Vigorously defended and attacked, pragmatism frankly abandoned the search for final answers to great problems such as the nature of God and the existence of immortality. Rather, it contented itself with more modest goals stemming from social experience. Utilizing scientific methodology, pragmatism pursued such issues as morals and aesthetic values in a democratic, industrialized society, and the means by which to achieve the highest personal fulfillment in education. Whether pragmatism is a philosophy or an adjunct of sociology, as some have claimed, and whether it can successfully address the

problems it seeks to address must be judged by those of a later era.

Science in the twentieth century has formulated and reformulated a series of fundamental concepts. Quantum Theory, Theory of Relativity, and atomic theory are unique to our age. In quantum theory the German physicist Planck upset previous beliefs by suggesting that energy is released in spurts of little units called "quanta." Einstein overturned the physics of Newton by suggesting that the absolutes of space, time, and length, were not absolute, but, rather, relative. (In 1982 some researchers have suggested that Einstein was in error and that the Theory of Relativity requires re-examination). Finally, atomic theory reduced the universe to units smaller than the atom—to positive and negatively charged particles. Thus atomic theory revised previously held concepts about matter itself. The very creation of life has come within the possibility of twentieth-century science. Is Man, after all, the measure of all things?

Scientific methodology was turned also to the social sciences in the hope that organized approaches could yield the same precision and validity in concerns relating to humankind and society as occurred in studies of nature. Great bodies of data were amassed in attempts to understand economics, government, social classes, primitive cultures, and so on. Conclusions derived from social–scientific fact finding remain to be fully drawn.

Undoubtedly the most significant development in the social sciences, and one which had profound influence on the arts, occurred in psychology. Probes into the deep recesses of the human mind through psychoanalysis became dogma in the findings of Sigmund Freud. Variations on Freud such as those of Jung increased the popularity of psychoanalysis and gave birth to modern psychiatry. Earlier, John Watson argued that man was a machine operating in a stimulus and response environment. Watson's, as well as B. F. Skinner's behavioralism continues to enjoy credence as the millennium draws to a close.

As enticing as it may be, and as necessary to maintain a consistent pattern among these six chapters, an examination of the politics and economics of the twentieth century is beyond the scope of these pages. Hopefully, the century in which we live has enough intrinsic appeal and direct relationship to our daily existence that even the most phlegmatic of individuals has taken the trouble to learn about it. Nevertheless, a few words are in order.

In the late nineteenth century, capitalism, colonialism, and competition for survival and expanding marketplaces left Europe in a state of fear of itself. The sun never set on the British Empire, and the Indian Ocean was called a "British Lake." The German Empire was the most powerful on earth. Every European nation maintained armed forces the equal to which the world had never seen. As many as three years of compulsory military service for young men was the rule—not the exception. Behind burgeoning armies stood millions of reserves among the general population. Few wanted war, but it seemed that everyone expected war to come. European nations banded together in rival political alliances. The Triple Alliance of Germany, Austria– Hungary, and Italy was countered in 1907 by the Triple Entente of England, France, and Russia. The Balkan Wars of 1912–13 ignited the conflagration, which, upon the assassination of the Austrian archduke, burst into world war.

The causes, the conflict, and the casualties of this catastrophe defy logic, and the resolution of affairs in the Treaty of Versailles (1919) served only to set the Western world on a course toward chaos. The treaty was supposed to protect Europe from Germany. It failed miserably to do so.

European society changed significantly because of the war. Capitalism, especially, showed profound redirection. *Laissez-faire*

liberalism had been a prominent factor in the previous century, but even before the war governments had become increasingly active in economic and other affairs. Governments erected tariffs, protected national industries, created colonial markets, and passed protective social legislation. The First World War made governmental control of nearly every aspect of society imperative. When the war ended the Western world experienced disruption of monetary traditions, inflation, taxes, and chaotic industrial output.

Equally important to twentieth-century directions was the Russian Revolution. Boiling forth from old causes and new, the revolution shook Russia first in 1905 and then again in 1917 when Lenin came to power. This was followed by a bloody civil war in 1918, which lasted until 1922. Lenin died in 1924, but the communist die was cast. Stalin and Trotsky sent Russia through five-year plans and purges and established an adversarial struggle with the West that continues today, with only an uneasy abatement during World War II.

The years after World War I were troubled ones. Even the victors encountered difficulty in returning to peacetime conditions. Nonetheless, distinct advances in social democracy occurred. Women now held the vote in Britain, Germany, the United States (as of 1913), and most of the smaller states of Europe. Social legislation proliferated. An eight-hour legal working day became common, as did government-sponsored insurance. The welfare state was well on its way to universality. Nevertheless, significant difficulties remained in economics, industrialization, and agriculture. Inflation was rampant, and credit, overextended. The entire Western economic system walked a delicate tightrope.

The 1920's was a decade of contrast. Struggling from its early years, the 20's experienced an apparent burst of prosperity. The mood was euphoric. But 1929 witnessed an economic crash, which sent the entire Western world into the deepest economic crisis it had even known. Industry and agriculture collapsed. Still, optimists proclaimed that prosperity lay "just around the corner."

Out of the crisis of the 30's came the forces that shaped World War II. The United States witnessed a "New Deal" under Roosevelt; Britain and France struggled through trial and error to adjust their democracies; Germany and Italy turned to totalitarianism, to Hitler and Mussolini. Dictatorship and totalitarianism were not isolated occurrences: By 1939 only ten out of twenty-seven European countries remained democratic.

In the 1930's neither Germany, Italy, Russia, or Japan was satisfied with the peace treaty that ended World War I. In addition, those countries, which had instituted the peace, were too weak or otherwise unwilling to enforce it. So, from 1931 (when Japan invaded Manchuria) onward, Great Britain, France, and the United States stood aside and watched the boundaries they had established fall, one after the other. By 1939 Europe was fully at war, and three years later when Japan attacked Pearl Harbor, the entire world, again, was engulfed by hostility.

On August 6, 1945 a nuclear explosion over the city of Hiroshima, Japan forever altered the state of the world and humankind's relationship to it. An old order had disappeared, and the approaching millennium was overshadowed by a specter even more discomforting than its predecessor in the tenth century.

THE ARTS
OF THE EARLY TWENTIETH CENTURY

Two-Dimensional Art

The first half of the twentieth century exploded with new styles and approaches to the visual arts. We will briefly examine some of these, namely, expressionism, fauvism, cub-

ism, abstract art, dada, and surrealism. We also will briefly examine one significant national aspect of painting, and that is twentieth-century departures from European traditions in the United States.

Expressionism traditionally refers to a movement in Germany between 1905 and 1930, but its broad applications include a variety of specific approaches, essentially in Europe, that focused on a joint artist/respondent reaction to composition elements. Any element (line, form, color, and so on) could be emphasized to elicit a specific response in the viewer. The artist

would consciously try to stimulate a response that had a specific relationship to his or her feelings about or commitment to the subject matter. Subject matter itself mattered little; what counted was the artist's attempt to evoke in the viewer a similar response to his or her own. In Max Beckman's "Christ and the Woman Taken in Adultery" (Fig. 6.1), the artist's revulsion against physical cruelty and suffering is transmitted through distorted figures crushed into shallow space. Linear distortion, changes of scale and perspective, and a nearly Gothic spiritualism communicate Beckman's unforgotten reactions to the

Fig. 6.1. Max Beckman. "Christ and the Woman Taken in Adultery." 1917. Oil on canvas. 58¾ × 49⅞". The St. Louis Art Museum. Bequest of Curt Valentin.

horrors of World War I. In this approach, meaning relies on very specific nonverbal communication.

Closely associated with the development of the expressionist movement, were the *fauves* ("wild beasts"). The label was applied by a critic in response to a sculpture (exhibited in 1905), which appeared like "a Donatello in a cage of wild beasts." Violent distortion and outrageous coloring mark the subjective expression of the fauves. Their two-dimensional surfaces and flat-color areas were new to European painting. Undoubtedly, the best-known artist of this short-lived movement was Henri Matisse (1869–1954). Other fauves included Albert Marquet, Raoul Dufy, Othon Friesz, André Derain, and Maurice de Vlaminck. Matisse tried to paint pictures that would "unravel the tensions of modern existence." In his old age he

made a series of very joyful designs for the Chapel of the Rosary at Vence, not as exercises in religious art, but, rather, to express the joy and nearly religious feeling he had for life. "The Blue Nude" (Fig. 6.2) illustrates Matisse's and fauvism's wild coloring and distortion. The painting takes its name from the energetically applied blues, which occur throughout the figure as darkened accents. For Matisse color and line were indivisible, and the bold strokes of color in his work comprise coloristic and linear stimulants, as well as revelations of form. Literally, Matisse "drew with color." Underlying this work, and illustrative of the fauves' relationship to expressionism is Matisse's desire, not to draw a nude as he saw it in life, but rather to express his feelings about the nude as an object of aesthetic interest. Expressionism had wide diversity and was associated with a number of

Fig. 6.2. Henri Matisse. "The Blue Nude—Souvenir of Biskra." 1907. Oil on canvas. 36¼ × 55⅛". The Baltimore Museum of Art. The Cone Collection.

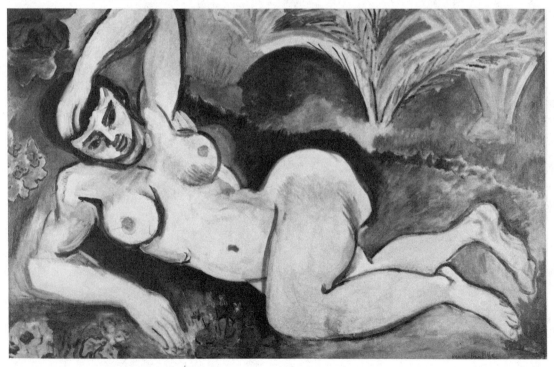

trends, including "The Bridge" and "Blue Rider" groups and artists such as Kandinsky, Rouault, Corinth, Kollwitz, Marce, Klimt, and Kokoschka.

The years between 1901 and 1912 experienced an entirely new approach to pictorial space to which the term *cubism* was applied. Cubist space violates all concepts of two- or three-dimensional perspective. In the past the space within a composition had been thought of as separate from the main object of the work. That is, if the subject were removed, the space would remain, unaffected. Pablo Picasso (1881–1973) and Georges Braque (1882–1963) changed that relationship to one in which the artist tried to paint "not objects, but the space they engender." The area around an object became an extension of the object itself. If the object were removed, the space around it would collapse. Cubist space typically is quite shallow and gives the im-

pression of reaching forward toward the viewer, thereby intruding into space outside of the frame. Essentially the style developed as the result of Braque and Picasso's independent experiments with various ways to describe form. The results of those experiments brought them to remarkably similar conclusions. Picasso's "Demoiselles d'Avignon" (Fig. 6.3) illustrates concern for spatial construction, expressive powers, and formal properties, especially in the exaggeration of certain features of the face, head, and body. These exaggerations resulted from Picasso's interest in primitive African sculpture, which showed similar distortions. The "Demoiselles" portrays an aggressive and harsh expression. Forms are simplified and angular, and colors are restricted to blues, pinks, and terra cottas. Cubism uniformly reduced its palette range to nearly monochromatic parameters, thereby allowing emphasis to fall

Fig. 6.3. Pablo Picasso. "Les Demoiselles d'Avignon." 1906–7. Oil on canvas. 96 × 92″. Collection, The Museum of Modern Art, New York. Acquired through the Lillie P. Bliss Bequest.

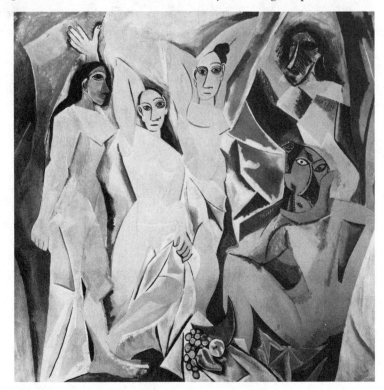

Fig. 6.4. Fernand Léger. "Three Women" (Le Grand Dejeuner). 1921. Oil on canvas. 72½ × 99". Collection, The Museum of Modern Art, New York. Mrs. Simon Guggenheim Fund.

on spatial exploration, without the distraction of other elements.

Braque showed similar concerns for spatial construction, and reduced objects to geometrical shapes. It was in response to Braque's geometric forms that the term "cubist" was first applied. Unfortunately, such a term has led many observers to look for opaque cubical shapes rather than for a new kind of space "which was only visible when solid forms became transparent and lost their rigid cubical contours."[1]

The complexities of cubism, of course, go beyond these brief remarks. Diverse subject matter, disciplinary experiments (for example, collage), evolving depiction, and applications such as those of Fernand Léger (Fig. 6.4), Juan Gris, and numerous others, carried cubism throughout the first half of the twentieth century. The cubists had a brief association with a movement in Italy called *futurism*, which denounced contemporary culture and sought more adequately to express and reflect the mechanistic and dynamic qualities of twentieth-century life. Balla, Severini, Boccioni, Carrà, and Russolo exemplify futurism in painting and in sculpture.

In the last chapter I used the words "dissolving image" to describe tendencies in visual art that appeared to be moving away from recognizable or objective reality. Undoubtedly the approach most recognizable or most illustrative of what many people would call

[1]George Heard Hamilton, *19th and 20th Century Art* (Englewood Cliffs, N.J.: Prentice–Hall, Inc. and New York: Harry N. Abrams, Inc.; n.d.), p. 211.

"modern art" is abstract art. A more precise term would be "nonrepresentational" art.[2] All art is "abstract," that is, an abstraction of, or "standing apart," from the object it purports to reveal; paintings, sculptures, plays, and/or symphonies all are abstractions regardless of the degree of verisimilitude they contain. However, "abstract art," or "nonrepresentational art," contains minimal reference to natural objects, that is, objects in the "phenomenal," or natural, world (see paragraphs on philosophy in Chapter Five). In many ways abstract and nonobjective art stand in contrast to impressionism and expressionism in that the observer can read little or nothing in the painting of the artist's feelings about any aspect of the universe. Abstract and nonobjective art seek to explore the expressive qualities of formal design elements in their own right. These elements are assumed to stand apart from subject matter. The aesthetic theory underlying abstract and nonobjective art maintains that beauty can exist in form alone, with assistance needed from no other quality. Numerous painters from variously described "movements" have explored these approaches, among them Hölzel, Kandinsky, Gabo, Larionov, and Kupka; several subgroups such as de Stijl, suprematists, constructivists, and the Bauhaus painters have pursued its goals. Piet

[2]The term "nonobjective" often is used as a synonym for "abstract" and "nonrepresentational." A difference of opinion exists on such usage. The term "nonobjective" was coined to differentiate its nonrepresentational subjects from *abstract* works. Some works are "abstract" because they are derived from nature and may contain intentional symbolism. Works similar in appearance may be truly nonobjective because the shapes were not meant to suggest or represent anything. Since one has to know the intent of the artist to know the difference in many cases, usage of the terms can be problematical further illustrating the definitional difficulties of technical terminology.

Mondrian (1872–1944) and Kasimir Malevich can illustrate many of the principles at issue in abstract and nonobjective painting.

Mondrian believed that the fundamental principles of life consisted of straight lines and right angles. A vertical line signified active vitality and life; a horizontal line signified tranquility, rest, and death. The crossing of the two in a right angle expressed the highest possible tension between these forces, positive and negative. "Composition in White, Black, and Red" (Figure 6.5) explores Mondrian's philosophy in a manner characteristic of all his linear compositions. The planes of the painting are close to the surface of the canvas, creating, in essence, the thinnest space possible, in contrast to the "deep space" of other styles. The palette is restricted to three hues. Even the edges of the canvas take on expressive possibilities as they provide additional points of interaction between lines. Mondrian believed that he could create "the equivalence of reality" and make the "absolute appear in the relativity of time and space" by keeping visual elements in a state of constant tension.

A movement within the nonrepresentational tradition was *suprematism,* whose works puzzle many individuals. A work such as "White on White" (Fig. 6.6) seems simple and confusing even by abstract standards. For Malevich these works extend beyond reducing art to its basic common denominators. Rather, he sought to find basic pictorial elements that could "communicate the most profound expressive reality."

The horrors of World War I caused tremendous disillusionment in many individuals, and gave birth to a movement called *Dada*. During the years 1915–16 numerous artists gathered in neutral capitals in Europe to express their disgust with the directions of all Western societies and, especially, their cultures. Dada became a political protest. Con-

Fig. 6.5. Piet Mondrian. "Composition in White, Black, and Red." 1936. Oil on canvas. 40¼ × 41". Collection, The Museum of Modern Art, New York. Gift of the Advisory Committee.

Fig. 6.6. Kasimir Malevich. "Suprematist Composition: White on White." c. 1918. Oil on canvas. 31¼ × 31¼". Collection, The Museum of Modern Art, New York.

siderable debate exists as to when and how the word "dada" came to be chosen, but the dadaists themselves accepted the word as two nonsense syllables, like the first sounds uttered by a baby. In many places the dadaists produced more left-wing propaganda than they did art. By 1916 a few works began to appear; these comprised many experiments in which chance played an important factor. For example, Jean Arp produced collages constructed by dropping haphazardly cut pieces of paper onto a surface and pasting them as they fell. A large dadaist exhibit in 1920 featured the compositions of George Grosz, John Heartfield, and Raoul Hausman. Max

Ernst, inspired by de Chirico, juxtaposed strange, unrelated items to produce unexplainable phenomena. Such usage of conventional items placed in circumstances that alter their traditional meanings is characteristic of dadaist art. Irrationality, meaningless malevolence, and harsh, mechanical effects are typical, as in Figure 6.7.

Mechanism proved to be a popular artistic theme in the early twentieth century, when the world was becoming more and more dominated by machines. Mechanistic themes can be seen in the works of Marcel Duchamp, who often is associated with the Dada Movement and is sometimes called protodadaist,

Fig. 6.7. Max Ernst. "Woman, Old Man and Flower." 1923–24. Oil on canvas. 38 × 51¼". Collection, The Museum of Modern Art, New York. Purchase.

especially regarding his famous "Nude Descending a Staircase" (Philadelphia Museum of Art). "The Bride" (Fig. 6.8) is a mechanistic diagram of contrasting male and female forces whose internal parts bear striking resemblance to a flesh-colored, internal-combustion engine. Duchamp apparently saw men and women as no more than machines. Human passion comprised the fuel on which men and women moved. Many of Duchamp's works exploit chance and accident, a further tie to Dada.

Fascination with the subconscious mind, as popularized by the psychologist Sigmund Freud, stimulated explorations in psychic experience such as is found in the automatic writings of the poet Philippe Soupault. By

1924 a *surrealist* manifesto had developed and tied the subconscious mind to painting. "Pure psychic automatism" described surrealist works. Surrealism was seen by its advocates as a means for discovering the basic reality of psychic life through automatic association. A dream was supposedly capable of transference directly from the unconscious

Fig. 6.9. Giorgio de Chirico. "Nostalgia of the Infinite." c. 1913–14 (dated on painting 1911). Oil on canvas. 53¼ × 25½". Collection, The Museum of Modern Art, New York. Purchase.

Fig. 6.8. Marcel Duchamp. "The Bride." 1912. Oil on canvas. 35⅛ × 21¾". Philadelphia Museum of Art. Louise and Walter Arensberg Collection.

mind to the canvas without control or conscious interruption by the artist.

The metaphysical fantasies of Georgio de Chirico and Paul Klee have surrealist associations. De Chirico's works (Fig. 6.9) contained no rational explanation for their juxtaposition of strange objects. Rather, they reflect a dreamlike condition, that is, in the way strange objects come together in a dream. These works are not rational and reflect a world humankind does not control. In them "there is only what I see with my eyes open, and even better, closed."

However, surrealism probably is more accurately described by the paintings of Salvador Dali and Joan Miro, as well as by Magritte, Delvaux, Brauner, and some of the works of Ernst (especially the "frottages"—rubbings). Dali called his works, such as "The Persistence of Memory" (Fig. 6.10), "hand-colored photographs of the subconscious," and the high verisimilitude of this work coupled with its nightmarish relationships of objects makes a forceful impact. The whole idea of "time" is destroyed in these "wet watches" (as they were called by those who first saw this world) hanging limply and crawling with ants.

Until the early twentieth century, painting in the United States had been little more than a reflection of European trends translated to the American experience. However, since the early twentieth century, a strong and vigorous American painting has emerged. It encompasses many individuals and diverse styles and approaches. As usual, our discus-

Fig. 6.10. Salvador Dali. "The Persistence of Memory." 1931. Oil on canvas. 9½ × 13". Collection, The Museum of Modern Art, New York. Given anonymously.

sion will be an overview with only a few ar-bitrarily selected examples.

An early group called The Eight emerged in 1908 as painters of the American "scene." These included Robert Henri, George Luks, John Sloan, William Glachens, Everett Shinn, Ernest Lawson, Maurice Prendergast, and Arthur B. Davies. Each shared a warm and somewhat sentimental view of American city life and presented it both with and without a sense of social criticism. Although uniquely American in tone, the works of The Eight often revealed European influences, for example, impressionism in the works of Ernest Lawson. Modernism in America was effectively furthered in the aesthetically adventurous works of Arthur Davies and Maurice Prendergast.

The modern movement also owed much to the tremendous impact of the International Exhibition of Modern Art (called the "Armory Show") in 1913, in which rather shocking European modernist works, such as Duchamp's "Nude Descending a Staircase" and Braque and Picasso's cubist work, first were revealed to the American public. Following thereafter came Marsden Hartley, Arthur G. Dove, Alfred Maurer, John Marin, and Georgia O'Keeffe. Max Weber, a Russian-born Jew, brought an ethnic cultural heritage to American painting through works that explored and manipulated many of the current European styles such as cubism and fauvism.

Precisionists, such as Stuart Davis (1894–1964), took natural objects and arranged them into what amounts to abstract arrangements (Fig. 6.11). Characteristic of these paintings also is a use of strong and vibrant color appropriate to commercial art and much like the "pop" art of the 1960's.

Pictorial objectivity continued in the "realist" tradition in the works of Edward Hopper, Reginald Marsh, Thomas Hart Benton,

Fig. 6.11. Stuart Davis. "Lucky Strike." 1921. Oil on canvas. 33¼ × 18". Collection, The Museum of Modern Art, New York. Gift of The American Tobacco Company, Inc.

John Steuart Curry, and Grant Wood (Fig. 6.12). The era closed to the frustrating tunes of the Depression and World War II, and significant in those years, not because it produced great art, but because it allowed Federal funding for and moral encouragement of the arts, was the Federal Arts Project of the Works Progress Administration (WPA).

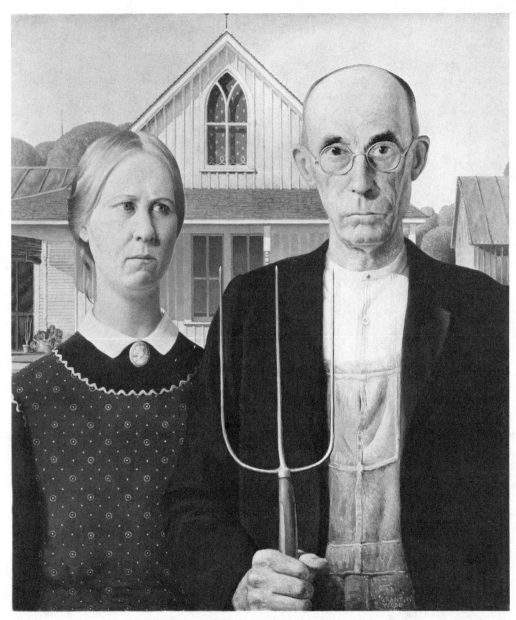

Fig. 6.12. Grant Wood. "American Gothic." 1930. Oil on beaver board. 28⅜ × 24⅞". Courtesy of The Art Institute of Chicago. Friends of American Art Collection.

Sculpture

Sculpture revived significantly in the twentieth century. Interest in cultures other than European (for example, African and Polynesian) in which sculpture played a dominant role, added new dimensions to the search for expressive elements owing nothing to the classically idealized human body. New con-

cerns for space turned, logically, to three-dimensional space and the potential relationships it presented. Technological developments and new materials also encouraged the search for new forms characteristic of the age. "Futurists" in the visual arts searched for dynamic qualities, representative of the times (Fig. 6.13), and believed that many of the new machines of the era comprised sculptural form. Some sculptures followed mechanistic lines and also included motion.

German expressionist themes were pursued in sculpture by Ernst Barlach (1870–1938). Man's loneliness and search for God formed much of the somber symbolism of Barlach's, work. The direct influence of African art can be seen in the sculptures of Constantin Brancusi (1876–1957) (Fig. 6.14). Yet beyond this, the smooth, precise surfaces of much of his work seem to have an abstract, mechanistic quality. Brancusi's search for essential form led to very economical presentations, often ovoid and simple, yet animate. Certainly great psychological complexity exists in "Bird in Space" (Fig. 6.15). Brancusi was very influential in the works of the English sculptor Henry Moore, whose "Recumbent Figure" (Fig. 6.16) carries forward

Fig. 6.13. Umberto Boccioni. "Unique Forms of Continuity in Space." 1913. Bronze (cast 1931). 43⅞ × 34⅞ × 15¾". Collection, The Museum of Modern Art, New York. Acquired through the Lillie P. Bliss Bequest.

Fig. 6.14. Constantin Brancusi. "Mlle. Pogany." 1931. Marble. Height: 17¼". The Philadelphia Museum of Art.

Fig. 6.15. Constantin Brancusi. "Bird in Space." c. 1928. Bronze. Height: 54". Collection, The Museum of Modern Art, New York. Given anonymously.

Fig. 6.16. Henry Moore. "Recumbant Figure." 1938. Green Hornton stone. Length: 55". The Tate Gallery, London.

Fig. 6.17. Henry Moore. "Hill Arches." 1973. The Serpentine. Hyde Park, London.

Fig. 6.18. Henry Moore. "Three-Piece Reclining Figure." 1975. The Serpentine. Hyde Park, London.

the theme of figure depiction in a most un-traditional manner. Primitive objects, es-pecially the Chacmool figures of Mexico ap-pear repeatedly in his works. References to nature abound in these unique sculptural pre-sentations which span the last forty years (see also Figs. 6.17 and 6.18). African influence also existed in the work of Amedeo Modigliani (1884–1920) and Jacob Epstein (Fig. 6.19).

In 1925 Jacques Lipchitz created a series of "transparents" cast from cardboard cut and bent to approximate Picasso's paintings. When he opened the interiors of these works, he "discovered" a radical new understanding of space: Interior spaces need not be "voids," but, rather, could become integral parts of the sculptural work itself. From this understand-ing came the concept of "negative space,"

which played an important role in sculpture, especially that of Henry Moore. In addition, many of his works, such as Figure 6.20, re-flect Lipchitz's interest in primitive and ar-chaic art and cubism.

In the United States between the two world wars, the carvings of William Zorach came to prominence. His work has a forth-right attitude and avoids academic idealism. Soft curvilinear line and form hold works such as Figure 6.21 together in a comfortable, if conventional composition. At the same

Fig. 6.20. Jacques Lipchitz. "Man with a Guitar." 1915. Limestone. Height: 38¼". Collection, The Mu-seum of Modern Art, New York. Mrs. Simon Gug-genheim Fund.

Fig. 6.19. Jacob Epstein. "The Visitation." 1926. Bronze (cast 1955). Height: 66". The Tate Gallery, London.

Fig. 6.21. *LEFT:* William Zorach. "Child with Cat." 1926. Bronze. 17½ × 10 × 7½". Museum of Art. The Pennsylvania State University.

Fig. 6.22. *BELOW:* Alexander Calder. "Spring Blossoms." 1965. Painted metal and heavy wire. Extends to 52 × 102". Museum of Art. The Pennsylvania State University. Gift of the Class of 1965.

time, the original mobiles of Alexander Calder (Fig. 6.22) put abstract sculpture into motion. Deceptively simple, these colorful shapes turn at the whim of subtle breezes or by motors. Here is the discovery that sculpture can be created by movement in undefined space.

Music

Music took no less a radical path from its nineteenth-century heritage than did painting and sculpture. Nevertheless, contemporary concert programs illustrate for us the unique phenomenon that we mentioned in the Preface. That is, response to works of art is always in the present tense. Our own experiences with and responses to the meanings in works of art are today's, whether the artwork was created this morning or twenty thousand years ago. So we have the luxury of sharing experiences in a direct fashion with Michelangelo, William Shakespeare, Leonardo Da Vinci, J. S. Bach, and the architects of Athens, as well as with those men and women of our own era who illuminate and comment upon the events and circumstances surrounding us. Our contemporaries may and do choose to follow the traditions of the past or invent new ones.

Twentieth-century music took both paths. New directions in twentieth-century music differed from past traditions, essentially, in three ways. The first was rhythmic complexity. Prevailing tradition since the Middle Ages, when composition began to formalize its structures and conventions, emphasized grouping beats together in rhythmic patterns called *meter*. The characteristic accents of duple and triple meters helped to unify and clarify compositions, as well as to give them certain flavors. For example, triple meter with its *one*-two-three, *one*-two-three accent patterns created lilting dance rhythms, of which the waltz was characteristic. Duple meter's alternating accents could, for exam-

ple, stimulate a marching regularity. The modern composer did away with such patterns and regularity of accents, choosing, instead, to utilize complex, changing rhythms in which it is virtually impossible to determine meter or even the actual beat.

The second change consisted of a focus on dissonant harmonies. Prior to the late nineteenth century, musical convention centered upon consonance as the norm to which all harmonic progressions returned. Dissonance was utilized to disturb the norm, so as to enable the music to return to consonance. All art requires some disturbance of an established stasis in order to elicit the respondent's interest, in the same sense that a play must have a complication in order to move it forward, and then (using traditional approaches) have something to resolve. Dissonance in music fulfilled much the same role. Dissonances were expected to be brief and passing in nature and to return to consonance. As we saw, the late nineteenth century witnessed significant tampering with that concept; by the twentieth century composers were using more and more dissonance, focusing on it, and refraining from consonant resolution.

The third major change from the past comprised the rejection of traditional tonality or sense of key altogether. Traditional thinking held that one note, the "do" or tonic of a scale, was the most important; all music was composed with a specific key in mind; modulations into distant or related keys occurred, but even then the tonic of the key was the touchstone to which all progression related. Many composers rejected that manner of systematizing musical sound and chose, instead, to pursue two other paths. One was to reject any sense of tonal center and importance of one tone over the other. All twelve tones of the chromatic scale became equal. The systems that resulted from such a path were called *twelve-tone composition* and *serialism*. Less radical approaches also were utilized in

which traditional major/minor tonality was denied, but in which some sense of tonal center still existed.

In order to capture the flavor of the diverse approaches occurring in the first half of the twentieth century, we need to move forward in a fairly irregular manner. We shall pause to examine kinds of music as well as composers and events as the first five decades of the century unfolded.

Transition from the nineteenth to the twentieth centuries rode primarily on the works of one major composer, the impressionist Claude Debussy, whom we discussed in the previous chapter. Several other traditions were current. One, of German–Italian influence, built upon the contributions of Richard Wagner and was called the "cosmopolitan style." The principal composer in this group was César Franck. A classically oriented style came into the century in the works of Camille Saint-Säens, Jules Massenet, and Gabriel Fauré.

Debussy's style linked him closely with the French composer Maurice Ravel (1875–1937), who began as an impressionist, but became more and more classical in orientation as years went by. However, even in his earlier works, Ravel did not adopt Debussy's complex sonorities and ambiguous tonal centers. Ravel's *Bolero* (1928) exhibits strong primitive influences and the unceasing rhythm of Spanish dance music. (*Bolero* enjoyed a new burst of popularity from its appearance as the theme in the movie *10.*) More typical works of Ravel, for example, his *Piano Concerto in G,* use Mozart and traditional classicism as their models. As a result of Ravel's tendencies and the similar concerns of composers such as Eric Satie, Arthur Honegger, Darius Milhaud, and Francis Poulenc, the early twentieth century witnessed a neoclassic direction, which stayed completely within the established conventions of Western music, but rejected both romantic and impressionistic developments.

Traditional tendencies continued throughout this period and can be seen in various quarters, one of which is the music of an American, William Schuman, in the 1930's and 40's. His symphonies exhibit bright timbres and energetic rhythms and focus on eighteenth and nineteenth century American folklore. The eighteenth-century American composer William Billings figures prominently in the works of Schuman in the *William Billings Overture* (1943) and the *New England Triptych* (1956), based on three pieces by Billings. *American Festival Overture* (1939) is perhaps his most famous work. Traditional tonality also encompassed the works of England's Benjamin Britten and Russia's Shostakovich and Prokofief. Notwithstanding traditional tonality, Prokofief's *Steel Step* reflected the encroachment of mechanization felt in the 1920's. The machine as a symbol for tremendous energy and motion found its way into music, and in the *Steel Step* Prokofief intentionally dehumanized the subject in order to reflect contemporary life.

American in its origins, although debatable as to its classic or baroque qualities, is the musical phenomenon called jazz. Undoubtedly the most significant Black contribution to American music, jazz began near the turn of the century and went through many changes and forms. Jazz comprises sophisticated and complicated styles focusing on improvised variations on a theme. The earliest form, "blues," went back to the music of the slaves and consisted of two rhythmic lines and repeat of the first line (aab). Performers at the end of the nineteenth century, for example, Bessie Smith, gave the blues an emotional quality, which the accompanying instruments tried to imitate. At approximately the same time came ragtime, a piano style with a strict, two-part form. Syncopation played an important role in this style, as evidenced by Scott Joplin. New Orleans, the cradle of jazz, also produced traditional jazz, which featured improvisational development

from a basic, memorized chordal sequence. All this was followed in the '30's and '40's by "swing," "bebop," and "cool jazz."

Experimentation and departure from traditional tonality marked the compositions of Paul Hindemith (1895–1963). Concerned with problems of musical organization, he systematized his approach to these problems and theorized solutions in *The Craft of Musical Composition*. Hindemith's work was extremely chromatic, almost atonal. His system of tonality was based on the establishment of tonal centers, but did not include the concepts of major and minor keys. He hoped that his new system would become a universal music language, but it did not. He was, however, extremely influential in twentieth-century music composition, both as a composer and a teacher. His works are broad and varied, encompassing nearly every musical genre, including ten operas, art songs, cantatas, chamber music, requiems, and symphonies. *Kleine Kammermusik für fünf Bläser* is a delightful composition for five woodwinds in five contrasting movements. Its overall form is very clear, as are its themes. Its dissonant harmonies and untraditional tonalities typify Hindemith's works. Part of Hindemith's approach to composition embraced the concept of functional music or *gebrauchsmusik*. This approach was a reaction to what Hindemith considered "esoteric isolationism in music." Rather, he (and others) tried to write music that the general public could easily understand and also that the amateur musician could play.

Another nontraditional approach to tonality was the unique style of Béla Bartók (1881–1945). He was interested in folk music and often is considered a representative of a nationalistic school of composition. Whether or not that is true, Bartók's interest in Eastern European folk music is significant, because much of that music does not utilize Western major/minor tonalities. So Bartók's interest in it and in nontraditional tonality in general

went hand in hand. Bartók invented his own type of harmonic structure, which could accommodate particular Eastern folk melodies. As nontraditional as some of his work is, however, he also employed traditional devices and forms. His style was precise and very well structured. He often developed his works from one or two very short motives; his larger works were unified by repetition of thematic material throughout. He even used sonata–allegro form. Textures in Bartók's works are largely contrapuntal, which gives them a melodic emphasis with little concern for harmony; dissonances occur freely.

However, Bartók's employment of traditional devices was always bent to his own desires and nearly always lay outside the traditional tonal system. Bartók contributed significantly to string quartet literature, and his quartets, in a way not dissimilar to Chopin's études, each set out a particular problem, which it then proceeded to solve, combining simple melody with complex tonality. One characteristic of his melodic development was "octave displacement," in which successive notes of a melody occur in different octaves. Apparently this characteristic also came from the folk music in which he was so interested. He had discerned that when peasants found the notes of a melody too high or low, they simply jumped up or down an octave so as to sing them comfortably.

In addition to melody, rhythm was very important to Bartók. His works tended to focus on rhythmic energy, utlizing many different devices, such as repeated chords and irregular meters (always to generate dynamic rhythms). His use of polyrhythms, that is, various juxtaposed rhythms, created a nonmelodic counterpoint of unique quality.

Nontraditionalism was followed in other quarters, and with *The Firebird* (1910) Igor Stravinsky burst into prominence; *The Rite of Spring* (1912–13) created an even greater impact. Both works were scores for ballets; *The*

Firebird was a commission for the Russian impressario, Diaghilev, and premiered successfully at the Paris Opera; *The Rite of Spring* created a near riot and a great scandal because of revolutionary orchestrations and driving primitive rhythms. These were Stravinsky's early works. On the whole his works encompassed a variety of styles and forms, but of whatever nature, they mark a significant composer who was as prolific as he was diverse.

The effect of *The Rite of Spring* was so cataclysmic that a closer look is necessary. The third of his ballet commissions for Diaghilev, it is subtitled *Pictures of Pagan Russia,* and depicts the cruel rites of spring which culminate in the sacrifice of a virgin who dances herself to death accompanied by frenetic, primitive music. The compelling rhythms of the work give it its unique character. Rapid, irregular, and mechanical mixtures of very short note values create unbelievable tension. Melodic material is quite unconventional, consisting of short driving motives, which are cut short of thematic fulfillment. Melodies are short and fragmentary. Every musical element is experimentally treated in order to achieve expressive ends. After World War I Stravinsky embraced neoclassicism in a series of works with classic and baroque references. His flexibility ranged even to the creation of serial compositions toward the end of his life.

The movement which drew the most attention in the first half of the twentieth century grew out of German romanticism and took a radical turn into atonality. The composer at the root of the movement was Arnold Schoenberg (1874–1951). During the years between 1905 and 1912 Schoenberg turned away from the gigantic postromantic works he had been composing to a more contained style, in works for small ensembles and in orchestral works, which treated instruments individually. In orchestral works his timbres alternate swiftly, contrasting with large blocks of tone colors characteristic of earlier works. They also display rhythmic and polyphonic complexity together with fragmented melodies.

Although the word "atonality" (without tonality) is used to describe Schoenberg's works, he preferred the term "pantonality," that is, inclusive of all tonalities. His compositions sought freedom to use any combination of tones without the necessity of having to resolve chordal progressions. He called that concept "the emancipation of dissonance." Prior to World War I, Schoenberg created one of his most famous works, *Pierrot Lunaire (Moonstruck Pierre,* 1912). This cycle of twenty-one songs is based on French surrealist poems translated into German and utilize a female solo voice accompanied by various instruments. Important in this work is the use of the speaking voice (*sprechstimme*) and a very stylized declamation.

At times in their careers Schoenberg, Alban Berg, and Anton Webern represented expressionism in music. Similar to the movement of the same name in painting, expressionism (sometimes called the twentieth century's neurotic form of romanticism) approached humanity in terms of its psychological relationship to the modern world: Humankind was helpless in a world beyond its control and governed by subconscious forces in rebellion against established order. *Erwartung,* in which Schoenberg utilized complex rhythms, dissonance, strange orchestration, and fragmented melodies, evokes great intensity of feeling; as with many of his works, it sought, by all means available to him, to portray the complex thoughts and emotions of the composer relative to his subject matter.

By 1923 Schoenberg was composing in a twelve-tone or *dodecaphonic* technique, in which a row or series of the twelve tones in an octave was utilized in various ways—as melodies and harmonies, with rhythmic considerations, upside down, backward, upside

down and backward, that is, in whatever pre-determined form the composer desired. The logical structure of such a technique is fairly mathematical and somewhat formalized, but it does maintain a balance between emotion, accident, and mechanization. The important thing for a listener to understand about these apparently "strange" works, that is, works which stand outside conventional tonal organization, is the fact that they do contain specific organization and logical order. When the listener knows the guideposts to look for, Schoenberg's music progresses just as comfortably as does that of traditional tonality. Schoenberg regarded pantonality as a logical step forward from a situation in which all the possibilities of the older system had been exhausted.

Two additional composers bear noting, both Americans with experimental and highly personal styles: Ives and Copland. The first, Charles Ives (1874–1954), was so experimental and ahead of his time that many of his compositions were considered unplayable and did not receive public performances until after World War I. Content to remain anonymous and unmotivated to shape his experiments into a "system" as did Schoenberg, Ives went unrecognized for many years. Complexity underlies Ives' compositions. His melodies spring from folk and popular songs, hymns, and other, often familiar, material, which he treated in most unfamiliar ways. His rhythms are "hopelessly" irregular and often without measure delineation except for an occasional bar line to indicate an accent beat. Textures involve such dissonant counterpoint that frequently it is impossible to distinguish one melodic line from another. Some of the tone clusters in his piano music are unplayable without using a block of wood to depress all the necessary keys at once. Ives' experiments, such as *The Unanswered Question* (1908), also utilize ensembles placed in various locations to create stereophonic ef-

fects. For Ives all music related to life's experiences and ideas, some of which were consonant and some, dissonant, and his music reflected that philosophy accordingly.

Aaron Copland (1900–) integrated national American idioms into his compositions. Jazz, dissonance, Mexican folksongs, and Shaker hymns all appear. The latter of these figure prominently in Copland's most significant work, *Appalachian Spring* (1944). First written as a ballet, it later was reworked as a suite for symphony orchestra. Copland also utilized a variety of approaches, some reserved and harmonically complex, and some simple; often he utilized all tones in the diatonic scale, such as in the opening chord of the work. Despite a diversity of influences, he achieved a very personal and individual style, which is traditionally tonal. His unique manipulation of rhythms and chords has been highly influential in twentieth-century American musical composition.

Theatre

Two important theorists bridged the turn of the century. Adophe Appia (1862–1928) and Gordon Craig (1872–1966) had some symbolist leanings and tried to articulate new ideas and ideals about theatre production. Appia attempted to find a new means for unifying theatre action among the diverse visual forms and conditions of the theatre—moving actors, horizontal floors, and vertical scenery. In 1899 Appia, a Swiss, published his influential work *Die Musik und die Inscenierung,* setting forth his suggested reforms. Beginning with the actor, he maintained that the stage design must be in harmony with the living presence of the performer. Accurate depictive reality was unnecessary. Rather, there should be an atmosphere of a man or woman amidst the setting. The audience's attention should be focused on the character, not on scenic details. Appia believed that two-dimensional painted scen-

ery was incompatible with the live actor because of the extreme and distracting contrast between flat scenic elements and a plastic, three-dimensional human form. For Appia the human body was reality itself, and the stage floor should only set the human body in relief; scenic reality was the living presence of the actor, and the stage should be cleared of everything that "is in contradistinction with the actor's presence."

The Englishman Gordon Craig was more a visionary and theorist than an actual man of the theatre. He found the theatre lacking in artistic purpose and direction and believed in a unity of production elements under the aegis of a superdirector. He sought to replace scenic imitation or depiction with suggestion and insisted upon a "spiritual" relationship between setting and action. Theatre was "a place for seeing"; moving figures, light and shadow, and dramatic color all had tremendous potential, which Craig tried to explore. For the most part Craig's theories remained just that. His designs proved impractical, and in many cases, disastrous to the production. He had some successes, however, and managed to convince many theatre artists of the significance of his viewpoint.

Appia and Craig were important proponents of eclecticism, sometimes called "artistic realism" and sometimes called organic unity, which drastically changed theatre style at the turn of the twentieth century. Previously, all plays were held to a single standard—whatever was the vogue of the day. For example, in the mid-nineteenth century, when antiquarian realism was the fashion, all plays—melodramas, Greek tragedies, or Shakespearean comedies—would have been staged in the same style. However, artistic realism, or eclecticism held that the stage environment must be appropriate to the given play. Style, in large part, was seen to be reflective of the style appropriate to the period in which the play was written. Therefore, the twentieth century became, and still is, an era of stylistic diversity, of eclecticism, in which each play and each production of each play determines the actual style the audience witnesses.

The "organic" approach to theatre grew principally from the work of Max Reinhardt (1873–1943). He treated each play as an aesthetic problem and saw the physical environment of the production (the *mise en scène*) as a vital part of stylistic communication. Also, to enforce organic unity, since numerous separate artists may contribute to one production, he, like Craig and others, cast the director as the supreme theatre artist, ultimately responsible for all aspects of production—actors, lighting, costumes, scenery, props, sound, and even the final version of the script itself. When this approach finally reached the United States around 1910, it was called "The New Stagecraft," and was carried forward primarily by the efforts of two influential designers, Robert Edmond Jones and Lee Simonson. For the most part, artistic realism (and also realism as a depictive style) has remained the dominant approach to the theatre in the twentieth century, especially in the United States.

American theatre came of age in the twentieth century, the early years of which were dominated by Clyde Fitch (1865–1909). Broadway epitomized the height of theatrical success, and in 1901 Mr. Fitch had four plays running concurrently on "The Great White Way." *The Truth* and *The Girl with the Green Eyes* were more theatrical than realistic, but they did advance the cause of American theatre, as did William Vaughn Moody (1869–1910) in *The Great Divide*, which contrasted New England refinement and its narrow moral codes with the rough honesty and freedom of the West.

Elsewhere, expressionism brought to the theatre ideas which reflected disillusionment more than they did realism. But here we must

tread carefully, because the theatre is both visual and oral. The painter's revolt against naturalism came to the theatre in visual form in scenic design. Settings which followed expressionism in painting occurred often. For the playwright, "expressionism" was merely an extension of realism and naturalism and allowed the playwright a more adequate means to express his own reaction to specific items in the universe around him. August Strindberg, for example, turned inward to the subconscious in expressionistic plays such as *The Dream Play* and *The Spook Sonata*. In so doing, he created, as did Leonid Andreyev in *He Who Gets Slapped* and Frank Wedekind in *Spring's Awakening,* a presentational rather than representational style.

The disillusionment of German expressionism after World War I typified the plays of Ernst Toller (1893–1939) and George Kaiser (1878–1945). Toller's personal struggles, his communistic idealism, and his opposition to violence and revolution are reflected in the heroine of *Man and the Masses.* Sonia, a product of the upper class, leads a strike for peace. Her desire to avoid violence and bloodshed is opposed by the mob Spirit (The Nameless One), who seeks just those results and an abrogation of the peace the strike intended to achieve. For leading the disastrous strike, Sonia is imprisoned and sentenced to death. Kaiser's *From Morn until Midnight* traces its way through the nightmarish life of a bank clerk whose pursuit of happiness is shattered at every turn.

Expressionism also found its way to America. Elmer Rice's *Adding Machine* (1923) depicts Mr. Zero, a cog in the great industrial machinery of twentieth-century life, who stumbles through a pointless existence. Finding himself replaced by an adding machine, he goes berserk, kills his employer, and is executed. Then, adrift in the Hereafter he is too narrow-minded to understand the happiness offered to him there; so he becomes an adding machine operator in Heaven and finally returns to earth to begin his tortured existence all over again.

The early years of the twentieth century witnessed numerous production experiments aimed at creating social action. Typical of the devices used by social-action advocates were subjective attitudes toward subject matter, fragmentary scenery, and generally distorted visual elements. For the most part they sought to combine theatre's traditional goals, to entertain and to teach, so that by entertainment they could teach and thereby motivate the spectator into action outside the theatre. An excellent example grew out of the Moscow Art Theatre in the late nineteenth century and involved the work of Vsevolod Meyerhold (1874–1942). Meyerhold's plays grew from the seeds of the Russian Revolution and its attempts to transform society. For Meyerhold a revolutionized society required a revolutionized theatre. However, his approach led him to difficulty on two counts. First, his mechanized treatment of the actor was not acceptable to Constantin Stanislavsky, the dominant force in the Moscow Art Theatre; second, Meyerhold was considered too formalistic to appeal to the masses. Nevertheless, by the time he was removed from his post, in the 1930's, he had made a significant contribution to the theatre and had earned fame and influence throughout Europe and America.

Meyerhold shared the belief that the director was the supreme artist in the theatre and freely rewrote scripts to suit his own ends. He devised a system of actor training called *biomechanics,* the object of which was to make an actor's body an efficient machine for carrying out the instructions of its operator (the director). Meyerhold's actors often were required to swing from trapezes, do gymnastic stunts, and spring up through trap doors.

Central to Meyerhold's viewpoint was the concept of *theatricalism.* Rather than striving

to imitate or depict life, he wished the audience to be fully aware that they were in a theatre and never to confuse theatre with life. He wished to stir the audience to desirable social action outside the theatre. As a result, he removed many of the devices that theatre uses to hide its theatricality. Curtains were removed so that backstage areas and lighting instruments were fully visible. He also introduced a practical and theatrical style of staging called *constructivism*. The settings utilized in such an approach were called "constructions" and consisted of various levels and playing areas of completely nonobjective nature. Scenery was not a background, but, rather, a series of structures on which the actors could perform and with which they could be totally integrated. Ultimately, the stage, the actor, and all aspects of performance were parts of a machine to be utilized by the director.

Social action and protest also found a home in the American theatre during the first half of the twentieth century. The spiritual and economic collapse of the Great Depression prompted many playwrights to examine the American social fabric. Maxwell Anderson had questioned America's values earlier, but the most poignant protest came from the pen of Clifford Odets. In 1935 he produced a one-act play concerning New York's bitter taxicab strike. "Waiting for Lefty" removed audience–actor separation by making the audience part of the auditorium portion of a labor hall. At the front, on the traditional stage, several characters waited for the appearance of Lefty, so that the meeting could begin. As the play progressed, actors rose from seats in the audience to voice their complaints. Tension mounted; and when it was discovered that Lefty had been assassinated, actors began to chant "strike, strike, strike . . ." The involvement of the audience within the aesthetic environment of the action actually caused the audience to take up

the chant themselves. During the Depression, when the play was produced, its impact was significant. However, even today productions of "Waiting for Lefty" often create the same effects in an audience.

Odets followed with *Golden Boy* and *Awake and Sing,* and was joined by other notable social-action writers such as Lillian Hellman with *The Children's Hour, The Little Foxes, Another Part of the Forest,* and *Toys in the Attic.* At the same time came the social criticism of John Steinbeck's *Grapes of Wrath* and his masterpiece, *Of Mice and Men,* although these were staged in a more traditional, realistic style.

The Independent Art Theatre Movement, mentioned in the last chapter, gave birth to one of America's greatest playwrights, Eugene O'Neill. The first two decades of the twentieth century saw an intense struggle for theatre monopoly between the theatrical Syndicate and the Schubert Brothers. Unions were formed, the movies drained audiences away from the theatre, and little attention was being paid to nurturing the soul of any vital theatre, the playwright. However, one independent theatre led the way. The Provincetown Players consisted of a group of young actors and writers who spent their summers together on Cape Cod. Banding together, they opened The Wharf Theatre in Provincetown and later moved to New York where their commitment to playwright development led to productions of young Eugene O'Neill (1888–1953). Son of the famous actor James O'Neill, Eugene knew the theatre well and was influenced especially by the expressionist works of August Strindberg as well as the sea stories of Joseph Conrad. Amid the prolific output of O'Neill's pen came wide-ranging subjects, styles, and a restless search for new approaches. *The Emperor Jones, The Hairy Ape,* and *Dynamo* (Fig. 6.23) employed expressionistic techniques; *The Great God Brown* used masks to contrast

Fig. 6.23. Constructivist set for Eugene O'Neill's *Dynamo* (1929), designed by Lee Simonson. Courtesy, Dance Collection, New York Public Library. Vandam Collection.

internal and external reality. *Strange Interlude* employed soliloquies and was so long that the production started at 5:30 P.M. and broke for an hour and a half for dinner before resuming and running until 11:00 P.M. *Mourning Becomes Electra* was based on a Greek tragedy and set in New England. *Ah, Wilderness!* was a warm, realistic comedy. The list goes on and on.

Finally came a playwright who spread new roots, out of which grew the Theatre of the Absurd. A product of disillusionment, Luigi Pirandello (1867–1936) had lost faith in religion, realism, science, and humanity itself. Still searching, however, for some meaning or basis for existence, he found only chaos, complexity, grotesque laughter, and perhaps, insanity. His plays were obsessed with the question "What is real?" and he pursued that question with brilliant variations. *Right You Are If You Think You Are* concerned a situation in which a wife, living with her husband in a top-floor apartment, is not permitted to see her mother. She converses with her daily; mother is in the street and daughter is in a garret window. Soon the neighbors' curiosity demand an explanation from the husband. A satisfactory answer is forthcoming;

however, the mother has an equally plausible, but radically different explanation. Finally, the wife, who is the only one who can clear up the mystery is approached. Her response, as the curtain falls, is loud laughter! Pirandello cried bitterly at a world he could not understand, but he did so with mocking laughter directed at those who purported to have the answers or were sure that they soon would. *As You Desire Me, Henry IV, Naked, Tonight We Improvise,* and perhaps his most popular, *Six Characters in Search of an Author* all reflect the confusion and suffering Pirandello found in the early twentieth century.

Film

On April 23, 1896, at Koster and Bial's Music Hall in New York, the Leigh Sisters performed their umbrella dance. Then, waves broke upon the shore. Those were the exciting subjects shown at the revelation of a new process for screen projection of movies, the *Vitascope*. Invented by Thomas Armat, although Thomas Edison has received much of the credit, the Vitascope was the realization of centuries of experimentation in how to make pictures move. Relying on the principle of persistence of vision (Glossary) and the basics

of photography, the Vitascope could capture real objects in motion and present them on a screen for a mass audience.

Technological experiments in rapid-frame photography were numerous in the last half of the nineteenth century, but it remained for Thomas Armat and others to perfect a stop-motion device essential to screen projection. Two Frenchmen, the Lumières brothers usually are credited with the first public projection of movies on a large screen in 1895. By 1897 the Lumières had successfully exhibited their *Cinématographie* all over Europe and listed a catalogue of 358 films. They opened in America three months after the première of the Vitascope. Later that year the American Biograph made its debut using larger film and projecting twice as many pictures per minute: It had the largest, brightest, and steadiest picture of all.

At that point "movies" were nothing more than a recording of everyday life. Fortunately, George Méliès in France and Edwin S. Porter in the United States would demonstrate the narrative and manipulative potential of the cinema. Between 1896 and 1914 Méliès turned out more than one thousand films. Edwin S. Porter, in charge of Edison Company Studios studied the narrative attempts of Méliès, and, acting as his own scriptwriter, cameraman, and director spliced together old and freshly shot film into *The Life of an American Firefighter*. Later in 1903 Porter made *The Great Train Robbery*, the most popular film of the decade. It ran a total of twelve minutes. The popular audience was entranced, and flocked to "electric theatres" to see movies that could "engross, excite, and thrill them with stories of romance and adventure." The movies were a "window to a wider world" for the poor of America.

By 1910 the young film industry counted a handful of recognized stars, including Danish actress Asta Nielsen and the French comedian Max Linder, who had made more than four hundred films for the screen's first mogul, Charles Pathé. Short films remained the staple of the industry, but especially in Europe the taste was growing for more spectacular fare. 1912 witnessed the Italian, *Quo Vadis,* complete with lavish sets, chariot races, Christians, lions, and a cast of hundreds. A full two hours in length, it was a landslide success.

Lawsuits regarding patents and monopolies marked the first decade of the century, and in order to escape the constant badgering of Thomas Edison's lawyers, independent filmmakers headed West to a sleepy California town called Hollywood, where among other things, weather and exotic and varied landscape were much more conducive to cinematography. By 1915 over half of all American movies were being made in Hollywood.

That year also witnessed the release of D. W. Griffith's *The Birth of a Nation* (Fig. 6.24), three hours in length, popular, controversial, and destined to become a landmark in cinema history. It unfolds the story of two families' lives during the Civil War and the Reconstruction Period. Roundly condemned for its depiction of leering, bestial blacks rioting and raping white women, and for the rescue of whites by the Ku Klux Klan, the film, nonetheless contains great artistry and a refinement of filmmaking techniques. Griffith is cited as defining and refining nearly every technique in film: the fade-in, fade-out, long shot, full shot, close-up, moving camera, flashback, crosscut, juxtaposition, editing, and preshooting rehearsals.

As if *The Birth of a Nation* were not colossal enough, Griffith followed it in 1916 with *Intolerance,* a two-million dollar epic of ancient Babylon, Biblical Judea, sixteenth-century France, and modern (1916) America. As the film progressed, brilliant crosscutting increased in frantic pace to heighten suspense and tension. However, audiences found the film confusing; it failed miserably at the box office and ruined Griffith financially.

Fig. 6.24. D. W. Griffith. *The Birth of a Nation*. 1915.

The same era produced the famous Mack Sennet comedies, which featured the hilarious antics and wild chase scenes of the Keystone Kops. Sennet was a partner of Griffith in the Triangle Film Company. A third partner was Thomas Ince, who brought to the screen the prototypical cowboy–hero, William S. Hart, in such works as *Wagon Tracks*. However, nothing better represents the second decade of the twentieth century then does the baggy pants comedian and true film genius, Charlie Chaplin, "The Little Fellow." Chaplin represented all of humanity, and he communicated through the silent film as eloquently and deeply as any human ever has. In an era marked by disillusionment Chaplin presented a resiliency, optimism, and indomitable spirit that made him the love of millions. By the end of World War I, Chaplin shared the limelight with that most dashing of American heroes, Douglas Fairbanks.

German expressionism made its mark in film as well as in the visual and other performing arts, and in 1919, its most masterful example, Robert Wiene's *The Cabinet of Dr. Caligari* (Fig. 6.25) shook the world. Macabre

Fig. 6.25. Robert Weine. *The Cabinet of Dr. Caligari*. 1919.

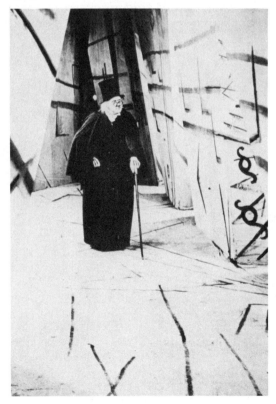

sets, surrealistic lighting effects, and distorted properties, all combined to portray a menacing postwar German world.

A rebirth of film engulfed Europe after the war and saw the talents of filmmakers such as Carl Mayer, F. W. Murnau, G. W. Pabst, and Fritz Lang. Lang's futuristic *Metropolis* told the story of life in the twenty-first century; critics called the plot ludicrous, but marvelled at the photographic effects. In France, film found its first real aesthetic theorist in Louis Delluc and came to be regarded as a serious art form.

Theory also concerned Russian filmmakers and emerged in the concepts and expressions of Sergei Eisenstein in *Potemkin* (1925). This cruel story of the crew of the ship Potemkin contains one of the most legendary scenes in cinema. A crowd of citizens are trapped on the great steps of Odessa between the Czar's troops and mounted Cossacks. The editing is truly fantastic; the scene comprises a montage of short, vivid shots—a face, a flopping arm, a slipping body, a pair of broken eye glasses—all deftly combined into a powerful whole.

The 1920's were the "heyday" of Hollywood, and its "star system" dazzled the world with Gloria Swanson and legions of other starlets. Extravagance ran rampant. It was the era of large studios, such as MGM, Paramount, Universal, Fox, and Warner Brothers, and a wave of construction of fantastic movie houses, which rivaled the opulence of baroque absolutism. The scandals, the intrigues, and the glamour, mostly immoral, were the stuff of legends. Out of such decadence came Cecil B. DeMille and *The Ten Commandments* and *The King of Kings.* Hollywood's image was redeemed—a bit.

Twenty thousand movie theatres existed around the country, and to keep apace of demand, movie studios turned out one film after another—mostly on a formula basis. Nevertheless, the decade produced some

great artistry, for example, Eric Von Stroheim's *Greed* (1924). Although cut from nine hours to two by MGM employees, the film, nonetheless, was a brilliant story of a boorish dentist, practicing without a license, who murders his greedy wife.

The twenties was the era of Fairbanks and Pickford and an Italian immigrant, tango dancer, named Rudolph Valentino, who made millions of American women swoon in movies such as *Four Horsemen of the Apocalypse, The Sheik, Blood and Sand,* and *Son of the Sheik.* After Valentino's death, John Gilbert set feminine hearts fluttering, and his costar on three occasions, Greta Garbo, did the same for American men. The Talmadge and Gish sisters, along with Pola Negri helped fuel the amorous fires of the "roaring twenties." The lighter side of the decade included Harold Lloyd, Harry Langdon, Buster Keaton, and Laurel and Hardy.

Actually, the technological breakthrough had come many years earlier, and short, talking films had been released, but *The Jazz Singer* in 1927 heralded the age of "talkies," with Al Jolson's famous line "You ain't heard nothin' yet!" As eager as individuals usually are to present new technological advances, the film industry was not particularly enthusiastic about introducing talking films. The public was very satisfied with silent movies; profits were enormous, and the new invention required a vast capital investment to equip movie theatres with sound projection equipment. However, the die was cast; for some it meant continued stardom; for some, whose voices did not match their visual appearance, it meant obscurity. Early successes in utilizing sound as an aesthetic component of the film came from directors King Vidor in *Hallelujah* and Rouben Mamoulian in *Applause* (1929). Lewis Milestone's *All Quiet on the Western Front* used sound to unify visual compositions in a truly remarkable and unforgettable antiwar statement.

The early thirties witnessed crime and violence, and films such as *Little Caesar,* with Edward G. Robinson, kept Hollywood's coffers full amidst the Depression. However, the gangster genre came to end amid public cries that American youth were being harmed by films that glorified violence. The baser side of films also showed itself in the mid-thirties' sexually explicit dialogue of Mae West. Again amid public outcry, the Production Code was strengthened, and Miss West was toned down. From the mid-thirties on, new types emerged, including the musicals of Fred Astaire and Ginger Rogers, in a Busby Berkeley world of glitter and tinsel that attempted to bolster sagging mid-thirties' attendance and salve the sores of a Depression-weary populace. The screen overflowed with Jeanetté MacDonald and Nelson Eddy, Maurice Chevalier, Shirley Temple, and a new star, Judy Garland, in *The Wizard of Oz* (1939). The tawdry faded, and wholesomeness abounded. Happiness poured forth in *The Thin Man* (1934). A new genre of comedy films featured Clark Gable and Claudette Colbert in Frank Capra's *It Happened One Night* (1935).

But there was more to the thirties. Dozens of new stars arose (MGM boasted "more stars than there are in heaven"): Bette Davis, Henry Fonda, Spencer Tracy, Jean Harlow, Joan Crawford, Katherine Hepburn, Leslie Howard, Norma Shearer, Robert Taylor, Tyrone Power, Errol Flynn, Frederick March, James Cagney, Will Rogers, Wallace Beery, Mickey Rooney, Gary Cooper, James Stewart: The list seems endless, as do the films. The most popular and unusual star of the thirties, however, was a product of the artistic genius of Walt Disney. Mickey Mouse led a genre of animated films whose popularity and creativity persists to this day. The western continued, and in 1939 John Ford's classic, *Stagecoach,* made John Wayne the prototypical cowboy–hero. This superb-ly edited film exemplified the technique of "cutting within the frame," which became a Ford trademark (and also prohibited others from re-editing and tampering with the product). On the other end of the spectrum, the thirties sent the Marx Brothers crashing through slapstick comedies and popping pompous bubbles and produced W. C. Fields's ill-humor, which stemmed from bubbles of an alcoholic nature.

Chaplin's comedy continued into the thirties. *City Lights* (1931) was a silent relic in an age of sound, but its consummate artistry made it a classic, nonetheless. It depicts the story of Chaplin's love for a blind girl, who erroneously believes he is rich. He robs a bank and pays for an operation that restores her sight. He is apprehended and sent to prison. Years later she happens across a tramp being chased by a group of boys. Amused and yet saddened, she offers the tramp a coin and a flower. At the touch of his hand she recognizes him but is stunned by the realization that her imagined rich and handsome lover is really nothing more than a comical tramp. The film ends with the awareness that their relationship cannot be. *City Lights* is a moving film containing touching scenes and great comedy, including a society party scene in which Chaplin swallows a whistle, and in a fit of hiccups, destroys a musical performance and calls a pack of dogs and several taxicabs.

The epic of the decade was David O. Selznick's *Gone with the Wind,* a four-million-dollar, three-and-three-quarter-hour, eternally popular extravaganza with an improbable plot and racial stereotypes. Nonetheless, Clark Gable, Vivian Leigh, Leslie Howard, and Olivia De Haviland, along with magnificent cinematography made the film a lasting piece of entertainment.

The rise of Nazism in Germany virtually eliminated the vigorous German film industry by the late thirties. That did not happen, however, until after Fritz Lang had produced

his psychological thriller *M,* which utilized subtle and deft manipulation of sound, including a Grieg leitmotif. Peter Lorre's performance as a child-murderer was significant. From Europe during the thirties also came the master of suspense and shot manipulation, Alfred Hitchcock, whose *The Man Who Knew Too Much, The Thirty-Nine Steps, Sabotage, Secret Agent,* and *The Lady Vanishes* were only a prelude to decades of further artistry. Throughout this era Hollywood film was unabashedly nondidactic. "Message" was not in its working vocabulary. Entertainment was its primary goal, but that did not preclude artistry and virtuosity in shaping a celluloid strip into an aesthetically articulated series of forms and images.

World War II and its aftermath brought radical change to the form and content of the cinema. 1940 witnessed a film that stunned even Hollywood. Darryl Zanuck and John Ford's version of John Steinbeck's *Grapes of Wrath* artistically visualized the social criticism of Steinbeck's portrayal of the Depression through superb cinematography and compelling performances. Theme and social commentary burst forth again in 1941 with two outstanding works, *How Green Was My Valley,* which dealt with exploited coal miners in Wales, and *Citizen Kane,* about wealth and power, and perhaps the best film ever produced. The cinematic techniques of *Citizen Kane* forged a new trail. Orson Welles, director and star, and Greg Toland, cinematographer, brilliantly combined deep-focus photography, unique lighting effects, rapid cutting, and moving camera sequences.

The forties also saw Van Johnson, Alan Ladd, and, of course, Humphrey Bogart, Lauren Bacall, Gregory Peck, Cary Grant, and Ingrid Bergman in such works as *The Philadelphia Story, Notorious,* and *Casablanca.* But as the war ended and Italy revived from the yoke of Fascism, a new concept set the stage for the years ahead.

In 1945 Roberto Rossellini's *Open City* graphically depicted the misery of Rome during the German occupation. It was shot on the streets of Rome using hidden cameras and mostly nonprofessional actors and actresses. Technically, the quality of the work was deficient, but the effectiveness of its objective viewpoint and documentary "realism" changed the course of cinema and inaugurated a style called "neorealism."

Dance

Dance revolutionaries leaped through two different doors in the early twentieth century. The first door not only was held open, but mostly was built, by Sergei Diaghilev. Diaghilev arrived in St. Petersburg, Russia, in 1890 to study law. Through his cousin he soon became friends with several artists, among them, Alexandre Benois, Walter Nouvel, and Leon Bakst. Not particularly interested in ballet, Diaghilev studied music (with Rimsky–Korsakov, who dissuaded Sergei from attempting a musical career) and also painting. His artistic interests combined to cause him to take six years instead of four to get his law degree. In 1898 Diaghilev's artistic friends launched a new magazine, *World of Art,* and appointed Sergei as editor. His entrepreneurial and managerial talents made the venture a success and launched him in a career of artistic management which shaped the ballet world of the entire twentieth century. His love of the arts, his associations with ballet, and his social contacts made it possible for him to produce outstanding works employing the finest choreographers, dancers, and designers of the age. Diaghilev played a tremendously important role in bringing the art of Paris and Munich to Moscow and Leningrad and *vice versa.* The *World of Art* had a wide impact on the arts in general, as did Diaghilev himself.

Having successfully produced opera abroad, that is, outside of Russia, Diaghilev

was encouraged by designer Benois to take Russian ballet to Paris. In 1909 he opened the first of his many *Ballets Russes*. The dancers included the greatest dancers of Russia, among them Anna Pavlova and Vaslav Nijinsky. For the next three years Diaghilev's ballets were choreographed by Mikail Fokine, whose originality of approach stood quite in contrast to the evening-long spectaculars of Petipa. Fokine was in tune with theatrical and musical theories stemming from Wagner, Reinhardt, Appia, and so on, which insisted on artistic unity of all production elements—costumes, settings, music, as well as dancing. Dancing, in turn, he felt, should blend harmoniously with the theme and subject of the production. Fokine was to leave Diaghilev's company in 1912, but probably the great contribution made by their association, in addition to the aesthetic unity just mentioned, was the reintroduction of the male dancer as a premier performer.

The first production of the *Ballets Russes* in Paris was a resounding success and nearly instantaneously revived a stagnant and debased Parisian entertainment, which was what ballet in France had become. Invited to return in 1910, Diaghilev included in his program for that appearance a work commissioned from the young composer Igor Stravinsky, *The Firebird*. By the advent of World War I, the Russian ballet had conquered London, Berlin, Rome, Monte Carlo, Vienna, and Budapest, and a decaying ballet tradition had been reborn.

The success, in all honesty, was due equally as much to the superb integration of outstanding music, costume, and set design as it was to Fokine's choreography. The consummate artistry of Alexandre Bakst's costumes and sets must be acknowledged, and a glimpse of their exquisite line and style can be seen in Figure 6.26 (color). His vibrant colors and rich textures greatly influenced fashion and interior decoration in the period.

In one of those twists of fate and personality, Diaghilev was not content to allow Nijinsky to remain his *première danseur*; rather Sergei insisted that Nijinsky be a choreographer as well. That fact partially accounted for Fokine's departure. In 1912 Nijinsky choreographed the controversial *Prelude to the Afternoon of a Faun* with music by Debussy. The choreography was latent with sexual suggestion, and the performance caused an uproar over its obscenity. Nijinsky's choreography was strangely angular in contrast to Debussy's music. The dancing suggested the linear and geometric qualities of a Greek frieze or vase painting. A year later Nijinsky caused an actual riot when his choreography of Stravinsky's *Le Sacre du Printemps* was unveiled. However, this time the controversy had more to do with the music than with the dancing; nevertheless, the choreography was controversial, hinting at deep primordial forces, especially in the scene we noted in the music section, wherein a virgin dances herself to death to satisfy the gods. Nijinsky's decision to marry in 1913 caused a schism with the homosexual Diaghilev, resulting in Nijinsky's dismissal from the company.

Diaghilev's new choreographer, Leonard Massine, took the company (and ballet in general) in new directions. Previously the *Ballets Russes* had featured picturesque Russian themes. Now it turned to tastes emerging in the visual arts, to cubism and surrealism. *Parade* in 1917 found dancers in huge skyscraper-like cubist costumes designed by Pablo Picasso. The music, by Satie, included sounds of typewriters and steamship whistles.

In 1924 Diaghilev hired a new choreographer who was to be a force in ballet for the next sixty years. George Balanchine came to Diaghilev from St. Petersburg and choreographed ten productions for him over the next four years. Two of these continue to be danced: *The Prodigal Son* composed by Pro-

kofief and *Apollo,* composed by Stravinsky. When Diaghilev died in 1929 his company died with him, and an era ended. Ballet had been reborn as a major art form with elegance and excellence, a blending of choreography, dancing, music, and visual art—a rival to opera in claiming "perfect synthesis of the arts."

In the previous chapter our discussion closed by noting the revolutionary approaches of Loie Fuller. These were indicative of dissatisfaction with the formal conventions and static qualities into which ballet had fallen, and against which even Diaghilev responded. However, while Diaghilev continued within balletic traditions, others did not, and the most significant of these was the remarkable and unrestrained, Isadora Duncan. By 1905 Isadora had gained notoriety for her barefoot and deeply emotional dancing. She was considered controversial among balletomanes and reformers alike, but even Fokine saw in her style a confirmation of his own beliefs.

Although an American, Isadora Duncan achieved her fame in Europe. Her dances were emotional interpretations of moods suggested to her by music or by nature. Her dance was personal; her costume was inspired by Greek tunics and draperies; she danced in bare feet, a strictly unconventional and significant fact, which continues to be a basic quality of the "modern dance" tradition she helped to form.

The personalized emotion and unstructured form of Duncan's approach to dance certainly differed from established dance tradition, and its novelty alone proved noteworthy. However, it was as much Miss Duncan herself that accounted for the impact of her style. Unabashedly forward, she maintained, "I have discovered the art which has been lost for two thousand years." Outgoing and eccentric, she gained entrance to numerous circles, which would have been closed to anyone of lesser steel, and, as a result, she was able to

raise untold funds for her numerous projects. She was a curiosity, and, as it turned out, a tragic one, but her ability to keep the spotlight on herself, coupled with her undeniable performance magnetism, made her and her dancing style a significant force in the era. She died of a broken neck when the fringe of her shawl caught in the tire spokes of a car in which she was riding. Only moments before she called to friends, as she stepped into the car, "Goodbye, my friends. I go to glory."

Despite the notoriety of the young feminist, Isadora, it remained for her contemporary, Ruth St. Denis, and St. Denis's husband, Ted Shawn, to lay more substantial cornerstones for "modern" dance. Much more serious than Duncan, Miss St. Denis numbered among her favorite books, Kant's *Critique of Pure Reason* and Dumas's *Camille.* Her dancing began as a strange combination of exotic, oriental interpretations, and Delsartian poses. (*Delsarte* is a nineteenth-century system originated by François Delsarte as a scientific examination of the manner in which emotions and ideas were transmitted through gestures and posture. His "system" came from overzealous disciples who formed his findings into a series of graceful gestures and poses, which supposedly had specific denotative value. To us, it all may look rather foolish.) Ruth St. Denis was a remarkable performer with a magnificently proportioned body. She manipulated it and various draperies and veils into graceful presentations of line and form, in which the fabric became an extension of the body itself.

St. Denis's impact on dance was solidified by the formation, with her husband Ted Shawn, of a company and a school to carry on her philosophies and choreography. The Denishawn school and company were headquartered in Los Angeles and took a totally eclectic approach to dance. Any and all traditions were included, from formal ballet to Oriental and American Indian dances. The

touring company presented tremendously varied fare, from Hindu dances to the latest ballroom crazes. Branches of the school were formed throughout the United States, and the touring company occasionally appeared with the *Ziegfeld Follies.* By 1932 St. Denis and Shawn had separated, and the Denishawn Company ceased to exist. Nevertheless it had made its mark on its pupils (although not always positively).

First to leave Denishawn was Martha Graham, probably the most influential figure in modern dance. Although the term "modern dance" defies accurate definition and satisfies few, it remains the most appropriate label for the nonballetic tradition Martha Graham has come to symbolize. Graham found Denishawn unsatisfactory as an artistic base; nevertheless, her point of view, essentially, maintained that artistic individualism is fundamental. "There are no general rules. Each work of art creates its own code." Nevertheless, even modern dance has come to include its own conventions, principally because it tried so hard to be different from formal ballet. Ballet movements were largely rounded and symmetrical. Therefore, modern dancers emphasized angularity and asymmetry. Ballet stressed leaps and based its line on toework; modern dance hugged the floor and dancers went barefoot (more natural). As a result, Graham's and other's early works tended to be rather fierce and earthy, as opposed to graceful. But beneath it all was the desire to express emotion first and foremost. The execution of conventional positions and movements, on which ballet is based, was totally disregarded. Martha Graham described her choreography as "a graph of the heart."

As her career progressed, Martha Graham's work has emerged, through her own dancing and that of her company, as a reaction to specific artistic problems of the movement. Early works were notorious for their "jerks and tremblings," which Graham saw as based on the natural act of breathing. The dynamics of contraction and release fundamental to inhalation and exhalation created a series of whiplash movements in which energy and effort were expressly revealed (in contrast to ballet in which effort is concealed). Gradually her style became more lyrical in line and movement, but passion was always the foundation.

After the Depression, when social criticism formed a large part of artistic expression, Graham pursued topical themes (unusual for her) concerning the shaping of America: *Frontier* (1935), *Act of Judgement, Letter to the World,* and, finally, her renowned work to the music of Aaron Copland, *Appalachian Spring* (1944). *Appalachian Spring* dealt with the effects of Puritanism and depicted the overcoming of its fire-and-brimstone by love and common sense.

Another influential modern dancer to leave Denishawn was Doris Humphrey, for whom all dance existed on "the arc between two deaths," that is, between absolute motionlessness and complete collapse. Her choreography stressed the dynamic tension between balance and imbalance, between fall and recovery. She and her partner, Charles Weidman, who was famous as a pantomimist, developed their modern dance techniques from elementary principles of movement. Various treatments of conflict and resolution were basic and led to such works as *The Shakers* (1931) and the *New Dance* trilogy (1935–36). From the Humphrey–Weidman company came two significant additional forces in modern dance's exploration of individualism in artistry: Anna Sokolow and José Limon.

Ballet, of course, did not succumb to obscurity with Diaghilev's departure. Strong national traditions were developed and maintained throughout Europe. Attention turned in the United States to attempts to establish

an American ballet. In 1933 Lincoln Kirstein and Edward Warburg combined forces to create the School of American Ballet, which opened on January 1, 1934 with George Ballanchine as its head. Elsewhere in the country the thirties witnessed the establishment of the San Francisco Ballet and the Philadelphia Ballet.

Attempts to develop artistically significant ballet companies in the United States found themselves continually in competition with a company which stressed its Russian character, the new *Ballet Russes de Monte Carlo,* an attempt to perpetuate the traditions of Diaghilev. Its American tours in the thirties were greeted by sensational responses from the American public. If the *Ballets Russes de Monte Carlo* was competition for young American companies, it also was a blessing, because its tours introduced many Americans to ballet. It fostered positive public response to an art form, which was struggling against modern dance experiments and also was wrapped in unfortunate stereotypes of "sissy stuff" and of lunatic local teachers who forced young dancers *en pointe* before their feet had matured sufficiently to withstand such strain.

World War II brought an end to the American Ballet Company and provided a watershed for exciting new efforts, which would occur after peace returned.

Architecture

The early years of the twentieth century witnessed a continuation of art nouveau, producing designs such as those of Antoní Gaudí (Fig. 6.27). At the same time widespread experimentation with new forms and materials continued. Descriptive terminology has been applied to many of the directions taken by individual architects, and attempts have been made to categorize more general tendencies, so as to bring the period under some kind of

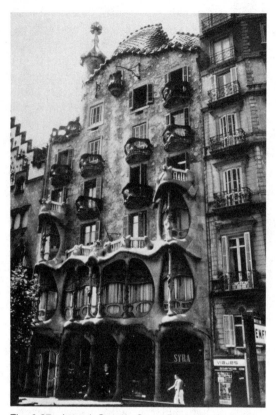

Fig. 6.27. Antoní Gaudí. Casa Batllo. 1905–7. Barcelona.

stylistic label. As was the case with modern dance, attempts at far-ranging categorizing have not met with universal acceptance. Terms such as "rational," "functional," "international," and "modern" have been suggested. Some have quite specific application to some tendencies, but, perhaps only the undefinable term "modern" can cope with them all. We will leave such discussion to others and will focus as much as possible on the wide-ranging nature of individual attempts. Such individualism, as we have seen, has been the hallmark of the arts in our century. A few very significant architects will not appear in this first section of the chapter but will be mentioned later, since some of their most notable work occurred after World War II.

Structural expression and preoccupation with building materials dominated the early twentieth century, as it, in fact, had the nineteenth. Of vital importance to the new century and its approaches was reinforced concrete or ferro-concrete. Ferro-concrete had been utilized as a material since around 1849, but its development and importance in architecture had taken nearly fifty years to emerge fully. Auguste Perret (1874–1954) single-mindedly set about to develop formulas for building with ferro-concrete, and his efforts were influential in the works of those who followed. We can grasp some of the implications of this approach in Perret's Garage Ponthieu (Fig. 6.28). The reinforced concrete structure emerges clearly in the exterior ap-

Fig. 6.28. Auguste Perret. Garage Ponthieu. 1905–6. Paris.

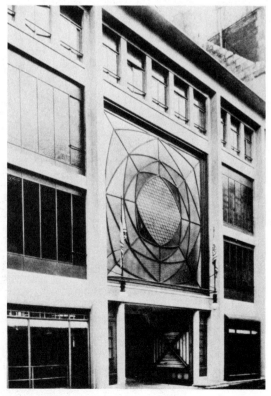

pearance. The open spaces were filled with glass or ceramic panels. The result achieved a certain elegance and logical expression of strength and lightness.

If Perret was single-minded in his approach to problems in structure and materials, his contemporary (and assistant to Louis Sullivan), Frank Lloyd Wright (1867–1959) was one of the most far-reaching and all-encompassing of twentieth-century architects. Perret summarized and continued earlier tradition, but Wright wished to initiate new ones. One manifestation of Wright's pursuits was the "prairie style," developed around 1900 and drawing upon the flat landscape of the Midwest for its tone (Fig. 6.29). The prairie houses reflected Japanese influence in their simple horizontal and vertical accents. Wright also was influenced by Sullivan in pursuit of form and functional relationships. Wright attempted to devise practical arrangements for his interiors and to reflect the interior spaces in the exterior appearance of the building. He also tried to relate the exterior of the building to its context (natural environment) and took great pains to suggest an interrelationship of interior and exterior space.

Wright also designed some of the furniture for his houses; comfort, function, and design integration were the chief criteria. Textures and colors in the environment were duplicated in design materials, including large expanses of wood both in the house and its furniture. He made a point of designing furniture that would serve several functions, for example, tables that also served as cabinets. All spaces and objects were precisely designed to present a complete environment. Wright was convinced that houses profoundly influenced the people who lived in them, and he saw the architect as a "moulder of humanity." Wright's works ranged from simple to complex, from the serene to the dramatic (Fig. 6.30), and from interpenetration to enclosure of space. He always pursued

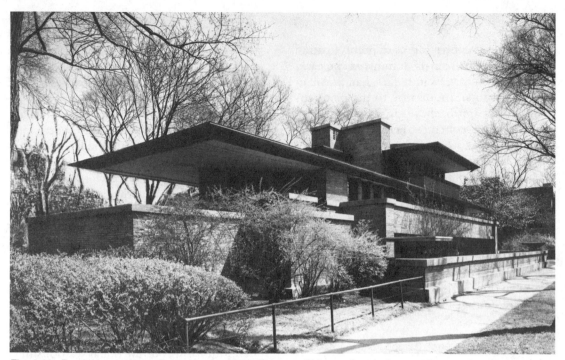

Fig. 6.29. Frank Lloyd Wright. Robie House. 1909. Chicago. Chicago Convention and Tourism Board.

experimentation, and the exploration of various interrelationships of spaces and geometric forms mark his designs.

As we mentioned, the early twentieth century witnessed numerous individual experiments in form and materials. The United States produced Purcell and Elmslie. George W. Maher, Schmidt, Garden and Martin, as well as Charles and Henry Green, Irving Gill, and Bernard R. Maybeck. In Germany emerged Peter Behrens, Bonatz and Scholer, Max Berg, and Fritz Höger. Other Europeans included Otto Wagner, Josef Hoffmann, Adolf Loos, H. P. Berlage, Michael de Klerk, and Piet Kramer. There were, of course, many others, all reflecting individualized concepts and approaches.

Use of poured concrete and exposed steel, both of whose textures contributed to the external expression of a building, can be seen in the A.E.G. Turbin factory of Peter Behrens (Fig. 6.31). Except for supporting girders, the side walls of the factory are totally of glass and create an expressly open feeling. The façades have no decoration whatsoever, but the front corners of poured concrete are striated almost as if to suggest masonry blocks. The flat plane of the façade is broken by the overhanging gabled roof and the forward-reaching window panels.

Poured concrete and new concepts in design also emerged in the works of Le Corbusier in the 1920's and 30's. Le Corbusier was concerned for integration of structure and function, especially in poured concrete. His belief that a house "was a machine to be lived in" exemplified several residences in these two decades. The "machine" concept did not imply a depersonalization, as much machine-related art in the first half of the century did. Rather, it implied efficient construction from standard, mass-produced parts, logically designed for usage as the parts of an efficient house-machine. Le Corbusier had espoused a "domino system" of design for houses, utilizing a series of slabs supported on

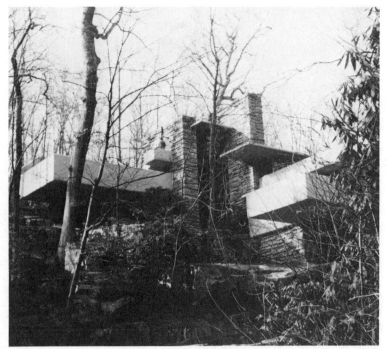

Fig. 6.30. Frank Lloyd Wright. Falling Water. 1936–37. Bear Run, Pennsylvania.

Fig. 6.31. Peter Behrens. A. E. G. Turbin factory. 1909–10. Berlin.

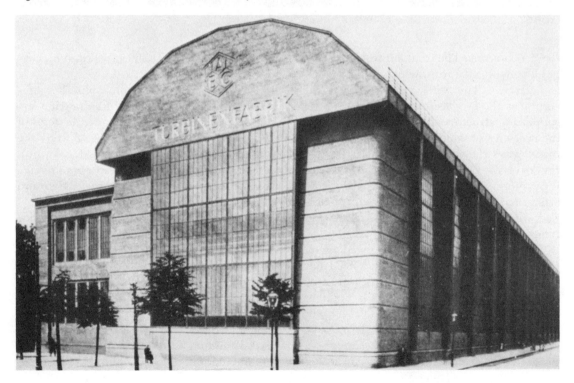

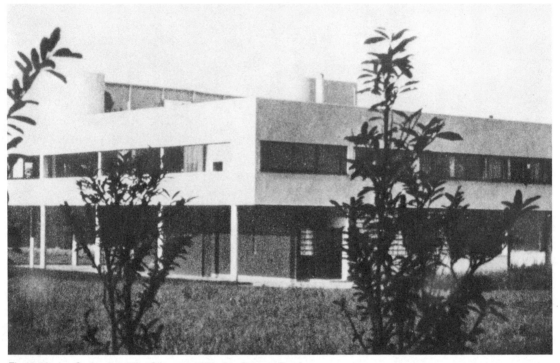

Fig. 6.32. Le Corbusier. Villa Savoye. 1929–31. Poissy, France.

slender columns. The resultant residence was boxlike, with a flat roof, which could be used as a terrace. The Villa Savoye (Fig. 6.32) combines these concepts in a design whose supporting structures freed the interior from the necessity of weight-supporting walls. In many ways the design of the Villa Savoye reveals classic Greek inspiration, from its delicate columns and human scale to its precisely articulated parts and totally coherent and unified whole. The design is crisp, clean, and functional.

In addition, this period continued many traditional approaches, which we need not dwell upon in any detail, but which must be noted. Cass Gilbert's Woolworth building (Fig. 6.33), is illustrative, stimulating not only considerable discussion, including the appellation "Woolworth Gothic," but also a wave of Gothic skyscrapers including

Howells and Hood's Chicago Tribune Tower (1923–25).

Probably the most philosophically integrated approach to architecture came in Germany in the mid-twenties. Under the aegis of Walter Gropius and Adolph Meyer, the Bauhaus School of Art, Applied Arts, and Architecture approached aesthetics from a spirit of engineering. Experimentation and design were based on technological and economic factors rather than on formal considerations. The Bauhaus philosophy sought to establish links between the organic and technical worlds and thereby to reduce contrasts between the two. "Spatial imagination," rather than "building and construction," became the Bauhaus objective. The design principles Gropius and Meyer advocated produced building exteriors completely free of ornamentation. Several juxtaposed, func-

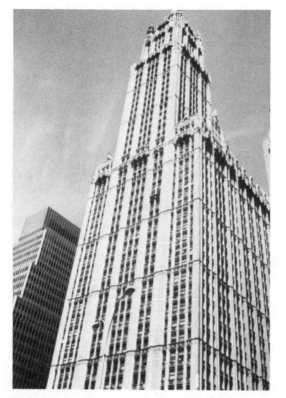

Fig. 6.33. Cass Gilbert. Woolworth Building. 1913. New York.

tional materials form externally expressed structure, and such an expression clearly marks the fact that exterior walls are no longer structural, merely a climate barrier. Bauhaus buildings evolved from a careful consideration of need and reflect a search for dynamic balance and geometric purity.

TOWARD ANOTHER MILLENNIUM

The second half of the twentieth century is now well past its halfway point. The events of this era are well within the direct experience of my lifetime, and, are, therefore, journalistic, not historic, in perception. Societies exist in a global environment in which the actions of even the smallest nation can have universal ramifications, often well beyond the significance of the original cause.

The optimism of democracy's victory over totalitarianism in World War II has been replaced by a more realistic, if less positive, appreciation of social inequities within democracy itself and with the struggle between democracy and international communism. The peace of the late forties gave way to numerous regional "conflicts," such as the Korean War (called by the United Nations a "police action"), the Arab–Israeli conflicts, the Vietnam "conflict," and incessant Latin American "struggles." The idealism of "individual liberty" has been forced to face the need for "societal" rights, and the questions of where one ends and the other begins remains one of the most taxing problems of the era.

Elsewhere, multinational corporations rule the business world, and test-tube fertilization and DNA modification are scientific realities. Mechanization has assumed universal proportions, and computer-generated conclusions threaten to replace human reason as the source of problem-solving. Technocrats threaten to rule a world of individuals whose education, if any, has consisted solely of "job training." Philosophy in many quarters is considered unproductive speculation, and usefulness alone has become the touchstone of value. Many of our contemporaries have progressed to the point that they, like Oscar Wilde's cynic, "know the price of everything and the value of nothing."

THE ARTS OF OUR TIME

Two-Dimensional Art

The first fifteen years following the close of World War II were dominated by a style called *abstract expressionism*. Beginning essentially in New York, abstract expressionism spread rapidly throughout the world on the

wings of our modern, instantaneous mass-communication networks. Like most modern styles, which have great variation among individual artists, abstract expressionism is difficult to define in specific terms, although some scholars believe it to be self-explanatory. Two characteristics seem fairly certain. One is a freedom from traditional utilization of brushwork, and the other is the exclusion of representational subject matter. Complete freedom of individual expression to reflect "inner life" gave rein to create works of high emotional and dynamic intensity. Absolute individual freedom of expression and freedom from rationality seem to underlie this style. There appeared to be some relationship to the optimistic post-World War II feeling of individual freedom and conquest over total-itarianism. By the early 1960's, when life was less certain and conflicts and nuclear possibilities more predominant, abstract expressionism had all but ceased to exist.

Probably the most heralded artist of this style was Jackson Pollock (1912–1956). A rebellious spirit, Pollock evolved into this approach to painting only ten years before his death. Although Pollock insisted that he had absolute control, his compositions consisted of what appeared to be totally unfettered dripping and spilling of paint onto huge canvases placed on the floor. Nevertheless, his work (Fig. 6.34), often called "action painting," elicits a sense of tremendous energy, actually transmitting the action of paint application to the respondent through a new concept of line and form.

Fig. 6.34. Jackson Pollack. "Number 1." 1948. Oil on canvas. 68 × 104". Collection, The Museum of Modern Art, New York. Purchase.

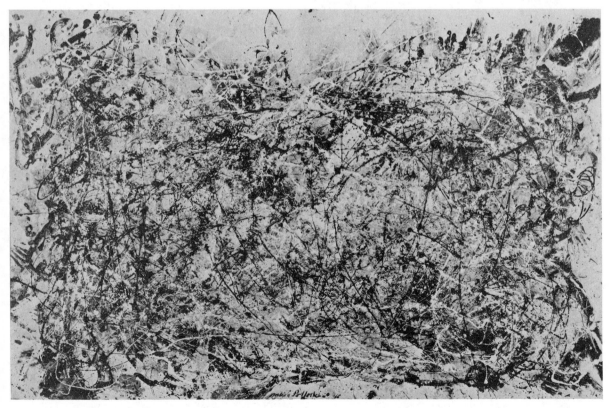

A different approach to abstract expressionism can be seen in the work of Willem de Kooning (1904–). Sophisticated texture and focal areas (Fig. 6.35) emerged from De Kooning's practice of reworking, scraping off, repainting, and repainting again. Yet from his laborious approach resulted works that display spontaneity and free action. Underneath rests a ferocity and dynamic passion, which tend to build in intensity as the eye moves from one focal area to the next.

Included also among the abstract expressionists is the "color-field" painting of Mark Rothko, whose highly individualistic paintings follow a process of reduction and simplification (Fig. 6.36). He removed from his canvases all of "memory, history, and geometry." He referred to these as "obstacles between the painter and the idea." Rothko's works are intensely personal and appear to reflect an expression from deep within the mind of an extremely sensitive experience. Other abstract expressionists include Arshile Gorky, Hans Hoffman, Franz Kline, Clyfford Still, Richard Diebenkorn, and Jean Dubuffet.

After, and in some instances as a reaction against, the emotionalism of abstract expressionism came an explosion of styles: *pop art, op art, hard edge, minimal art, postminimal art,*

Fig. 6.35. Willem de Kooning. "Excavation." 1950. Oil on canvas. 80⅛ × 100⅛". Courtesy of The Art Institute of Chicago. Gift of Mr. and Mrs. Edgar Kauffman and Mr. and Mrs. Noah Goldowsky.

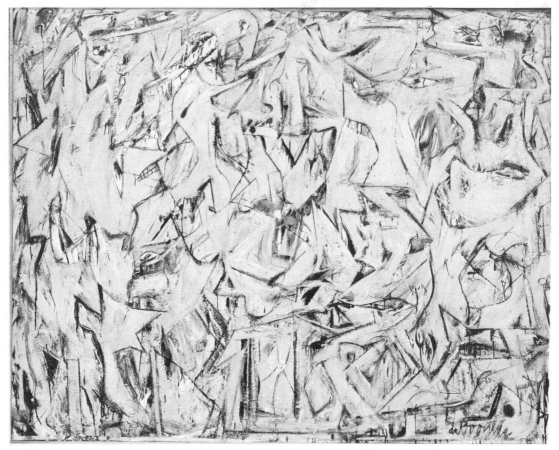

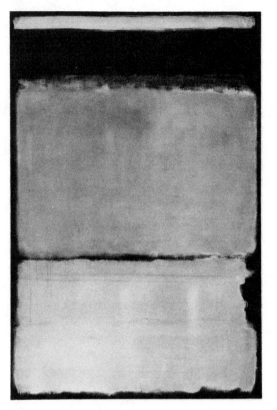

Fig. 6.36. Mark Rothko. "Number 10." 1950. Oil on canvas. 7′ 6⅜″ × 57⅛″. Collection, The Museum of Modern Art, New York. Gift of Philip Johnson.

environments, body art, earth art, video art, kinetic art, photo realism, and *conceptual art.* We have space to note, however briefly, only some of these.

Pop art grew in the 1950's, and concerned itself above all with image in a representational sense. Subjects and treatments in this style come from mass culture and commercial design. These bases provided pop artists with what they considered to be essential aspects of today's visual environment. The pop artists traced their heritage to Dada, although much of the heritage of the pop tradition continues to be debated. However, pop is essentially an optimistic reflection of the contemporary scene. The term "pop" was coined by the English critic Lawrence Alloway and related to the images found in popular culture that marked this approach. Jasper Johns, Robert Rauschenberg, Robert Indiana, Andy Warhol, and James Rosenquist all illustrate the pop style, but probably the compelling depictions of Roy Lichtenstein are the most familiar (Fig. 6.37). These magnified cartoon-strip details actually utilize the Ben-Day screen of dots by which colored ink is applied to cheap newsprint. Utilizing a stencil, about the size of a dime, the image is built up into a stark and dynamic, if sometimes violent, portrayal.

Op art concerns itself with optics and perception. Growing out of the 1950's op art is an intellectually oriented and systematic style, very scientific in its applications. Based on perceptual "tricks," the misleading images of these paintings capture our curiosity and pull us into a conscious exploration of what the optical illusion does and why it does it. Victor Vasarely bends line and form to create a very deceiving sense of three-dimensionality. Complex sets of stimuli proceed from horizontal, vertical, and diagonal arrangements. Using nothing but abstract form, Vasarely creates the illusion of real space. Vasarely's lead was followed by other op artists, among whom Richard Anuzkiewicz probably is the most notable.

Hard edge or *hard edged abstraction* also came to its height during the 1950's. In this style, of which Ellsworth Kelly and Frank Stella are the premier examples, flat color areas have hard edges which carefully separate them from each other. Essentially, hard edge is an exploration of design for its own sake. Stella abandoned the rectangular format in favor of irregular compositions to be sure his paintings had no relationship to "windows." The shape of the canvas was part of the design itself, as opposed to being a frame or a formal border within which the design was executed. Some of Stella's paintings have irides-

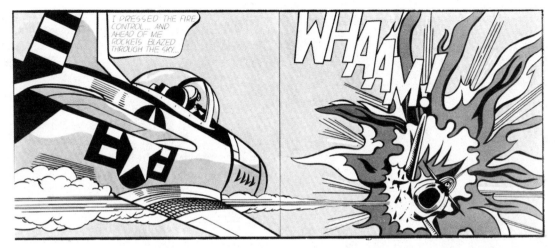

Fig. 6.37. Roy Lichtenstein. "Whaam!" 1963. Magna on canvas. Two panels. Entire work: 5' 8" × 13' 4". The Tate Gallery, London.

cent metal powder mixed into the paint, and the metallic shine further enhances the precision of the composition.

Photo realism is an offshoot of pop art concerned with photographic images. Using photographic images as a basis, photo realist works usually consist of extreme complexity. The works of Chuck Close are examples. Finally, *conceptual art* challenges the relationship between art and life, and, in fact, the definition of art itself. Essentially anti-art, like Dada, conceptual art attempts totally to divorce the imagination from aesthetics. It insists that only the imagination, not the artwork, is art. Therefore, artworks can be done away with; the creative process needs only to be documented by some incidental means such as a verbal description, a photograph, or a simple object like a chair. The paradoxes adhering to conceptual art are many, including its dependence on a physical "something" to bridge the gap between artist's conception and respondent's imagination.

Sculpture

Much contemporary sculpture shows a similarity to abstract expressionist painting especially in its rejection of traditional materials in favor of new ones, notably materials which do not require molds or models. Individualized shapes and action–stimulants have severed sculpture, as much as is possible, from the natural world. Yet, even in such a context, abstract sculpture often has a title by which the sculptor links his nonobjective expression to objective associations. The range of variation in works of this approach is immense and encompasses artists such as David Smith, Theodore Roszak, Seymour Lipton, Ibram Lassaw, and Isamu Noguchi. The simplicity of shape characteristic of David Smith's work (Fig. 6.38) has been called, among other things, "primary structure" and "environmental sculpture," names which forge a strong link with architecture. Here the respondent encounters an experience in three-dimensional space in which he or she can walk through as well as around the sculptural form.

Isamu Noguchi, perhaps less concerned with expressive content than others, has continually experimented with abstract sculptural design since the 1930's. His creations have gone beyond sculpture to provide highly dynamic and suggestive designs for the choreography of Martha Graham, with

Fig. 6.38. David Smith. "Cubi XIX." 1964. Height 9′ 5″. The Tate Gallery, London.

ture, that is, objects taken from "life" and presented as art for their inherent aesthetic, communicative value. In the same sense, and perhaps an outgrowth of cubist collages, is the movement called "junk culture." Here natural objects are assembled and/or joined to create a single "artwork." Philosophies or interpretations of this kind of "assemblage" art vary widely and may or may not have significant relationship to or reflection upon a social scene in which obsolescence and "throw away" materials are fundamental.

Fig. 6.39. Isamu Noguchi. *Kouros*. 1944–45. Marble. Height: 9′ 9″. The Metropolitan Museum of Art, New York.

whom he was associated for a number of years. Noguchi's *Kouros* figures (Fig. 6.39) contain abstract relationships with archaic Greek sculpture and also exhibit exquisitely finished surfaces and masterful technique.

Objectivity returns in the unique approaches of Albert Giacometti. He was a surrealist sculptor in the 1930's but continued to explore the "reality" of the human figure and to explore surface depiction and meaning, as can be seen in Figure 6.40. Here form is reduced to its essence in a tortured fragmentation that appears to comment on the nature of humankind in the contemporary world.

Another approach to sculpture emerging since World War II is that of "found" sculp-

Fig. 6.40. Alberto Giacometti. "Man Pointing." Bronze. Height: 70½". Collection, The Museum of Modern Art, New York. Gift of Mrs. John D. Rockefeller 3rd.

"Pop" objects serve as source materials for Claes Oldenburg (1929–). "Dual Hamburgers" (Fig. 6.41) presents an enigma to the viewer. What are we to make of it? Is it a celebration of the mundane? Or is there a greater comment on our age implicit in these objects? Certainly Oldenburg calls our attention to the qualities of design in ordinary objects by taking them out of their context and changing their scale. The influence of the Pop Movement also can be seen in the plaster figures of George Segal (1924–). Working from plaster molds taken from living figures, Segal builds scenes from everyday life with unpainted plaster images (Fig. 6.42). These unpainted "ghosts" remove the sculptural "environment" from reality to a different plane altogether. Similar in a way, but in stark contrast are the *photo realistic* sculptures of Duane Hanson (1925–), whose portrayals, including hair and plastic skin, often are displayed in such circumstances that the respondent, on first experience, does not know for sure that he is viewing a sculpture or a "real" human. Hanson's portrayals express a tragic quality and an exposé of crassness and bourgeois tastelessness; they often portray the dregs of American society.

Fig. 6.41. Claes Oldenburg. "Dual Hamburgers." 1962. Burlap soaked in plaster, painted with enamel. 7 × 14¾ × 8⅝". Collection, The Museum of Modern Art, New York. Philip Johnson Fund.

Fig. 6.42. George Segal. "The Bus Driver." 1962. Figure of plastic over cheesecloth; bus parts including coin box, steering wheel, driver's seat, railing, dashboard, etc. Figure: 53½″ × 26⅞″ × 45″. Wood platform: 5⅛″ × 51⅝″ × 6′ 3⅝″. Overall height: 6′ 3″. Collection, The Museum of Modern Art, New York. Philip Johnson Fund.

In the late 50's and 60's a style called *minimalism* in painting and sculpture sought to reduce design complexity to a minimum by concentrating on nonsensual, impersonal, geometric structures. No communication was intended from artist to respondent. Rather artists such as Tony Smith present these neutral objects without interpretation to stimulate whatever the viewer wishes.

Ephemeral art has many possible implications, including the works of the conceptualists, who insist that what is revealed is that "art is an activity of change, of disorientation and shift, of violent discontinuity and mutability." Designed to be transitory, ephemeral art makes its statement and then, eventually, ceases to exist. Undoubtedly the largest work of sculpture ever designed encompassed that concept. Christo's "Running Fence" (Fig.

6.43) was an event and a process, as well as a sculptural work. In a sense, Christo's works, such as this and "Valley Curtain," are conceptual in that they call attention to the experience of art in opposition to its actual form. At the end of a two-week viewing period, "Running Fence" was removed entirely and ceased to be.

What comes next? Was the recent German *Documenta VI,* with its diverse examples of transitory art, a harbinger of the future? Is television our next art medium? Nam June Paik's "Video Composition X" was a sensational display in which a large room was turned into a garden of shrubbery, ferns, and small trees, scattered among which, and looking up from the greenery were thirty television sets, all repeating the same program in unison. Bill Viola's "He Weeps for

Fig. 6.43. Christo. "Running Fence, Sonoma and Marin Counties, California, 1972–75." Nylon fabric and steel poles. Height: 18′. Length: 24½ miles. Fall 1976, 2 weeks. © Christo; photo by W. Volz.

You" featured a drop of water forming at the end of a tiny copper pipe and then falling on a drumhead. The image was blown up on a large television screen, and the sound of the falling drop was amplified into a thunderous boom. M.I.T.'s "Centerbeam" was a 220-foot long contraption using holograms, video, colored stream, and laser beams—art or a science fair project?

Music[3]

After World War II, several distinctly different directions began to develop which tended further to polarize schools of music along lines which had begun before the war. Two general tendencies have been taken: 1) To-ward control and formality; 2) toward less control of all elements to the point of random occurrences and total improvisation by performers. The post-Webern serialism of Milton Babbit in America and Pierre Boulez in France are clear examples of a move toward tighter control and predetermination of events. The improvisational works of Earl Brown and the many and varied approaches taken by John Cage exemplify a move away from composer control and predetermination, leaving decisions to performers or to chance. At the same time a number of composers continued in more traditional styles, which stemmed from the musical principles of Hindemith, the neoclassicism of Stravinsky, Prokofiev, and Shostakovich, and the nationalistic styles of Bartók, Copland, and Ernest Bloch.

Post-Webern or postwar serialism reflects

[3]The text for this section was prepared by David Kechley. I have edited where necessary to conform to the rest of the chapter.

a desire to exert more control and to apply a predetermined hierarchy of values to all elements of a composition. Before the war, 12-tone technique involved the creation of a set or row of twelve pitch classes arranged in a specific order. Although the order could be manipulated in a number of ways, certain relationships between the pitches of the "tone-row" were constant and provided the underlying structure and much of the flavor of this style. To a certain extent structural decisions were made before the composer actually began writing the composition itself. The composer was then subject to fairly strict limitations regarding the selection of pitches as the work progressed, since all pitch order was pre-established. Proponents of the technique argued that composers have always worked within limitations of some kind and that the discipline required to do so is an essential part of the creative problem-solving process. Opponents argued that writing music in this fashion was more a matter of mathematical manipulation appealing to the intellect and less the function of a composer's ear and basic musical instincts.

Three Compositions for piano by the American composer Milton Babbit, written in 1947–48, is one of the earliest examples of serial technique applied to elements other than pitch. In this work, rhythm and dynamics also are predetermined by serial principles. Oliver Messiaen was largely responsible for the postwar revival of serial principles in Europe, and two of his students, Pierre Boulez and Karlheinz Stockhausen, both produced works in the 1950's which were "totally serialized," for example, *Structures* for two pianos by Boulez, and *Kreuzspiel* (*Crossplay*) for oboe, bass clarinet, piano, and percussion by Stockhausen. Both of these composers later moved away from these techniques. A group of Italian composers, including Luciano Berio, Luigi Nono, and Bruno Mader-

na, also began as postwar serialists, and later moved in other directions.

While some composers were developing techniques and even systems of highly controlled composition in the late 1940's, others went in the opposite direction. John Cage has been a major force in the application of aleatoric or chance procedures to composition with works such as *Imaginary Landscape No. 4* for twelve radios and *The Music of Changes* (1951). Cage relied on the *I Ching* or *Book of Changes* for a random determination of many aspects of his works. The *I Ching* dates from the earliest period of Chinese literature and contains a numerical series of combinations based on the throwing of yarrow sticks (not unlike the throwing of a dice or coins). The ultimate example of "chance" music is Cage's *4'-33"* (1952) in which the performer makes no sound whatever. The sounds of the hall, audience, traffic outside, that is, whatever occurs is the content of the composition.

Cage toured Europe in 1954 and 1958 and is thought to have influenced composers such as Boulez and Stockhausen to incorporate aspects of chance and indeterminacy into their music. Examples of this influence are Boulez's *Third Piano Sonata* and Stockhausen's *Klavierstück,* both dating from 1957. These works, however, only go so far as to give options to the performer concerning the overall form of the work or the order of specific musical fragments, which are, for the most part, conventionally notated, and thus controlled. Other composers who experimented with indeterminacy are Earl Brown, Morton Feldman, and Christian Wolff.

An open, improvisatory tradition was carried on by composers like Lukas Foss with the Improvisation Chamber Ensemble of which he was founder. A number of other improvisation groups, many funded by granting organizations and universities, sprang up in the United States during the 1960's along

with the intense exploration of new sound possibilities from both conventional and electronic instruments.

What is often referred to as a "main stream" of musical composition also continued after the war. The source of much of this music is a combination of nineteenth century romantic tradition, the folk styles of Bartók and Copland, quartel harmonies of Hindemith, the modality of the impressionists Ravel and Debussy, and the neoclassicism of Prokofiev and Stravinsky. To some degree, both serialism and indeterminacy can be found here as well as popular or "jazz" elements. American composers of the so-called mainstream include Aaron Copland, Samuel Barber, Elliot Carter, William Schuman, William Bergsma, Vincent Persichetti, Roger Sessions, and Leonard Bernstein, to name only a few. In Europe such composers as Benjamin Britten, Luigi della Piccola, Geoffredo Petrassi, and Hans Werner Henze would be called "mainstream" by most. The only similarity in the music of these composers is that none of them gravitates toward the extremes of total predetermination or total randomness, and their music generally relies upon traditional musical principles.

Styles stemming from traditional jazz proliferated after the war. There was a gradual move away from the big bands to smaller groups and a desire for much more improvisation within the context of the compositions. The term "bebop" was coined as a result of the characteristic long-short triplet rhythm which ended many phrases. The prime developers of this style were alto-saxophonist Charlie Parker (The Bird) and trumpeter Dizzie Gilespie. Pianists, Thelonius Monk, Earl "Bud" Powell, and "Todd" Dameron were also innovative and influential in developing this style. The "cool jazz" style developed in the early 1950's with artists like Stan Getz and Miles Davis. Although the

technical virtuosity of bebop remained, a certain lyric quality, particularly in the slow ballads, was emphasized and, more importantly, the actual tone quality, particularly of the wind instruments, was a major distinction. "Third Stream" was a term used by composer Gunther Schuller to describe his own attempt to blend Euro-American art music techniques such as serialism with elements of the bebop and cool jazz styles. Other composers rooted in the jazz tradition such as Charles Mingus, Ted Macero, and Lee Konitz were employing techniques similar to the avant-garde composers previously discussed as aleatoric or indeterminate.

The development of the RCA synthesizer and the establishment of the Columbia–Princeton Electronics Music Center provided an opportunity for composers such as Milton Babbit to pursue the application and further development of primarily serial techniques. Composers such as John Cage found electronics a logical means to achieve his musical goals of indeterminacy as in *Imaginary Landscape No. 5*. Mainstream and jazz composers were not seriously affected by the electronic medium until the 1960's.

We need to note that electronic production and alteration of sound does not imply, in itself, a specific musical style. However, electronic sound production led to two new approaches during the 1950's: 1) *musique concrète*—the use of acoustically produced sounds, and 2) electronically generated sound. In recent times this distinction has become less meaningful due to the vast advances in technology since that time.

Composers such as Edgard Varese, Otto Luening, and Vladimir Ussachevsky utilized *musique concrète* techniques, and Pierre Schaeffer in Paris also is well known for developing *musique concrète* in his early experiments and works such as *Étude aux Objects* (1954). *Musique concrète* by its nature is less

controlled than the synthesized music of Babbit and later composers such as Mario Davidovsky and Charles Wuorinen, who tended to use only electronically produced sine waves, square waves, and so on.

The 1960's and early 70's saw even further extremes in the "ultrarational" and "antirational" directions[4] in addition to an even stronger desire constantly to create something "new." At times this desire for newness superseded most other considerations. Many composers, such as Donald Martino, Henry Weinberg, and Peter Westergard, continued using strict serial techniques often involving a "total control" concept in the tradition of Babbit. The serialism of the European composers, however, evolved into something quite different. Stockhausen, for example, became more interested in the total manipulation of sound and the acoustic space in which the performance was to take place. His work *Gruppen* (1957) for three orchestras is an early example. As he became more and more interested in timbre modulation, his work encompassed a greater variety of sound sources both electronic and acoustic in an interesting combination of control and noncontrol. An example of this is *Microphonie* I (1964). Igor Stravinsky, one of the most influential composers of the early part of this century, developed his own serial style in the late 50's and early 60's.

Elliot Carter, although not a serialist, developed a highly organized approach toward rhythm often called "metric-modulation," in which the mathematical principles of meter, standard rhythmic notation, and other elements are carried to complex ends. The pitch content of Carter's music is highly chromatic and exact, and his music requires virtuoso playing both from the individual and the ensemble. A number of other composers such as Wolpe, Shapey, and Chou Wen-Chung also stressed complex rhythmic subdivisions and virtuoso instrumental technique to some degree or other.

Virtuoso playing produced an important composer–performer relationship in the 1960's, and many composers, such as Luciano Berio, wrote specifically for individual performers, such as trombonist Stewart Dempster. In the same vein percussionist Max Neuhaus was associated with Stockhausen, and pianist David Tudor, with John Cage.

Experimentation with microtones has been of interest to music theorists throughout history and many non-Western cultures employ them routinely. Microtones can be defined as intervals smaller than a half step. Our system divides the octave into twelve equal parts. There seems to be no reason why the octave cannot be divided into 24, 53, 95 or any number of parts. The possibilities are limited only by our ability to hear such intervals and a performer's ability to produce them. Alois Haba experimented in the early part of the century with quartertone (24 per octave) and sixth tones (36 per octave) as did Charles Ives. Composer Harry Partch developed a number of instruments designed to produce microtones. Since the war, experimentation and composition in the area of microtones has been carried on by Ben Johnston, John Eaton, Julian Carrillo, Lou Harrison, and others.

In an atmosphere of constant searching and experimentation, composers often questioned the validity of traditional concepts of art in general and specifically the limitations of the traditional concert hall. The earlier work by Cage and others led in a number of directions including "theatre pieces," multimedia or mixed media, so called "danger music," biomusic, soundscapes, happenings, and total environments which might include stimulation of all the senses in some way.

[4] Eric Salzman, *Twentieth Century Music: An Introduction* (Englewood Cliffs, N.J.: Prentice–Hall, Inc.; 1967), pp. 155, 164.

Thus the definition of a composer as opposed to playwright, filmmaker, visual artist, and so on was often obscured.

Since the early 1960's electronic instruments which could be utilized in live performance have been highly influential in music composition. Live performance mixed with prerecorded tape occurred in the 1950's, and by the 1960's it became common to alter the sound of live performers by electronic means. Computer technology has been added to the composition and performance of music, and the options available through computer application appear endless.

Theatre music, sometimes called experimental music, ranges from relatively subtle examples of performers playing or singing notated music and moving to various points on the stage as in Berio's *Circles* (1960) to more extreme examples, such as the works of La Monte Young, in which the performer is instructed to "draw a straight line and follow it" or react to the audience just as an audience was to react to the performers, that is, exchange places. A more active example is Nam June Paik's *Homage to John Cage* in which the composer ran down into the audience, cut off Cage's tie, dumped liquid over his head, and ran from the theater, later to phone and let the audience know the composition had ended. Needless to say, such compositions contain a high degree of indeterminacy.

Some works were never intended to be performed, but only conceptualized, such as Nam June Paik's *Danger Music for Dick Higgins,* which instructs the performer to "Creep into the vagina of a living whale" or Robert Moran's *Composition for Piano with Pianist,* which instructs the pianist to climb into the grand piano.

There was also a return to minimal materials exemplified by Stockhausen's *Stimmung* (Tuning), dating from 1968, for six vocalists singing only six notes. "Minimal" music generally can be defined as music which used very little musical material, but often for an extended length of time, such as *One Sound* for string quartet by Harold Budd and the electronic piece *Come Out* (1966) by Steve Riech. Works such as *In C* or *Rainbow in Curved Air* by Terry Riley and *Drumming* by Steve Reich are "minimal" also, but stress a periodic rhythm; thus they have been termed "periodicity music."

Many mainstream composers continued writing throughout the 1960's and early 70's. However, a noticeable element of controlled indeterminacy has found its way into the music of many of them. The late 60's and 70's brought greater tolerance and acceptance on the part of composers for each other's varying aesthetic viewpoints and musical styles. Thus a blending of avant-garde (largely indeterminant) techniques with the traditional values of the mainstream has resulted in music produced by composers such as George Crumb, *Ancient Voices of Children* (1970); Donald Erb, *The Seventh Trumpet* (1969); and Karel Husa, *Apotheosis of this Earth* (1970).

Just as indeterminacy and aleatoric procedures had been developed during the 1950's by composers of the Western European music tradition, freedom from melodic, rhythmic, and formal restraints in jazz led to the "free jazz" style of the 1960's. Saxophonist Ornette Colman was one of the earliest proponents of such freedom. Others, such as John Coltrane, developed a rhythmically and melodically free style based on more modal materials, while Cecil Taylor developed materials which were more chromatic. In the mid-to-late sixties a mature blend of this freedom, with control and sophistication, was reached in Miles Davis's *Bitches Brew* album of 1967. A number of musicians, such as Wayne Shorter, Bill Evans, Herbie Hancock, Ron Carter, Chic Corea, and Keith Jarrett, who originally worked with Miles Davis, became leading artists in the 1970's, developing a style called "jazz-rock," or "fusion."

The postwar period has been one of rapid change due to the constant quest for something new. Whether it be new sounds, the application of new technology, new notation, new formal parameters, entirely new ways of presenting music, or combining music with visual and other stimuli, aesthetic viewpoints and styles have been both numerous and varied. Extremism and intolerance from both the conservative and avant-garde have not been uncommon. An insatiable appetite for something new affected composers of almost all music styles since World War II. The influence of music composition for film and television has made the era an interesting one, bringing together varying styles for dramatic purpose and proliferating new sounds and applications to a wide audience, occasionally gaining acceptance for a form which, in a traditional concert hall, would be unacceptable.

There is no doubt that the extremism beginning after the war and culminating gradually during the 70's has given way to a re-evaluation and acceptance of all styles as containing valid material upon which to draw for a composition.

Theatre

A breaking point such as World War II is, like a century mark, an arbitrary guidepost. However, World War II, falling nearly at mid-century, is more than merely convenient, because the world did nearly cease all peaceful activities during that period. Nevertheless, many playwrights whom we have yet to examine began their careers before the war, and our neglect of them until this point is a matter of convenience and not a commentary on their prewar significance.

Theatre of social action, of which Meyerhold was an example, found a very successful proponent in Berthold Brecht's *Epic Theatre*. Although most of Brecht's plays were written prior to the war, they did not see production until after. Then, with his

Berliner Ensemble, Brecht brought his theories and productions to a wider audience and acclaim. Drawing heavily on the expressionists, Brecht developed complex theories about theatre and its relationship to life, and he continued to mold and develop those theories until his death. Brecht called his approach *epic,* because he saw it as a revolt against *dramatic* theatre. Essentially, he desired to move the audience out of the role of passive spectator and into a more dynamic relationship with the play. To achieve his ends, Brecht postulated three circumstances: historification, alienation, and epic. Historification removed events from the lifelike present to the past in order to "make strange" the actions presented. According to Brecht, the playwright should make the audience feel that if they had lived under the conditions presented, they would have taken some positive action. Having seen this, the audience should recognize that, since things have changed, they can make changes in the present as well. "Alienation" was part of the goal of making things "strange," that is, part of historification. Many devices could be used, such as calling the audience's attention to the make-believe nature of the production or by inserting songs, film sequences, and so on.

As did Meyerhold, Brecht believed the audience should never confuse the theatre with reality. The audience should always see the play as a comment on life, which they must watch critically. Therefore, "alienation" meant that the spectator should judge what he sees in the theatre and apply it to life outside— he must be alienated from the play's events, although he may become emotionally involved. Brecht did not subscribe to the unified approach to production. Rather, he saw each element as independent, and, thereby, as a device to be utilized for further alienation. Theatricality characterized the production elements of scenery, lighting, costumes, and properties. Finally, Brecht called his theatre epic because he believed that his plays re-

sembled epic poems more than they did traditional drama. His plays presented a story from the point of view of a storyteller and frequently involved narration and changes of time and place, which could be accomplished with nothing more than an explanatory sentence. *Caucasian Chalk Circle, The Good Woman of Setzuan, The Three-Penny Opera, Mother Courage, Galileo,* and *Mahagonny* are some of Brecht's more important works.

Following the Brechtian tradition were German playwrights such as Max Frisch (*The Chinese Wall, Biedermann and the Firebugs,* and *Andorra*), whose works deal with the general question of guilt, and Frederick Dürrenmatt (*The Visit, The Physicist*), dealing with moral responsibility. Later came Peter Weiss (*The Persecution and Assassination of Jean-Paul Marat as Performed by the Inmates of the Asylum of Charenton under the Direction of the Marquis de Sade*).

Luigi Pirandello's nonrealistic departures forged the mold from which emerged a movement called *absurdism.* Also an important contributor to absurdist style was existentialism, a philosophy which questioned the nature of existence, placing a meaningless present amid a guilt-ridden past and an unknowable future. From such antecedents came numerous dramas, probably the most familiar of which were written by the French philosopher/playwright Jean Paul Sartre. Sartre's existentialism held that there were no absolute or universal moral values and that humankind was part of a world without purpose. Therefore, men and women were responsible only to themselves. His plays attempted to draw logical conclusions from "a consistent atheism." Plays such as *The Flies* (1943), *No Exit* (1944), *The Devil and the Good Lord* (1951), and *The Condemned of Altona* (1959) translate Sartre's philosophies and existential viewpoint into dramatic form.

Albert Camus was the first playwright to use the term *absurd,* and saw that state as a result of the dichotomy between human-kind's aspirations and the meaninglessness of the universe in which individuals live. Finding one's way in a chaotic universe, then, became the theme of Camus's plays, such as *Cross-Purposes* (1944), *Caligula* (1945), and *The Just Assassins* (1949).

Following these two playwrights were a series of absurdists who differed quite radically from both Sartre and Camus, both of whom strove to bring order out of absurdity. However, the plays of Samuel Beckett, Eugene Ionesco, and Jean Genet all tend to point only to the absurdity of existence and to reflect the chaos they saw in the universe. Their plays are chaotic and ambiguous, and the absurd and ambiguous nature of these plays make direct analysis purely a matter of interpretation. Beckett's most popular work, *Waiting for Godot* (1958), has been interpreted in so many ways to suggest so many different meanings that it has become an eclectic experience in and of itself. Beckett, like the minimalist sculptors, left it to the audience to draw whatever conclusions they wished about the work confronting them. Ionesco's works are even more baffling, utilizing nonsense syllables and clichés for dialogue, endless and meaningless repetition, and plots that have no development. He called *The Bald Soprano* (1950) an *antiplay,* and his other works, among them *The Chairs, The Lesson,* and *Rhinoceros,* reflect virtually the same approach. The Absurdist Movement has influenced other playwrights and production approaches, from Harold Pinter to Edward Albee.

Realism continued its strong tradition throughout the postwar era and owes much of its strength to the works of Tennessee Williams and Arthur Miller. However, "realism" has expanded from its nineteenth-century definitions to include more theatrical approaches and devices such as fragmentary settings. Realism also has become more eclectic in the inclusion of many nonrealistic devices such as symbolism. Undoubtedly the theatre has concluded that stage realism and

life's realism are two different concepts entirely. Tennessee Williams skillfully blended the qualities of realism with whatever scenic, structural, or symbolic devices were necessary to meet his goals. *The Glass Menagerie, A Streetcar Named Desire, Summer and Smoke,* and *The Night of the Iguana,* among others, dealt sensitively and poignantly with the problems and psychology of everyday people. His character development is thorough and occupies the principal focus in his dramas as he explores the mental and emotional ills of our society. Arthur Miller probed the social and psychological forces that destroy contemporary men and women in plays such as *All My Sons, Death of a Salesman, The Crucible, A View From the Bridge, After the Fall,* and *Incident at Vichy.*

Theatre since the 1960's has remained vital due to its diversity. Unfortunately that diversity makes it impossible to do more than quickly scan the landscape. The social distress of the sixties spawned a reaction against the

traditional commercial theatre in the United States. Called the "New Theatre" this somewhat limited movement produced in coffeehouses and off-off Broadway theatres. Participants in the movement stressed creativity and nontraditional production standards and forms, and sought new kinds of theatrical materials. Ellen Stewart's *La Mama Experimental Theatre Club,* Joe Cino's *Café Cino,* Julian Beck's *Living Theatre,* and the *Open Theatre* experimented with hundreds of plays, techniques, and styles. Outside of the groups just mentioned, many other individuals need to be noted in these contemporary approaches: Jerzy Growtowski, Peter Brook, Robert Wilson, and Richard Schechner, to name a few.

Still, theatre requires that the playwright emerge and bring to the theatre new works for production—in whatever style. The commercial limitations of theatre production cause great difficulty in this regard. Significant efforts such as those of the Actors The-

Fig. 6.44. D. L. Coburn. *The Gin Game.* Actors Theatre of Louisville. Georgia Healslip (left), Will Hussung (right). Photo by David S. Talbott.

atre of Louisville, are greatly responsible not only for developing new playwrights, but also for bringing new works to production, and for keeping theatre vital in areas of the United States not contiguous to New York City and Broadway. The significance of these efforts can be seen in two productions, *The Gin Game* and *Agnes of God*. D. L. Coburn's *The Gin Game* emerged from the Actors Theatre's First Festival of New Plays, in 1976–77. Its story evolves around an elderly man and woman who meet in a retirement home. The vehicle for their reviews, debates, and intimacy is an on-going card game (Fig. 6.44). *The Gin Game* won a Pulitzer prize in 1978 and enjoyed a successful Broadway run. John Pielmeier's *Agnes of God* (Fig. 6.45) was produced as part of the Fourth Festival of New American Plays, 1979–80. It deals with a psychiatrist who becomes obsessed with an un-

Fig. 6.45. John Pielmeier. *Agnes of God.* 1980. Actors Theatre of Louisville. Mia Dillon (left), Adale O'Brien (right). Photo by David S. Talbott.

usually mystical nun who has been charged with murdering her child at birth. These and other Actors Theatre of Louisville plays, such as Beth Henley's *Crimes of the Heart* (1978–79), Marsha Norman's *Getting Out* (1977–78), and William Mastrosimone's *Extremities* (1980–81), continue to make a significant contribution to the contemporary theatre, often finding their way to the commercial forum of Broadway.

Film

In an era in which interest in the cinema has reached new heights, not necessarily in terms of casual audience attendance, but rather in terms of serious study, film has turned in divergent directions. Mostly it has returned to feature-length entertainment aimed at profit-making. Melodramatic spectacle and special effects have relegated character and message to secondary status. Films such as *Star Wars, Raiders of the Lost Ark, Jaws, Superman II, Star Trek,* and *E.T.* once again attempt to take us beyond our reality to a world of adventure and imagination.

The early years after World War II were extremely profitable, but the era of the "big studio" was on the wane. The strengthening of labor unions and antitrust rulings on theatre ownership completely changed the nature of the film industry. In addition, the House Un-American Activities Committee hearings produced a decade in which all liberal thought was stifled. Any subject or individual that might in any way be considered controversial was cast aside. Hundreds of careers and lives were destroyed, and films turned to "safe" and escapist fare almost exclusively. "Message" movies became virtually nonexistent in the United States. Even the most daring film of the period, *On the Waterfront,* obfuscated the facts when it came to revealing the "higherups" who were manipulating corrupt unions. At the same time television made it possible for the public to have "moving pictures" in the living room.

Hollywood's immediate response was a series of technological spectaculars such as Cinema Scope, Cinerama, and 3-D. Soon, it became clear that good movies, not special effects, were needed to stimulate attendance. John Ford's westerns such as *Red River*, Billy Wilder's *Sunset Boulevard*, and Alfred Hitchcock's *North by Northwest* were forthcoming, as was the blockbuster success *Ben Hur*, in 1959. Fred Zinnemann's *High Noon* and *From Here to Eternity* earned high plaudits. Elia Kazan, a theatre entrepreneur, turned to the film in 1944 and produced outstanding dramas, such as *A Tree Grows in Brooklyn*, *A Streetcar Named Desire* (with Marlon Brando repeating his famous Broadway role), and *On the Waterfront*.

The forties and fifties saw a revival of musical comedies, more John Wayne, and an unforgettable genre of forgettable Saturday matinee series from *Captain Video* to *Buck Rogers*. Elvis Presley first gyrated across the screen in 1956, and the tragic fall of Judy Garland captured the American heart. Elizabeth Taylor and Audrey Hepburn came to stardom in *National Velvet* and *Roman Holiday* respectively. However, no actress better represented the fifties than Marilyn Monroe, movie sex symbol and tragic off-screen personality. *The Misfits* (1962), an appropriately titled work, brought her and Clark Gable together for their last film appearances.

The sixties was an era of international film and of the independent producer. No longer did the "studio" undertake programs of film production, nor did they keep stables of "contract players." Now each film was an independent project whose artistic control turned to the hands of the director. A new breed of film-maker came to prominence: Rossellini, De Sica, Kurosawa, Fellini, Antonioni, Bergman, Godard, and Truffaut. *Neorealism*, a movement dating to World War II, predominated in the "foreign film" tradition, which saw such superb works as Fellini's *La Strada* (1954) and *La Dolce Vita* (1960). Film art was universal, and the stunning artistry of Kurosawa's *Rashomon* (1951) and *Seven Samurai* (1954) had tied East and West in an exploration of the human condition that could penetrate to great depths or slide across the surface in inane superficiality. Imagery, symbolism, and an unusual vision marked the films of Sweden's Ingmar Bergman. *Wild Strawberries*, *The Virgin Spring*, and *Persona*, among others, creatively and often horrifyingly delved into human character, suffering, and motivation.

The seventies and eighties have seen curious directions in film. Devotées have come to regard it as an art form with a significant enough heritage to provide for historical and scholarly study and analysis. More and more films are being made to appeal to a very specific and sophisticated clientele, and even movies made for and achieving wide commercial success have levels directed at an "ingroup" of film buffs. For example, the tremendously popular *Star Wars* consisted of a carefully developed series of repetitions and satires of old movies. Lack of knowledge of old films did not hamper one's enjoyment of the film and its tremendous visual accomplishments, but awareness of the parodies enhanced the response of those who were knowledgeable.

Questions remain to be answered regarding whether cable television and "pay TV," in which first-run films are released not to movie theatres but to television outlets, will doom the "theatre film." Certainly such an approach has and will have a significant effect on the basic aesthetics of film-making. Films shot for theatre screens are basically "long shot" oriented, because the size of the screen enhances broad visual effects. Television, on the other hand, is a close-up medium. Its small viewing area cannot manage wide-angle panoramas. Details, simply, are too small. Television must rely mostly on the

close-up and the medium shot. Television movies must be written to "hook" an audience in the first few minutes to prevent viewers from changing channels. A theatre movie can develop more slowly since the audience is unlikely to go to another theatre if something exciting does not happen in the first few moments. Compromises with film aesthetics already influence some film-making, whose directors have one eye on the theatre box office and the other on the lucrative re-release to television. As a result, this perspective produces films which try to meet the aesthetic parameters of both media. It is clear, however, that, as the twentieth century draws to a close, only the mass marketplace will decide what the art of the cinema will be, because whether art, entertainment, or both, cinema depends upon commercial success for its continuation.

Dance

Much of what we said of dance in the early portion of this chapter applies to the years since 1945. José Limon and Martha Graham, as well as George Ballanchine, continued to influence dance well into the second half of this century. Limon's *Moor's Pavane,* utilized Purcell's *Abdelazar* for its music. Based on Shakespeare's *Othello* and structured on the Elizabethan court dance, the *Pavane* is an unusual dramatic composition that sustains tension from its beginning to its end.

Martha Graham's troupe produced a radical and controversial choreographer who broke with many of the traditions of modern dance (as flexible as those traditions have been). He incorporated chance or aleatory elements into his choreography and often has been associated with the composer John Cage. Merce Cunningham uses everyday activity as well as dance movements in his works. His concern is to have the audience see the dance in a new light, and, whatever the reaction may be, his choreography is radi-

cally different from anyone else's. His works show elegance and coolness, as well as a severely abstract quality. Works such as *Summerspace* and *Winterbranch* illustrate Cunningham's use of chance, or indeterminacy. His object is to keep the dance fresh, and he thoroughly prepares numerous options and orders for sets, which then (sometimes by flipping a coin) can be varied and intermixed in different order from performance to performance. Therefore, the same piece may appear totally different from one night to the next. Cunningham also treats stage space as an integral part of the performance and allows focus to be spread across various areas of the stage, unlike classical ballet, which tends to isolate its focus on center stage or downstage center alone. So Cunningham allows the audience member to choose where to focus, as opposed to forcing that focus. Finally, he tends to allow each element of the dance to go its own way. As a result, the direct, beat-for-beat relationship that audiences have come to expect between music and footfalls in ballet and much modern dance simply does not exist.

Since 1954, another graduate of Martha Graham's troupe (and also of Merce Cunningham's) has provided strong direction in modern dance. Paul Taylor's work has a vibrant, energetic, and abstract quality that often suggests primordial actions. Taylor, like Cunningham, often uses strange combinations of music and movement in highly ebullient and unrestrained dances such as *Book of Beasts.* Interestingly, Taylor's music often turns to traditional composers, such as Beethoven, and to specialized works like string quartets. The combination of such a basically esoteric musical form with his wild movements creates unique and challenging works for the viewer to grasp.

In a tradition which encourages individual exploration and independence, there have been many accomplished dancer/choreogra-

phers. Alwin Nikolais was among these. His works (he designs the scenery, costumes, and lights and composes the music, as well as the choreography) tend to be mixed-media extravaganzas, which celebrate the electronic age with spectacles that many have compared to early court masques. Often the display is so dazzling that the audience loses the dancers in the lighting effects and scenic environment. Another figure of importance is Alvin Ailey, a versatile dancer whose company is known for their unusual repertoire and energetically free movements. Twyla Tharp and Yvonne Ranier both have experimented with space and movement. James Waring has incorporated Bach and 1920's pop songs, florid pantomimes and abstractions, as well as romantic point work.

Another form of dance, which has its roots in the black musical heritage, but which draws upon the broad experiments of modern dance is "jazz dance." Its forms are not universally agreed upon, and like modern dance's, its directions are still in flux. Nevertheless, stemming from sources as diverse and yet as allied as primitive Africa and the urban ghetto, this discipline has seen significant activity and experimentation throughout the United States (Figs. 6.46 and 6.47). Choreographers such as Asadata Dafora Horton in the 1930's and Katherine Dunham and Pearl Primus in the 1940's, have been the pioneers in this approach, which has seen contemporary works from choreographers such as Talley Beatty and Douglas McKayle.

Contemporary ballet is so universal that it

Fig. 6.46. *Nameless Hour.* Jazz Dance Theatre at Penn State. The Pennsylvania State University. Choreographer: Jean Sabatine. Photo by Roger Greenwalt.

Fig. 6.47. *Family Tree.* Jazz Dance Theatre at Penn State. The Pennsylvania State University. Choreographer: Jean Sabatine. Photo by Roger Greenwalt.

is virtually impossible even to suggest the plethora of excellent companies and dancers around the world. If modern communication and travel have made our world a global neighborhood, they also have made it possible for individuals in "the hinterlands" to have access to fine experiences in ballet and modern dance through numerous international tours of the world's great companies. The Bolshoi, The Stuttgart, Royal Danish, and so on have made occasional trips to the United States. Often large numbers of American tourists are found in the ballet houses of London, Moscow, and Vienna. In the United States and Canada fine professional regional companies keep ballet traditions alive and fresh. Dance has become one of this country's most popular and growing art forms, with availability of quality works growing each year.

Architecture

Architecture affords no relief from the problem of trying to sample or overview an era still in the making. In a sense, the task is more difficult here, because the human element of artistic creation has been blurred by architectural corporations, as opposed to individual architects. There also is a tendency for the contemporary observer to see a "sameness" in the glass and steel boxes that dominate our cities and to miss the truly unique approach to design that may comprise a housing project in an obscure locale.

The war caused a ten-year break in architectural construction and, to a certain extent, separated what came after from what went before. However, the continuing careers of architects who had achieved significant accomplishment before the war did bridge that gap from one period to another. In addition,

geographical focus changed from Europe to the United States, Japan, and, even, South America. However, the overall approach still remained "modern" or "international" in flavor, which does help us to select a few examples to illustrate general tendencies.

As a type, the skyscraper saw a resurgence of building in the fifties, in a "glass and steel" box approach that continues today. Illustrative of this type and approach is Lever House in New York City (Fig. 6.48). A very important consideration in this design is the open space surrounding the tower. Created by setting the tower back from the perimeter of the site, the open space around the building creates its own envelope of environment or context. Reactions against the glazed appearance of the Lever Building have occurred through-

out the last thirty years, with surfaces such as aluminum pierced by small windows, for example. In the same sense, an intensification of the glazed exterior has occurred, wherein actual metallic, glazed windows, rather than normal glass, have formed the exterior surface. Such an approach has been particularly popular in the "Sun Belt," because glazed glass reflects the sun's rays and their associated heat. In any case, the functional, plain rectangle of the "international style" has continued as a general architectural form regardless of its individual variation.

The rectangle, which has so uniformly, and in many cases thoughtlessly, become the mark of contemporary architecture leads us to the architect who, before World War II, was among its advocates. Mies van der Rohe

Fig. 6.48. Gordon Bunshaft (Skidmore, Owings, and Merrill). Lever House. 1950–52. New York City.

Fig. 6.49. Mies van der Rohe and Phillip Johnson. Seagram Building. 1958. New York City.

insisted that form should not be an end in itself. Rather, the architect should discover and state the function of the building. His pursuit of those goals and his honesty in taking mass-produced materials at face value, that is, bricks, glass, and manufactured metals, and outwardly expressing their shapes was the basis for the rectangularization that, as noted, is the common ground of twentieth-century architecture. His search for proportional perfection can be traced, perhaps, to the German Pavilion of the Barcelona Exposition in 1929 and was expressed in a number of projects, culminating in New York's Seagram Building (Fig. 6.49).

The simple straight line and functional structure basic to Mies' unique insights were easily imitated and readily reproduced. However, such commonplace duplication, al-though overwhelming in numbers, certainly has not overshadowed creative insight and exploration of other forms. Differing reflections in contemporary design ultimately have pursued the question formulated by Louis I. Kahn, "What form does the space want to become?". In the case of Frank Lloyd Wright's Guggenheim Museum (Fig. 6.50), space has become a relaxing spiral that reflects the leisurely progress one should make through an art museum. Eero Saarinen's Trans-World Airline Terminal takes the dramatic shape of flight in curved lines and carefully designed spaces, which accommodate large masses of people and channel them to and from waiting aircraft. (Such shapes could only be executed by modern construction techniques and materials such as reinforced concrete.) Flight also has been suggested by

Fig. 6.50. Frank Lloyd Wright. The Solomon R. Guggenheim Museum. 1942–59. New York City.

Fig. 6.51. Le Corbusier. Nôtre-Dame-du-Haut. 1950–55. Ronchamp, France.

Le Corbusier's dynamic church, Nôtre-Dame-du-Haut (Fig. 6.51). However, this pilgrimage church appears more like a work of sculpture than it does a building. Here function cannot be surmised from form. Rather, the juxtaposed rectilinear windows and curvilinear walls and the overwhelming roof nestled lightly on thin pillars above the tops of the walls all appear as a "pure creation of the spirit."

The simple curvilinearity of the arch and the dome is the mark of two different and noteworthy architects. The unencumbered free space in their projects represents a contrast to the self-contained boxes of the international style. Pier Luigi Nervi's, Small Sports Palace (Fig. 6.52) and R. Buchminster Fuller's Climatron (Fig. 6.53) illustrate the practical need for free space, but they also suggest the trend to spansion architecture

which stretches engineering to the limits of its materials, and which, in the case of the Kansas City Hyatt Regency Hotel, took design tragically beyond practicality.

If our space were unlimited we could continue to note original and controversial designs such as the Georges Pompideau National Arts and Cultural Center in Paris, The Sydney Opera House in Australia, Habitat in Montreal, and the numerous architects of the age such as Piano and Rogers, Moshe Safdie, I. M. Pei, Vilgo Revel, Jorn Utzon, Edward Durell Stone, Oscar Neimeyer, Kenzo Tange, Paul Rudolph, and many others, including such widespread projects as Chandigarh and Brasília, which encompassed entire cities, not to mention the colorful influences of pop art and the directions called "post-modern." However, for such additional material you must turn elsewhere. In so doing you

Fig. 6.52. Pierluigi Nervi. Small Sports Palace. 1957. Rome.

Fig. 6.53. R. Buckminster Fuller. Climatron. 1959. St. Louis.

will enter a new universe of excitement and horizons, which will forever change the way you view the world around you.

Summary

Our civilization has emerged from small, medieval beginnings to global applications of commerce, economics, and government, and to global conflicts between capitalism and socialism, nationalism and imperialism, and Christianity and innumerable other philosophies and religions. In 1914 a war that defied logic ushered in the twentieth century and radically changed humankind's general view of itself. The end of the war brought about disruption of monetary traditions, inflation, taxes, and chaotic industrial output. Equally important to twentieth-century directions was the Russian Revolution. Undoubtedly the most significant development in the social sciences, and one which had profound influence on the arts, occurred in psychology in the psychoanalytical findings of Sigmund Freud.

The years after World War I were troubled ones. Nonetheless, distinct advances in social democracy occurred. The 1920's was a decade of contrast; the early years experienced an apparent burst of prosperity, but 1929 brought the worst economic crisis the Western world had ever known. Out of the crisis of the 30's came the forces that shaped World War II. Then, on August 6, 1945, a nuclear explosion over the city of Hiroshima, Japan, forever altered the state of the world and humankind's relationship to it. Now into the last quarter of the century, the optimism of democracy's victory over totalitarianism in World War II has been replaced by a more realistic, if less positive, appreciation of the world, its conflicts, and its potentials.

The arts in the first half of the twentieth century exploded with new styles and approaches, many of which crossed disciplinary lines, embracing visual and performing arts. In two-dimensional art expressionism, fauvism, cubism, abstract art, dada, and surrealism emerged from the view of Beckman, Matisse, Picasso, Bracque, Mondrian, Arp, DuChamp, Dali, and so many others. Sculpture revived singificantly in the twentieth century. New concerns for space, new forms, and new materials abounded. Expressionism, futurism, primitive influence, psychological complexity, and motion in undefined space found sculptural expression in the works of Barlach, Brancusi, Lipchitz, and so on.

Music took no less radical a path from its nineteenth-century heritage than did two-dimensional art and sculpture. Nonetheless, old traditions continued. New directions differed from past traditions essentially in three ways. First was rhythmic complexity, in some cases doing away with regularity of accents so that meter was virtually impossible to determine. The second change comprised a focus on dissonant harmonies. The third major change involved the rejection of traditional tonality or sense of key, altogether. The systems that resulted from such a path were called twelve-tone composition and serialism.

This century also gave rise to popular exploration of jazz. Blues, traditional jazz, swing, bebop, and cool jazz each had its day. Many individualized experiments occurred in jazz and in all areas of music, and like so much of twentieth-century art must be examined in terms of the individual artist making those experiments. Such was the nature of our examination in this chapter, and a repeat of names here in the summary is pointless. The arts were in flux in the first half of the century. No tradition was sacred, and no convention unbreakable. In the same sense, an eclectic spirit also made reference to and incorporation of previous styles equally acceptable.

Expressionism, eclecticism, and contructivism in many ways tied the theatre to the

visual arts and music. The most significant direction in theatre stemmed from the theories of Adolphe Appia and Gordon Craig who attempted to articulate new ideas and ideals concerning unifying theatre action among the diverse visual forms and conditions of the theatre. The result was eclecticism, "artistic realism," or organic unity. In the United States these new theories included The New Stagecraft and were carried forward primarily by the efforts of two influential designers, Robert Edmond Jones and Lee Simonson. For the most part, artistic realism has remained the dominant approach to the theatre in the twentieth century, especially in the United States, although many diverse approaches and experiments have occurred.

The turn of the century found a new, technological medium beginning to make its mark. At that point "movies" were nothing more than a recording of everyday life. Fortunately George Méliès in France and Edwin S. Porter in the United States would demonstrate the narrative and manipulative potentials of the cinema. Lawsuits regarding patents and monopolies marked the first decade of the century and found the movie industry settling in a dusty California town called Hollywood. The second decade witnessed *Birth of a Nation,* Mack Sennet comedies, and German expressionism. The 1920's were the heyday of Hollywood and a decade of development in theory and aesthetics, especially in Russia in the efforts of Sergei Eisenstein. By 1927 "talkies" revolutionized the industry and its aesthetics. New genres and stars marked the 30's, most notably the animation work of Walt Disney and the arrival of Mickey Mouse. Also emerging were *Gone with the Wind* and the works of such European artists as Alfred Hitchcock. World War II and its aftermath brought radical change to the form and content of cinema in works of social criticism, brilliant cinematography, and compelling performances. By the end of World War II objective viewpoint in filmmaking changed the course of cinema through a style called neorealism.

Certainly the most influential figure in ballet, and perhaps in all the arts in the early twentieth century was Sergei Diaghilev, who brought Russian ballet and art to the rest of Europe and European art to Russia. His *Ballets Russes* had profound influence and employed the best dancers and choreographers available. Basic to the *Ballets Russes* and its artists was the theory of artistic unity of all production elements. Dancing, according to the choreographer Fokine, should blend harmoniously with the theme and subject of the production. By 1917 the *Ballets Russes* reflected new directions, such as cubism, emerging in the visual arts, and utilized artists such as Picasso to design costumes. In 1924 a new choreographer was hired by Diaghilev, and George Balanchine became a premier force in ballet for the next sixty years, especially in early attempts to develop American ballet.

Parallel with Diaghilev's efforts in ballet came an entirely new direction, stemming principally from the theories and works of Isadora Duncan. From this tradition came the Denishawn Company of Ruth St. Denis and Dick Shawn. That company, in turn, spawned Martha Graham and Doris Humphrey. Modern dance held to no rules or conventions except to contrast itself with ballet. So, for example, while ballet sought to conceal effort, modern dance made it expressly revealed; while ballet was lyrical, modern dance was angular and jerky.

In architecture the early years of the twentieth century witnessed continuation of art nouveau and widespread experimentation with new forms and materials. Approaches and results were very diversified, and such diversity can be seen in the career of Frank Lloyd Wright. "Rational," "functional," "international," and "modern" are terms

which have been used in an attempt to describe directions in twentieth-century architecture. Structural expression and preoccupation with building materials dominated the early twentieth century. Of special importance was reinforced concrete. Poured concrete and new concepts in design also emerged in the works of Le Corbusier in the 1920's and 30's. For Le Corbusier a house was "a machine to be lived in." Probably the most philosophically integrated approach to architecture came in Germany in the mid-twenties through the Bauhaus School of Art, Applied Arts, and Architecture. Its philosophy sought to establish links between the organic and technical worlds. "Spatial imagination" became the objective.

The first fifteen years following the close of World War II were dominated by a style in painting called abstract expressionism, which spread rapidly throughout the world. Characterized, like most modern styles, by a great variation among individual artists, it exemplifies a freedom from traditional brushwork and an exclusion of representational subject matter. Illustrative, but not typical, is the "action painting" of Jackson Pollock. After, and in some cases as a reaction against the emotionalism of, abstract expressionism came an explosion of styles: pop art, op art, hard edge, minimal art, post-minimal art, environments, body art, earth art, video art, kinetic art, photo realism, and conceptual art.

Much contemporary sculpture shows similarity to abstract expressionist painting especially in its rejection of traditional materials in favor of new ones. Individualized shapes and action–stimulants have severed sculpture as much as possible from the natural world. However, objective reference is not unknown. "Found sculpture," "junk culture," pop, photo realism, minimalism, and ephemeral art have all made their mark on contemporary sculpture.

After World War II several distinctly different directions began to develop which tended further to polarize music along lines which had begun before the war. Two general tendencies have occurred: 1) toward control and formality; 2) toward less control of all elements to the point of random occurrences and total improvisation by performers. Milton Babbit and Pierre Boulez are examples of the former; Earl Brown and John Cage exemplify the latter. What often is referred to as a "mainstream" of musical composition also continued after the war, sometimes combining romanticism, folk themes, quartel harmonies, impressionism, and/or neoclassicism in various proportions. Styles stemming from traditional jazz also proliferated after the war, as did the use of and experimentation with electronic sound production, such as *musique concrète,* and electronic alteration of sound. Music which turned to other art disciplines also has been prevalent: theatre, conceptual art, minimalism, and the pursuit of the "new" have helped shape music since 1945.

Variety also marked theatre after the war. A significant postwar tradition was Berthold Brecht's Epic Theatre, which had considerable influence throughout the world. Also influential was a movement called absurdism, forged from the nonrealistic departures of Luigi Pirandello. Absurdism saw diverse approaches and interpretations, in some cases similar to sculptural minimalism, in which the audience was left to draw whatever conclusions they wished. Realism continued its influence, owing much of its strength to the works of Tennessee Williams and Arthur Miller. However, realism had expanded from its nineteenth-century definitions to include more theatrical approaches and devices. Theatre since the 1960's has remained vital due to its diversity. Reactions, such as The New Theatre, against the traditional commercial

theatre, and numerous attempts to redefine theatre itself have occurred. However, a strong link continues to exist between experiments, regional theatre, and "Broadway."

In an era in which interest in the cinema has reached new heights, especially in terms of serious study, film has turned in divergent directions. Mostly it has turned to feature-length entertainment aimed at profit making. The strengthening of labor unions and anti-trust rulings in the forties did much to reduce the influence and control of the "big studio." The character of American society in the McCarthy era virtually eliminated controversial subjects, while at the same time ruining numerous lives and careers. The sixties was an era of international film and the independent producer. Each film was an independent project in the hands of the director. Neorealism predominated in the "foreign film" tradition. The seventies and eighties have recognized film's aesthetic base as a legitimate art form and the legitamacy of both special-interest films and mass audience, profit-making fluff.

Dance since World War II continues its diverse and individualized directions in ballet, modern dance, and companies and programs combining the two traditions. Also noteworthy is a movement called jazz dance. The use of aleatory or chance elements has appeared in dance as well as the visual and other performing arts. Artists of significance in their own nondance disciplines have brought contemporary styles into the visual and musical aspects of dance.

World War II caused a ten-year break in architectural construction and to a certain extent separated what came after from what went before. However, the continuing careers of architects who had achieved significant accomplishment before the war bridged the gap from one period to another. The type of architecture exemplified by the "glass and steel box" continues prevalent, but highly individualized and creative works abound throughout the world. These might be as local and human in scale as a single-family residence or as all-encompassing as a university campus or an entire city such as Brazilia. Modern construction techniques and materials, as well as the daring creativity of contemporary architects, have pushed architecture toward and sometimes beyond the balance of aesthetics and practicality. Architecture, like all the arts, found in its brethren inspiration and support.

GLOSSARY

absolute music: music that is free from any reference to nonmusical ideas, such as a text or a program.

abstraction: a thing apart, that is, removed from real life.

accent: in music, a stress that occurs at regular intervals of time. In the visual arts, any device used to highlight or draw attention to a particular area, such as an accent color. See also *focal point*.

aereal perspective: the indication of distance in painting through use of light and atmosphere.

aesthetic distance: the combination of mental and physical factors that provides the proper separation between a viewer and an artwork; it enables the viewer to achieve a desired response.

affective: relating to feelings or emotions, as opposed to facts. See *cognitive*.

aleatory: chance or accidental.

arcade: a series of arches placed side by side.

arch: in architecture, a structural system in which space is spanned by a curved member supported by two legs.

aria: an elaborate solo song found primarily in operas, oratorios, and cantatas.

articulation: the connection of the parts of an artwork.

art song: a vocal musical composition in which the text is the principal focus.

atonality: the avoidance or tendency to avoid tonal centers in musical composition.

b

barrel vault (tunnel vault): a series of arches placed back to back to enclose space.

basilica: in Roman times a term referring to building function, usually a law court, later used by Christians to refer to church buildings and a specific form.

beats: in music, the equal parts into which a measure is divided.

binary form: a musical form consisting of two sections.

biomorphic: representing life forms, as opposed geometric forms.

bridge: a musical passage of subordinate importance played between two major themes.

c

cadence: in music, the specific harmonic arrangement that indicates the closing of a phrase.

capital: the transition between the top of a column and the lintel.

cast: see *sculpture.*

chamber music: vocal or instrumental music suitable for performance in small rooms.

chiaroscuro: light and shade. In painting, the use of highlight and shadow to give the appearance of three-dimensionality to two-dimensional forms. In theatre, the use of light to enhance the plasticity of the human body or the elements of scenery.

chord: three or more musical tones played at the same time.

choreography: the composition of a dance work; the arrangement of patterns of movement in dance.

classic: specifically referring to Greek art of the 5th century B.C.

classical: adhering to traditional standards. May refer to Greek and Roman art or any art in which simplicity, clarity of structure, and appeal to the intellect are fundamental.

cognitive: facts and objectivity as opposed to emotions and subjectivity. See *affective.*

collage: an artwork constructed by pasting together various materials, such as newsprint, to create textures or by combining two- and three-dimensional media.

composition: the arrangement of line, form, mass, color, and so forth in a work of art.

conjunct melody: in music, a melody comprising notes close together in the scale.

consonance: the feeling of a comfortable relationship between elements of a composition, in pictures, sculpture, music, theatre, dance, or architecture. Consonance may be both physical and cultural in its ramifications.

contrapposto (counterpoise): in sculpture, the arrangement of body parts so that the weight-bearing leg is apart from the free leg, thereby shifting the hip/shoulder axis.

conventions: the customs or accepted underlying principles of an art.

Corinthian: a specific order of Greek columns employing an elaborate leaf motif in the capital.

cornice: a crowning, projecting architectural feature.

corps de ballet: the chorus of a ballet ensemble.

counterpoint: in music, two or more independent melodies played in opposition to each other at the same time.

crosscutting: in film, alternation between two independent actions that are related thematically or by plot to give the impression of simultaneous occurrence.

curvilinear: formed or characterized by curved line.

cutting within the frame: changing the viewpoint of the camera within a shot by moving from a long or medium shot to a close-up, without cutting the film.

d

denouement: the section of a play's structure in which events are brought to a conclusion.

disjunct melody: in music, melody characterized

by skips or jumps in the scale. The opposite of *conjunct melody*.

dissonance: the occurrence of inharmonious elements in music or the other arts. The opposite of *consonance*.

dome: an architectural form based on the principles of the arch in which space is defined by a hemisphere used as a ceiling.

doric: a Greek order of column having no base and only a simple slab as a capital.

drames bourgeois (bourgeois drama): pseudo-serious plays utilizing middle-class themes and settings, with emphasis on pathos and morality.

e

eclecticism: a style of design that combines examples of several differing styles in a single composition.

empathy: emotional–physical involvement in events to which one is a witness but not a participant.

engaged column: a column, often decorative, which is part of and projects from a wall surface.

en pointe: see *on point*.

entablature: the upper portion of a classical architectural order above the column capital.

entr'acte: between acts.

ephemeral: transitory, not lasting.

étude: literally, a study, a lesson. A composition, usually instrumental, intended mainly for the practice of some technique.

f

farce: a theatrical genre characterized by broad, slapstick humor and implausible plots.

focal point (focal area): a major or minor area of visual attraction in pictures, sculpture, dance, plays, films, landscape design, or buildings.

foreground: the area of a picture, usually at the bottom, that appears to be closest to the respondent.

form: the shape, structure, configuration, or essence of something.

found object: an object taken from life that is presented as an artwork.

fresco: a method of painting in which pigment is mixed with wet plaster and applied as part of the wall surface.

fugue: originated from a Latin word meaning "flight." A conventional musical composition in which a theme is developed by counterpoint.

g

gailliard: a court dance done spiritedly in triple meter.

genre: a category of artistic composition characterized by a particular style, form, or content.

geometric: based on man-made patterns such as triangles, rectangles, circles, ellipses, and so on. The opposite of *biomorphic*.

groin vault: the ceiling formation created by the intersection of two tunnel or barrel vaults.

h

harmony: the relationship of like elements such as musical notes, colors, and repetitional patterns. See *consonance* and *dissonance*.

Hellenistic: relating to the time from Alexander the Great to the first century B.C.

heroic: larger-than-life size.

homophony: a musical texture characterized by chordal development supporting one melody. See *monophony* and *polyphony*.

hue: the spectrum notation of color; a specific, pure color with a measurable wavelength. There are primary hues, secondary hues, and tertiary hues.

i

intensity: the degree of purity of a hue. In music, theatre, and dance, that quality of dynamics denoting the amount of force used to create a sound or movement.

interval: the difference in pitch between two tones.

Ionic: a Greek order of column that employs a scroll-like capital with a circular base.

k

key: a system of tones in music based on and named after a given tone—the tonic.

kouros: an archaic Greek statue of a standing, nude youth.

l

labanotation: a system for writing down dance movements.

linear perspective: the creation of the illusion of distance in a two-dimensional artwork through the convention of line and foreshortening, that is, the illusion that parallel lines come together in the distance.

lintel: the horizontal member of a post-and-lintel structure in architecture.

m

melismatic: a single syllable of text sung on many notes.

melodrama: a theatrical genre characterized by stereotyped characters, implausible plots, and emphasis on spectacle.

melody: in music, a succession of single tones.

modulation: a change of key or tonality in music.

monophony: in music, a musical texture employing a single melody line without harmonic support.

montage: in the visual arts, the process of making a single composition by combining parts of other pictures so that the parts form a whole and yet remain distinct. In film, a rapid sequence of shots which bring together associated ideas or images.

monumental: works actually or appearing larger-than-life size.

Moog synthesizer: see *synthesizer.*

motive (motif): in music, a short, recurrent melodic or rhythmic pattern. In the other arts, a recurrent element.

musique concrète: a twentieth-century musical approach in which conventional sounds are altered electronically and recorded on tape to produce new sounds.

n

neoclassicism: various artistic styles which borrow the devices or objectives of classic or classical art.

nonobjective: without reference to reality; may be differentiated from "abstract."

nonrepresentational: without reference to reality; including *Abstract* and *Nonobjective.*

o

octave: in music, the distance between a specific pitch vibration and its double; for example, concert A equals 440 vibrations per second, one octave above that pitch equals 880, and one octave below equals 220.

on point: in ballet, a specific technique utilizing special shoes in which the dancer dances on the points of the toes. Same as *en pointe.*

opus: a single work of art.

organum: "singing together." Earliest form of polyphony in Western music.

p

palette: in the visual arts, the composite use of color, including range and tonality.

pas: in ballet, a combination of steps forming one dance.

pas de deux: a dance for two dancers.

pathos: the "suffering" aspect of drama usually associated with the evocation of pity.

pediment: the typically triangular roof piece characteristic of classical architecture.

perspective: the representation of distance and three-dimensionality on a two-dimensional surface. See also *linear perspective* and *aereal perspective.*

plainsong (plain chant): referring to various types of medieval liturgical music sung without accompaniment and without strict meter.

plasticity: the capability of being molded or altered. In film, the ability to be cut and shaped. In painting, dance, and theatre, the accentuation of dimensionality of form through chiaroscuro.

polyphony: see *counterpoint*.

polyrhythm: the use of contrasting rhythms at the same time in music.

post-and-lintel: an architectural structure in which horizontal pieces (lintels) are held up by vertical columns (posts).

program music: music that refers to nonmusical ideas through a descriptive title or text. The opposite of *absolute music*.

prototype: the model on which something is based.

r

rake: to place at an angle. A raked stage is one in which the stage floor slopes slightly upward from one point, usually downstage, to another, usually upstage.

recitative: sung dialogue, in opera, cantata, and oratorio.

relief: see *sculpture*.

representational: objects which are recognizable from real life.

Requiem: a Mass for the dead.

rhythm: the relationship, either of time or space, between recurring elements of a composition.

s

saturation: in color, the purity of a hue in terms of whiteness; the whiter the hue, the less saturated it is.

scale: in music, a graduated series of ascending or descending musical tones. In architecture, the mass of the building in relation to the human body.

scenography: the art and study of scenery design for the theatre and film.

sculpture: a three-dimensional art object. Among the types are: 1. *cast:* having been created from molten material utilizing a mold. 2. *relief:* attached to a larger background. 3. *statuary:* freestanding.

statuary: see *sculpture*.

strophic form: vocal music in which all stanzas of the text are sung to the same music.

stylobate: the foundation immediately below a row of columns.

symmetry: the balancing of elements in design by placing physically equal objects on either side of a center line.

syncopation: in a musical composition, the displacement of accent from the normally accented beat to the offbeat.

synthesizer (also called Moog synthesizer): an electronic instrument that produces and combines musical sounds.

t

tempo: the rate of speed at which a musical composition is performed. In theatre, film, or dance, the rate of speed of the overall performance.

texture: in visual art, the two-dimensional or three-dimensional quality of the surface of a work. In music, the melodic and harmonic characteristics of the composition.

theatricality: exaggeration and artificiality; the opposite of *verisimilitude*.

theme: the general subject of an artwork, whether melodic or philosophical.

timbre: the characteristic of a sound that results from the particular source of the sound. The difference between the sound of a violin and the sound of the human voice is a difference in timbre, also called *tone color*.

toccata: a composition usually for organ or piano intended to display technique.

tonality: in music, the specific key in which a composition is written. In the visual arts, the characteristics of value.

tondo: a circular painting.

tonic: in music, the root tone (*do*) of a key.

tragicomedy: a drama combining the qualities of tragedy and comedy.

tragedie bourgeois: see *drame bourgeois*.

tunnel vault: see *barrel vault*.

tutu: a many-layered, bell-shaped crinoline skirt worn by a ballerina.

tympanum: the open space above the door beam and within the arch of a medieval doorway.

V

value (value scale): in the visual arts, the range of tonalities from white to black.

variation: repetition of a theme with minor or major changes.

verisimilitude: the appearance of reality in any element of the arts.

virtuoso: referring to the display of impressive technique or skill by an artist.

BIBLIOGRAPHY

ANDERSON, JACK, *Dance*. New York: Newsweek Books, 1974.

ARNOTT, PETER D., *An Introduction to the Greek Theatre*. Bloomington, Ind.: Indiana University Press, 1963.

BENTLEY, ERIC, ED., *The Classic Theatre* (four vols.). Garden City, N.Y.: Doubleday Anchor Books, 1959.

BOHN, T. W., R. L. STROMGREN, AND D. H. JOHNSON, *Light and Shadows, A History of Motion Pictures* (2nd ed.). Sherman Oaks, Cal.: Alfred Publishing Co., 1978.

BORROFF, EDITH, *Music in Europe and the United States: A History*. Englewood Cliffs, N.J.: Prentice–Hall, Inc., 1971.

BRINDLE, REGINALD SMITH, *The New Music: The Avant-Garde since 1945*. London: Oxford University Press, 1975.

BROCKETT, OSCAR G., *History of the Theatre*. Boston: Allyn and Bacon, Inc., 1968.

CHENEY, SHELDON, *The Theatre: Three Thousand Years of Drama, Acting, and Stagecraft* (rev. ed.). New York: Longmans, Green, 1952.

CHUJOY, ANATOLE, *Dance Encyclopedia*. New York: Simon and Schuster, Inc. 1966.

CLARKE, MARY, AND CLEMENT CRISP, *Ballet*. New York: Universe Books, 1973.

CLOUGH, SHEPARD B. *et al.*, *A History of the Western World*. Boston: D. C. Heath and Co., 1964.

COPE, DAVID H., *New Directions in Music*. Dubuque, Iowa: William C. Brown Company, 1981.

CORYELL, JULIE, AND LAURA FRIEDMAN, *Jazz–Rock Fusion*. New York: Delacorte Press, 1978.

CROCKER, RICHARD, *A History of Musical Style.* New York: McGraw–Hill Book Company, 1966.

ERNST, DAVID, *The Evolution of Electronic Music.* New York: Schirmer Books, 1977.

FLEMING, WILLIAM, *Arts and Ideas.* New York: Henry Holt and Co., Inc., 1960.

FREEDLEY, GEORGE, AND JOHN REEVES, *A History of the Theatre* (3rd ed.). New York: Crown Publishers, 1968.

GILBERT, CREIGHTON, *History of Renaissance Art throughout Europe: Painting, Sculpture, Architecture.* New York: Harry N. Abrams, Inc., 1973.

GOETHE, JOHANN WOLFGANG, *Faust: Part I,* trans. Philip Wayne. Baltimore: Penguin Books, 1962.

GRIFFITHS, PAUL, *A Concise History of Avant-Garde Music.* New York: Oxford University Press, 1978.

GROUT, DONALD JAY, *A History of Western Music* (rev. ed.). New York: W. W. Norton and Co., Inc., 1973.

HAMILTON, GEORGE HEARD, *Nineteenth and Twentieth Century Art: Painting, Sculpture, Architecture.* New York: Harry N. Abrams, Inc., 1970.

HARTT, FREDERICK, *Art* (2 vols.). Englewood Cliffs, N.J.: Prentice–Hall, Inc. and New York: Harry N. Abrams, Inc., 1979.

HEWITT, BARNARD, *Theatre U.S.A..* New York: McGraw–Hill Book Company, 1959.

HITCHCOCK, HENRY–RUSSELL, *Architecture: Nineteenth and Twentieth Centuries* (Pelican History of Art). Baltimore: Penguin Books, 1971.

HOPPIN, RICHARD H., *Medieval Music.* New York: W. W. Norton and Co., Inc., 1978.

JACOBS, LEWIS, *An Introduction to the Art of the Movies.* New York: Noonday Press, 1967.

JANSON, H. W., *A Basic History of Art* (2nd ed.). Englewood Cliffs, N.J.: Prentice–Hall, Inc. and New York: Harry N. Abrams, Inc., 1981.

KARSAVINA, TAMARA, *Theatre Street.* New York: E. P. Dutton, 1961.

KNIGHT, ARTHUR, *The Liveliest Art: A Panoramic History of the Movies* (rev. ed.). New York: Macmillan, Inc., 1978.

LAWLER, LILLIAN, *The Dance in Ancient Greece.* Middletown, Conn.: Wesleyan University Press, 1964.

LEISH, KENNETH W., *Cinema.* New York: Newsweek Books, 1974.

LIPPARD, LUCY R., *Pop Art.* New York: Oxford University Press, 1966.

MACHIAVELLI, NICCOLO, *The Prince,* trans. George Bull. Baltimore: Penguin Books, 1963.

MARTIN, JOHN, *The Modern Dance.* Brooklyn: Dance Horizons, 1965.

MCDONAGH, DON, *The Rise and Fall of Modern Dance.* New York: E. P. Dutton, Inc., 1971.

MCNEILL, WILLIAM H., *The Shape of European History.* New York: Oxford University Press, 1974.

MYERS, BERNARD S., *Art and Civilization.* New York: McGraw–Hill Book Company, Inc., 1957.

NICOLL, ALLARDYCE, *The Development of the Theatre* (5th ed.). London: Harrap and Co., Ltd., 1966.

NYMAN, MICHAEL, *Experimental Music: Cage and Beyond.* New York: Schirmer Books, 1974.

OSTRANSKY, LEROY, *Understanding Jazz.* Englewood Cliffs, N.J.: Prentice–Hall, Inc., 1977.

PIGNATTI, TERISIO, *The Age of Rococo.* London: Paul Hamlyn, 1969.

READ, HERBERT E., *Art and Society* (2nd ed.). New York: Pantheon Books, Inc., 1950.

ROBERTS, J. M., *History of the World.* New York: Alfred A. Knopf, Inc., 1976.

ROBINSON, DAVID, *The History of World Cinema.* New York: Stein and Day Publishers, 1973.

ROTHA, PAUL, *The Film Till Now.* London: Spring Books, 1967.

ROWELL, GEORGE, *The Victorian Theatre* (2nd ed.). Cambridge: Cambridge University Press, 1978.

SALZMAN, ERIC, *Twentieth-Century Music: An In-*

troduction. Englewood Cliffs, N.J.: Prentice–Hall, Inc., 1967.

SCHEVILL, FERDINAND, *A History of Europe*. New York: Harcourt, Brace and Co., Inc., 1938.

SORELL, WALTER, *Dance in Its Time*. Garden City, N.Y.: Doubleday Anchor Press, 1981.

_____, *The Dance Through the Ages*. New York: Grosset and Dunlap, Inc., 1967.

SPORRE, DENNIS J., *Perceiving the Arts*. Englewood Cliffs, N.J.: Prentice–Hall, Inc. 1981.

SOUTHERN, RICHARD, *The Seven Ages of the Theatre*. New York: Hill and Wang, 1961.

STAMP, KENNETH M. AND ESMOND WRIGHT, EDS., *Illustrated World History*. New York: McGraw–Hill Book Company, 1964.

TIRRO, FRANK, *Jazz: A History*. New York: W. W. Norton and Co., Inc., 1977.

WHEELER, ROBERT ERIC MORTIMER, *Roman Art and Architecture*. New York: Praeger Publishers Inc., 1964.

INDEX